$85.00
3/24/11

Encyclopedia of African American Artists

ENCYCLOPEDIA OF
AFRICAN AMERICAN ARTISTS

dele jegede

Artists of the American Mosaic

GREENWOOD PRESS

Westport, Connecticut • London

Library of Congress Cataloging-in-Publication Data

jegede, dele, 1945–

 Encyclopedia of African American artists / dele jegede.

 p. cm. — (Artists of the American mosaic, ISSN 1939–1218)

 Includes bibliographical references and index.

 ISBN 978–0–313–33761–1 (alk. paper)

1. African American artists—Biography—Dictionaries. 2. African American art—20th century—Dictionaries. 3. African American art—21st century—Dictionaries. I. Title.

N6538.N5J44 2009

700.89′96073—dc22

[B] 2008045604

British Library Cataloguing in Publication Data is available.

Library of Congress Catalog Card Number: 2008045604

ISBN: 978–0–313–33761–1

ISSN: 1939–1218

First published in 2009

Greenwood Press, 88 Post Road West, Westport, CT 06881

An imprint of Greenwood Publishing Group, Inc.

www.greenwood.com

Printed in the United States of America

∞

The paper used in this book complies with the Permanent Paper Standard issued by the National Information Standards Organization (Z39.48–1984).

10 9 8 7 6 5 4 3 2 1

This book is dedicated to Toyin Falola (Elenu Nlá!). His mouth is indeed big, but not nearly as big as his prodigious capacity for scholarship.

Contents

Preface

One of the primary objectives of *Encyclopedia of African American Artists* is to bring together, in one volume, black artists from the African Diaspora who have worked and lived, or continue to do so, in the United States. Comprised of 66 artists who work in a diverse array of media and manifest an even more diverse range of ideas, this book places at the disposal of students of art and culture the significant contributions of a category of artists who have made profound contributions to world art and enriched the creative fabric of American culture, but about whom much more remains unwritten and unexplored than has been published. Writing this book stemmed from the need to address the imbalance that exists in the way that black artists in the United States are presented in exhibition circuits but even more so in the literature. This imbalance is itself an outcome of the reluctance—some might even say condescension—of the art world to accord equal respect to all art, regardless of the racial origin of the artists.

There is a correlation between the frequency with which artists are granted access to dominant exhibition and gallery spaces and the volume of literature that is generated. Critical or biographic narratives about artists are, in turn, essential in shaping public awareness, perception, and appreciation of the works of artists, just as they are in empowering individuals to become more independent in the way that they formulate personal aesthetic preferences. Attempts at bringing the works of black artists to public attention have occurred on two important platforms. First, exhibitions and attendant catalogs provide perhaps the most intimate encounter with artists, especially if they give in their own words information about the philosophical or doctrinal basis for their work. The inherent disadvantage to this desirable aspect pertains to the potential unevenness in the quality and content of some exhibition catalogs, in addition to the limited circulation that many such catalogs have.

The second avenue through which the public becomes exposed to the work of black artists is publications either in journals or, more especially, books. One must acknowledge the impact of technology in this regard. The Internet offers a fluid, seamless field for generating and disseminating information within a relatively short pace in addition to having the power to reach a global audience with relatively minimum constraints. Personal Web pages and

associative Internet sources promote public access to individual artists. But they also have an unlimited capacity to distort and efface, and lend themselves so readily to manipulations and compromises. In some hands, these are converted into outright propaganda or self-promotion tools. There is, in principle, hardly anything wrong with the use of the Internet for self-aggrandizement, except that such an outcome runs counter to the objective of books and edited volumes, which strive to present information that is aimed at satisfying public appetite for verity. Relative to the number of black artists and the prodigious amount of work that black artists do, there is a paucity of scholarly publications. This is not meant to vitiate the heroic attempts by scholars, curators, and artists, mainly of African or African American extraction, whose work continues to fill a void. This development tends to suggest two things: either major publishers are unenthusiastic about investing in this area, or scholars are somewhat tepid about pursuing research in this field. A corollary of this problem is one that may be referred to as the silo effect, by which publications on black art and artists have remained almost exclusively within the purview of black artists and/or scholars. For black artists to receive their due recognition, high schools, colleges, and the general public need to have much wider access to information about the life and work of a diverse range of artists and become conversant with the context within which productivity thrives.

These are some of the justifications for *Encyclopedia of African American Artists*. It adopts a personal and companionable approach to writing about each artist, an approach that stems from the desire to humanize every one rather than present him or her as yet another figure who happens to be black. Most publications on artists rely heavily on visual tableaus as accompaniments to critical or analytical presentations. This method is deemed to be effective because such visual plates vivify points being made and allow readers to relate to issues of style, subject matter, and composition, among others. On the other hand, encyclopedic volumes or biographical entries on artists tend to operate from the other end of the pole: they are often economic with images and emphasize factuality and historical veracity in a brutally academic fashion that purges the subjects of life or vitality. This book uses both visuals and facts to paint lively textual images of the artists.

Their stories are told in a way that gives the reader an insight into the prevailing culture within which individual growth is enhanced or constrained. What are the familial threads that provided the initial creative fabric that galvanized some of these artists? In what ways did their childhood—the socialization process, the early education that they received, the political and cultural environment in which they grew, their immediate family and mentors—shape their emergence as artists? What specific elements spurred or dampened their quest for creative fulfillment? What has been the impact of culture and environment on their work? These are, in varying forms, some of the issues that this book attempts to bring to relief as it narrates the distinctive story of each artist.

The artists on this list are drawn from a broad spectrum of creative explorations and cultural affiliations. They come from Africa, the United States, and the Caribbean and work in media that span a wide field: from photography

to sculpture, installation to digital art. The list includes those artists who, as pioneers of a new creative idiom during the Harlem Renaissance, invented an appropriate language in response to the creative fervor that the time demanded. A good number of the artists received the highest formal education attainable in addition to forging their own individual syntax, while many of them created art in response to their inner vision and an unfettered creative impulse. Patchwork quilt, which has lately been endowed with a new attitude and a commanding presence, is included just as are figurative works and digital art, or art forms that are concerned with the sheer exploration of the cerebral orbit. **Horace Pippin** holds his own ground with **Henry Ossawa Tanner**, while the Egyptian **Ghada Amer** and the Nigerian-American **Donald Odili Odita** exemplify the multiplicity of perspectives and practices that are covered. Tested and familiar names such as **Jacob Lawrence, Elizabeth Catlett, Faith Ringgold, Martin Puryear**, and **Romare Bearden** share the same space with a new generation of artists—**Kara Walker, Wangechi Mutu**, Donald Odili Odita, **Marcia Kure**, and **Glenn Ligon**—whose work could be polemical or abrasive.

The inclusion of African artists was made with one stipulation: such artists must be resident in the United States. This was the tidiest way to have a handle on who is included from an array of contemporary African artists who, just like many of their counterparts elsewhere, remain largely unsung. The book makes one exception to the premise that everyone on the list must be an artist: it accords the scholar-ideologue the privilege of acknowledgment. Indeed, two such personalities are included because of the seminal roles that they have continued to play in initiating a new path that black artists must contemplate if they are to earn the respect of the art world. **David Clyde Driskell** is an artist of note whose inclusion in a book of this magnitude would not require any justification. But Driskell's role transcends his commitment to his art, which is a largely individual process. Beyond his art, he is highly regarded for his passion for the scholarship of art, especially his unrelenting quest for historicizing African American art, and for contextualizing current developments in the field. Equally compelling, especially with regard to his ability to galvanize artists of the Black Diaspora and map a stratagem for empowering them at the international arena, is **Okwui Enwezor**. He, probably more than any other individual in the last two decades or so, has catapulted black art to new heights through his work as curator, critic, and author.

The book is not just about well-established living or departed artists, important as their inclusion is. Indeed, a good number of those covered are relatively new. The determination to break away from parading yet another list of rehashed and recycled set of artists has been one of the significant breaks that this book offers. This quest resulted in poking for new trends and emerging artists. Here, "emerging" is used to connote not untested hands or unknown elements, but artists who are deserving of greater acknowledgment and national exposure than they have received. The process of marshaling information for the book entailed scouring exhibition catalogs, attending exhibitions whenever possible, tracking Web sites, calling artists, screening video recordings, contacting galleries and agents, and sending out numerous e-mail

messages. Even more exciting was getting to know many of the artists who are included in this volume at a personal level. Through exchange of correspondence and conversations, or through personal interviews conducted long distance or face-to-face, a closer understanding of the artists emerged. Follow-up conversations gave a sense of the distinctive personality of each artist that is not often projected or communicated through his or her work. It is hoped that this book has succeeded in capturing the individuality of each artist.

Encyclopedia of African American Artists is written for high school and college students. It is also aimed at the general public: those who are interested in learning about African and African American artists but who neither have the interest and time, nor the resources to dig into ponderous reference sources or dense treatises. This book presents in a readable language the dazzling mosaic of thoughts, inscriptions, and precepts that are expressed by the artists. The range of styles that they work in reflects the history and struggle, the spirit and the frustrations, the aspirations and affirmation of their collective individuality. While a considerably fertile harvest of literature on artists of the African Diaspora now exists, most of which dates back to less than a century, what has emerged is that the critique of black art has been essentialized largely by black scholars and artists. This book, which enables students and the general public to have ready access to authoritative biographies on black artists, contributes to our knowledge in this area.

This project builds upon the collective efforts of many who, over the years, have toiled to establish what has developed into a distinctive field of study. While *Encyclopedia of African American Artists* presents a robust array of artists working in an assortment of media, the concept of providing succinct narratives about them dates back to much earlier times. The seminal work that addressed the connections—spiritual, cultural, perceptual, and artistic among others—between black American artists and African art was Alain Locke's *The New Negro*, which was published in 1925, first in *Survey Graphic* magazine and later, as a result of high demand for it, as a book. Locke analyzed the American art scene in the first quarter of the twentieth century and came to a grim conclusion: "The Negro is a far more familiar figure in American life than in European, but American art, barring caricature and genre, reflects him scarcely at all" (Locke 1997, 262). His mandate to a fledgling coterie of African American artists was that they had so much to benefit from looking to Africa for inspiration. After all, it was the classical art of Africa that provided the "ferment in modern art" and the platform from which modern art took a giant leap.

What Locke was unable to address in his brilliant treatise was the homogenization of classical African art through a deliberate anonymization of the artists. It was relatively easy for Locke to reel off a list of European artists, including Matisse, Picasso, Derain, Modigliani, Pechstein, Stern, Marc, Archipenko, and Lipschitz as avatars of modern art. Yet, there was not a single artist from the continent of Africa whose controlled and disciplined abstractions Locke had extolled and recommended to black America. Locke simply did not have such information at his disposal because classical African art began, in the

estimation of early Euro-Americans, as non-art: as fetishes and mere curios produced by a group of brutes and savages. Those objects that found their way to European collections were rounded up in Africa and lumped together as mementoes and indulgencies furnished by the colonial project. Indeed, the scholarship of African art did not begin in earnest until the third decade of the twentieth century, when Carl Kjersmeier introduced a classificatory method that favored the group approach to the study of African art. Locke had no access to any specific African artist; the only way to relate to Africa was by identifying the art on the basis of location and group. Thus, there was Baule, Benin, Yoruba, Gabon, Bushongo, and Dogon art, but never a specific artist from the continent. This embedded prejudice reflects the disdainful attitude of the West to Africa and has impeded a desirable symbiotic relationship amongst artists of the African Diaspora.

The Harlem Renaissance owed as much to Locke's critical temper as it did to the Harmon Foundation, which, between 1928 and 1935, organized exhibitions that featured African American artists and produced catalogs that have now become significant archival treasures on many artists of that generation. The Harmon Foundation played a pivotal role in documenting the achievements of artists from both sides of the Atlantic. In addition to providing the most consistent support for black American artists, it also maintained contact with hundreds of them. In 1966, it undertook what was then unquestionably a bold and unprecedented move: it facilitated Evelyn Brown's publication, *Africa's Contemporary Art and Artists,* the first comprehensive documentation, which lists more than 300 artists from the African continent. One of the beneficiaries of the Harmon Foundation's commitment to highlighting the contributions of blacks in the visual arts was James A. Porter, a graduate of Howard University's art program, whose painting was recognized in a 1929 exhibition. Porter made his mark as a painter and exhibited widely. His major contribution to American art, however, lies is his research and scholarship. His 1943 publication, *Modern Negro Art,* was the culmination of a strong belief in the value of historical narratives that contextualized the contributions of black artists and painstakingly constructed profiles that were meant to stimulate pride in their achievements. Coming nearly two decades after Locke's *The New Negro,* Porter's publication was galvanized by the indignity that he felt at the falsehood that was being perpetrated at that time, to the effect that blacks had no art.

Unfortunately, the African Diaspora has not been able to replicate Evelyn Brown's vision. From time to time, contemporary African artists continue to be invited to exhibit in the United States—by galleries, universities, major museums, private art galleries, or individuals and art organizations. Two institutions stand out in the extent to which they have used institutional facilities and clout to support the production of African and African American artists in the United States. The National Museum of African Art at the Smithsonian Institution in Washington, DC, has, since its inception in the late 1980s, been at the vanguard of promoting contemporary African art. In 1993, Bernice M. Kelly and Janet Stanley published *Nigerian Artists: A Who's Who and Bibliography,* which remains the main comprehensive work in this area. Perhaps more enterprising is the Studio Museum in Harlem. Since 1968, it has remained the

dominant platform for all African and African American art. Its major 1990 exhibition on contemporary African art, which was curated by Grace Stanislaus, sensitized the American public to significant work being done by contemporary African artists.

Encyclopedia of African American Artists is not just about the art; it is about the artists. It is about the passion that culminated in art and the art that speaks about epochs and ideas. This book is about black artists from the many sides of the Atlantic divide for whom the United States of America remains a space for creative experimentation.

Acknowledgments

Although I am ultimately responsible for the outcome of this book, I cannot claim sole success for all the work that went into it. From its inception to its completion, various people—friends, family members, colleagues, and primary sources—stepped up and offered assistance in a variety of ways. Toyin Falola's initial challenge actuated what has become an exciting project. This book cannot be divorced from one of those brain waves that he regularly indulges himself in. From inception, Debra Adams provided advice and guidance in ways that combined astute professionalism with understanding. The beginning of this project coincided with my relocating from one institution in Indiana to another in Ohio. Familiarizing myself with the culture in my new station was challenging enough. Added to that was the task of undertaking the research on which this book would be based. Debby's understanding proved pivotal in my commitment to this project and her persistent and friendly "nag" proved to be a winning elixir.

Larry Collins furnished me with a wealth of information that resulted in abundant yields and ultimately enhanced the quality of this book. In Ohio, where he has an intimate knowledge of the art scene, he led me to uncover a fertile field that is populated with artists who deserve more than regional prominence. I am indebted to Collins for placing at my disposal his personal files containing precious archival information on some of the artists, for the contacts that he facilitated, and for sharing with me information that will otherwise be difficult to procure. It was through Collins that I met **Ed Colston,** a supreme colorist and disciplined extrapolator who excelled in the art of reducing complex notions to simple but effective abstract symbols. It was exhilarating to have met Colston in his studio in Columbus, where we he granted me an interview and where we traded banters as if we were long-lost kindred spirits. Less than three months after our first encounter, the follow-up that he demanded, and which I looked forward to paying with eagerness, was aborted by fate: Colston passed on to the great beyond. My gratitude goes to his widow Billie Colston for graciously assisting me with my research on Colston.

Several individuals deserve my gratitude for responding to my enquiries, and for the efforts that they put into supplying me with helpful information, exhibition catalogs, and photographs. Among this group are Karen Del Aguila,

Wangechi Mutu's studio manager; Mike Weiss and Alison Zingaro of Mike Weiss Gallery; **Kara Walker**; **Barbara Nesin**; **Obiora Udechukwu**; **Marcia Kure**; **Sonya Clark**; **Donald Odili Odita**; and **Wosene Kosrof**. Ellen Price opened her studio to me and shared with me information about her family and childhood in ways that illuminated her art. To these and many more, my gratitude is due. I am particularly thankful to my colleague at Michigan State University, Professor Assefa Mehretu, who facilitated my contact and interview with Julie Mehretu. It is such acts of kindness as this that one finds difficult to sufficiently reciprocate. Getting to know **Lalla Essaydi** was as enlightening as seeing her work. Beyond the initial contact, Essaydi remained steadfast in sharing with me information about her creative escapades. She also helped a great deal during the interview in explaining concepts and ideas regarding the confluence of Arabic, Islamic, and African cultures that she embodies. Even more impressive is her enculturation into Western culture and the extent to which her art has become emblematic of our quest for global understanding. To my friend and colleague, **Carolyn Mazloomi**, I am thankful for the understanding and tolerance shown. Visiting with her in her studio provided me the necessary background against which her quilts assumed immense status.

In the summer of 2006, I took advantage of my visit to **Benny Andrews**'s exhibition in New York to request through his gallery for an interview. A few days later, Andrews called, and we had a discussion that left an indelible impression on me for his forthrightness and pragmatism. A few weeks later, Andrews's formal response came in the form of a bulky carton containing a rich trove of publications, many of which are so specific and rare that only the artist could have parted with them. Unfortunately, my relationship with Andrews was terminated by his demise a few months later. Among those whose help I cherish is **Mel Edwards**. I am indebted to him for so generously giving of his time, and for allowing me to benefit from his encyclopedic knowledge of the field. Edwards is the epitome of the black artist. With deep roots in the United States and tentacles in Africa, where he has continued to work and impact many lives, Edward speaks through his art what he lives in actuality. He continues to plough back into Africa as much as he has received from the continent.

Photographs are essential to a book of this type, and the task of tracking the right photographs and obtaining appropriate rights could be challenging. My deep appreciation goes to Elizabeth Kincaid and members of her team for her competence in handling this aspect of the book. In the process of working on this book, I have come to admire the friendliness and forthrightness of Matthew Van Atta; he took the tedium out of copyediting and offered professional assistance of inestimable value. I am also grateful to the library staff at the Wertz Art and Architecture Library, Miami University, Ohio, for their unwavering support and enthusiasm. The librarian, Stacy Brinkman, deserves my gratitude for her selflessness and professional knowledge.

Above all, I am indebted to my wife, Joke, for her patience, tolerance, and encouragement. Nudging me during those times when I felt overwhelmed and was inclined to let down my guard, serving as my companion during most

of the exhibition trips and interview sessions, and infusing me with a constant dose of enthusiasm: all of this made this a worthwhile project. To my loving children—Ronke, Tolu, Ayo, and Laolu—your encouragement and unwavering enthusiasm worked. In particular, Tolu deserves my appreciation for allowing me to bully him into doing much-needed editorial work on several drafts, and for his unstinted assistance and willingness to debate those arcane aspects of syntax and respect for simple mechanics.

A

Ghada Amer (b. 1963), Painter, Sculptor, Installation Artist.

At many levels, Ghada Amer personifies the African artist in exile. A fusion of multiple cultures and a catalyst for new perspectives for perceiving and engaging old and incipient conundrums, Amer brings to her work in subtle and overt ways complex, multicultural, and multi-nuanced issues and splays them out in a new medium that speaks volumes about her own feminism. As an African and female painter in a world that privileges white male artists, and as a Muslim who has lived in and become acculturated into Western lifestyle, Amer's work stirs debate in Western exhibition circuits as much as it draws concerns in Egypt, her home country. Amer works as a painter and installation artist and favors threads and colors on canvas, or soft sculpture with printed text. For her paintings, Amer appropriates images of women from pornographic magazines and places multiple versions of them in stitched outlines on canvas. Loose threads of assorted colors, which are glued to the canvas with a clear gel, are deliberately allowed to run over the canvas in ways that give an all-over pattern, initially appearing to obfuscate images of the women. Amer's women are usually positioned in sexually explicit poses. They assume seductive postures—fondling their breasts or one another, exposing their genitals, masturbating, or otherwise engaged in erotic activities.

In making art, Amer is also making a bold statement about societal values: on the one hand, about what she perceives as the puritanical dictates of Islamic leaders in Egypt; and on the other, about Western feminism that tends to deny women the pleasures that should be customarily associated with their gender: "I totally reject the 'old' feminist attitude toward the female body: women should behave like men and despise make-up, mini-skirts and seduction" (Auricchio 2001). At yet another level, her work critiques the male dominance of painting, with the associative power of the medium to dictate dominant movements. "This history of art," in her words, "was written by men, in practice and in theory. Painting has a symbolic and dominant place inside this history, and in the twentieth century it became the major expression of masculinity, especially through abstraction." Amer was not content to issue an "artist statement"; it was a "Feminist Artist Statement," in which she lays claim to, at least in part, the territory that has been traditionally occupied by the Western male painter:

For me, the choice to be mainly a painter and to use the codes of abstract painting, as they have been defined historically, is not only an artistic challenge: its main meaning is occupying a territory that has been denied to women historically. I occupy this territory aesthetically and politically because I create materially abstract paintings, but I integrate in this male field a feminine universe: that of sewing and embroidery. By hybridizing those worlds, the canvas becomes a new territory where the feminine has its own place in a field dominated by men, and from where, I hope, we won't be removed again. I integrate this same feminine universe into my gardens.

(Brooklyn Museum 2008)

As one who was born into the Islamic religion, Amer has been deferential to the tenets of her faith in her work. An example was her 1999 installation *Private Rooms,* which was comprised of a rack of soft bags of satin clothes on which quotes from the Quran were inscribed. For this work, Amer ferreted the Quran for all references to women, which she translated into French before embroidering them onto the surfaces. By translating the relevant quotes into French, Amer deliberately demonstrates her awareness of the sacrosanctity of any Quranic text written in Arabic. This gesture has, however, done relatively little to stem the harshness of the criticism that Islamic constituencies have leveled at her work. Amer insists that her art and the "feminist" reading that it draws is neither meant to draw attention to herself nor show that she is a porn addict. "I am actually a prude. . . . I started doing it for myself. I wanted to break my own barrier, not the barriers of the West or the Muslim world. Everybody loves to see me as a Muslim, but they don't see it's not about Islam, it's about something else. I'm not trying to shock, it's not perverse, I'm not doing this with a political agenda. It just happens that I'm Muslim and a woman" (Kolesnikov-Jessop 2007).

Ghada Amer, New York City, 1997. Photo by John Jonas Gruen/Hulton Archive/Getty Images.

Amer was born into a Muslim family in Cairo, Egypt, in 1963. As a teenager, she moved with her family to France in the 1970s, where she earned a B.F.A. in 1986, followed by an M.F.A. in painting in 1989 from Ecole Pilote Internationale d'Art et de Recherche, Villa Arson Epiar, in Nice, France. She also studied at the Museum of Fine Arts in Boston and the Institut des Hautes Etudes in Arts Plastiques in Paris. In 1999, she was artist-in-residence at the School of the Art Institute of Chicago. She has received significant grants and awards, including the 1997 Pollock-Krasner Foundation grant and the 1999 UNESCO award at the Venice Biennale. Her sojourn in Europe and North America has highlighted her position as an exile. While her work is viewed with concern and, sometimes, outright disapproval in Egypt, she has earned professional recognition in the West. Yet, this has not been without

the constant reminder of her status, which almost always emphasizes her status as an émigré: a woman identified with a religion but who in her work engages in a constant critique of the interpretation of that religion; an artist who is embraced by the West, perhaps because she has found a way of unleashing the insatiable urge for sexual indulgence of her audience, but who is repulsed by the feminist agenda that spawned the libidinousness that her audience condones.

Since she relocated to New York in 1996, Amer has participated in major group and solo exhibitions in Asia, Europe, Africa, and North America. Among the numerous venues where she had solo exhibitions are the San Francisco Art Institute; De Appel Foundation, Amsterdam; Indianapolis Museum of Art, Indiana; Gagosian Gallery, New York; and Institut Valencia d'Art Modern, Spain. She has taken part in several group exhibitions, including those at the Mori Art Museum, Tokyo; Espace Karim Francis, Cairo; Deste Foundation Centre for Contemporary Art, Athens; the National Museum of African Art at the Smithsonian Institution in Washington, DC; Institute of International Visual Arts, London; P.S. 1, New York; and Queens Museum of Art in New York. Her participation in international biennales include the 1995 Istanbul Biennale; the 1997 Johannesburg Biennale in South Africa; the 1999 Venice Biennale; the 2000 Kwangju Biennale in South Korea; the 2000 Whitney Biennial; and the 2005 Venice Biennale.

Places to See Amer's Work

Art Institute of Chicago, Chicago, IL
Birmingham Museum of Art, Birmingham, AL
Centre Pompidou, Paris, France
Leeum, Samsung Museum of Art, Seoul, Korea
Museum Kunst Palast, Düsseldorf, Germany
Tel Aviv Museum of Art, Tel Aviv, Israel

Bibliography

Amer, Ghada, Sahar Amer, and Olu Oguibe. *Ghada Amer.* Catalog of an exhibition held at De Appel Amsterdam from April 5 through May 19, 2002. Amsterdam: DeAppel Amsterdam, 2003.

Aurrichio, Laura. "Works in Translation: Ghada Amer's Hybrid Pleasures." *Art Journal* 60, no. 4 (Winter 2001): 26–37.

Brietz, Candice. *Ghada Amer: Critical Stands.* Kassel: Museum Fridericianum, 1998.

Brooklyn Museum. "Elizabeth Sackler Center for Feminist Art. Feminist Art Base. Ghada Amer." July 21, 2008. http://www.brooklynmuseum.org/eascfa/feminist_art_base/gallery/ghada_amer.php.

Enwezor, Okwui, ed. *The Short Century: Independence and Liberation Movements in Africa.* New York: Prestel, 2001.

Farrell, Laurie Ann. *Looking Both Ways: Art of the Contemporary African Diaspora.* New York: Museum for African Art; Gent: Snoeck, 2003.

Kolesnikov-Jessop, Sonia. "Ghada Amer: Defusing the Power of Erotic Images." *International Herald Tribune,* March 13, 2007.

Martinez, Rosa. "*No Limits:* A Triptych—Ghada Amer, Gregor Zivic, and Carl Michael von Hausswolff." *Flash Art* (January–February 2000): 80–82, 86.

National Museum of African Art. "Textures: Words and Symbol in Contemporary African Art." Smithsonian Institution, July 21, 2008. http://africa.si.edu/exhibits/textures/full-amer.html.

Oguibe, Olu. "Love and Desire: The Art of Ghada Amer." *Third Text* 55 (Summer 2001): 63, 74.

———. "The Regarded Self." In *Ghada Amer.* Amsterdam: DeAppel, 2003.

Rattenmeyer, Christian. "Feminine Feminism." *Culturebase,* July 21, 2008. http://www.culturebase.net/artist.php?1316.

Schwabsky, Barry. "Ghada Amer." *Art Forum,* September 1996.

Sheets, Hilarie M. "Stitch by Stitch, a Daughter of Islam Takes on Taboos." *New York Times,* November 25, Arts section, 33.

Olu Amoda (b. 1959), Sculptor, Installation Artist.

Olu Amoda's art is an unapologetic reflection of three tiers of social experience: street, city, and cosmos. These are the tiers that have shaped his growth as a child in Okere-Warri, his ancestral village in the Delta area of Nigeria. These tiers have exerted considerable influence on his professional growth in Lagos and the United States.

Amoda grew up as a child on the streets of Okere, near the city of Warri, in an atmosphere that was dominated by the inescapable influence of total arts. In Okere as in Warri, festivals provided the arena for the ultimate spectacle in which the synergy of the arts was experienced, with colorful masquerades providing the central impetus. Dance, music, poetry, and athleticism became the necessary complements that highlighted the visual hierarchy of masks, costumes, and colors. Children learned to grow up on the streets, much to the chagrin of their parents who felt, quite understandably, that the fluid, unsupervised activities on the streets did not augur well for healthy development of their children. For the children, the streets were the inevitable arenas for extracurricular growth; they are the platform, away from the preening eyes of teachers and parents, where children-organized competitions in the verbal and visual arts among many were fierce, and battles for bragging rights were quite intense. Amoda placed his art at the service of masquerades such as "olisha" and "oki" by helping to apply colors to selected headdresses. Survival of the harsh streets of Okere-Warri, where insolence was elevated to an art from known as "stroking," was earned through success at the various competitions, and Amoda found refuge in the visual arts.

Amoda comes from a considerably large family in which immersion in the arts was standard. He was born on February 6, 1959, to Ali Amoda and Nesumiji Anukpe Amoda, both of whom are deceased. His father, a highly visible public figure and confidant of the monarch of Warri, was a successful goldsmith and property speculator who had 14 wives and 42 children. Amoda, the last of his mother's six children, is 17th on the list of his father's children.

His mother was a popular gourmet whose cuisine was savored by every kid who ate at her public stall. After elementary school at the Government Primary School, Amoda attended St. Peter Claver's High School at Agahalokpe, near Sapele, from 1972 to 1975. He entered Auchi Polytechnic in 1979 to study sculpture, after his initial quest to pursue architecture failed. In 1983, at the completion of the Ordinary National Diploma (OND) and Higher National Diploma (HND), Amoda moved to Lagos. There he encountered yet another dimension of the street phenomenon: in contradistinction to the open and borderless streets of Okere-Warri, Amoda met a city that was under siege from armed robbers. While most streets were gated and policed by vigilante groups, almost every building, especially in the once-stable high-class residential areas and the emerging sprawls, was shielded by tall cinder walls crowned by menacing lines of spikes, barbed wire, or jagged pieces of bottle. Every building of note became an impenetrable fortress with fortified windows and menacing gates, most of which were fashioned by craftsmen who made no claims about any aesthetic doctrines.

Olu Amoda. Courtesy of dele jegede.

After the initial culture shock that he experienced upon moving to Lagos subsided, Amoda began to assert his creative individuality; he began to create sculptures from found steel and iron objects, which he transformed with welding. This transformative process, which entails endowing a spent force with new vigor, is an apt metaphor for Amoda's encounter with the city of Lagos. Moving from Okere-Warri, with its seamless but ever-relevant streets through which kids organize and process their own rites of passage, to Lagos, with its forbiddingly dense population and a corresponding lack of security, gave Amoda the impetus for a new art form, one that accommodated his penchant for weight and large-sized sculptures. The rise in crime rate was met with a corresponding height in the fences and gates built by homeowners. As armed robbers operated with undeterred recklessness, even in broad daylight, Amoda rationalized that they succeeded in inverting the unwritten social norm: through their brazen and often unchallenged activities, robbers effectively incarcerated owners while they roamed the streets freely and uninhibited. The necessity to respond to this social menace led to the creation of burglarproof gates and windows, which he christened "Doors of Paradise" and "Windows of Dreams," respectively. With this, Amoda chose to make the streets of Lagos his gallery. Prior to this development, Amoda had to pull out of some exhibitions in protest of the poor and unprofessional way in which his relief sculptures were displayed. On their part, galleries were concerned

about the weight and size of Amoda's relief sculptures, which they considered rather cumbersome and difficult, if not unsafe, to hang. "Doors of Paradise" offered what appeared to be a satisfactory solution to this dilemma.

Nzegwu (1999) emphasizes the duality of Amoda's novel idea, which proffers an aesthetic solution to a social terror: Amoda's sculpture, Nzegwu avers, is a living art. "Each door and window he created is an original design, employing heavy steel bars and thick gauge sheet metals, and then tastefully fortified with heavy found-metal parts. Completed, they look like three-dimensional drawings grandly sketched into the gap that once served as windows or doors." Within this context, Amoda's work represents a continuum of the classical African concept of art that does not belabor the distinction between aesthetics and functionality. Amoda's doors and gates thus occupy the same creative and intellectualized precinct as some of the elegant and imposing architectural mansions that have sprouted up in Lagos and, indeed, other major cities in Nigeria especially since the military rudely inserted itself into the political life of the country. In addition to the functional approach to aesthetics, Amoda continues to investigate second lives and the transformation of materials. His work thrives on discarded materials, which are salvaged from junkyards, picked from streets, or donated by friends.

In 2006, Amoda moved to Appalachian State University in Boone, North Carolina, for a one-year residency. There, the third tier of his social experience blossomed. Although he has traveled to European and African countries—Austria, France, Germany, Kenya, Senegal, and Kenya—to conduct workshops, the Appalachian residency was the first opportunity for Amoda to create and experience art on a much more expansive and universal scale. His residency unleashed a new creative spirit. The radical shift in location imposed its own limitations on availability of scraps and other discarded materials. Amoda responded by outright purchase of small, portable items like nails, or by soliciting items such as unusable keys from students and colleagues. The sculptures that he produced during his residency are dazzling, bejeweled pieces that resonate with spatial fragrance and a lighthearted playfulness. In contradistinction to his gates, doors, and representational relief or freestanding works of the past, Amoda was able to tease the essence of his new materials and play up their strength. Two pieces that represent this phase are *Ice Cream* (2006) and *Face I* (2006), both of which were fashioned from hinges and nails that appear held together by a magical substance over an armature. While the origin of this new stylistic thrust dates back to the early 2000s, when he began using spent nails and other linear scraps, it is in Boone that Amoda was able to articulate a wholesome aesthetic agenda that frees him from his penchant for huge, cumbersome pieces. In this new aesthetic, nails are immensely privileged over other objects. Explaining the value of nails as employed in his 2003 *Queen of the Night,* which was one of the items that were on display at the Victoria and Albert Museum in London in the fall of 2007, Amoda stated that he uses nails as a metaphor because they are a piece of engineering that have survived because of their ruggedness. Furthermore, "[n]ails depend on the notion of shared responsibilities, like ants. Small but lethal, a nail is able to defend itself, but yields to will of the craftsman. What we call little things

are merely the causes of great things: they are the beginning, the embryo and the point of departure, which generally speaking, decides the whole future of an existence."

Amoda, who is now a resident of the United States, has had numerous exhibitions in Africa and the West. In 2007, he held his first solo exhibition at the Skoto Gallery in New York. His work is in the New Jersey Museum collection and on display on major corporate premises and individual mansions in Nigeria.

Places to See Amoda's Work

French Cultural Center, Lagos, Nigeria
Gates and windows in major cities in Nigeria, including Lagos, Ikeja, Warri, Benue, Ibadan, Ijebu-Ode, and Abuja
National Council for Arts and Craft, Lagos, Nigeria
National Gallery of Modern Art, Lagos, Nigeria
The Newark Museum, Newark, NJ
Signature Gallery, Lagos, Nigeria
Yaba College of Technology, Lagos, Nigeria

Bibliography

Amoda, Olu. "Interview." *Glendora Review: African Quarterly on the Arts, Lagos* 3, no. 1 (2000): 77–89.
———. Interview by author, Liberty Township, Ohio, March 25, 2007.
Fall, N'goné, and J. L. Pivin, ed. *An Anthology of African Art: The Twentieth Century.* New York: D.A.P. Distributed Art Publishers; Paris: Revue Noir Editions, 2002.
jegede, dele, ed. *Creative Dialogue: S.N.A. at 25.* Lagos: Society of Nigerian Artists, 1990.
Kelly, Bernice, and Janet Stanley. *Nigerian Artists: A Who's Who and Bibliography.* London and New York: Published for the National Museum of African Art Branch, Smithsonian Institution Libraries, Washington, DC [by] Hans Zell, 1993.
Kennedy, Jean. *New Currents, Ancient Rivers: Contemporary African Artists in a Generation of Change.* Washington, DC: Smithsonian Institution Press, 1992.
Nzegwu, Nkiru, ed. *Contemporary Textures, Multidimensionality in Nigerian Art.* Binghamton, NY: International Society for the Study of Africa, 1999.
Skoto Gallery. *Olu Amoda: Head 'N' Tie: Fashion Architectonic* (exhibition catalog). New York: Skoto Gallery, 2007.
Victoria and Albert Museum. "Out of the Ordinary: About Olu Amoda." July 21, 2008. http://www.vam.ac.uk/vastatic/microsites/1637_outoftheordinary/artists_detail.php?artistTag=amoda.

Emma Amos (b. 1938), Painter, Printmaker, Fiber Artist.

In 1993, Emma Amos produced *X Flag*. This is a relatively large (58×40″) painting in which she uses laser transfer to imprint on the upper right corner of a

vertical version of the American flag, a photograph featuring a group of African American children on a neighborhood street with a collective gaze that is fixed on the viewer. Atop this black-and-white picture is a band that features a triptych portrait of Malcom X in a way that suggests that the defiant mode and alert posture of the six children are premised upon their belief in the legacy of Malcolm X. By appropriating the flag and repositioning it, Amos changed the format. By supplanting the 50 stars with a picture of a group of African American children, Amos seems to assert that the labor of past heroes endures. The rest of the painting features the red and white stripes of the American flag painted in acrylic on linen canvas. Beneath the flag is yet another: the Confederate flag, which appears determined to push itself to the fore from under the overpowering spread of the Stars and Stripes, suggesting the resiliency of bigotry, segregation, and slavery. Amos puts a stop to that by canceling out the struggling Confederate flag, using a black swash of paint with streaks of white. This bold "X" becomes the cynosure of this work. In the trembling, frenetic energy that this central "X" packs, one can almost feel Amos's rage. The flag itself is framed by strips of the Confederate flag, suggesting that we are indeed products of our own history: that we cannot chart a meaningful future unless we acknowledge our past.

This work is significant in the oeuvre of Amos for a number of reasons. First, it constitutes an interruption of the "Falling" series that the artist started in the 1980s, which questions the doctrine of Reaganism that further pauperized the poor. Second, it has an inherent constituent presence: it is a reminder of Amos's unmitigated bristle at what she perceives as institutionalized disempowerment, particularly of the marginalized and the underprivileged. Third, *X Flag* remains a smoldering ember of the artist's protestant spirit and an abiding activism, the type that saw her membership in Spiral, the only female artist to be so privileged. Finally, this work attests to Amos's versatility and awareness of sociopolitical issues that animate diverse populations on a global scale. While she favors figuration within an abstract field in which objects assert their individuality as they tumble in space unmediated by the constraints of perspective, in this specific instance, she demonstrates an ability to grapple with explosive subjects through recourse to abstract concepts.

The "Falling" series is as much a statement about the political as it is about the personal. It is a series that Amos has continued to explore because it provides an encompassing ambience for drawing attention to global issues at home (Katrina), in the Middle East (Iraq, Israel-Palestine conflict), and Africa (Darfur and the AIDS rampage in parts of the continent.) In the words of Amos, "No metaphors in paint and prints seem strong enough to represent the horror of these disasters." (Farrington 2007, 32). While the series may indeed emphasize the powerlessness of the masses on a global scale, it could also be read as symbolizing the empowerment of those same individuals whom the political class has emasculated by fiat. Equally feasible is the reading of the series as constituting the ultimate perdition of apocalyptic proportions in which all dramatis personae—athlete and coach, gentry and proleteriat, become equalized in a zero-gravity space precisely because they have lost control of the power to regulate and compartmentalize; anoint and disenfranchise.

The younger of two children, Emma Amos was born on March 16, 1938 in Atlanta, Georgia, to a cosmopolitan middle class family. Her father Moses Amos, the first black pharmacist in the state of Georgia, operated a drugs store for more than four decades. He was a self-sufficient man who, out of principle, insisted on paying Amos's way through college without taking advantage of scholarship availability. Her mother who graduated from Fisk with a degree in anthropology, joined in the drugs store operations. She developed love for art as a young girl and took art classes at Morris Brown College, Atlanta, when she was just eleven years old. She was a brilliant child who mastered the tricks of producing beautiful art by copying from the heaps of magazines—Esquire, New Yorker, and Vargas—that were always around. She received encouragement from those who saw her "work," while her mother attempted, in vain, to have her study privately with Hale Woodruff, who was at that time at Atlanta College (Murray 2008). This was in the mid-forties, a time when racial segregation was an unquestionable fact of life and opportunities were limited even for brilliant children like Amos. But the situation was less than ideal as there was little incentive for all the segregated children who had to make do with whatever was available. In her 1968 interview with Al Murray, Amos underlines the confused state in which people functioned at this time:

> Well, we were all confused at that time. I didn't know then what commercial art and real art was. But I knew when I saw what they were doing that it wasn't real art. And they didn't seem to know. I can remember just seeing stacks of awful paintings on unbelievable material, masonite and makeshift stuff; no canvas. And using terrible paint. It just would be so strange and all very murky, ugly colors and what not. And that really wouldn't be the teacher's fault, you see. You know, we were so far from the mainstream of art. There were no museums and no galleries you could go to. There was nowhere in the world to know what art was about.

As a nearsighted child, Amos kept close to her art and enjoyed the company of her brother, who was two years older. She attended Booker T. Washington High School in Atlanta. Just like her brother had done, Amos graduated from high school at age 16 and, with the encouragement of her father who had attended Wilberforce College in Ohio, she applied to Antioch College and began her education there in 1953. Prior to attending Antioch, the family had sent Amos to a prep school in Hampton Institute, Virginia, for a summer. In her fourth year at Antioch, Amos left for the London Central College, where she learned etching techniques with Anthony Harrison and painting with William Turnbull. This was the first time that Amos had the feeling of what being an artist entailed, as she became exposed to a different creative culture that spurred her to work in media that she had not been previously exposed to or did not take seriously. After one year in London, Amos returned to the United States with a body of work that allowed her to get into exhibitions in Antioch and Provincetown, among others. In 1958, she graduated from Antioch with a B.A. degree. She returned to London in 1959, received a diploma for her coursework in etching and returned home to Atlanta, where she had a show that brought her to the attention of the art community. The following year, she

moved to New York, determined to create space for herself. She secured employment at the Dalton School and assisted with first-, second-, and third-grade classes. While at Dalton, she met her future husband, Bobby Levine, whom she married in 1965—a marriage that was blessed with two children and lasted until 2005 when Levine died.

After leaving Dalton in 1961, Amos worked in her own studio in the 1960s while she had her two children: Nicholas (1967), and India (1970). She also worked as a designer for Dorothy Liebes, who specialized in custom-designed hand-woven textiles for interior decoration. In 1964, she went back to New York University for her master's degree. There, she finally met **Hale Woodruff**, who invited her to join the Spiral Group, which comprised prominent African American artists, including Woodruff, **Romare Bearden**, and Charles Alston. The group was concerned primarily with finding a collective creative response to the status of African American artists in light of the Civil Rights Movement and the spate of sociopolitical upheavals in the nation. Amos entered New York University in 1964 and obtained her M.A. degree in 1966. Between 1977 and 1979, she cohosted "Show of Hands," a crafts series that she originated for WGBH Educational TV in Boston. In 1980, she began her career as professor at the Mason Gross School of the Arts at Rutgers University. During this period, too, after she put behind her the professional lull that she experienced as a result of raising two children and returning to school to update her art, she went back to the studio in full force and began producing a series of paintings that dealt with a variety of topics, including politics.

One of her major pieces is a 1991 glass mosaic, *The Sky's the Limit*, which is installed on the ceiling of Intermediate School 90 in Manhattan, New York. Amos continues to produce art that demonstrates her multidimensional approach to art making, and her interest in a variety of social and political issues on a global scale. She is the recipient of major awards and honors, which include an honorary doctorate and the James Van DerZee Award in 2002.

Places to See Amos's Work

Colgate-Palmolive Collection, New York, NY
College of Wooster Art Museum, Wooster, OH
Columbia Museum, Columbia, SC
Dade County Museum of Art, Miami, FL
The Forbes Collection, New York, NY
The Ford Foundation, New York, NY
Jane Voorhees Zimmerli Art Museum, New Brunswick, NJ
Library of Congress, Washington, DC
Minnesota Museum of Art, Minneapolis, MN
Museum of Modern Art, New York, NY
Newark Museum, Newark, NJ
New Jersey State Museum, Trenton, NJ
Schomburg Collection, New York Public Library, New York, NY
Skandinaviska Enskilda Banken, Stockholm, Sweden
Spelman College, Atlanta, GA

Studio Museum of Harlem, New York, NY
Wadsworth Atheneum, Hartford, CT
Williams College Art Museum, Williamstown, MA

Bibliography

Billops, Camille. "Interview with Emma Amos, December 6, 1974." http://negroartist.com/writings/EMMA%20AMOS/Interview%20of%20Emma%20Amos%20by%20Camille%20Billops.htm.

Driskell, David, ed. *African American Visual Aesthetics: A Postmodernist View.* Washington, DC: Smithsonian Institution Press, 1995.

Farrington, Lisa. "Emma Amos: Art as Legacy." *Woman's Art Journal* 28, no. 1 (Spring-Summer 2007): 3–11.

———. "Emma Amos: Bodies in Motion." *IRAAA* 21, no. 2 (2006): 32–44.

Gardner, Paul. "Taking the Plunge." *ARTnews* 97, no. 2 (February 1998): 110–13.

Harris, Juliette. "Private Dancer, Private Dealer: Private Show!" *International Review of African American Art* 16, no. 3 (1999): 2–60.

Henkes, Robert. *The Art of Black American Women: Works of Twenty-four Artists of the Twentieth Century.* Jefferson, NC: McFarland, 1993.

hooks, bell. *Art on My Mind: Visual Politics.* New York: New York Press, 1995.

Lippard, Lucy. "Floating, Falling, Landing: An Interview with Emma Amos." *Art Papers* 15, no. 6 (November–December 1991): 13–16.

Murray, Al. "Interview with Emma Amos." Smithsonian Archives of American Art, October 3, 1968. http://www.aaa.si.edu/collections/oralhistories/transcripts/amos68.htm#top (accessed July 27, 2008).

Otfinoski, Steven. *African Americans in the Visual Arts.* New York: Facts on File, 2003.

Patton, Sharon. "Emma Amos: Art Matters." *NKA: Journal of Contemporary African Art* no. 16–17 (Fall–Winter 2002): 40–47.

Thompson, Mildred. "Interview: Emma Amos." *Art Papers* 19, no. 2 (March–April 1995): 21–23.

Benny Andrews (1930–2006), Painter, Sculptor, Illustrator, Collagist, and Printmaker.

Benny Andrews's oeuvre is a mirror of his life experiences and the harsh economic conditions that he experienced growing up as one of 10 children in a sharecropper family in Madison, Georgia, during the Great Depression. In many of his drawings which are done with economic and disciplined lines, and in his collaged or assemblage paintings with subjects that appear to have been molded in response to their austere environments, Andrews uses his art to inscribe a visual text, allowing us to read the history of the climate in which he grew, and the times that shaped his art. In a 2005 *Race Relations* article, Andrews explained why he chose to illustrate a book by Flannery O'Connor, a white American writer who grew up in Milledgeville, only 30 miles from Madison, but who lived in a social space in which blacks were invisible. Here,

we see disturbing vignettes of the inequalities that society affirmed: "we existed, during her lifetime, in two different [but] . . . opposing worlds. . . . We spoke of them 'white ladies' like one would speak of unworldly creatures, like moss growing high up on tall trees out of reach of mere earthlings, us. To many of her kind we weren't even mere earthlings; we were just a few years and steps removed from being living farm equipment." Andrews's article brings to life the segregationist world of the South and the cold, impregnable social boundaries that must be scrupulously observed in the two parallel worlds that the South was: "Whenever we'd meet her kind on the streets of my hometown Madison . . . racial customs demanded that we step aside and not dare to look up and connect with their eyes." Yet, in choosing to illustrate O'Connor's book, Andrews was interested in embracing the challenge to use his art to reconcile these two parallel worlds. This challenge stands as a metaphor for the work and life of Benny Andrews.

Often regarded as a militant artist because of his activities that were aimed at drawing attention to the inequities and blatant discriminatory practices that were the norm in major museums in the country, Andrews surmised that the best way to effect change was to learn and play what he sees as the white man's game. It was a game for which his experiences as a child have unwittingly prepared him. Benny Andrews was born in Madison on November 13, 1930. He was the second of 10 children of George and Viola Andrews. George Andrews was a self-taught artist who earned the sobriquet, "The Dot Man" in Madison on account of his penchant for using dots in embellishing household objects. He and Viola Andrews were married during the Depression in Plainview, a small community near Madison. Although Viola Andrews dropped out of school after ninth grade, she became a writer, and would not compromise on getting Andrews all the education that he needed. Elton Fax wrote that with regard to the Southern sharecroppers' lot: "He toils and scratches for an existence on someone else's land, and the bulk of what he cultivates and harvests belongs to the landlord. . . . White sharecroppers live in hell. Black sharecroppers live in hell's jim-crow section and have to stoke its fires" (Fax 1971, 236).

School was a simple one-log cabin, which was built through the levies collected by members of the black community in Plainview. Andrews attended elementary school only after he was done picking cotton, and in the months when there was a lull in farming activities. In the year that Andrews was born, George Andrews left his job at a local lumber mill to start working as a sharecropper. The plantation owner detested the idea of sending Andrews to school; he would rather have him work on the farm year round. But Viola insisted, even as George Andrews shied away from confronting the plantation owner. It was a game that Andrews's mother took on—and won. Andrews began drawing as early as age three. He drew compulsively on any available materials and copied profusely from comic books, newspapers, and magazines (Gruber 1997, 22). For this, he received encouragement from his parents. Viola, who enjoyed writing, was pleased at young Andrews's talents. Indeed, Viola encouraged all her children to read and draw. George, on the other hand, took pleasure in helping to develop his son's creative instincts and skills. He, too,

read widely. According to Raymond, one of his children, George "read a lot—the newspaper, detective and western magazines, and novels and comic books. He was Plainview's 'closet' reader, since reading wasn't 'mainly'" (Gruber 1997, 24). By the time he entered elementary school, Andrews had become something of a star, whose skills at drawing cowboys were admired by his fellow students.

In September 1944, Andrews enrolled at Burney Street High School. It did not take long for him to realize how grossly inadequate his elementary education had been. But his teachers recognized his drawing skills and gave him support and encouragement, without which he probably would have dropped out of high school. In 1945, with the sponsorship of the county's 4-H Club, Andrews made his first trip to a big city—Savannah. High school was not the most pleasant experience. The arrangement brokered by Viola as a way of appeasing George—who was opposed to Andrews receiving a high school education—had ensured that Andrews would work in the fields first, and only after that would he attend school. The exception to this rule was during the winter, and on rainy days, when Andrews was free to attend school because there would be no work in the fields. Andrews's displeasure at the limitations that such an arrangement imposed on his quest for education drove him to draw more and, with his brother Raymond, to seek escape in movies and cartoons. In addition to being active in drawing for his biology class, he became the art editor of the school's yearbook and was a member of the school's basketball team.

In 1948, he graduated from Burney Street High School. Graduating from high school was a landmark for the Andrews family, with Benny Andrews becoming the first to achieve this feat. He left for Atlanta soon after graduation and work and stayed with his older brother while he continued to draw. He jumped at the opportunity to complete a mural for Emile's restaurant—the first time he ever worked in oil. He received a partial scholarship from the 4-H Club and, with additional support from his mother, Andrews attended Fort Valley State College for two years. In 1950, Andrews joined the U.S. Air Force and served in Korea. After he was discharged from service, Andrews headed for the Art Institute in Chicago in 1954, with the G.I. Bill providing the much-needed funding.

It was at the Art Institute that Andrews first saw an original oil painting for the first time. It was the first time that he had been in a museum. At the Institute, Andrews realized, as he had when he enrolled at Fort Valley State College, that his

Benny Andrews. Courtesy of The Benny Andrews Estate.

educational background did not quite prepare him for the rarified and intellectual approach to art that went on in the 1950s. As a self-taught artist, he appeared out of date with his social realist approach and his inability to grasp all the nuanced philosophizing that went on with Abstract Expressionism, which was the prevailing style. Andrews was out of sync with the rest of his students, with only a couple of his professors—Jack Levine and Boris Margo—giving him the much-needed encouragement. "I was very unpopular as a student because I wasn't doing what was in vogue. I never qualified for anything, never made any of the student shows. Why, I never even made the veteran's show, and that convinced me that I'd never meet their approval with anything I did" (Fax 1971, 246). Although he had considerable difficulty in staying on the same creative base with his fellow students, he was successful at exploring life in the city where he sketched on the streets and in clubs where jazz musicians played. Additionally, his album cover designs for record companies gave him extra income and satisfaction. In Chicago, he met Mary Ellen Jones Smith, whom he would marry in 1959, the same year that they had their second son.

Upon graduating with the B.F.A. degree from the Art Institute in 1958, Andrews moved to New York with Mary Ellen. From the 1960s, he had learned enough about the culture game in New York that he was able to determine the terms for participation in group and solo exhibitions. But it was in New York that Andrews's tenaciousness and organizational skills became manifest, as he and others mobilized against the insensitive and disdainful manner in which black artists were treated by the museum establishment in New York. His involvement in cultural activism dates back to 1968, when he attended a reception at the Metropolitan Museum of Art, which was meant to launch the exhibition, "Harlem on My Mind: Cultural Capital of Black America, 1900–1968."

In his journal, excerpts of which was published in *Artworkers News* in December 1980, Andrews documented the various demonstrations that he and other members of the Black Emergency Cultural Coalition (which was established in January 1969) held to demand that black artists be given equal treatment in the way their works were presented and represented by museums. For almost a decade, from December 21, 1967, to January 3, 1976, Andrews and others focused on three major museums in New York: the Whitney Museum of American Art, the Museum of Modern Art, and the Metropolitan Museum of Art, as sites for raising the stakes. Although the trigger for the series of protests of the decade was the exhibition, "Harlem on My Mind," the issues tackled by Andrews and BECC covered curatorial practice, marginalization representation and misrepresentation, and the absence of patronage of African American art.

Since the seventies, Andrews has become recognized not only for his activism, but also for the uniqueness of his style, which combines his interest in cartoons with a penchant for tactility to bring his subjects to life. One work that captures the spirit of Andrews's life is his 1968 *Champion*. In this, a battered but unbent boxer sits at his corner, his head covered in white, gazing intently at the onlooker. In his gaze, the champion carries the hopes and aspirations

of generations, according to Andrews: "Nobody will ever know how many black people Joe Louis pulled through when there was no other hope for them. We'd sit around those little battery radios in our shacks and listen to the fight broadcasts. And the hope of a whole people was riding on that man's defeating whoever he was fighting" (Fax 1971, 247). In a way, Andrews saw himself in *Champion*. He won laurels and accolades, completed major commissions, illustrated several books, taught in colleges and universities, gave invited lectures and workshops, traveled extensively, and served on the boards of major national organizations. Among his awards are the University of Bridgeport Dorne Professorship; the MacDowell Fellowship; the National Endowment for the Arts; and The Atlanta University Negro Art Collection. He was director of the Visual Arts Program for the National Endowment for the Arts from 1982 to 1984, and was elected as member of the National Academy of Design in New York in 2006. In addition to innumerable group exhibitions that he took part in, he held several solo exhibitions in major exhibition arenas. Andrews participated in numerous group exhibitions and held many solo outings. Benny Andrews died on November 10, 2006.

Places to See Andrews's Work

Brooklyn Museum of Art, New York, NY
Chrysler Museum of Art, Norfolk, VA
Columbus Art Museum, Columbus, OH
Detroit Institute of Art, Detroit, MI
High Museum of Art, Atlanta, GA
Hirshhorn Museum, Washington, DC
Little Rock Art Center, Little Rock, AR
Metropolitan Museum of Art, New York, NY
Morris Museum of Art, Augusta, GA
Museum of Modern Art, New York, NY
Newark Museum of Art, Newark, NJ
New Jersey State Museum, Trenton, NJ
Philadelphia Museum of Art, Philadelphia, PA
Studio Museum in Harlem, New York, NY

Bibliography

Andrews, Benny. "American Art of the Past Twenty Years: A Wonderful Pot-pourri of Styles and Sources." *Art Journal*, 39, no. 4 (June 1980): 292.
———. *Race Relations: Why a Black Artist Would Choose to Illustrate a Story by a White Southern Writer of the 1950s*. New York: The Limited Editions Club, 2005.
Belton, Sandra. *Pictures for Miss Josie*. Illustrated by Benny Andrews. New York: Greenwillow Books, 2003.
Black America Series. *Morgan County Georgia: Lynn Robinson Camp*. Chicago: Arcadia Publishing, 2004.
Bladon, Patricia. "Folk: The Art of Benny and George Andrews." In *Folk: The Art of Benny and George Andrews*. Memphis, TN: Memphis Brooks Museum of Art, 1990.

Fax, Elton. *Seventeen Black Artists.* New York: Dodd, Mead, 1971.

Freeman, Linda. *Benny Andrews: The Visible Man.* Video recording. Chappaqua, NY: L&S Videos, 1998–99.

Gaither, Edmund B. "Comments on 'Trash.'" In *Benny Andrews Paintings and Watercolors Including Trash.* New York: ACA Gallery, 1972.

Goodman, Jonathan. "Benny Andrews at ACA." *Art in America* 91, no. 5 (May 2003): 148.

Greben, Deidre Stein. "Benny Andrews." *ARTnews* 103, no. 8 (September 2004): 142.

Gruber, Richard J. *American Icons: From Madison to Manhattan, the Art of Benny Andrews, 1948–1997.* Augusta, GA: Morris Museum of Art, 1997.

Haskins, James. *John Lewis in the Lead: A Story of the Civil Rights Movement.* Illustrated by Benny Andrews. New York: Lee & Low, 2006.

Heit, Janet. *Icons and Images in the Work of Benny Andrews.* Atlanta, GA: Southern Arts Federation, 1984.

Hills, Patricia. *Syncopated Rhythms: 20th-Century African American Art from the George and Joyce Wein Collection.* Boston: Boston University Art Gallery; Seattle: Distributed by University of Washington Press, 2005.

Timpano, Anne. *A Different Drummer: Benny Andrews, the Music Series, 1991–98* (exhibition). Cincinnati, OH: DAAP Galleries, College of Design, Architecture, Art, and Planning, University of Cincinnati, 1999.

Weathers, Diane. "Images of an Era, 1976–1996." *International Review of African American Art* 13, no. 2 (1996): 13.

B

Jean-Michel Basquiat (1960–1988), Painter.

Undoubtedly one of the most celebrated artists of his time, and perhaps the most colorful African American artist of all time, Jean-Michel Basquiat's rise to fame was meteoric as was the confounding suddenness of his death. His emergence in the New York art scene is a classical example of the outsider who rose to fame on the back of the very establishment that he set out to deride. Basquiat's antiestablishment art soon became a part of the art scene's neo-Expressionist movement of the 1980s, and he became one of the key artists whose presence was coveted and whose art was exhibited and collected far and wide. While his entrance and exit were short, fast, and furious, his influence on the art world promises to be long and sustained, if the staggering prices that his works fetch are used as indicators.

In 2002, Basquiat's large piece, *Profit I,* was sold at Christie's for $5,509,500, the highest price that his art has ever brought in up to that time (Horsley 2008). This record was shattered by the sale of his 1981 untitled work, which went for $14.6 million at Sotheby's (BBC 2008). The mythical heights that Basquiat has attained especially since his death, and the staggering commercial success that his works attract, have perhaps spurred unqualified generalizations. In writing about the artist, for example, Luca Marenzi asserts that "Jean-Michel Basquiat is the only black American painter to have made a substantial mark on the history of art" (Basquiat 1999, xxxi). Such statements like this demonstrate, in the first instance, the reason why Basquiat himself was disgusted with the art establishment.

The oldest and only male of three children, Basquiat was born on December 22, 1960, in Park Slope in the western section of Brooklyn, New York. His father, Gerard Jean-Baptiste Basquiat, migrated to the United States from Haiti, where he once served as a minister of the interior. His mother, Matilde Basquiat Andradas, was born in Brooklyn into a family of Puerto Rican parents. Basquiat was exposed to the arts by his bilingual mother, who taught him Spanish, instilled in him a love of music, and took him to visit museums, including Brooklyn Museum where he was enrolled as a junior member at age six. As one who was interested in fashion design, Matilde often drew with her son. At an early age, Basquiat took a liking to television cartoons, which he often tried to imitate in his drawings.

By the time Basquiat entered St Ann's private Catholic school in 1967, he had developed a flair for Spanish, English, and French texts. It was at this school that he collaborated with a friend, Marc Pozo, and put together a children's book complete with text and illustrations. When he was seven years old, a car ran over him as he was playing on the street (Emmerling 2003, 11). At the hospital where he was recuperating, his mother gave him a copy of *Gray's Anatomy*, which contains clinical illustrations of the human body that Basquiat spent much of his hospital time studying. In essence, these events—his early exposure to art and music, his trips to museums, and his introduction to *Gray's Anatomy*—would prove to be the critical factors in Basquiat's professional trajectory.

Basquiat's early childhood was full of incidents over which he had little control, but which exerted considerable influence on his character. In 1968, his parents divorced, and Gerard, who worked in an accounting firm, had custody of Basquiat and his two sisters, Lisane and Jeanine. Following Gerard's promotion at work in 1974, he relocated with his three children to Mira Mar in Puerto Rico, where Basquiat was enrolled in an Episcopalian school (Basquiat 1999, 197). Basquiat reacted unfavorably to this situation by running away from home, the first of such attempts at asserting his independence. In 1976, the family moved back to New York and Basquiat enrolled at Edward R. Murrow High School, from where he soon transferred to City-As-School, an alternative school in Manhattan, which was designed for precocious children who found it difficult to study within the standard educational system.

This was where he and his friend, Al Diaz, came up with the idea that led to the spraying of graffiti all over New York, from the Brooklyn Bridge to the School of Visual Arts; in SoHo and on the "D" train. Basquiat's logo, SAMO and the copyright sign ©, soon became as familiar and, indeed, inimitable as were the poetic lines that were inscribed on public sites. Citing Basquiat's 1978 statement in the *Village Voice,* Emmerling (2003, 12) writes that "SAMO was created while Basquiat and his school friend, the graffiti artist Al Diaz, smoked marijuana. Basquiat, inebriated, mentioned something about 'SAMe Old Shit.' SAMO grew from its beginnings, as the kernel of a lifestyle religion devoid of all ethical substance, to a grand experiment in semiotics with its own language of truncated sentences."

For two kids who had nothing to lose, spraying graffiti on public was not just a pastime; it was a fun project, the aim of which was to market a counter religion and, of course, draw attention to themselves in the process. A loftier aim was to stand up to the art world with its snobbish attitude and outlandish taste. SAMO, in the playbook of Basquiat and Diaz, was the antidote to the pretentiousness of the cognoscenti: "SAMO is an end to playing art . . . SAMO for the so-called avant garde. SAMO as an alternative 2 playing art with the 'radical chic' set on Daddy's $funds. SAMO as an end 2 confining art terms. Riding around in Daddy's convertible trust fund company. SAMO an an alternative to the 'meat rack' arteest on display" (Emmerling 2003, 12).

While Basquiat and his friend were busy tagging trains, the bridges, billboards, and every strategic space in New York, he obviously was having difficulty with his father at home. Increasingly, he became disenchanted

with parental authority. In 1977, he dropped out of school, and in June 1978, Basquiat ran away from home for the last time and survived by hanging out at night clubs at night and selling T-shirts and hand-painted postcards by day. At a restaurant in New York in 1978, he first met with Andy Warhol, to whom he sold a postcard; the two would eventually collaborate on projects in the 1980s: a collaboration that would subsist until the death of Warhol in 1987. In addition to his small-scale T-shirt business, Basquiat became a regular feature at the Mudd Club, where he mixed with a coterie of artists, performers, musicians, and filmmakers who frequented the club. In due course, and in concert with some friends, Basquiat formed his own band, Channel 9, which they later renamed Gray, apparently a reference to the *Gray's Anatomy* book that gave him his first look at art and life. In 1979, sensing that his friend had betrayed their cause by becoming cozy with the establishment that they had dedicated their graffiti to challenging, Diaz terminated his association with Basquiat. This appeared to have fueled Basquiat's resolve, formalized the nullification of his association with Diaz and his disengagement from graffiti by spray-painting the death of SAMO on public sites in SoHo.

His first break came when he participated in the "Times Square Show," a very large group exhibition that was held in New York in June and July 1980. The attention that he received at the exhibition proved, in the eyes of critics and others in the culture sector, to be solid after they saw Basquiat's entries at yet another exhibition, the January 1981 "New York/New Wave," that Diego Cortez had curated in Queens. With this show, Basquiat's place in the pantheon of artists was secured by the art establishment. A quote from Alanna Heiss, the director of P.S. 1 (quoted in Emmerling 2003, 19), captures the ecstasy and incredulousness of those who saw Basquiat's works:

We were paralyzed. It was so obvious that he was enormously talented. I realized when I saw it what Leo . . . had said to me about discovering Jasper Johns, that anyone can see these things. it doesn't take a genius. You have to be practically blind not to see it. Jean-Michel was the person in all the huge number of artists who stood out. I hadn't seen anything like it for ten years. And given that he was being shown in a space where Robert Ryman had shown, it placed him in an art-historical context for the first time.

Following a string of other group exhibitions in which Basquiat took part in 1981, he had his first solo exhibition in Modena, Italy. By the time he had his first one-man exhibition in the United States—at the Annina Nosei Gallery in March 1982—Basquiat's fame had been so solidly established that he was invited to the Documenta VII in Kassel, Germany, the youngest of the 176 artists that participated that year (Basquiat 1999, 200). Eventually, Basquiat would travel all over the world, to such places as Spain, Switzerland, Japan, Jamaica, United Kingdom, France, and Africa. Of significance is the role of Basquiat in bringing to the attention of the New York art world, the work of **Ouattara Watts**, whom he had met in Paris in 1988 during a reception for Basquiat's exhibition.

On August 12, 1988, Basquiat died of drug intoxication in his New York loft.

Places to See Basquiat's Work

Berardo Museum, Collection of Modern and Contemporary Art, Lisbon, Portugal
Broad Art Foundation, Santa Monica, CA
Dayton Art Institute, Dayton, OH
Everson Museum of Art, Syracuse, NY
FRAC-Picardie, Amiens, France
Fukuoka Art Museum, Fukuoka, Japan
Funda Fundación La Caixa CaixaForum, Barcelona, Spain
High Museum of Art, Atlanta, GA
Ludwig Forum fur Internationale Kunst, Aachen, Germany
MOCA Grand Avenue, Los Angeles, CA
Modern Art Museum of Fort Worth, Fort Worth, TX
Musée National d'Art Moderne, Centre Georges Pompidou, Paris, France
Museu d´Art Contemporani de Barcelona MACBA, Barcelona, Spain
Museum der Moderne Salzburg, Salzburg, Australia
Museum of Modern Art, New York, NY
Museum Würth, Künzelsau, Germany
Princeton University Art Museum, Princeton, NJ
Stephanie and Peter Brant Foundation, Greenwich, CT
Vancouver Art Gallery, Vancouver, BC
Whitney Museum of American Art, New York, NY
ZKM | Museum für Neue Kunst & Medienmuseum, Karlsruhe, Germany

Bibliography

Basquiat, Jean-Michel. *Jean-Michel Basquiat: The Notebooks.* New York: Art+Knowl-
edge, 1993.
———. *Basquiat.* Exhibition catalog. Milan: Charta, 1999.
Basquiat, Jean Michel, and Civico museo Revoltella. *Basquiat.* Milan: Charta, 1999.
Basquiat, Jean Michel, Glenn O'Brien, Diego Cortez, and Deitch Projects. *Jean-
Michel Basquiat 1981: The Studio of the Street.* Milan: Charta, 2007.
BBC. "Huge Bids Smash Modern Art Record." July 21, 2008. http://news.bbc.co
.uk/2/hi/entertainment/6660487.stm.
Clement, Jennifer. *Widow Basquiat.* Edinburgh: Payback, 2000.
Dimitriadis, Greg, and M. Cameron. *Reading and Teaching the Postcolonial: From
Baldwin to Basquiat and Beyond.* New York: Teachers College Press, 2001.
Emmerling, Leonhard. *Jean-Michel Basquiat: 1960–1988.* Los Angeles: Taschen
GmbH, 2003.
Horsley, Carter B. "Art/Auctions: Post-War and Contemporary Art." *City Review,*
July 21, 2008. http://www.thecityreview.com/s02ccon1.html.
Hughes, Robert. "Jean-Michel Basquiat." *The Artchive,* July 21, 2008. http://www
.artchive.com/artchive/B/basquiat.html.
Mac Donald, Heather. "What Aerosols!" *City Journal,* Summer 2002. July 21, 2008.
http://www.city-journal.org/html/12_3_what_aerosols.html.
Mercurio, Gianni, ed. *The Jean-Michel Basquiat Show.* Milan: Skira, 2006.
Phoebe, Hoban. *Basquiat: A Quick Killing in Art.* New York: Penguin, 1999.

Sirmans, M. Franklin. "Chronology." In *Jean-Michel Basquiat,* edited by Richard Marshall, 233–50. New York: Whitney/Abrams, 1992.

Romare Bearden (1911–1988), Painter, Printmaker, Collagist, Author, Composer.

Of all the artists of his generation, Romare Bearden ranks high among those who had an intensely analytical and intellectual approach to the process of making art. Going by the social status of his family in New York—his disciplined, contemplative approach to art, his embracement of art that is grounded in enduring principles and syntax, his family's love of the arts, and the company of artists and performers with whom he grew up—it appeared inevitable that Bearden's art would reflect an intellectualization that places him high in the hierarchy of those who favor a cerebral, rather than intuitive, approach to form. While drawing copiously on the memory of places, things, and events that he experienced in the course of growing up in Charlotte, North Carolina, Pittsburgh, Pennsylvania, and New York, among other places, Bearden developed a creative approach that accommodated his intellectual curiosity and deeply introspective persona. It was an approach that allowed him to continue expressing himself in the cubist idiom that he favored despite the pressure that was brought to bear on him to embrace abstraction, the prevalent stylistic current of the period.

His preoccupation with the nature of art was not limited to understanding the elements and principles of art; it extended to the psychology of promotion and patronage. In a 1942 letter to Walter Quirt, a friend and mentor, Bearden seems to be in a quandary: how does he produce art that is true to his own ideas without appearing to pander to the audience? He acknowledged, rather painfully, that a fellow artist from the South had written to accuse him of pandering to the interest of critics by doing their bidding. Further: "To many of my own people, I learn, my work was very disgusting and morbid—and portrayed a type of Negro that they were trying to get away from. One man bought a painting and brought it back in three days because his wife couldn't stand to have it in the house" (Schwartzman 1990, 121).

Bearden's birth conferred on him a privilege that shaped the trajectory of his professional development at the same time that it inflected his philosophical approach to the arts. Fred Romare Howard Bearden was born on September 2, 1911, to Bessye and Richard Howard Bearden. Both of his parents were college-educated, and many members of the extended Bearden family were passionate about the arts. Bearden's great grandparents, Henry B. Kennedy and Rosa Kennedy, and his grandmother, Rosa Catherine (Cattie) Bearden, were into painting. His maternal grandmother, Carrie Banks, gave Bearden a lesson in art that he would later put to good use: she advised him to simplify his efforts (Schwartzman 1990, 20). Growing up in Charlotte, Bearden had the good company of another member of the extended family, one who was a source of

creative inspiration to Bearden—Charles Alston—who was some years older. Bearden's father, was a pianist and friend of jazz artists such as Duke Ellington. Bearden's uncle Harry was a good pianola player who loved opera, while his aunt, Anna, was a church organist in Greensboro who also taught piano organ. Add to this the activities of an gregarious and politically active mother, and it was clear that Bearden, an only child, had no excuse not to become an artist. Bessye wielded considerable clout in her capacity as editor of the *Chicago Defender*, a newspaper that was acknowledged as the most powerful voice for blacks nationwide. The Bearden household at 140th Street in Harlem was a social fulcrum for writers, musicians, and artists, including African American artists **Aaron Douglas** and Charles Alston, Duke Ellington, the writer Countee Cullen, poet Langston Hughes, W.E.B. Du Bois, and social activist, actor, and athlete Paul Robeson.

Bearden's family had moved to New York City when he was three. During World War I, his father worked with the Canadian railroads as a steward, a move that necessitated yet another relocation to Moose Jaw in Canada. In 1917 Bearden attended Public School (P.S.) 5 in Harlem and had his fourth-grade education in Pittsburgh, where he lived with his maternal grandparents in 1921. While he entered DeWitt Clinton High School in New York in 1925, Bearden returned to live and attend school two years later with his grandparents, this time in East Liberty, where he attended Peabody High School for a year, graduating in 1929. In his last year at Peabody High, Bearden developed an interest in cartooning. Until his high school years, his interest was mainly in sports; he cared little for art and took only those art courses that were mandatory. His mother had wanted him to become a physician. In 1929, Bearden entered Lincoln University in Oxford, Pennsylvania, from where he transferred to Boston University. In 1932, he transferred again, this time to New York University, where he declared a major in mathematics. He would eventually graduate in 1935 with a degree in education, although he continued drawing cartoons and had his work published in the *Medley*, a monthly journal at New York University, on which he later worked as art editor. His cartoons also appeared in other national publications such sources as the *Crisis,* (the major political publication of the National Association for the Advancement of Colored People), and the *Baltimore Afro American*, a weekly publication on which he served as editorial cartoonist from 1935 to 1937.

One of the earliest influences on Bearden was Elmer Simms Campbell, the popular African American cartoonist whose cartoons had appeared in *Esquire,* the *Saturday Evening Post,* and the *New Yorker* among others. Upon being advised by Campbell, Bearden studied art with the German émigré George Grosz at the Art Students League in New York. Grosz was a superb draftsman, caricarturist, and painter, credentials that were obviously not lost on Campbell and, as it turned out, on Bearden. Through Grosz, Bearden was exposed to a new world of neoclassical art and, in particular, the work of Dominique Ingres and William Hogarth. New York of the 1930s was not the most comfortable zone for African American artists to operate in. It was bad enough to be black in the years before the Civil Rights Movement. To be a black artist during the Depression needed more than commitment: it demanded fortitude and a

cohesive network of kindred spirits. Bearden depended on a coterie of friends, among whom were the writers Claude McKay and Bill Attaway, and a fellow artist, **Jacob Lawrence**, through whom Bearden secured his first studio at 33 West 125th Street. For regular income, Bearden secured employment as a caseworker with New York City Department of Social Services in 1938, a job that he held on to full time until 1966 when he chose to work part time, which he did until 1969. Taking a full-time job forced Bearden to, in the words of Schwartzman (1990, 92), " 'moonlight' as a painter during the afternoons and evenings; gave him an independent income, which allowed him to have his own studio through the years; [and] shut out the possibility of combining painting with university teaching, which many of his friends eventually came to do."

In 1940, Bearden had his first solo exhibition at the 306 Studios. His work in the 1940s was executed in a variety of media, which ranged from watercolor or gouache and casein on paper to oil on canvas, with a style that oscillated between representational and abstract rendition. During this time, his indebtedness to the French modernist tradition was obvious, as he espoused creative affinity with Cubism and abstraction. In terms of subject matter, Bearden explored themes that were based on music, ancient Greek literature, the poetry of the Spanish poet Garcia Lorca (who was introduced to him by Langston Hughes), and the Bible. The multi-nuanced and storied collage works that would become his stylistic hallmark would become more fully developed in the 1960s. Meanwhile, in 1942, Bearden joined the U.S. Army and served with the all-black 372nd Infantry Division in the 15th Regiment, from which he was honorably discharged in 1945. Soon after, Bearden became a member of artists in the stable of the gallerist Samuel Kootz, who exhibited his work alongside others like Carl Holty, Robert Motherwell, Fernand Leger, and Alexander Calder. In a way, working with such a team deepened Bearden's commitment and his quest for enduring art. Among those that his association with Kootz brought him in contact with was Carl Holty, who became one of Bearden's closest friends and a teacher who exerted enormous influence on him. The two eventually coauthored a book, *The Painter's Mind: A Study of the Relations of Structure and Space in Painting* (1969).

In 1950, Bearden took a two-year leave from his employment and, using the G.I. Bill, traveled to Paris, France; there, for nine months, he studied philosophy, French, and Buddhism. While he did not produce work in Paris, the totality of his experience—his acquaintance with major artists, including Constantin Brancusi; his travels to Italy and Spain; his observations of French culture; and, above all, his immersion in museums where he contemplated masterpieces—had a significant impact on his perspectives about art, his own American culture, and, most importantly, his creative approach. In the early 1950s, Bearden went into music and wrote a number of songs. He collaborated with Dave Ellis, founded Bluebird Music Company, and became a member of American Society of Music Authors and Publishers in 1955. But it was apparent that his prospects lay more in making art than in writing music. While Bearden continued to write music and exhibit in the 1950s, perhaps one of

the most significant moves he made was his marriage to Nanette Rohan, a dancer and choreographer, in 1954.

By the 1960s, all of the tutelage and self-education that Bearden had acquired began to pay off. He did listen to advice and returned full-scale to making art. In the 1950s, he had utilized collage in his work. But it was in the 1960s that he developed collage to a style that radically changed Bearden's sty-listic trajectory. The style that would typify Bearden began in 1963 when a group of African Americans, including **Hale Woodruff,** Charles Alston, **Emma Amos,** and Richard Mayhew met in Bearden's studio and formed the Spiral, which was meant to provide the group a common platform from which to address bothersome sociopolitical issues of the day. Bearden's idea that Spiral produce a collaborative piece from a pile of cutout pictures having been met with little enthusiasm, he turned them into a series called "Projections" with the encouragement of Codler and Ekstrom, the gallery that represented him for the rest of his professional life. The resultant exhibition brought Bearden to the national limelight.

Bearden's compositions are built from fragments: of faces, bodies, limbs, and dresses, arranged in a choreographed medley akin to the improvisations of jazz music. Using a smorgasbord of materials—patterned fabrics, pieces of magazine cutouts, glossy and matter paper, and spray paint among others—Bearden portrayed subjects that reflect his own world. His published works include *A History of African-American Artists* (Bearden and Henderson 1993) and *Six Black Masters of American Art* (Bearden and Henderson 1972). He con-tributed to asserting African American presence in the art world with his involvement with a number of causes, which included the formation of the Spiral group, the establishment of Harlem Cultural Council, the founding of Cinque Gallery, and the founding of the Studio Museum in Harlem. He exhib-ited in major museums and spaces across continents and was elected to the American Academy of Design, and the National Institute of Arts and Letters. President Ronald Reagan presented him with the National Medal of Arts. Bearden died in New York in 1988.

Places to See Bearden's Work

Arizona State University Art Museum, Tempe, AZ
Art Institute of Chicago, Chicago, IL
Brooklyn Museum of Art, New York, NY
Canton Museum of Art, Canton, OH
Cleveland Museum of Art, Cleveland, OH
Dallas Museum of Art, Dallas, TX
High Museum of Art, Atlanta, GA
Hirshhorn Museum and Sculpture Garden, Washington, DC
Howard University Art Collection, Washington, DC
Jersey City Museum, Jersey City, NJ
Kemper Museum of Contemporary Art, Kansas City, MO
Metropolitan Museum of Art, New York, NY
Museum of Modern Art, New York, NY

National Gallery of Art, Washington, DC
Pennsylvania Academy of the Fine Arts, Philadelphia, PA
Saint Louis Art Museum, St. Louis, MO
The Smithsonian American Art Museum, Washington, DC
Virginia Museum of Fine Arts, Richmond, VA
Yale University Art Gallery, New Haven, CT

Bibliography

Bearden, Romare. "The Negro Artist and Modern Art." *Opportunity,* December 1934, 371–72.

———. *The Art of Romare Bearden: The Prevalence of Ritual.* New York: Harry N. Abrams, 1973.

———. *A Graphic Odyssey: Romare Bearden as Printmaker.* Edited by Gail Gelburd. Philadelphia: University of Pennsylvania Press, 1992.

Bearden, Romare, and Harry Henderson. *Six Black Masters of American Art.* Garden City, NY: Zenith Books, Doubleday, 1972.

———. *A History of African-American Artists from 1792 to the Present.* New York: Pantheon Books, 1993.

Bearden, Romare, and Carl Holty. *The Painter's Mind: A Study of the Relations of Structure and Space in Painting.* New York: Crown Publishers, 1969.

Brenson, Michael. "A Collagist's Mosaic of God, Literature and His People." *New York Times,* January 11, 1987.

Campbell, Mary Schmidt, and Sharon F. Patton. *Memory and Metaphor: The Art of Romare Bearden, 1940–1987.* New York: Studio Museum in Harlem: Oxford University Press, 1991.

Driskell, David. *Two Centuries of Black American Art.* Los Angeles: Los Angeles County Museum; New York: Knopf, 1976.

Fax, Elton. *Seventeen Black Artists.* New York: Dodd, Mead, 1971.

Fine, Elsa Honig. *The Afro-American Artist: Search for Identity.* New York: Holt, Rinehart and Winston, 1973.

Glazer, Lee Stephens. "Signifying Identity: Art and Race in Romare Bearden's Projections." *The Art Bulletin* 76, no. 3 (September 1994): 411–26.

Greenberg, Jan. *Romare Bearden: Collage of Memories.* New York: Harry N. Abrams, 2003.

Hills, Patricia. *Syncopated Rhythms: 20th-Century African American Art from the George and Joyce Wein Collection.* Boston: Boston University Art Gallery; Seattle: University of Washington Press, 2005.

Price, Sally, and Richard Price. *Romare Bearden: The Caribbean Dimension.* Philadelphia: University of Pennsylvania Press, 2006.

Pruitt, Sharon. "Bearden's Country Still." *International Review of African American Art* 19, no. 1 (2003): 49.

Schwartzman, Myron. "A Bearden-Murray Interplay: One Last Time." *Callaloo* 11, no. 3 (Summer 1988): 410–15.

———. *Romare Bearden: His Life and His Art.* New York: Harry N. Abrams, 1990.

Sims, Lowery Stokes. "Black Americans in the Visual Arts: A Survey of Bibliographic Material and Research Sources." *Artforum,* November 1973, 66–79.

———. *Romare Bearden.* New York: Rizzoli Publications, 1993.

———. "African American Artists and Postmodernism: Reconsidering the Careers of Wilfredo Lam, Romare Bearden, Norman Lewis, and Robert Colescott." In *The African American Visual Aesthetics: A Postmodernist View*, edited by David Driskell. Washington, DC: Smithsonian Institution Press, 1995.

John Thomas Biggers (1924–2001), Painter, Author, Printmaker, Sculptor, Muralist.

In a 1970s graphite drawing, John Biggers captures the penetrating eyes of the inimitable author James Baldwin in a captivating and surrealistic manner. Portrayed in profile, Baldwin's distinctive facial features—his bulging eyes and furrowed forehead—are perched above an intimidating ridge, which offers a protective cover for a smart, albeit shy lower lip. In this abbreviated profile, Biggers brings Baldwin to life by reining in the viewer's focus on Baldwin's scorching gaze. The visual artist has expended the precise combination of medium and skills needed to portray the intellectual attributes of Baldwin. Yet, Biggers's reputation is anchored not on his incomparable draftsmanship —although this is certainly an attribute that cannot be neglected—but on his powerful murals. In a 1989 conversation with Theisen, Biggers confirmed the obvious: "It has been in the preparation for, as the result of a mural study, that I have created most major images for my paintings, drawings and lithographs" (Theisen 1996, xi). For yet another group, Biggers is known as a teacher who placed the accent on experiential learning. In all of these instances, Biggers's work exemplified the extent to which he successfully processed the various streams of ideas from diverse sources that included family, mentors, and ancestry. Yet, by the time he entered Hampton Institute (which became Hampton University) in Hampton, Virginia, in 1941, Biggers's intent was to learn plumbing. Biggers puts this in a jocular perspective: "Mama was sending me to Hampton to become a work-study student and to major in heating and sanitary engineering. . . . Man, I was on my way to becoming a plumber and Mama was tickled to death!" (Fax 1971, 273).

The youngest of seven children, John Biggers was born in Gastonia, North Carolina, on April 13, 1924 to Paul and Cora Biggers. Life in Gaston was predictably harsh for a black family that had to endure poverty, racism, and all manner of social injustice on account of their race and social status. Paul and Cora Biggers braved the odds and graduated from Lincoln Academy, which prepared the Biggers family for the resourceful and stable character that would prove advantageous in later years, especially after the death of Paul in 1937 when Cora had to be persuaded to leave Gaston in order to work at an orphanage close to Lincoln Academy, where John Biggers was enrolled (Wardlaw 1995, 23). The elder Biggers was a teacher and cobbler who was also skillful at carpentry and basketry. In addition to household chores like cooking and cleaning, Cora Biggers did sewing and quilting. Biggers and his siblings internalized these skills, which were as important as were reading, raising poultry,

or growing all the food that the family needed. It was these quotidian observations that sharpened Biggers's sense of personhood; they would come in handy later as he developed his murals.

The confluence of forces that would impact Biggers began almost as soon as he entered Hampton. Prior to that, he had been enrolled along with his brother Joe in Lincoln Academy, which was founded in 1892 by the American Missionary Association to cater to the educational needs of freed slaves and their offspring (Wardlaw 1995, 23). This was the same institution that Biggers's parents attended, and from which two of his siblings had graduated. Lincoln prepared Biggers for the challenges ahead. In order to offset tuition fees, Biggers took up employment in the institution as the heat provider for all the dormitories and offices, a task that necessitated waking up early to start the fires. The advantage that accrued to him from this employment was that he had sufficient downtime and space that allowed him to become contemplative and introspective. In the nice, warm, and quiet boiler room after the fires had been lit, Biggers had time to draw, read copies of the *New York Times Book Review,* and copy from the black-and-white engravings that held so much fascination for him. His aptitude for drawing had been nurtured back in Gaston. There, together with his brother Joe and with encouragement from his father, he would work every spring on making a model of their town, street by street: "We made miniature wagons, trains, automobiles, houses, and farm animals from discarded thread spools, cigar boxes, and soft pinewood. . . . We used moss for the lawns and created 'live' streams with running water. Our two older brothers and Papa would encourage and help us with the intricate carving" (Fax 1971, 269).

At Hampton, Biggers came under the influence of Viktor Lowenfeld, the widely influential Austrian psychologist, artist, and art educationist who had fled his country in 1938 when it was invaded by Nazi Germany. In 1939, he took up appointment at Hampton, where he utilized the institution's collection of African art to impress on his students the essence of drawing upon the rich repository of ancestral heritage for inspiration. Lowenfeld was the keystone in Biggers's creative arch. It was through his teaching and prodding that Biggers eventually divested himself of the notion that studying at Hampton was tantamount to acquiring a trade. He gave his students insights into European art without neglecting to steer them towards the appreciation of African art. This was at a time that Africa was portrayed as the "Dark Continent," with an agglomeration of uncivilized savages who lived a primitive existence, something that was antipodal to Euro-American refinement. Biggers acknowledges his indebtedness to Lowenfeld: "This great educator opened new vistas to his students with his teachings of self-identification and self-esteem through art expression. At last I had found a way to deal with the life-long yearning to speak in line, form, and color of the aspirations of the black man I had become" (Fax 1971, 273–74). An additional source of influence and inspiration for Biggers were the murals of Mexican artists—Diego Rivera, David Alfaro Siqueiros, and José Clemente Orozco—to whom he was introduced at Hampton. The notion of using murals as a social register resonated with Biggers, who vividly remembered the murals that adorned the post office building in his hometown

of Gastonia during the Depression. Among African American artists who worked on murals under the aegis of the Federal Art Project were **Hale Wood-ruff**, Richmond Barthé, and **Jacob Lawrence**. While Lowenfeld gave Biggers the doctrinal base from which to explore his heritage, the presence of an African American couple, **Charles Wilbert White** who was a superb draftsman and muralist, and his wife, **Elizabeth Catlett** on the campus provided tremendous fillip for Biggers. With a Julius Rosenwald grant, White had chosen Hampton as the site for his mural, *The Contribution of the Negro to American Democracy*. Catlett broadened Biggers's education by exposing him to sculpture.

From 1943 to 1945, Biggers served in the U.S. Navy. In 1946, he transferred to Pennsylvania State University, following Lowenfeld who had accepted a position in the art department there. In 1948, he received two degrees: the B.S. and the M.S. in art education from Pennsylvania State University. That same year, he married Hazel Hales, whom he had met in Hampton. After a short stint at Alabama Teachers College, Biggers accepted the offer to be the pioneering chair of a department of art, which he would also found, at Texas State University for Negroes, which in 1951 became Texas Southern University (TSU). Early in his tenure at TSU, Biggers had made the decision that the best way to cut through the palpable cynicism that surrounded the status of art in the university was to couple his teaching with a hands-on approach. He institutionalized mural painting as a project for every art major during his tenure at TSU. He became professionally active in Houston and earned honors and awards at many of the shows that he participated in. With these came recognition by the community, which in turn led to mural commissions. In 1954, he earned his doctorate degree from Pennsylvania State University.

It was his trip to Africa that provided him with the overarching context within which his philosophy and his art would eventually resonate. In 1957, with a UNESCO fellowship, he traveled to Africa for six months with his wife and visited Ghana, Nigeria, Togo, and Republic of Benin. The visit, which occurred in the year that Ghana attained independence from Britain, gave him a firsthand experience that contradicted the pejorative projections of Africa that was widely held in the West. From his travels came a portfolio of drawings that vividly present African personalities—rulers, chiefs, religious leaders, drummers, farmers, village scenes and market scenes, and festivals

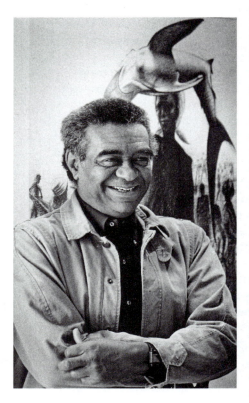

John Biggers, *Jubilee: Ghana Harvest Festival*, 1959–63 (tempera and acrylic on canvas). © Museum of Fine Arts, Houston, Texas, USA, Museum purchase with funds provided by Duke Energy/The Bridgeman Art Library.

that recall the pomp and gaiety of diverse African peoples. His tour of the continent led directly to the publication in 1962 of the book *Ananse: The Web of Life in Africa,* which offers a gripping personal perspective in text and drawings of the positive energy and renewed sense of selfhood that his trip imbued him with. The publication of his book coincided with the rise of the Civil Rights Movement and catapulted Africa to the center of African American creative consciousness.

A slew of mural commissions followed, with Biggers digging into his repertoire of African symbols and imageries. His 1981 *Quilting Party,* which he executed for Music Hall of the City of Houston, is a complex mosaic of narratives with multiple perspectives, which are unified by a network of checkerboard patterns that recall the design of the Kongo people, whose sculptures and designs he must have been exposed to during his Hampton years. His retirement from teaching in 1983 gave him new impetus to create new murals that moved further away from the representational to the schematized. He received appreciation and recognition for his contributions to art and to the education of students, art teachers, and artists. In 1988, the Art League of Houston named him the Texas Artist of the Year while in 1989 his art was part of a major traveling show, "Black Art Ancestral Legacy: The African Impulse in African-American Art." In 1995, a major retrospective of his work was jointly organized by the Museum of Fine Arts in Houston and the Hampton University Art Museum. Until his death on January 25, 2001, Biggers continued to study African culture. He also continued to work on murals on which he collaborated with his nephew, James Biggers and Harvey Johnson.

Places to See Biggers's Work

Blue Triangle Branch YWCA Building, Houston, TX
Burrowes Hall, Pennsylvania State University, University Park, PA
Christia V. Adair Park, Harris County, TX
Dowling Veterinary Clinic, Houston, TX
Elementary School Library, New Addition, Paul Pewitt Independent School District, Omaha-Naples, TX
Hampton University Museum, Hampton, VA
International Longshoremen's Association Local 24, Houston, TX
Museum of Fine Arts, Houston, TX
Paul Robeson Cultural Center, Pennsylvania State University, University Park, PA
Smithsonian American Art Museum, Washington, DC
Student Life Center, Texas Southern University, Houston, TX
Tom Bass Regional Park, Harris County, TX
UTSE-CIO Temple, Chicago, IL
Winston-Salem University, Winston-Salem, NC
W. L. Johnson Branch, Houston Public Library, Houston, TX

Bibliography

Bearden, Romare, and Harry Henderson. *A History of African-American Artists from 1792 to the Present.* New York: Pantheon Books, 1993.

Biggers, John. *Ananse: The Web of Life in Africa.* Austin: University of Texas Press, 1962.

Biggers, John and Carroll Simms, with John Edward Weems. *Black Art in Houston: The Texas Southern University Experience.* College Station: Texas A&M Press, 1978.

Fax, Elton. *Seventeen Black Artists.* New York: Dodd, Mead, 1971.

Hills, Patricia. *Syncopated Rhythms: 20th-Century African American Art from the George and Joyce Wein Collection.* Exhibition catalog. Boston: Boston University Art Gallery; Seattle: Distributed by University of Washington Press, 2005.

Ritter, Rebecca, and Jeffrey Bruce. *Five Decades: John Biggers and the Hampton Art Tradition.* Exhibition catalog. Hampton, VA: Hampton University Press, 1990.

Short, Alvia Jean Wardlaw. "Strength, Tears, and Will: John Biggers' 'Contribution of the Negro Woman to American Life and Education.'" *Callaloo,* no. 5, *Women Poets: A Special Issue* (February 1979): 135–43.

Theisen, Olive J. *The Murals of John Thomas Biggers.* Hampton, VA: Hampton University Museum, 1996.

Theisen, Olive J. *A Life on Paper: The Drawings and Lithographs of John Thomas Biggers.* Denton: University of North Texas Press, 2006.

Wardlaw, Alvia. *The Art of John Biggers: View from the Upper Room.* Exhibition Catalog. New York: Harry N. Abrams in association with the Museum of Fine Arts, Houston, 1995.

Zeidler, Jeanne. "John Biggers' Hampton Murals." *International Review of African American Art* 12, no. 4 (1995): 51–57.

Alexander (Skunder) Boghossian (1937–2003), Painter.

In the annals of contemporary art, Boghossian looms large as one phenomenally talented painter and experimentalist who produced works that draw from his appreciation of the interdependence of thoughts, epochs, and events on a universal scale. He ranks as one with a profound knack for teasing out on his canvases those ideas that constitute the essence of a cosmic order: bejeweled, dazzling, and sometimes ethereal. Boghossian's paintings are unlike any other, which says much about his individuality and craftsmanship, especially in an era when sampling or appropriating the works or ideas of others has become normative.

While he was privileged as a budding artist to study and practice in the circle of major Parisian artists in the 1960s, he had the strength and integrity to chart a personal creative path that would become his own inimitable stylistic identity, one that assimilates the salient values of Western and African creative output without succumbing to fads or clichés. Boghossian's preeminence has been confirmed by the prodigiousness of his creative output and the number of prestigious spaces where he exhibited. Equally important was the recognition accorded him by the Museé d'Art Moderne in Paris, which in 1963 purchased his work, making him the first African to have this honor. Similarly, the Museum of Modern Art in New York acquired his work in 1965, thus making him the first Ethiopian artist to earn this distinction.

Boghossian's work exists in the wide but often isolated space between consciousness and beyond. Driskell (1985, 44) credits him with a perceptive ability that transcends the shape of form to involve an empathy for the creative space: "Skunder does see and feel those things, which allows him to integrate meaningful spatial relations in compositional statements that present, in an orderly fashion, the historical revelation of one of the world's richest and most ancient cultures." Boghossian himself confirms his interest in a message that plumbs the depths of his viewer's spirituality. In his work, the medium occupies a secondary place:

> The medium is second only to the message. The message grows from the totality of my living experience. The message is a survey of an African artist in "time and space" in search of himself and his roots. The message is a spiritual celebration that dares to paint the evil with the holy. The message is the sounding of a church bell on a Sunday morning. The message is a masochistic act of puncturing out the eye. The message is the self-healing process in a world where diseases abound.
>
> (quoted in Driskell 1985, 33)

Boghossian's Ethiopian ancestry becomes an essential factor in the extent to which he was able to assimilate disparate streams of creative consciousness and synthesize them to his own advantage. Boghossian was born in 1937 in Addis Ababa, Ethiopia, one of the world's most ancient nations, with traditions that match its ancientness. It was the second country after Armenia to adopt Christianity as the official religion in the fourth century. Vestiges of the intensity of Ethiopia's religiosity are visible today in its sacral practices and in the astounding number of freestanding churches—11 of them—that were fully carved from granite in Lallibela. But Ethiopia also admits of religious pluralism, as it is also home to an ancient tribe of Jewish and a respectable community of Islamic faiths. Add to this a small but important group of practitioners of traditional religion, and it becomes relatively easy to appreciate the interplay of visual referents in the work of Boghossian.

His Armenian father, Colonel Kosrof Boghossian, served on the Imperial Body Guard in Ethiopia. He joined the army when Boghossian was just a year old, and spent seven years as a POW, having been captured by the invading fascist regime of Italy. The responsibility of rearing Boghossian and Aster, his sister, fell not only on his mother, Weizero Tsedale Wolde Tekle, but also on other members of the extended family, among whom was his uncle Kathig Boghossian (Debela 2004). According to Aster, Boghossian was a precocious and inquisitive little boy with a great sense of humor who loved hunting and soccer, and drew as soon as he was able to hold a pencil (Debela 2004). Boghossian's early education started at the Tafari Makonnen School, while he received early encouragement on his drawings from an African American family friend, Larry Erskine, through whom he became familiar with jazz on Voice of America (Deressa 2000, 82). Writing about her visit to Boghossian's Washington, DC, studio, Elizabeth Giorgis recalls hearing in succession Ethiopian Orthodox chant, John Coltrane, and music from Mali. Boghossian's early encounter with jazz would leave an indelible imprint on him, as he would

absorb the essence of jazz music into his repertoire of aural and visual sources. Although he grew up in an environment in which magical scrolls complemented religious paintings and in neighborhoods where symmetrically designed processional crosses, classic parchment paintings, and illuminated scripts were commonplace, there was not a single art school in art in Ethiopia at this time, and his interest in art needed some molding. This was done with the assistance of Stanislas Chojnacki, a water colorist with expertise in the history of the art of Ethiopia, who taught Boghossian watercolor painting. Additional words of advice came from a French Canadian philosopher and painter, Jacques Goudbet, who opened Boghossian's eyes to the need to allow the painting to emerge without being forced.

As an enterprising artist who was yet to receive formal training, Boghossian had an exhibition of his works in Ethiopia and, in 1954, won second prize at a national art exhibition organized in commemoration of Emperor Haile Selassie's Jubilee Anniversary. With the prize that he received as a result of his success at this exhibition, Boghossian traveled to Europe in 1955 to pursue his art studies. After spending two years in London, during which time he studied at St. Martin's School of Art, the Central School, and the Slade School of Fine Arts, Boghossian found the British art regiment too rigid and academic; he wanted something expansive enough to accommodate his desire to learn the fundamentals of art. On the advice of his professors, he left for Paris in 1957 and enrolled at the Ecole Nationale Supérieure des Beaux Arts, where he grappled with mural painting. Boghossian also realized that he learned best outside of the school where he met other artists from the African Diaspora.

His stay in Paris coincided with the Negritude Movement, and he had the opportunity to meet with some of the century's most brilliant minds in the visual and literary arts and philosophy, including Leopold Sedar Senghor, apostle of the Negritude Movement, and Aimé Césaire, whose ideas he found captivating. His association with the prime movers of the ideological thrust saw him selected as one of three students to participate in the Second Congress of Negro Artists and Writers in Rome. Boghossian, a mere 22-year-old art student, admitted that he was perhaps much too young at that time to grasp the historic import of his participation: "I was very young. I didn't know what was really happening, its significance. All I knew was that I was exhibiting in Rome, with Sekoto from South Africa, an elder; Tiberio from Brazil, a devout socialist; and Ibrahim Papa-Taal from Senegal, who was a student at L'Ecole des Beaux Arts" (Cassel 1993, 54). In effect, Boghossian had a truly liberal arts education, one that allowed him to benefit from a hands-on approach to learning. It was in Paris that he met Madelaine Rousseux, a collector of classical African art who exposed Boghossian to Dogon cosmology and their grasp of the vital force.

For artists of the African Diaspora, Paris offered a congenial environment, away from the limitedness of facilities or the newness of medium that Africa offered at this point, or the racial bigotry and blatant social disequilibrium that African Americans at home had to endure. Boghossian mingled with other African artists in Paris, including the South African Gerald Sekoto, who introduced him to the Cuban modernist Wilfredo Lam. While Boghossian soaked

up the scene and absorbed the diverse sources of influence, he maintained a perspective that gave credence to his personality and a distinctive style that seemed to oscillate in a hallucinatory but dazzling firmament. In 1964, his work at the Galerie Lambert in Paris drew remarkably positive reviews from Parisian critics. This led to an invitation to become a member of the avant-garde movement, Phase, which he left shortly after he joined the group, to work with André Breton.

The first time that he visited the United States was in 1961. His visit, which coincided with the riots in Harlem, was organized by the Harmon Foundation; it afforded him the opportunity to see the works of African American artists, and to meet with **William H. Johnson**. In 1964, back to Paris, he fell in love with Maureen, an African American woman from Tuskegee, Alabama, who was in Paris studying cinematography. They were married in Tuskegee and, together, returned to Ethiopia where they had daughter, Aida Mariam. In Addis Ababa, Boghossian joined the faculty at the School of Fine Arts, where he was a colleague of another great Ethiopian abstract painter, Gebre Kristos Desta, who had studied in Germany before returning to Ethiopia in 1962 to initiate what would eventually become a major tradition of modernist expression in the country. Boghossian had his first one-man exhibition in 1966 in Addis Ababa, with works that set a precedent for a new generation of contemporary Ethiopian artists. For an artist who was the only Ethiopian to participate at the 1965 fourth Biennale in Paris, and as one who had in 1966 participated in the Salon de Comparison, (Benjamin 1972, 22) the Addis Ababa exhibition represented a much-needed homecoming; it gave him the opportunity to light the creative fire of a new group of artists in his home country. In 1969, he left Ethiopia for the United States as a resident instructor at the Atlanta Center for Black Art in Georgia, and also as visiting artist to Creighton University and Atlanta University. In 1971, he joined the faculty of Howard University as artist-in-residence and, from 1974 to 2000 when he retired, served as a full-time faculty member there.

While he spent only three years in Ethiopia, it was significant enough to initiate a new order in the country's contemporary art scene. He was largely responsible, directly or indirectly, for the significant presence of a generation of Ethiopian-American artists who continue to practice in the United States. Among his students who have attained international recognition are Zerihum Yetmegeta, Tesfaye Tessema, and **Wosene Worke Kosrof**. In 2003, the Museum of African Art at the Smithsonian Institution had a major exhibition, "Passages," which featured the works of key Ethiopian artists, including Aida Muluneh, Kebedech Tekleab, and Elizabeth Atnafu. On May 4, a few days after Boghossian sat for an interview, he died in Washington DC.

Places to See Boghossian's Work

Blanchette Rockefeller Collection, New York, NY
Ethiopian Embassy, Washington, DC
Hilton Hotel, Addis Ababa, Ethiopia
Ministry of Foreign Affairs Building, Addis Ababa, Ethiopia

Musée d'Art Moderne, Paris, France
Museum of Modern Art, New York, NY
National Museum of African Art, Smithsonian Institution, Washington, DC
North Carolina Museum of Art, Raleigh, NC
Studio Museum in Harlem, New York, NY

Bibliography

Benjamin, Tritobia H. "Skunder Boghossian: A Different Magnificence." *African Arts* 5, no. 4 (Summer 1972): 22–23.

Biasio, Elisabeth. "Magic Scrolls in Modern Ethiopian Painting." *Africana Bulletin* 52 (2004): 31–42.

Casey, David M. "African Art Today: Four Major Artists." *African Arts* 8, no. 1 (Autumn 1972): 61–62.

Cassel, Valerie. "Convergence: Image and Dialogue. Conversations with Alexander 'Skunder' Boghossian." *Third Text* 23 (Summer 1993): 53–68.

Cotter, Holland. "Skunder Boghossian, 65, Artist Who Bridged Africa and the West." *New York Times* 152, no. 52487 (May 18, 2003): 43.

Debela, Achamyeleh. "Alexander (Skunder) Boghossian: A Jewel of a Painter of the 21st Century (1937–2003)." Paper presented at the 12th Triennial Conference of the Arts Council of the African Arts Association, Harvard University, Cambridge, MA, April 3, 2004.

Deressa, Solomon. "Skunder in Context." *NKA: Journal of Contemporary African Art*, no. 11–12 (Fall–Winter 2000): 80–85.

Driskell, David, and Leonard Simon. "Skunder." *International Review of African American Art* 6, no. 3 (1985): 33–51.

Duerden, Dennis. "Letter from London: The Exhibition of Contemporary African Art/1967." *African Arts* 1, no. 1 (Autumn 1967): 27–29, 67.

Hassan, Salah, and Achamyeleh Debela. "Addis Ababa Connections: The Making of the Modern Ethiopian Art Movement." In *Seven Stories about Modern Art in Africa*, edited by Clementine Deliss, 127–249. New York: Flammarion, 1996.

Herney, Elizabeth, ed. *Ethiopian Passages: Contemporary Art from the Diaspora.* Washington, DC: National Museum of African Art, Smithsonian Institution, 2003.

"I'm Just Time Itself" (obituary). *International Review of African American Art* 19, no. 2 (2003): 63.

Stanley, Janet. "Three Contemporary Ethiopians." *African Arts* 26, no. 1 (January 1993): 76–77.

C

Elizabeth Catlett (b. 1915), Sculptor, Printmaker, Painter, Multimedia Artist.

Elizabeth Catlett is a consummate artist, trailblazer, and devoted student of relevant and committed art. Although she had the choice of focusing on painting, in which she majored at Howard University, Catlett's inquisitive and exploratory spirit had the better of her and she ended up exploring other media: ceramics, lithography, and sculpture—areas in which she has left a substantial body of work, many of which, like her 1968 linocut *Sharecropper,* have become national icons. Beyond the passion and empathy that suffuse her work and the intensity and sensitivity with which they are rendered, there is the unmistakable connection between the artist as a maestro of the various media that she works in, and Catlett as a socially astute and politically sensitive persona. It is this fusion of medium and vision that has earned Catlett the national and international recognition that she enjoys. Her role as an artist is as important as her commitment to social justice and her advocacy for using art as a causative agent of change.

Catlett, who was born in Washington, DC, on April 15, 1915, to John and Mary Carson Catlett, is the youngest of three children. Catlett, whose grandparents on both sides were slaves, received a sound education, no doubt because both of her middle-class parents were teachers. Her father, who died soon after Catlett was born, was a multidimensional individual who demonstrated skills in both the arts and the sciences. A sculptor, musician, and composer, he taught mathematics as a teacher in Washington, and also at the Tuskegee Institute in Alabama. Catlett received her elementary, high school, and university education in Washington. After her elementary education at the Lucretia Mott Elementary School, she attended Dunbar High School, after which she gained admission to Howard University in 1932, where she studied with **Loïs Mailou Jones** and James A. Porter, who influenced Catlett's decision to major in painting. Howard University during Catlett's time was a vibrant center for creative engagement and scholarly discussions on the place of the African American artist in a society grappling with racial dissonance. It was the institutional base of Alain Locke, the intellectual power behind the emergence of the "New Negro" that focused on the empowerment of the African American artist. James A. Porter, a young faculty member who taught painting, would go on to write *Modern Negro Art,* the book that blazed the trail in chronicling the history of African American artists. At Howard University,

Porter mentored Catlett, exposed her to the work of Mexican muralists, and assisted in getting her a job at the mural division of the Public Works of Art Project in 1934. In 1935, Catlett graduated cum laude from Howard University and secured employment as a teacher in Durham, North Carolina, where she taught art in a black high school and exercised oversight for art in eight additional elementary schools (Bearden and Henderson 1993, 420). Catlett left two years later, appalled at the prevalent socioeconomic conditions in which students learned.

In 1938, Catlett went to study with Grant Wood at the University of Iowa in Iowa City, where, in 1940, she became the recipient of the first MFA degree ever awarded by the university. Although Catlett's embracement of social cause came as a result of her involvement in the Civil Rights Movement of the 1960s, the antecedents for creating relevant art dates back to the late 1930s when, as a student at the University of Iowa, she took Grant Wood's advice to heart and began focusing on subjects that she is most familiar with: her own people. Looking back at the influence of Wood on her career, Catlett remarked that her attitude and artistic perspective were shaped by racism: "Grant Wood, one of the first white people that I had contact with, emphasized that we should paint what we knew most intimately . . . and my people have always been just that—what I know most intimately" (Bearden and Henderson 1993, 421). Catlett's "people" would eventually include those in Mexico, to which she first traveled in 1946. "I decided a long time ago that mine is with the only people in the United States that call each other 'brother' and 'sister,' and with the Mexicans who are trying to get food and freedom for everybody" (Lewis 1994, 135).

Under the watchful direction of Grant Wood at Iowa, Catlett found her comfort level in sculpture, a medium that was not available while she was studying at Howard. By the time she graduated in 1940, she had become quite proficient in carving. Her *Mother and Child*, a limestone sculpture that she carved while at Iowa, won first prize in 1940 at the American Negro Exhibition in Chicago. That same year, Catlett studied ceramics at the Art Institute of Chicago, married her first husband, **Charles Wilbert White**—an artist who is remembered for his superb draftsmanship and powerfully rendered subjects —and secured employment as chair of the Department of Art at Dillard University in New Orleans. She left in 1942, moved to New York with her husband and studied lithography at the Art Students League. During this period, Catlett studied with Ossip Zadkine, a Russian Jewish artist who had come to New York as a World War II refugee. For a period, Catlett and White taught at Hampton Institute in Virginia, employed by Viktor Lowenfeld, the Austrian psychologist and art educationist who moved to the United States in 1939 and eventually established Hampton's art department. Lowenfeld wielded tremendous influence on a number of students and artists, including **John Thomas Biggers**.

Catlett returned to New York with her husband in 1944 and became a teacher at the George Washington Carver School in Harlem. In 1946, she received a Rosenwald Fund Fellowship and traveled to Mexico with Charles White. She became enchanted with life in Mexico and took advantage of the

presence of notable Mexican sculptors and artists—Francisco Zuniga, Jose L. Ruiz, and Jose Elarese—to expand her knowledge of sculpture and the new culture and make lithographic work at the Taller de Grafica Popular. Catlett made the acquaintance of leading Mexican artists, including David Siqueiros, Diego Rivera, and Leopold Mendez. In 1947, she married Francisco Mora after divorcing Charles White and decided to settle in Mexico permanently.

Elizabeth Catlett attends Oprah Winfrey's Legends Ball in Santa Barbara, California, 2005. Photo by Frederick M. Brown/Getty Images.

The oeuvre of Catlett is a testimony to her staunch belief in the power of art to present and re-present the fundamental tenets and socioeconomic conditions of the black and underprivileged peoples of the world. This principled stand has been a critical factor in the subject matter favored by Catlett, in the audiences that she has consistently been interested in cultivating, and in the style in which she has continued to express her concerns and apprehensions. As one who has devoted her entire life to the cause of employing art to speak for the downtrodden, her lithographic prints exert looming presences because of their ability to capture in economic lines the dignity and pride that her subjects exude despite the oppressive and brutal conditions under which they labor and toil. One of her most popular prints is *Sharecropper,* a 1968 linocut that depicts a compact and elegant woman whose radiates strength and resoluteness even as she covers her head from the inclement weather with a large hat. In her 1975 linocut, *Harriet,* Catlett presents a messianic Harriet Tubman directing her people to freedom. The indomitable presence of Tubman is captured in swirling lines that privilege her stature as a leader and catalyst. Catlett's prints resonate with empathy for the multitude of poor, underclass, and overworked peoples, especially women workers and nursing mothers. In her life as well as in her work, Catlett has been consistent in using her art to critique the arrogant and disdainful manner in which many artists have continued to work, seemingly oblivious to the abject poverty that stare the poor in the face. It is an elitist approach that Catlett finds unacceptable: "I can't do what white people with money want at the same time I'm doing what my people need." Furthermore, Catlett believes—and, indeed, charges—that artists would benefit humanity if they would serve people's needs. "We ought to stop thinking we have to do the art of other people. We have to create an art for liberation and for life" (Lewis 1994, 135). Her sculptures are equally recognized for the fullness of their authority and presence. Whether they are full figures or busts, Catlett's sculptures do not glamorize the penchant of the rich to indulge in art that induces pure contemplation at the expense of the poor. "I want the ordinary person to be able to relate to what I am doing. Working, figuratively, is the dues I must, want, and am privileged to pay so that ordinary people can relate to my work at and get lost trying to figure out what it means.

True art always comes from cultural necessity" (University of Iowa Alumni Association).

Catlett, who is the subject of several publications, has received numerous honors and awards in addition to having a string of solo exhibitions and group shows at national and international venues. In 1996, she was honored with a Distinguished Alumni Award by the University of Iowa. In 2006, the Art Institute of Chicago made Catlett the first recipient of its Legends and Legacy Award, in addition to organizing an exhibition to commemorate its acquisition of an acquisition of five of her prints that date to the 1940s.

Places to See Catlett's Work

Baltimore Museum of Art, Baltimore, MD
Cleveland Museum of Art, Cleveland, OH
Columbus Museum of Art, Columbus, OH
DuSable Museum of African American History, Chicago, IL
High Museum of Art, Atlanta, GA
Metropolitan Museum of Art, New York, NY
Mississippi Museum of Art, Jackson, MS
Museo de Arte Moderno, Mexico City
Museum of African American History, Detroit, MI
Museum of Modern Art, New York, NY
Narodniko Musea (National Museum), Prague, Czechoslovakia
National Museum of American Art, Washington, DC
New Orleans Museum of Art, New Orleans, LA
Studio Museum in Harlem, New York, NY
Wadsworth Atheneum, Hartford, CT

Bibliography

Bearden, Romare, and Harry Henderson. *A History of African American Artists from 1792 to the Present.* New York: Pantheon Books, 1993.

Brenson, Michael, and Lowery Stokes Sims. *Elizabeth Catlett Sculpture: A Fifty-Year Retrospective.* Purchase, NY: Neuberger Museum of Art, Purchase College, State University of New York; Seattle: Distributed by University of Washington Press, 1998.

Carroll, Valinda. "Samella Lewis' Catlett Collection at the Hampton University Museum." *International Review of African American Art* 21, no. 1 (2006): 59–61.

Driskell, David C. *Two Centuries of Black American Art.* Los Angeles: Los Angeles County Museum of Art, 1976.

Freeman, Linda. *Elizabeth Catlett: Sculpting the Truth.* Video recording. Chappaqua, NY: L&S Video, 1999.

Herzog, Melanie. *Elizabeth Catlett: An American Artist in Mexico.* Seattle: University of Washington Press, 2000.

———. *Elizabeth Catlett: In the Image of the People.* Chicago, IL: Art Institute of Chicago; New Haven, CT: Distributed by Yale University Press, 2005.

Hills, Patricia. *Syncopated Rhythms: 20th-Century African American Art from the George and Joyce Wein Collection.* Boston, MA: Boston Art Gallery; Seattle: Distributed by University of Washington Press, 2005.

LaDuke, Betty. *Africa: Through the Eyes of Women Artists.* Trenton, NJ: Africa World Press, 1991.

Lewis, Samella. *African-American Art and Artists.* Berkeley: University of California Press, 1994.

Martin, Elizabeth. *Female Gazes: Seventy-Five Women Artists.* Toronto: Second Story Press, 1997.

Perry, Regenia. *Free Within Ourselves: African-American Artists in the Collection of the National Museum of American Art.* Washington, DC: National Museum of American Art, Smithsonian Institution in association with Pomegranate Artbooks, San Francisco, 1992.

University of Iowa Alumni Association. "The University of Iowa Presents: The Distinguished Alumni Awards: Elizabeth Catlett Mora." July 21, 2008. http://www.iowalum.com/daa/mora.html

Sonya Clark (b. 1967), Multimedia Artist.

Sonya Clark sculptures are fashioned within a composite, ontological, aesthetically captivating but sometimes whacky genre that draws on visual referents, semiotics, and philosophical precepts from diverse sources, especially in the Black Diaspora. Glass beads and buttons; combs and human hair; wool felt and cloth; nails, coils, and ceramics; wrapped wire and tacks; stitched-down pennies, tacks, and synthetic fleece: these are some of the materials that Clark deploys in ways that address whimsical, social, and deeply philosophical notions. In Clark's words: "Some of my work is to find the places where things bridge and also find places where there is a crossroad. Identity is a complex thing; in its complexity, the river runs deep" (Clark 2008).

Beginning from the mid-1990s, Sonya began focusing on issues pertaining to the head. Employing wigs, cloth, and thread, she constructed a variety of scenarios portraying the numerous hair permutations that black women, and specifically African women, have popularized. Clark's intent is to draw attention to the primacy of the head as the intellectual base—the powerhouse and seat of wisdom—and the inexorability of (re)cognition and adornment that it deserves. In her "Wig Series," Clark uses semi-hemispherical base to represent the upper half of the skull and weaves cloth and thread to simulate the variety of hair configurations that highlight the creative vitality of hair sculptors at the same time that they recall plants, tendrils, and the curly sinuousness of some exotic sea creatures. In his note on this series, Michael D. Harris writes: "The works are referential, reverential, and irreverent all at once. Clark's wigs don't hide bad hair days, but suggest BAD hair days. They remind, and surprise. Yet they can be unsettling because they look a bit like disembodied scalps" (Harris n.d.). For Clark, the coiffure is a signifier—an unhidden and unhideable index of cultural identity, one that proclaims one's ethnicity at the same time that it emphasizes an incipient universalism.

In her work, Clark often seeks to create in visual forms fugitive notions that are grounded in intellectualized spaces. Her exploration of the head, or crowns, or head-ties, or the apex, for example, grew from an inspirational talk that she heard James Baldwin give when she was a student at Amherst College in the late 1980s. Baldwin had admonished African Americans to "find [their] lost crowns and wear them." While the sheer power of this phrase had forced Clark to immediately jot Baldwin's exhortation down, it would not be until years later, when Clark was pursuing her second baccalaureate at the School of the Art Institute of Chicago, that she would begin to ponder and process the signification of Baldwin's remarks. Baldwin would have a special place in Clark's memory because her ancestry, her family makeup, and her education have combined to sensitize her to issues pertaining to African American and Diasporic expressive and material cultures.

The younger of two sisters, Clark was born in Washington, DC, on March 23, 1967. Her parents had migrated from Jamaica to the United States in pursuit of higher education. Her father, Ranville Clark, hails from Trinidad but is believed to be of Yoruba extraction. Ranville Clark came to Howard University for his medical degree in psychiatry. Sonya Clark's mother, Lilleth Clark, a Jamaican by birth, had met her husband in Jamaica while he was a student. Ranville Clark moved to Howard University and Lilleth joined him later, after she completed her training as a nurse in Jamaica. By birth and education, Clark has experienced the fullness of cultural hybridity. As a young girl in Washington, Clark was exposed to multiple nuances of black identity. She grew up in a black community: in an African American neighborhood in an Afro-Caribbean household. A third manifestation of her sensitivity to her black heritage came through her education. She attended Sidwell Friends School, a private, predominantly white school that was founded on the Quaker religious doctrine. Her interest in Diasporic culture was fueled at such an early age through her exposure to the multiple streams of cultural engagements in her neighborhood. Living across the street from her home in Washington was the ambassador from the Republic of Benin. At an early age, Clark imbibed the belief that diversity transcended the physicality of human existence.

At Amherst, where she studied for her first degree and majored in psychology with a minor in black studies, Clark developed an interest in Africa and was excited about the systems of thought with which she came in contact. There, she studied with Rowland Abiodun, a highly regarded existentialist, aesthetician, and philosopher on Yoruba art and cognition. Clark also studied with another professor, an artist who brought to bear on his teaching his knowledge of Africa, Femi Richards. After graduating from Amherst in 1989, Clark embraced the opportunity to travel to Africa. In Cote d'Ivoire, she was struck by what she perceived as a symbiotic relationship between Jamaica and that part of Africa. Cote d'Ivoire reminded her of Jamaica. The country gave her the opportunity to weave on the loom for the first time—an opportunity that rekindled in her an insatiable love for sheer artistry and craftsmanship. Her grandmother, Vera McHardy, a tailor, was the one that first taught Clark how to sew. Her maternal grandfather was a skilled woodworker who made furniture. Clark's visit to Cote d'Ivoire seemed to have opened in her a

dormant passion for handicrafts. This passion would ultimately lead to her creating a syncretic genre—a visual tapestry that addresses multiple levels of psychoreligious, social, and visual concerns.

In 1995, Clark obtained her M.F.A. degree from Cranbrook Academy of Art. Two years later, she was appointed assistant professor of environment, textiles and design at the University of Wisconsin–Madison. There again, she found herself in a intellectually stimulating company of Africanists, including Henry Drewal, who is one of the pioneering scholars of Yoruba art. Bolaji Campell, an artist and colleague with whom Clark would eventually collaborate on an exhibition, "Common Ties," was completing his graduate program in Wisconsin. Among Clark's major projects during this time was "African Inspirations: Sculpted Headwear," which was exhibited at the University of Iowa Museum of Art in 2001 and traveled to the Indianapolis Museum of Art.

This was part of Clark's preoccupation with the exploration of all things relating to the temple: hair, hat, headgear, and all appurtenances. Through her research and professional association in Wisconsin, Clark became more appreciative of the relationship between thought systems and visual expressions especially among the Yoruba for whom tying the head gear, known as "gele," is an art. Yoruba women believe that the elegance of "gele" is in the mastery of its tie. The elaborate and colorful "gele" is but one of the ways of showing reverence to the head, the most important part of one's humanity. Although she made her first "gele" in 1995 when she was in graduate school at Cranbrook, she was able to expand on the concept at Wisconsin. Henry Drewal captures the import of Clark's exploration of the metaphysical essence of the head, "ori" in Yoruba, in his short essay for the 2000 exhibition catalog:

> The head is the site of the spiritual essence of a person—one's soul, personality, identity, and destiny. . . . Ori, like the person, has two dimensions—a visible, physical, outer part (*ori ode*) and an inner spiritual one (*ori inu*). One's outer appearance may reveal (as well as conceal) the inner, spiritual self. A visual artist's work may do the same, for the ideas of outer/inner aspects of the head also extend to the eye. To use one's outer eye (*oju ode*) is to capture surface appearance, while using one's inner eye (*oju inu*)—insight, intuition—is to reveal essence.
>
> (Drewal 2000)

In 1999, Clark started a major project, "The Beaded Prayers." This was a participatory engagement in which contributors created small beaded cloth packets within which personal wishes, prayers, and appeasements were embedded. The project was inspired by Clark's interest in exploring why many blacks in the United States wear leather amulets. The project, a traveling exhibition with workshops and lecture components, was initially designed to run for five years, an ambitious idea given the fact that its success would be hinged on the enthusiasm with which participants responded. "The Beaded Prayers" project became so phenomenally successful that Clark found it difficult to shut it down. The power behind the success of the project appeared anchored in the essence of spirituality and the infectiousness of participatory art.

Every participant was free to create an object, with the stipulation that such an object, which could be of any shape and medium, should not be bigger than a palm size, should contain a secret written prayer, be firmly sealed, and must have at least one bead stitched to the outside. The result was a project that developed its own spirit and became much more powerful than mere visual appropriations. Clark's project had unleashed a universal quest for spirituality, as "The Beaded Prayer" conjured equivalences among various groups across the world. In the United States, it is referred to as "mojo," or "hand." Among several groups in Africa, it is known by different names: "tira" among the Yoruba of Nigeria; "gris gris" in Senegal; "minkisi" in the Congo; and "patua" in Brazil. "The Beaded Prayer," which traveled to several museums in such cities as New York; Columbus, Ohio; San Francisco, California; Montreal, Canada; Baltimore, Maryland; Atlanta, Georgia; Kumasi, Ghana; and Canberra, Australia, has had about 5,000 participants and contributors.

Clark, who is professor and chair of the Craft and Material Studies Department of the Virginia Commonwealth University School of the Arts, has had numerous solo and group exhibitions in more than 150 sites nationally and internationally, in countries such as South Africa, Australia, France, the United Kingdom, Brazil, and Switzerland. Her honors include a Wisconsin Arts Board Fellowship, a Rockefeller Bellagio Residency, and a Pollock-Krasner Award.

Places to See Clark's Work

Cranbrook Art Museum, Bloomfield Hills, MI
Hampton Museum, Hampton, VA
Helen Louise Allen Textile Collection, Madison, WI
Indianapolis Museum of Art, Indianapolis, IN
Madison Museum of Contemporary Art, Madison, WI
Mead Art Museum, Amherst, MA
Montreal Museum of Decorative Arts, Montreal, Canada
Musees d'Angers, Angers, France
Sprint Corporation, Overland Park, KS
University of Iowa Museum of Art, Iowa City, IA

Bibliography

Andrews, Laura. "African Bead Project at Queens Library." *Caribbean Life,* May 9, 2007, 46.

Becker, Cynthia. "Review: Beaded Prayers." *African Arts* 39, no. 2 (Summer 2006): 9, 76–78.

Campbell, Mavis Christine. "Biographical Sketches." In *Black Women of Amherst College,* 196–202. Amherst, MA: Amherst College Press, 1999.

Cannarella, Deborah. *The Beading for the Soul,* 96–99, 146. Loveland, CO: Interweave Press, 2005.

Clark, Sonya. Personal telephone communication with author. May 12, 2008.

Douglas, Diane, and Vicki Halper. *Choosing Craft: A History in Artists' Words.* Chapel Hill: University of North Carolina Press, 2008.

Drewal, Henry. "Sources Re-Membered." In *Common Ties: Dots & Dashes, Beads.* Exhibition catalog. Madison: Wisconsin Union Gallery, 2000.

Halper, Vicki. "Trinket to Talisman." *Metalsmith* 24, no. 5 (Fall 2004): 33–39.

Harris, Juliette, and Pamela Johnson, ed. *Tenderheaded: A Collection of Hair Stories,* 159. New York: Pocketbooks, 2001.

Harris, Michael. Untitled entry. In *Wig Series,* unpaged exhibition catalog by Sonya Clark. N.d.

Hickman, Pat. "Awarding Talent." *American Craft* 65, no. 2 (April/May 2005): 48.

Krantwurst, Terry. *500 Beaded Objects: New Dimensions in Contemporary Beadwork.* Asheville, NC: Lark Books, 2004.

Lewis, Samella. "From Painting to Technology: Art before and into the New Millenium." In *African American Art and Artists,* 310–13. Berkeley: University of California Press, 2003.

O'Sullivan, Michael. "Richmond Artists Rooted in Histories." *Washington Post,* Friday, December 1, 2006, 50.

Powell, Richard. "Hampton University Museum." In *To Conserve a Legacy: American Art from Historically Black Colleges and Universities,* 22–23. New York: Studio Museum in Harlem; Cambridge, Massachusetts, 1999.

University of Iowa Museum of Art. *African Inspirations: Sculpted Headwear by Sonya Clark.* Iowa City: University of Iowa, 2001.

Visona, Monica Blackmun, Robin Paynor, Herbert M. Cole, Michael D. Harris, et al. *A History of Art in Africa,* 523. New York: Harry N. Abrams, 2000.

Robert Colescott (b. 1925), Painter.

Robert Colescott was born in Oakland, California. His parents were a part of the Great Migration generation of African Americans who moved northward in the second decade of the twentieth century. In 1919, his parents moved from New Orleans where his father, a jazz musician, trained as a violinist and played with Louis Armstrong and King Oliver. He was a World War I veteran and had worked as a railroad waiter with the Southern Pacific. Both of his parents were educated in segregated schools in New Orleans. A year after she was married, his mother, who was a pianist, lost her teaching job because the school system would not hire any married women to teach. One of the primary reasons for going to Oakland was education. For his parents, there was no shortcut to life but through education: there was an incontestable expectation of incremental family growth through the instrument of education. For the Colescott family, education was an imperative, and their children were obliged to go to college; Colescott's aunt had studied music at Oberlin College in Ohio, while his cousin attended Northwestern University in Illinois, where he studied medicine. According to Colescott, "it was understood that if your family reached a certain level of education that you would get education. And there was [sic] no two ways about it" (Karstrom 1999).

He joined the U.S. Army after high school and served in France for about four years during World War II. Upon his discharge, he attended San Francisco

State University in 1946 with the primary aim of preparing himself for a career in the diplomatic corps as an international relations officer. He was forced to reconsider art as a potential career with any degree of seriousness only when he was informed that as a person of color, his prospects in the civil service as a diplomat were not bright. He declared art as his major and transferred to the University of California at Berkeley in 1946. He graduated just as gestural painting and abstract expressionism emerged as the new expressive movements, although Colescott distanced himself from them because he preferred a structured approach to the "chaotic" posture of the new painting. Although he received his degree in art, he felt that his education did not adequately prepare him to be an artist, and thus he felt obliged to reeducate himself. According to Colescott, the teachers that he had "could teach theory but they couldn't teach painting" (Karstrom 1999). In 1949, he went to Paris, where, for one year, he studied with Fernand Leger, who encouraged him to abandon abstraction and embrace figurative painting. After his Paris education, he returned to the University of California in Berkeley, where he obtained his M.A. in 1952. For the next 14 years, Colescott combined teaching with making art. He taught art in public schools in Seattle, Washington, and at Portland State University in Oregon.

In 1964, with a grant to study contemporary Egyptian painting he traveled to Cairo, Egypt, as artist-in-residence. It was an epiphany for Colescott, who, for the first time, found inspiration in the overpowering presence of creative traditions that go back thousands of years. The effect of his sojourn in Egypt also stimulated his sense of selfhood: "I spent a couple of years in Egypt and was influenced by the narrative form of Egyptian art, by 3,000 years of a 'non-white' art tradition, and by living in a culture that is strictly 'non-white.' I think that excited me about some other things, some of the ideas about race and culture in our own country; I wanted to say something about it" (Lobel 2004). The outcome of the effect would take years to manifest in his art. When it did, his art underwent an unmistakably transformative process; it became at once shocking and amusing, and as outrageously acerbic as it was cajoling. Beginning in 1975, Colescott developed a new style of figurative art that appropriated familiar western images; inverted, twisted, or punned the content; and narrated blacks into the main frame in ways that generously satirize, horrify, or deflate egos. By inserting blacks into his own version of artworks of historical import, Colescott draws attention to the absence and, indeed, the relegation of blacks to a marginal status in the art of the Western world. At the same time, Colescott embarked on a project that was aimed at fulfilling his desire to "put black people into art history" (Sims 1987).

The groundbreaking painting that catapulted Colescott to national attention is *George Washington Carver Crossing the Delaware: Page from an American History Textbook,* a provocative even if satirical remake of Emanuel Leutze's 1851 painting *George Washington Crossing the Delaware.* While retaining the original thrust and format of Leutze's painting, Colescott turns his own version into a racial parade—a float of sorts—in which George Washington Carver, famous for his pioneering scientific work on peanuts, leads a parade of fun-seeking, broadly grinning black caricatures that include a chef, a fisherman, and a banjo player.

In place of the heroic George Washington in the original painting, Colescott's George Washington Carver strikes a comically cowardly posture that accentuates the parody. In this same stylistic vein, Colescott sets his gaze on other Western classics—a precondition for maximum effect—and injects them with his brand of sarcasm and humor. Van Gogh's *Potato Eaters* is resuscitated by Colescott in his 1975 *Eat Dem Taters*, while Jan van Eyck's *Giovanni Arnolfini and His Bride* undergoes a remake in which the bride, now pregnant, is a scared "darky."

For Colescott, it was not only the subject matter that changed; his palette also changed and became vivid and colorful. While in Egypt a decade earlier, Colescott had remarked on the extent to which his trip had affected his own perception of self and attitude to color:

> In terms of art, I was looking at 3,000 years of art history, and it was the art history of people of color. I came into contact with the narrative form because Egyptian art had a strong narrative sense to it; it was really important to tell a story. And the sense of monumentality that Leger kept trying to poke at me was so well-illustrated in Egyptian sculpture and architecture that it kind of put the pieces together.
>
> (Fitzgerald 1997)

Suddenly, his education was beginning to bear fruit. He had absorbed the theoretical crux that his college professors imparted to him and compensated for their lack of painting skills by broadening his education—in France and Egypt. Now, three decades after his formal education, Colescott had hit his stride; he had finally found a voice that allowed him to narrate blacks into history. George Washington Carver became the work that drew attention to issues of tokenism, race, bigotry, social status, and the perception of blacks in white America. By appropriating classical icons of Western art, Colescott successfully brought attention to those issues. However, he was surprised at the reception that trailed his work. His new creative stridency provoked a torrent of criticism and admiration in equal measures from both white and black quarters. Colescott admitted that he was jolted by the vigor of the responses that followed his new expressive mode. "There were white people who were offended because they felt guilty because their ... people had created these images. . . . So there were white people that felt threatened by these paintings which monumentalized these perceptions" (Karstrom 1999). There were those in the African American community who, while acknowledging the seminal import of Colescott's style, were apprehensive that his appropriation of the image of blacks as bumbling simpletons could resuscitate condemnatory visual imageries of the past. They felt that relying on the same tools and iconographic tropes that were used to depict blacks in unflattering and derogatory terms in the past may unleash new racial divides.

Throughout the seventies and the eighties, Colescott would continue exploring this theme by appropriating other classics: Willem de Kooning's *Woman* became transformed into a black figure with an appropriate title, *I Gets a Thrill Too When I Sees De Koo*. In 1985, Colescott did two versions of Picasso's *Les Desmoiselles d'Avignon*, and changed the titles in his characteristic fashion: *Les*

Demoiselles d'Alabama: Vestidas (and *Desnudas*). In all of his paintings of this period, racial identity, sexuality, politics, and history were spotlighted, the central issue being the relevance or marginalization of the African American race.

In 1995, he retired as Regents Professor of Art at the University of Arizona and, two years later, he represented the United States at the Venice Biennale, becoming the first painter since Jasper Johns, and the first African American to be accorded this honor. His long teaching career started at Portland State University in Oregon, where he taught from 1957 to 1966. He had short teaching stints at the American University in Cairo (1966–67) and the American College in Paris (1966–67). He taught at San Francisco Art Institute between 1976 and 1985 before moving to the University of Arizona in 1985. He has had several solo exhibitions and garnered numerous honors and awards. Among these were his appointment to the Regents' Endowed Professorship in Fine Arts in May 1990, a Roswell Foundation artist's residency in 1987, a 1985 Simon Guggenheim Foundation grant, and three National Endowment for the Arts grants—in 1976, 1980, and 1983.

Places to See Colescott's Work

Akron Art Museum, Akron, OH
Albright Knox Museum, Buffalo, NY
Bagley Wright Collection, Seattle, WA
Boston Museum of Fine Art, Boston, MA
Brooklyn Museum of Art, Brooklyn, NY
Corcoran Gallery of Art, Washington, DC
Denver Museum of Art, Denver, CO
De Young Memorial Museum (The Fine Arts Museums of San Francisco), San Francisco, CA
Greenville County Museum of Art, Greenville, SC
High Museum of Art, Atlanta, GA
Hirshhorn Museum, Washington, DC
Indianapolis Museum of Art, IN
McKinney Avenue Contemporary (The MAC), Dallas, TX
Metropolitan Museum of Art, New York, NY
Museum of Contemporary Art, San Diego, La Jolla, CA
Museum of Modern Art, New York, NY
Newark Museum of Art, Newark, NJ
New Orleans Museum, New Orleans, LA
Oakland Art Museum, Oakland, CA
Studio Museum in Harlem, New York, NY
Tucson Museum of Art, Tucson, AZ
Whitney Museum of American Art, New York, NY

Bibliography

Berlind, Robert. "Robert Colescott at Phyllis Kind." *Art in America* 91, no. 6 (June 2003): 118–19.

Brody, Jennifer DeVerve. "Memory's Movements: Minstrelsy, Miscegenation, and American Race Studies." *American Literary History* 11, no. 4 (Winter 1999): 736–45.

Danto, Arthur C. "Robert Colescott; Russell Connor." *Nation* 248, no. 20 (May 1989): 709–13.

Driskell, David, ed. *African American Visual Aesthetics: A Postmodernist View.* Washington, DC: Smithsonian Institution Press, 1995.

Edelman, Robert G. "The Figure Returns." *Art in America* 82 (March 1994): 38–41.

Fitzgerald, Sharon. "Robert Colescott Rocks the Boat." *American Visions,* June–July 1997. http://findarticles.com/p/articles/mi_m1546/is_n3_v12/ai_19508857 (accessed January 17, 2008).

Johnson, Ken. "Colescott on Black and White." *Art in America* 77 (June 1989): 148–53.

Karstrom, Paul. "Interview with Robert Colescott." Conducted on April 14, 1999, at Tucson, Arizona, for the Archives of American Art, Smithsonian Institution.

Lobel, Michael. "Black to Front." *Artforum International* 43, no. 2 (October 2004): 266–310.

Miller, Francine Koslow. "Robert Colescott's Acerbic Brush." *Art New England.* 19 (December 1997–January 1998): 22–24.

Odita, Donald Odili. "Don't Worry, Be Happy?" *Art Papers* 22, no. 6 (November–December 1998): 24–25.

Sims, Lowery Stokes. *Robert Colescott: A Retrospective, 1975–1986.* San Jose, CA: The Museum, 1987.

Todd, Elle Wiley. "Two Georges and Us: Multiple Perspectives on the Image." *American Art* 17, no. 2 (Summer 2003): 13–17.

Wilson, Judith. "Optical Illusions: Images of Miscegenation in Nineteenth- and Twentieth-Century American Art." *American Art* 5, no. 3 (Summer 1991): 88–107.

Larry Collins (b. 1955), Mixed-Media Artist; Illustrator; Interior Designer, Percussionist.

With his album, *Doo Bop,* Miles Davis, the legendary jazz artist, signaled his intent to fuse jazz with hip hop sounds. Although Davis did not live to complete this album and engineer the anticipated synergy, his idea has not fizzled out. In the hands of Larry Collins, Davis's idea has been recuperated and made to transcend music. The synergy that Davis seeks in his jazz music is precisely what Collins exemplifies in his 2008 (48″ × 30″) diptych, which is also titled *Doo Bop.* In it, Collins captures the mediated cadence of jazz, which is made more engaging by the use of organic and geometric shapes. His *Doo Bop* creates a new tempo, one that combines the improvisational characteristics of jazz with the transmutability of an enlivened visual surface. A dialog is engendered in a field of abstracted shapes, all of which suggest mobility between tactile reliefs and hollowed grooves, and recessions that seem to catapult the designs into space. Perhaps the most poetic element of this work is the embalming ambience. Collins's limited palette of blues and greens is accentuated by

a judicious deployment of neutrals, which combine with the gradated elevations to evoke the crisp, jazzy musicality the *Doo Bop* asserts. A cursory look at this piece summons the excitability that is associated with *adire,* the tie and dye textile designs of the Yoruba of Nigeria. The pervasive bluish coloration of Collins's *Doo Bop* brings to mind the indigo dye that the Yoruba have popularized: a calming presence that Robert Farris Thompson has termed *etutu.*

Yet another piece provides a sense of the eclectic streams from which Collins has continued to draw. Titled *A Song for Aaron,* this 10×7¾″ mixed-media relief piece uses asymmetrical balance in the arrangement of designs—rectangular, organic, triangular, ovoidal, and stitched, among others—which are placed within colored panels that evoke the festive celebratory air often associated with Africa. *A Song for Aaron* stems from a recessed, pinkish matrix that is agitated with actual texture. The panels in which the designs are embedded feature a limited number of colors—red, amber, and yellow—with the motifs rendered in white and delineated with black outlines. Collins's attraction to African designs, patterns, and colors are apparent in *A Song for Aaron,* which evokes patterns and colors associated with the prestigious *kente* cloth of the Asante in Ghana, the geometric sequencing associated with Kuba in the Federal Democratic Republic of Congo, and the arid color schema favored by the Dogon of Mali. Those who are familiar with contemporary African prints will not find it difficult to relate Collins's work to the plastocasts of Bruce Onobrakpeya, Africa's premier printmaker. The title of the work recalls Collins's first brush with Africa. It was derived from Aaron Brown, a Liberian student who was Collins's roommate at Columbus College of Art and Design in Ohio in the 1970s. The memories that the association produced provided the incentive for Collins to give serious consideration to going to Africa. In 1983, Collins secured a grant and headed to Senegal.

The trip was revelatory in a number of ways. Artistically, it confirmed for Collins the incipient notion of symbiotic relationship with the mother continent. But the trip also helped him to see anew the pervasiveness of race and marginalization in America. For the first time, Collins found out that in Senegal, he was not a minority. Much more jarring, perhaps, was the way that his African hosts perceived him: as American. For someone who has lived all his life as a classified or hyphenated American—colored, minority, black, Afro-American, African American—his characterization simply as American was as shocking to him as it was empowering. It was a jolt that he least expected: that it would take a trip to Senegal for him to realize that he is, after all, American. While the trip helped him see his place in American society, it also helped him affirm those creative impulses that he had intuited but that had remained unclear until that moment. Collins's work is American in the extent to which it focuses on the American experience:

> A lot of my work is about the African American experience . . . what it is like to be black in America; how we relate to things; what things affect us; who made a difference; historical things; how we came to be here—from The Middle Passage through slavery and the migration to the north;

it is the whole experience with race and
culture. Things that affect us: the music;
the church; the language; the families: all
of that affect my work.

(Collins 2008)

During his travel to Africa, he was mesmer-
ized by the deftness with which the carvers
worked and sought, upon his return to the
United States, to replicate it. The result was
his mixed-media series, which combines
the additive with the subtractive, with spikes
of color.

Collins is a child of the Civil Rights era. He
was born in the Corryville neighborhood of
Cincinnati, Ohio, on October 11, 1955, a few
months before Rosa Parks catalyzed the Mont-
gomery Bus Boycott by refusing to yield her
place for a white commuter in a public bus.
His father, Davy Collins, worked as a chef at
the General Hospital, which later became the
University of Cincinnati Hospital. His mother,

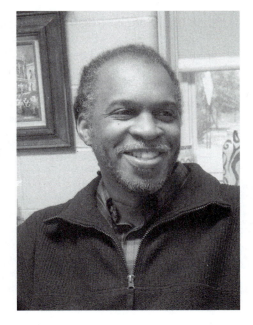

Larry Collins. Courtesy of dele jegede.

Lava Collins, was a school teacher at Schiel School in Cincinnati until she
retired. The middle child and one of three males in a family of five children,
Collins grew up with art and music. His elder brother, Davy Jr., was a music
major who played keyboard, guitar, and trombone. It was from him that Col-
lins, who was a member of his school band, honed his skills as a percussionist.
Collins grew up in the 1960s, a convulsive period in the history of blacks in the
United States. As a teenager, the key social and political upheavals of the
period, involving Martin Luther King, John F. Kennedy, Robert Kennedy, and
the Black Power movement, remained ingrained in his memory, just as was
what he perceived as the pervasive state of political strife in his hometown,
Cincinnati. This was when he also came to his own as "artist," the one who
in junior and high schools became the select: favored by teachers to produce
an endless stream of posters and charts for all classes. After his education at
Mary Junior High School, he attended Hughes High School from 1970 to
1974, where he was mentored by LeRoy Porter, his art teacher who convinced
him to pursue art as a career.

In 1974 at Columbus College of Art and Design, Collins met Aaron Brown
and nurtured the ambition to major in architecture, but eventually settled for
interior design with a minor in advertising. He graduated in 1979 and worked
as a freelance artist before accepting a position at a publishing company in
Columbus in 1980, where he rose through the ranks—as freelance artist, illus-
trator, and graphic designer—to become the design coordinator before he left
in 1990. In 1983, he married Cynthia, the sister of one of his band members.
Before he returned to Maryland Institute College of Art in 1991 to pursue his

M.F.A. degree, Collins had combined his work as a designer with that of a practicing artist with a string of exhibitions. As a graduate student living in Baltimore, taking public transportation opened his eyes to the presence and plight of homeless people. This prompted his interest in them as subject matter. On a visit to the National Museum of African Art at the Smithsonian Institution, he noticed the extent to which African artists had succeeded in incorporating materials from their environment into their art. This inspired him to become more inventive and source materials from his immediate environment. He moved back to Ohio after the completion of his studies and began to build up his reputation as a sculptor, illustrator, mixed-media artist, and percussionist.

Collins, who has had a string of solo and group exhibitions in diverse sources nationally and internationally, teaches at Miami University in Oxford, Ohio.

Places to See Collins's Work

Columbus Museum of Art, Columbus, OH
King Arts Complex, Columbus, OH
Kwanzaa Playground, Columbus, OH
Ohio State University Hale Center, Columbus, OH
Private collections
Ronald Pizzuti, Pizzuti Management Inc., Columbus, OH
Xavier Roberts, Cabbage Patch Dolls Inc., Atlanta, GA

Bibliography

Bremner, Ann. "Bill Agnew and Larry Winston Collins Revisited." *Dialogue: Arts in the Midwest* (Columbus, OH), March/April 2001, 52, 53.

Collins, Larry. Personal communication with author. Oxford, OH. April 5, 2008.

Hall, Jacqueline. "Separate Visions Come Together in Cohesive Exhibit." *Columbus Dispatch*, Visual Arts section, January 20, 2002, F8.

Hovey, Kendra. "African Influences in Contemporary Art: Artist of the Kwanzaa Playground." *Dialogue: Arts in the Midwest* (Columbus, OH), September–October, 1997, 9–11.

Maffay, Jonathan. "Current Dialogue Looks at African American Artists." *Athens Insider*, October 2, 2002, 8.

Mullins Lee, Chiquita. "Larry Winston Collins: Recent Works." *Dialogue: Arts in the Midwest* (Columbus, OH), March–April 1996, 29.

Schroeder, Robert. "Global Perspectives." *Dialogue: Arts in the Midwest* (Columbus, OH), May–June 1993, 30.

Shinn, Dorothy. "Ohio Perspectives Series Turns to Africa." *Akron Beacon Journal* (Akron, OH), March 14, 2002, B1.

Starker, Melissa. "Ripple Effect: CCAD Faculty Spread Throughout Canzani Center and Beyond." *Columbus Alive* (Columbus, OH), October 6, 2004, 16.

Yates, Christopher A. "Two Faces, One Vision." *Columbus Dispatch* (Columbus, OH), October 1, 2006, E4.

Edward J. Colston (1938–2006), Painter.

Ed Colston died suddenly in February 2006, less than three months after this author had the first encounter with him. Our meeting turned out to be extremely revealing in that the discussion that I had with the artist in his studio in Columbus, Ohio, provided invaluable insights into the mind of an extraordinary artist. Simple and unassuming, Colston's art is a condensation of the artist's humble life experience: the vicissitudes that he experienced in his journey through life, from reporter to art professor; through the dark period, when his indulgence with alcohol numbed his creative soul, to his redemptive reemergence with greater appreciation for the ways in which art can become an instrument of collective embalmment.

Edward J. Colston—known simply as Ed—was born on November 20, 1938, in Columbus. After his high school education at St. Mary in Columbus, he enrolled at Columbus College of Art and Design (CCAD) in 1957, and graduated in 1963. He began his career in 1962 as a reporter for the *Columbus Citizen-Journal,* where he covered sundry topics dealing with the suburban environment in Columbus. Colston left in 1968 and became associate editor of Ross Laboratories in Columbus. For the next two years, he worked as a medical research writer in creative and informational services. In addition to editing the *Ross Reporter,* Colston also disseminated company information regarding current research in community health and nutritional matters.

In 1970, he joined the faculty of CCAD, where he taught painting, drawing, design, composition, and theory for nearly 10 years. In 1979, Colston taught as a visiting artist at Kansas City Art Institute and, in 1981, he became the art instructor at the Cultural Arts Center in Columbus. This was a difficult phase in Colston's life. Working at Ross Laboratories came with considerable pressure. The brutalities that came with meeting production deadlines led Colston to seek easy refuge in alcohol. He carried home a library in his bag, and once had to work on two production displays overnight for delivery the following day. By the time he began teaching at the CCAD, the pressure had eased. By the late 1970s, however, Colston's personal battle with alcoholism had become full blown and constituted a health concern that he was able to fully overcome. He emerged from this encounter a much more creatively mature artist who was able to reassign values to things that emphasize universal commonalities.

After a brief stint at a handful of recreation centers in Columbus—Marion Franklin, Milo Crogan and Sawyer recreation centers—Colston became, in 1998, recreation leader and fine arts specialist for the Schiller Park Recreation Center in Columbus. He worked there until 1994, when he left to devote himself to full studio practice. Expectedly, he had several solo exhibitions, predominantly in the Ohio region, with a handful in places like Pennsylvania and Tennessee. In essence, Colston's work, significant as it is, has not been widely circulated outside of the regional orbit. This observation is important as a means of emphasizing the work of a significant artist who was underrated, underappreciated, and overlooked in his time, perhaps because he was unable

to covert the consideration of galleries and other cultural agencies whose intervention may have earned him mainstream recognition.

A close examination of the work of Colston reveals the deep-seated empathy that he had for universal understanding, and an appreciation for the simple values that the human race is meant to share. Colston's work, which is highly cerebral and rationalist, does not lend itself to a simple understanding upon first encounter, especially with its field of abstracted and seemingly disjointed agglomeration of elements. A recurrent element in the artist's work is the pyramid. However, his pyramid is not solely indebted to any of the pyramids in Egypt, although he certainly does not exclude such associative thoughts. The exception is that he arrived at his pyramids through a reductive painting approach that started as a self-portrait and eventually transformed into a basic pyramidal essence.

When Colston first started painting, he began with a known element: himself. His initial paintings were figurative self-portraits of massive figures that were cut off from the head, or totally masked to hide their identity. As his work progressed, he realized that he had neglected a major part of the human condition: the ability to think and reason. Thus he concluded that he would produce generic, nondescript heads that would conceal any traits of individual particularities. This eventually led him to the pyramid. Colston explained this development further:

> I have always had some formal element of the human in my work even if they were pyramids. As I was working on these figurative paintings, they seem to move so quickly toward the person viewing. And I thought I needed to have something to confine that figure to that space, using all these academic formulas. I feel positive about that as part of my art. So I started to maintain them in a box: a three-dimensional box. And as I drew the box and took away the figure, the box began to become my figure. And then I began to dissect the top of the box from the side to the middle and drew the point from inside of the box out to the edges, which gave me a pyramidal shape. And pyramidal shape has always been figurative, as far as I am concerned. But it also goes back to my upraising as a young kid because we were baptized Catholics. And one of the primary things in Catholicism is the Father, the Son, and the Holy Spirit. So you'll always see the pyramid in my work. I don't care how small they are.
>
> (Colston 2005)

The pyramid in his work represents a cross between a triangle and a pyramid. In an attempt to find formal purity and the optimal form that best embodies his ideas, Colston tried the box and the circle, neither of which worked as effectively as the triangle. For him, the triangle is subsumed in the pyramid, a form that he considers exceptional. Colston explained that in adopting the pyramid, he was also thinking of ancient Egypt. He admitted, though, that he was not thinking of Egypt in the physical sense. The Sphinx, which his quest for Egypt brought up, was not the most effective vehicle for resolving the dialog between human beings and the pyramid. The Sphinx represents a specificity frozen in the mind; it is somebody else's work, which did not represent the

quintessential notion of expressivity for which he was searching. Colston wanted something that fully represented Colston. By reducing all ideas to a basic pyramidal form, which is a synthesis of the triangle, as the representation of ideas, and the pyramid as a three-dimensional reality, with a physicality that one can touch, Colston believed that he was able to achieve a meeting of minds.

These ideas are alluded to in *Pyramidal History: A History of Civil Rights,* which he painted between 2000 and 2003. This is a mixed-media abstract piece that seems lugubrious and forbidding. A number of pyramids, some in neutral, and others in primary colors, constitute a jagged background against which a collage of items that include randomized lines and a black-and-white column of smaller pyramids are stacked. Colston's art is about pricking

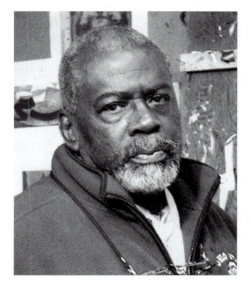

Edward Colston. Courtesy of dele jegede.

society's conscience; it is about bringing to the social fore those ideas that compromise the human capacity to accord dignity and respect to one another. Examples of Colston's concern for human rights include a painting by that title: *Human Rights—the South.* This is no doubt a resuscitation of the opprobrious conditions that existed in the Deep South, with its reprehensible treatment of blacks, and the wanton violation of human dignity and civil rights that became normative. This painting uses oil, acrylic, roofing compound, newspapers, and stenciled letters to depict what appears to be the truncated back view of a human being, with a head of thick, black, Afro hair that is suddenly cut off. Colston attempts, successfully, to evoke the repulsiveness of this historical phase by incorporating old newspaper articles and photographs as a collage assaulted by two inverted red pyramids and drips of paint.

Two paintings, *9-11 Running Figure* and *Dialo—Senseless Killing,* offer us a glimpse into Colston's sensitivity to contemporary national developments. The first is the artist's attempt at immortalizing the trauma that 9/11 inflicted on the collective national psyche, while the latter revisits the tragedy that occurred in New York when Amadou Diallo, an unarmed immigrant from Guinea, Africa, was brutally murdered by four police officers in February 1999. *9-11* is made up of an abstracted running, discomfited figure with an amputated head, whose body is traversed by geometric symbols and, as usual, a number of pyramids. The color scheme is minimalist, comprised mainly of ocher, black, and touches of blue and disused newspapers. *Diallo* is a powerful piece rendered even more compelling by the choice of colors and placement of the single figure. The subject matter is a mass of burnt umber whose outline suggests a male figure, lying flat across a placid field of sky blue, with two blazing red accents to the lower end of the canvas. The figure, which appears to clutch a rectangular object in its left hand—an object that presumably

represents the wallet that the police found on him—is peppered with red dots, a reference to the 41 shots that the four cops rained on him.

Colton's body of work includes paintings on the imbroglio in Kosovo and the senseless genocide in Sudan. Altogether, his work is a searing critique of social injustice. The dilemma that he strove to address was how he could draw attention to these injustices without becoming illustrative, demonstrative, or trivial. Colston did not see himself as a revolutionary and had no illusions that his work would change the minds of white police officers in New York, Los Angeles, or elsewhere. All he wanted was to serve, through his work, as a facilitator.

Places to See Colston's Work

Academy for Contemporary Problems, Ohio State University, Columbus, OH
AT&T Laboratories, Columbus, OH
Battelle Memorial Institute, Columbus, OH
Central State University, Wilberforce, OH
Columbus College of Art and Design, Columbus, OH
Columbus Teachers Federal Credit Union, Columbus, OH
Frank W. Hale Center, Ohio State University, Columbus, OH
Price Waterhouse, Columbus, OH

Bibliography

Ambush, Debra, and Vesta A. H. Daniel. "Ed Colston: A Brief Retrospective." *Columbus Art*, March–April 1991.
Colston, Edward J. Personal discussion with author, Columbus, OH, Ohio. October 29, 2005.
Gilson, Nancy. "A Community Transcendent." *Columbus Dispatch*, July 29, 1997.
Hall, Jacqueline. "Time Gap Hurts Exhibit's Continuity." *Columbus Dispatch*, January 29, 1989.

D

Willis "Bing" Davis (b. 1937), Sculptor, Ceramist, Painter.

Bing Davis works in a variety of media: pastel, clay, wood, metal, textiles, and found objects, among others. While this accretive gesture may have parallels in the African culture of which Davis is so enamored, the main thrust of his work—its essence and the philosophical values that it espouses—is to be found in his interest in reifying and re-presenting African values and perspectives for urban America. His fascination with African cultural tenets remains a dominant kernel that provides Davis with the impetus to create, inform, and motivate. He makes a deliberate effort to look to Africa for the creative resonance and spiritual connection that it offers, the historical anchor that it facilitates, and the aesthetic conditioning that the continent provides. His work reifies his interest in observing the many life-sustaining rituals that animate cultural practice in traditional African societies, and an attempt to process, adapt, recontextualize, preserve, and transform some elements of these rituals. In his abstracted and varied works, Davis deliberately explores methods, materials, concepts, and precepts that are African, including masks, shrines, and altars that are meant to evoke ancestral memories. In particular, African masks become, in the work of Davis, a metaphor that enables African Americans to confront the psychological trauma that slavery inflicted upon their social psyche.

For example, his *Anti-Police Brutality Dance Mask* series (2004) appropriates some of the elements that give African masks their visual appeal. One of them, #20, which has a long-drawn arched brow that projects over eyeless sockets divided by a long, angularized ridge, projects a hostile, mean mien. The forehead takes off sharply from the arched brow in a convex form, at the top of which two celebratory spikes protude. The ears of the mask have running black rows of drooping, neatly trimmed fibers that also double as facial beard. Strings of beads and cowbells hang from the chin of the mask, which is beautifully decorated with Davis's customary zigzag and chevron designs. This mask captures the spirit of some key masks from Africa. In particular, it recalls the elegance of Ndomo masks that are used among the Bamana people in Mali by pre-puberty boys, and the ferociousness of a Guere mask that the Wee peoples of Liberia and Cote d'Ivoire often employ to combat evil forces that cause social tension in their communities. The allusion to African masks by Davis is undoubtedly intentional. He has consistently indicated that African Americans should wear

Bing Davis. Willis Bing Davis Art Studio.

a mask for sanitizing and revitalizing the community. The penchant for cleaning up, which permeates Davis' work, "alludes to a people's efforts to divest itself of the burdensome psychological debris attached to a history of slavery, 'Jim Crow' policies, and other forms of caste like subordination" (Demerson 2006, 12).

Davis knew since his early childhood that he wanted to be an artist. Everybody in the Basely Appalachian east side community of Dayton, Ohio, where he grew up told him so: "Ooh wee, you're gonna be an artist" (Davis 1997, 5). By age 11 at Washington Elementary School, Davis had grown confident enough about his talents to declare unequivocally that he would grow up to be an artist. Born on June 30, 1937, in Greer, South Carolina, Davis is the fourth of six children, three boys and three girls, all of whom were involved in the creative arts, who were raised by a single mother after the death of their father. His mother, a shape note singer and quilter, relocated from South Carolina when Davis was two weeks old. His father was a gospel singer in South Carolina in the 1920s and 1930s. In Dayton, Davis grew up immersed in so many creative activities that he did not even know that they were poor. But outside of his immediate family, Davis grew up to admire a precocious African American poet and native Daytonian who had gained attention for his poems and public recitals before he was 10 and published his first collection of poetry at 20: Paul Lawrence Dunbar (1872–1906). Dunbar's 1896 poem, "We Wear the Mask," has become Davis's creative mantra.

In 1959, Davis graduated from DePauw University with a degree in art. From 1963 to 1965, he was at the School of Dayton Art Institute. He earned a master of education degree from Miami University, Ohio in 1967 and pursued

graduate study at Indiana State University between 1975 and 1976. Davis regards his formal education as one-half of his educational experience; the other half comes from his interest in the exploration of his African heritage. As an African American in a Eurocentric environment, Davis is determined to use his art to reflect his feeling and vision, and to mitigate the impact of his Western art education on the direction of his work. In order to fully address the social condition of peoples of color, Davis had to reeducate himself and grapple with the repressive environment with which African Americans had to contend in the seventies. This awareness led to the series *Oh Say Can You See!* He became aware of the commonality of the struggle and as he read more—about Negritude and Leopold Sedar Senghor, and the Harlem Renaissance. He came to the conclusion that his art would have to espouse an aesthetics that affirms the African American experience. He sees himself as an African American artist who recognizes the commonality of the struggles of peoples of color no matter where: the Caribbean, South America, and Africa. No matter where blacks are in the Diaspora, Davis believes that they all have a common struggle, and he wants to be part of that.

His trip to some African countries had a major effect on his work. Since 1973 when he first visited Nigeria, he has been to Africa 10 times, visiting countries such as Ghana, Senegal, and Gabon. What has now become his creative insignia—the triangulated motif that permeates his two-dimensional and three-dimensional work—is derived from African textiles. The large oil pastel drawings in his *Ancestral Spirit Dance* series explore the musical cadence and exuberance that traditional Yoruba *egungun* masquerades in Nigeria evoke. His ceramic pieces are presented as constructs that emulate the traditional hand-thrown pottery favored by African potters. While Davis uses clay slabs and coils as three-dimensional collage, the end product, as in his other pieces, is nothing but an acknowledgment of African heritage, even as he directs his aesthetic message to urban America. Davis has continued to use art to reach diverse audiences ranging from children to African Americans in urban settings. He has had numerous exhibitions and delivered lectures to various platforms since he retired as chair of the Department of Art at Central State University in Wilberforce, Ohio, in 1998, where he taught for 20 years. He continues to teach art to people in his EboNia Gallery, which he established in the same neighborhood in Dayton as his icon, Paul Lawrence Dunbar.

Places to See Davis's Work

Blue Cross of Philadelphia, Philadelphia, PA
Central State University, Wilberforce, OH
The Dayton Art Institute, Dayton, OH
Private collections
United States Embassy, Conakry, Guinea
University of Science and Technology, Kumasi, Ghana
Vectren National Headquarters, Evansville, IN
Woodburne Library, Centerville, OH

Bibliography

Davis, Wilis Bing. *We Wear the Mask.* Dayton, OH: Willis Bing Davis Art Studio and EbonNia Gallery, 1997.

———. *On the Shoulders of Ancestors: The Art of Willis Bing Davis.* Dayton, OH: Willis Bing Davis Art Studio and EbonNia Gallery, 2006.

Dayton Visual Arts Center. *The Art of Willis "Bing" Davis: Ceremony and Ritutal.* Dayton, OH: Dayton Visual Arts Center, 1997.

Demerson, Bamidele Agbasegbe. " 'Filled with the Spirit!'—Transforming Guises, Ritual Accoutrements, and Liminal Precincts Created by Willis 'Bing' Davis." In *On the Shoulders of Ancestors: The Art of Willis Bing Davis,* 11–18. Dayton, OH: Willis Bing Davis Art Studio and EbonNia Gallery, 2006.

Dlugos, Kathleen. "Stop Asking/We Exist." *American Craft* 59, no. 3 (1999): 46–49.

Garcia, Chris. "Willis 'Bing' Davis: A Community Artist." *Ceramics Monthly* 50 (2002): 86–87.

Harris, Juliette. "Private Dancer, Private Dealer: Private Show!" *International Review of African American Art* 16, no. 3 (1999): 2–60.

Robinson, F., and Ross Video Productions. *Willis "Bing" Davis: The Joy of Being Alive.* VHS Video. Dayton, OH: Fran Robinson and Ross Video Productions, 1996.

Achamyele Debela (b. 1947), Digital Painter; Designer.

Achamele Debela's preferred medium is digital media. Although he began his career as a painter, having trained under Gebres Kristos, one of the founding fathers of modern Ethiopian art, he has availed himself of the best education that the United States could offer in art education and digital media. With a Ph.D. in art education and digital media from the Ohio State University, the journey that young Debela began in Addis Ababa in the early fifties would take three more decades to blossom. Like many artists from continental Africa who have permanently relocated in the United States, Debela's work is a reflection of the two cultural streams to which he has been exposed: African and American.

Debela was born in the Merkato neighborhood of Teklai Biro in Ethiopia in 1947. He grew up in Addis Ababa, the capital of Ethiopia, with parents whose involvement with art spurred his own interest. His father, Ashame Debela, was an amateur artist whose constant doodles and sketches young Debela held with profound admiration. He began to emulate his father. His mother delighted in decorating gourds and other local crafts in colorfully woven wicker and Moroccan leather studded with cowrie shells. Equally powerful on Debela's impressionable mind were the murals depicting scenes from the New Testament that were painted on the walls of Ethiopian Orthodox Church. While he was fascinated and amazed by the murals, it was not until he started art school that he began to fully appreciate their aesthetic and iconic import. In 1967, Debela graduated from the Addis Ababa School of Fine Arts, where he

studied painting. In 1969, he attended the Ahmadu Bello University in Zaria, Nigeria, and graduated in 1972 with a B.A. in fine arts. His tour of Nigeria in the aftermath of the Biafran civil war gave him an appreciation of the country's cultural diversity. In 1972, he moved to the United States and earned an M.F.A. in painting from the Hoffberger Graduate School of Painting at the Maryland College of Art and a Ph.D. in computer graphics, animation, and art education from Ohio State University.

Debela's work attempts to reconcile the cultural dissonance and distinctions that his migrant status has accentuated. Working as an artist and art educator in the United States places certain demands on his sensibilities as an artist. What does he choose, what does he retain? How does he negotiate and affirm his identity as Ethiopian American?

Achamyele Debela. Courtesy of dele jegede.

His work is about the struggle to retain his individuality without becoming mired in the past. While his work celebrates the rise of technology, it does not succumb to its power.

He is influenced by the technology but also brings into that platform a culture context, which is what ultimately imposes his individuality on the work. His subject matter is drawn mainly from his African culture, even when the final product does not seem to bear this out. He is interested in exploring African surface decorations—scarifications, incisions, engraved gourds, textile designs, Ethiopian icons, and letters from Ethiopian Orthodox manuscripts. From this diverse visual menu, Debela extrapolates and reconfigures in accordance with specific creative goals that he wants to achieve. At play is the indelible impression that his city, Addis Ababa, left on him. His formative years were shaped by exposure to a diverse array of people and events at the Merkato, which is Ethiopia's largest market. His digital explorations are thus a visual metaphor for the various life experiences that he has had, and a reflection of the views and conditions existing in his new home and his ancestral home. These conditions include the ravaging consequences of a harsh environmental,

political, and economic climate: recurrent droughts, political instability that came in the wake of the 1974 overthrow of Emperor Haile Selassie, and the tyrannical rule of his successor, Mengistu Haile Mariam. A war with Eritrea, bouts of droughts, and the complicity by Western countries all translated to a poorer Ethiopia. These are conditions that Debela's work seeks to address, although most of the time in a subtle manner.

Places to See Debela's Work

National Museum of African Art, Washington, DC
North Carolina Museum of Art, Raleigh, NC

Bibliography

Debela, Achamyeleh. "Alexander (Skunder) Boghossian: A Jewel of a Painter of the 21st Century (1937–2003)." Paper presented at the 12th Triennial Conference of the Arts Council of the African Arts Association, Harvard University, Cambridge, MA, April 3, 2004.
———. "Early Childhood." *Ethiopians,* July 21, 2008. http://www.ethiopians.com/acha.html.
Duerden, Dennis. "Letter from London: The Exhibition of Contemporary African Art/1967." *African Arts* 1, no. 1 (Autumn 1967): 27–29, 67.
Hassan, Salah, and Achamyeleh Debela. "Addis Ababa Connections: The Making of the Modern Ethiopian Art Movement." In *Seven Stories about Modern Art in Africa,* edited by Clementine Deliss, 127–249. New York: Flammarion, 1996.
Herney, Elizabeth, ed. *Ethiopian Passages: Contemporary Art from the Diaspora.* Washington, DC: National Museum of African Art, Smithsonian Institution, 2003.
National Conference of Artists of New York. "Achamyeleh Debela," July 21, 2008. http://ncanewyork.com/achamyeleh_debela_ethiopia.htm.

Thornton Dial Sr. (b. 1928), Sculptor, Painter, Installation Artist.

In a 2006 documentary that was directed by Celia Carey of Alabama Public Television, Thornton Dial asserts: "Art is strange-looking stuff and most people don't understand art . . . Most people don't understand my art, the art of Negroes; because most people don't understand me, don't understand the Negroes at all. If everybody understand one another, wouldn't nobody make art. Art is something to open your eyes. Art is for understanding" (Alabama Public Television 2006). For a man who did not recognize that all the "things" that he had been fabricating with zeal and passion to adorn his yards and please himself for much of his life is called art until he was nearly 60 years old, a man with only a fourth-grade education but a seemingly inexhaustible store of ideas, Dial's statement strikes at the artificiality of boundaries that have more to do with the institutionalization of prejudice than with aesthetic quality. Dial continues: "It ain't about paint. It ain't about canvas. It's about ideas. Too many people died without ever getting their mind out to the world.

I have found how to get my ideas out and I won't stop. I got ten thousand left" (Alabama Public Television 2006).

Since he overcame his suspicion of outsiders and embraced the notion that what he does is art, Dial has proved that his ideas are unbound by any doctrinal imperatives. If anything, he seems to relish the thought of being paid to enjoy himself. Dial's large relief works or freestanding assemblages are as compelling as they are enigmatic. They speak a vernacular that emanates from an immersion in the Deep South: a vernacular that is best appreciated only when one is familiar with the depth of the cultural roots from which the art emanates. For those who are dismissive of any art that falls outside of the Western canon of academicism, with its celebration of figurative renditions of quotidian sites or imaginary events, or its fixation with the cerebral or the metaphysical, Dial's work may be more a nuisance than art—something produced by the untutored or the unlearned; something that belongs in the junkyard; art that is produced by somebody from outside of the mainstream. A closer examination of the work of Dial suggests that his work is powerful precisely because the art that he produces is unaffected by the constraints of formalist education. Dial's art is the expression of a spirit that derives immeasurable joy and pleasure from the act; it was not produced in response to any formal competition or a quest for acknowledgment by any art establishment. Indeed, until the late 1980s, Dial was oblivious of the existence of museums, having lived all his life in Sumter County, Alabama.

Thornton Dial was born on September 10, 1928, in Emelle, Alabama, which was a small town that specialized in growing cotton, sweet potatoes, and corn. Dial's mother was an unwedded 13-year-old girl, Mattie Bell, who worked as a sharecropper on the fields. William Arnett (2005, 10) provides a panoramic description of the landscape in Emelle: "On Hutchin's land, patterns found in wood constructions of barn walls, porches, sheds, and fences would richochet off each other like a diversity of themes performed simultaneously by members of a jazz quartet." Emelle, a small community of 31 in Sumter County, has continued to experience negative population growth. William Arnett (2005, 12–13) quotes Dial as describing Emelle as "a nice place, where white folks claimed that they treated the Negroes so good, and they treated them so good that the Negroes all left, and when the Negroes had left, the white folks couldn't make it by theirselves so they had to go, too."

Dial was barely a toddler when Mattie Bell gave him to her older cousin, Buddy Jake Dial, who raised him. (A slightly different version of Dial's childhood has been provided by Hobbs [1998, 174], which narrates that Mattie Bell, did not give up Thornton and his half brother Arthur until Dial was 10, when his mother had the opportunity to marry. At that time, according to Hobbs, Dial and his half brother went to live with Martha James Bell, their great grandmother, and later moved to Bessemer, where they were brought up by their great aunt, Sara Dial Lockett, who passed on in 1995.) Dial's father, he learned later, was James Hutchins, who lived in the same vicinity in the cornfields of Emelle, not far from Buddy Jake Dial's farm. Like Buddy Jake Dial, James Hutchins was also adept at yard beautification. Known simply as Buck, Dial has lived all his life in Alabama, where he married Clara Mae and is

blessed with five children—two daughters and three sons, two of whom—Richard and Thornton Jr.—are also artists. Dial never completed elementary education, having dropped out in the fourth grade. He grew up fast in Buddy Jake Dial's homestead and was socialized into an ascetic culture in which improvisation and inventiveness were a normative strategy for survival. At age five, Dial was as good a full-time worker in the field as any kid of that age could be; he worked with the farm's mules and cows and did all he could to assist in running the farm. He grew up surrounded by fanciful assemblages and associative objects that Buddy Jake Dial made to adorn the environment. His cousin Buddy was a skillful designer who constructed all the structures that they needed at Emelle and decorated the yard and the landscape around the homestead with an assortment of discarded and found objects.

In 1940, Dial migrated to Bessemer, near Birmingham, and lived in Pipe Shop, a community that catered to the housing needs of factory workers. He would remain there for 30 years, trekking the four-mile distance to his place of work at Pullman Standard Railroad Car factory. There, he worked on and off for nearly 33 years doing all manner of tasks: iron work, cement work, carpentry, house painting, and welding, among others. During the times that he was not in the employ of Pullman Standard, he worked intermittently with the Bessemer Water Works for 13 years, fixing broken pipes on the streets. At the same time, Dial also took to raising livestock and worked on commercial fishing, building houses, and patching sections of highways (Hobbs 1998, 174). In effect, unbeknownst to him, Dial's life has been nothing but a lifelong education, one that has prepared him to become a self-confident and mature artist. Before he was 13 years old, Dial was already skilled at fending for himself by undertaking menial jobs and performing manual labor. Above all, Dial delighted in using his skills to assemble and build what he calls "things," which he would be told later are artworks. Through the things that he constructed and assembled, he developed a personal vocabulary that compensated for his lack of formal education. Beyond that was the immense satisfaction that he derives from his ability to continue in the tradition of creating and improvising, pursuing in the process an aesthetic of environmental beautification that delighted in showcasing individual skills and virtuosity. He continued to adorn his yard with found objects—scrap iron, hubcaps, wheels, tires, and other disassembled automobile parts.

Dial retired from his job in 1986. A year later, Loney Holley, another artist working in the same genre, brought him to the attention of William Arnette, who has had considerable success in bringing his work and the work of many underrated artists working in the South to national and international attention. Dial soon expanded his art to cover other media: drawing and painting on paper. But it is his large assemblages that have continued to command attention because of the rawness of power and the inventive energy that they evoke. Dial's topics and themes range from the underprivileged condition of blacks in the American society to civil rights and social injustice. He often employs animals, especially the tiger, as icons for addressing a myriad of subtle and potentially explosive issues. Thomas McEvilley (1993, 9) describes Dial's work as "Art Brut with a stunning presence, like a wild animal tied up in the room."

Dial's work is indeed extraordinary both in the sheer size and the extraordinary mastery of media. One of his outstanding pieces, *The Tiger Cat*, (1987), a 69.5" × 107.5" × 57" steel, tin, and tubing piece, contains freestanding, painted depictions of five birds and an animal atop a tiger that is identified mainly by an outline within which a brood of small animals dangle. His 1988 piece *Alone in the Jungle: One Man Sees the Tiger Cat* (48" × 96") depicts a tiger resplendent and massive, with a vegetation that seems deferential to it. In the catalog notation for this piece, the lonely tiger is believed to be unknown "even among members of his own community. Faces, mostly green, probe the jungle, until one white profile takes notice. The encounter, however, does not end the tiger's struggle. The Caucasian is positioned, says Dial, 'looking up the tiger's ass'" (Whelchel and Donovan 1993, 71). Since 1987, Dial has had solo exhibitions at major venues that included the Museum of American Folk Art, and the New Museum in New York. His work has also been featured in the 1998 and 2000 Whitney Biennial. Additionally, he has also participated in numerous group exhibitions.

Places to See Dial's Work

Dolly J. Fiterman Collection, Minneapolis, MN
High Museum of Art, Atlanta, GA
Milwaukee Museum of Art, Milwaukee, WI
Museum of Fine Arts, Houston, TX
National Museum of American Art, Smithsonian Institution, Washington, DC
Philadelphia Museum of Art, Philadelphia, PA
Phyllis Kind Gallery, New York, NY

Bibliography

Alabama Public Television. "Alabama's Storyteller." March 2006.http://www.aptv.org/AS/Thornton/winpr.asp (accessed November 29, 2008).

Arnett, Paul, and William Arnett, eds. *Souls Grown Deep: African American Vernacular Art of the South.* Atlanta, GA: Tinwood Books in association with the Schomburg Center for Research in Black Culture, 2000.

Arnett, William. "The Road from Emelle." In *Thornton Dial in the 21st Century,* edited by William Arnett, John Beardsley, Alvin J. Wardlow, and Jane Livingston. Atlanta, GA: Tinwood Books in association with the Museum of Fine Arts, Houston, TX, 2005.

Cardinal, Roger. "The Self in Self-Taught Art." *Art Papers* 18, no. 5 (September–October 1994): 23–33.

Conwill, Kinshasha Holman. "In Search of an 'Authentic Vision.'" *American Art* 5, no. 4 (Fall 1991): 2–9.

Danto, Arthur. "Outsider Art." *Nation,* March 10, 1997, 33–36.

Dial, Thornton, et al. *Thornton Dial: Image of the Tiger.* New York: Harry N. Abrams, 1993.

Hobbs, Robert. "Thornton Dial Sr." In *Self-Taught Artists of the 20th Century: An American Anthology,* 174–79. New York: Museum of American Folk Art, 1998.

Lawal, Babatunde. "African Roots, American Branches: Tradition and Transformation in African American Self-Taught Art." In *Souls Grown Deep: African American Vernacular Art of the South,* edited by Paul Arnett and William Arnett, 30–49. Atlanta, GA: Tinwood Books in association with the Schomburg Center for Research in Black Culture, 2000.

McEvilley, Thomas. "Proud-stepping Tiger: History as Struggle in the Work of Thornton Dial." In *Thornton Dial: Image of the Tiger.* New York: Harry N. Abrams, 1993.

Mitchell, Mary Niall. "Outsider's Inside Track: Thornton Dial." *Cover,* December 1992, 15.

Rosenak, Chuck, and Jan Rosenak. "Thornton ('Buck') Dial, Sr." In *Museum of American Folk Art Encyclopedia of Twentieth-Century American Folk Art and Artists,* 100, 102. New York: Abbeville Press, 1990.

Scott, Sue. "Thornton Dial [Exhibition Review]." *ARTnews* 92, no. 4 (April 1993): 137.

Jeff Donaldson (1932–2004), Painter, Cultural Activist, Art Historian, Administrator.

Jeff Donaldson conjures various presences to various people, depending on the prism from which he is being viewed. As a painter, his paintings speak to social issues from an aesthetic premise that looks to Africa but also draws on his understanding of racial inequities in the United States. Some of the paintings that he began working on in the mid-1970s are composed of an intricate web of designs—chevrons, checkerboards, diamonds, and other design computations derived from geometric shapes. Most of his paintings of this period are layered and fragmented, leaving the viewer to disentangle the complex mosaic of designs in order to reveal accompanying subthemes. While the physical canvas is subject to dissection, analysis, and interpretation, the conceptual basis for the aesthetic statement does not admit of such analyses. Yet, one is more likely to see Donaldson's work in a more lucid light when one understands that it is based on "African imagery, that is to say the broad concurrences in symbology and in ideology that one finds in a wide range of imagery from countries throughout the continent" (Thorson 1990, 29). In looking to Africa, Donaldson was joined by fellow artists who were members of AfriCobra. Collectively, they "selected certain symbols, certain visual ideas, certain compositional techniques, certain organizational themes, that [they] saw in African art, particularly in the art of Egypt, and also in the art of West Africa. The Dogon cosmology and its imagery was very . . . attractive" (Thorson 1990, 29).

In such paintings as *Victory in Zimbabwe* and *One 4 Bear Den,* there are copious allusions to the primacy of Egyptian civilization. *Victory* was painted in 1980, the year that the former British colony of Southern Rhodesia became independent, marking an end to white minority rule of a country that had a new name, Zimbabwe, and a new African leader, Robert Mugabe. With its

multinuanced motifs that provide a colorful spectrum for the schematized figures referencing ancient Egypt, *Zimbabwe* is also a testament to Donaldson's Pan-African spirit. *One 4 Bear Den,* Donaldson's homage to **Romare Bearden**, has Egypt scribbled all over it: from the fugitive figure of a harp-playing lady to the decorative lotus designs that frame the lower end of the piece. Paintings rendered in this all-over style differ remarkably from his early, more representational work typified by *Aunt Jemima and the Pillsbury Dough Boy,* which was painted between 1963 and 1964. It is a brutally confrontational piece in which a visibly distraught African American woman summons every ounce of energy to fend off a baton-wielding police officer.

While Donaldson's paintings addressed issues dealing with the aesthetics and social concerns of the African American and the Black Diaspora, they meant little to the museum establishment, which showed little or no regard for the work of African American artists. It was Donaldson's understanding of the role of art in the Civil Rights Movement that thrust him to public limelight. Given the major role that Donaldson played in mobilizing artists to become cultural advocates, his name will forever be linked with *The Wall of Respect,* the 20-by-60-foot mural that a group of African American artists executed on a building which was then at 43rd and Langley streets in Chicago. The origin of *The Wall* dates back to the founding, in May 1967, of the Organization of Black American Culture (OBAC) by a group of 13 citizens, including Donaldson, with the primary concern of organizing a forum that would use the arts to support the advocacy of the Black Power movement and advance the African American struggle for social and political empowerment. In order to accomplish this task, a Visual Arts Workshop was set up within OBAC, which held a series of meetings beginning in June 1967 and ended up with a collective resolve to do a "guerilla mural" on the theme, "Black Heroes" (Donaldson 1998, 22).

Two months later, in August 1967, *The Wall* was completed. Because of its location in a part of the city with high volume of vehicular and pedestrian traffic, the project became an instant success, judging by the interest the community showed. According to Donaldson (1998, 22) "Curiosity seekers, uneasy tourists, art lovers and political activists of every stripe congregated daily and in ever increasing numbers. Musicians played as the work proceeded. Writers recited their works. . . . Dancers danced, singers sang, and the air was charged with camaraderie and pioneering confidence." *The Wall of Respect* represented, at one level, the physical field on which artists waged an ideological war. At another level, *The Wall* also offered opportunity for sabotage. What was initially meant to be a forum for the affirmation of black dignity and empowerment was soon racked by internal dissension, which has been attributed to the infiltration of the organization by agents of the FBI. Participating artists received anonymous threats to their lives, and a neighborhood leader who had rallied the community in support of the project was murdered. The Visual Arts Workshop split and *The Wall* became a turf for gangs. The political consequence was devastating: the city of Chicago declared the building as unsafe and, in 1973, razed it.

As one of the founders of OBAC and a key voice in the Visual Art Workshop's *Wall of Respect* mural, Donaldson realized that there was more to organizing and sustaining a group than a project; there was need for a philosophical base: an ideal—something more enduring than the execution of a project. The opportunity to put his insight into practice came in 1968, when he organized a group of artists who succeeded in aborting a conference that Columbia College in Chicago had put together to discuss the role of the arts in the life of the people. The conference, which had slated eminent scholars and culture experts, aroused the indignation of Donaldson because the group that had worked all along on this project in Chicago had been ignored. The success of Donaldson's new group in stopping the Chicago conference crystallized in the Coalition of Black Revolutionary Artists (COBRA), which comprised visual artists, poets, musicians, writers, and culture experts. A smaller group of visual artists within COBRA, which included Donaldson, decided to distinguish themselves by adopting the name AfriCobra. Based initially in Chicago, the group organized and held exhibitions and continued with its primary goal of bringing art to the populace through affordable reprints and posters.

Donaldson articulates the key ideas that members of AfriCobra subscribed to as

> any program that led to, first of all, identification, which we saw as fundamental to an understanding of what we wanted to accomplish. Secondly, we tried to endorse programs that our way of thinking would enhance the status of African Americans in this country. Later on our focus became much broader, and we saw ourselves in an international context of the development of non-European art. We were not for a specific organization, but the goals of many different organizations were expressed in the visual terms by AfriCobra. (quoted in Thorson 1990)

Over time, Donaldson and members of AfriCobra distilled their creative doctrine to three key principles: technical excellence, aesthetic appropriateness, and social responsibility. When the group had its exhibition at the Studio Museum in Harlem in 1970, it decided not to make any piece available for sale, opting instead to poll visitors on their visual preferences, from which prints were eventually made for sale.

Donaldson owed his skills as artist, ideologue, and organizer to the influences that he came under as a youngster in Pine Bluff, Arkansas, where he was born on December 15, 1932. He lost his father early and was raised his mother, Clementine Donaldson, an enlightened and well-educated woman who did not hide her disenchantment with the endemic racial problem that plagued the country (Richardson 2001). His exposure to art started at age three when he took after his older brother, whom he had observed drawing. He attended Arkansas Agricultural, Mechanical and Normal (AM&N) College, where he came under the influence of George G. M. James and John M. Howard, who was chair of the Department of Art at the college. Howard introduced Donaldson to prominent African American artists, including Elizabeth Prophet and **Hale Woodruff,** who was then teaching at Atlanta University, and who introduced the "outhaus" style that Donaldson employed in his *Aunt Jemima and*

the Pillsbury Dough Boy painting. Upon graduation, Donaldson headed for Jackson, Mississippi, where he taught art in high school and participated in NAACP activities. He attended the Illinois Institute of Technology in Chicago, and graduated in 1963 with an M.A. degree. By the time he became involved in organizing the cultural field in Chicago in the late 1960s, Donaldson was a visiting lecturer at Northwestern University, where he was also enrolled with Frank Willett as a doctoral student in art history. He received his Ph.D. in 1974.

In 1970, he left Chicago to serve as chair of the Department of Art and Director of the Art Gallery at Howard University's College of Fine Arts. He became the associate dean of the college in 1985 and, in 1991, became the dean, a position that he retained until 1998, when he retired. During his tenure, he expanded the university's art program and hired, among other faculty, **Skunder Boghossian**, Tritobia Benjamin, Wadsworth Jarrell, and Edgar Sorrells-Adewale. His teaching and administration responsibilities were a part of his global vision of propagating an art that espouses the aesthetic sensibilities of African and African American peoples. He organized workshops and seminars, gave lectures, published essays and took part in numerous solo and group exhibitions within and outside of the country. From 1973 to 1977, he chaired the North American committee for the most important cultural event of the seventies: the World Black and African Festival of Arts and Culture, FESTAC, which was held in Lagos, Nigeria, from January to February 1977. Donaldson died on February 29, 2004.

Places to See Donaldson's Work

Afro-American Art and Culture Museum, Philadelphia, PA
Arizona State University, Tempe, AZ
Atlanta University, Atlanta, GA
Fisk University, Nashville, TN
Howard University, Washington, DC
Musee Dynamique, Dakar, Senegal
National African American Museum, Wilberforce, OH
National Center of Afro-American Arts, Boston, MA
Schomburg Center, New York, NY
Southside Art Center, Chicago, IL
Studio Museum in Harlem, New York, NY
University of Arkansas, Pine Bluff, AR

Bibliography

Donaldson, Jeff. "The Rise, Fall and Legacy of the Wall of Respect Movement." *International Review of African American Art* 15, no. 1 (1998): 22–26.

Donaldson, Jeff. "AfriCobra Now!" *International Review of African American Art* 21, no. 2 (2006): 2–4.

Gaither, Edmund B. "Jeff Donaldson: The Mind Behind the Cultural Revolution." *International Review of African American Art* 18, no. 1 (2001): 28.

Harris, Michael. "Dedication to Jeff Donaldson." *International Review of African American Art* 19, no. 3 (2004): 3.

Howard University Center for Excellence in Teaching, Learning, and Assessment. "Jeff Donaldson," July 21, 2008. http://www.cetla.howard.edu/jdonaldson/index.htm.

Reed, Veronica. "Back to Basics for Donaldson." *International Review of African American Art* 16, no. 4 (1999): 58.

Richardson, Julieanna. "Video Oral Interview with Jeff Donaldson," April 23, 2001. "The HistoryMakers Video Oral History Interview," July 21, 2008. http://www.thehistorymakers.com/programs/dvl/files/Donaldson_Jefff.html.

Thorson, Alice. "An Interview with Jeff Donaldson: AfriCobra—Then and Now." *New Art Examiner* 17, no. 7 (March 1990): 26–31.

Van Deburg, William, ed. *Modern Black Nationalism: From Marcus Garvey to Louis Farrakhan.* New York: New York University Press, 1997.

Wright, Cherilyn C. "Reflections on Confaba: 1970." *International Review of African American Art* 15, no. 1 (1998): 37–43.

Aaron Douglas (1899–1979), Painter.

Aaron Douglas, more than any other artist, personalized the spirit of the Harlem Renaissance. Generally referred to as the father of black American art, his emergence in the second quarter of the twentieth century coincided with the Harlem that became the fulcrum of creative ebullience involving artists, writers, political personages, and patrons. The rise of Douglas was not mere happenstance, but rather the result of a combination of factors: a calculated professional move; an auspicious rise of a class of kindred spirits who was blessed with the presence of a committed conductor and philosopher who stirred the arts with unprecedented gusto; and the emergence of patrons at the private, individual, and institutional levels whose support was pivotal to the sustenance of the new creative order.

Douglas responded to the call for African American writers, artists, and intellectuals to embrace their cultural heritage and define their own collective personhood through the arts. His murals adopted a muted color palette of gradated hues in which flattened objects with sharp, angular edges predominate. Rendered in a range of silhouettes that are deftly manipulated to create appropriate spatial depth, Douglas's murals became the distinctive visual banner of the Harlem Renaissance. Central to his murals is a concentric band of colors, which tend to radiate in waves that impact the color scheme. These radiating waves are usually combined with light beams that intersect the subjects or the viewer's gaze on specific aspects of the painting. Douglas cultivated this new stylistic approach after he moved to New York in 1925 and had the opportunity to study with Winold Reiss.

Douglas was born in Topeka, Kansas, on May 26, 1899, to Aaron and Elizabeth Douglas. He credited his mother with his ultimate decision to become an artist. Elizabeth worked for the Malvane family in Topeka, which founded the Malvane Museum of Art at Washburn University in Topeka (Bearden and Henderson 1993, 127). Douglas believed that his mother may have told the

Malvane family about his interest in art because his mother once brought home for him a magazine that contained a reproduction of **Henry Ossawa Tanner's** *Nicodemus Visiting Jesus,* which provided Douglas with tremendous inspiration that bolstered his determination to become an artist.

Douglas graduated from Topeka High School in 1917 and attended the University of Nebraska in Lincoln, where he studied fine arts, the only black student in his class. He graduated from the university in 1922 and, a year later, obtained a B.F.A. degree from the University of Kansas. Soon after graduation, he began his career as a teacher at Lincoln High School in Kansas City, Missouri, but resigned his two-year appointment and headed for New York in search of creative adventure. He was introduced to Winold Reiss, a professional artist who had emigrated to the United States from Germany in 1913 and was particularly interested in using his art to advance human dignity. Reiss became fascinated by Native Americans and studied them intently as part of his creative work. In New York, Reiss established himself as a distinguished portrait painter, graphic artist, and muralist. It was because of his skills as a graphic artist and his empathy and respect for the dignity of humanity that he became a mentor to Aaron Douglas. In addition to producing exciting cover designs and illustrations for the *Survey Graphics,* the journal that published Alain Locke's special edition on Harlem in March 1925, Weiss also designed covers and did illustrations for *Opportunity,* which was established in 1923 by the Urban League as the preeminent forum on issues pertaining to the black person. When Locke's book, *The New Negro* was published in 1925, Reiss was the illustrator of choice. Equally important in the rise of Douglas in the 1920s was the role of Reiss as a muralist; Reiss executed murals for a variety of sites, perhaps the most significant of which are the murals that he did for the Cincinnati Museum Center at Union Terminal, and the Cincinnati–Northern Kentucky International Airport. From Reiss, Douglas would learn to synthesize his stylized graphic work with painting to produce the murals that would immortalize him.

The essential Douglas murals celebrate the black ideal. As one who studied with Reiss, Douglas imbibed the notion of using his art to celebrate the dignity of his race. He drew images of black Americans in charcoal and colored chalk. By the time the book version of Locke's initial essays in *Survey Graphics* was published, Douglas had established a personal graphic style that led to his being given a number of pages for illustrations. He soon received invitations to illustrate the works of several black authors, including Countee Cullen, Langston Hughes, W.E.B. DuBois, and Weldon Johnson. His drawings also appeared in the pre-eminent publications of the period: the *Crisis* and *Opportunity.*

He developed distinctive styles for different media. For example, his black-and-white drawings and illustrations adopted a stark, contrasty approach that was different from the painterliness of his landscape and portrait genre. Similarly, his murals, while stylistically homogeneous, differed remarkably from his watercolor and oil paintings. Douglas made a deliberate effort to create a drawing style that he would find useful for his murals: "I tried to keep my forms very stark and geometric with my main emphasis on the human body.

I tried to portray everything not in a realistic but ... abstract way. ... In fact, I used the starkness of the old spirituals as my model—and at the same time I tried to make my painting modern" (Bearden and Henderson 1993, 130).

The success that Douglas achieved in the 1920s owed as much to the auspiciousness of his arrival in New York as to a steady stream of eager patrons and mentors, including Alain Locke, Langston Hughes, and Albert C. Barnes. For example, following the publication of his black-and-white drawings in James Weldon Johnson's 1925 book, *God's Trombones,* Douglas received a sumptuous commission from Club Ebony nightclub to paint a mural that attracted considerable praise (Bearden and Henderson 1993, 128). This further consolidated Douglas's stature, as it earned him additional patronage, favor, and support from other sources. Albert C. Barnes, a successful entrepreneur and art collector, offered Douglas a scholarship to the Barnes Foundation in Merion, Pennsylvania, that he had founded. Around that time, too, Douglas had begun to sell his drawings. Among those who were interested in his work was a wealthy New York widow, Charlotte Mason, who also promised Douglas ongoing funding, although Douglas would eventually terminate the relationship because of the level of discomfort that it imposed upon him. Douglas's work was in demand as he received and executed mural commissions, which included one for the Shermon Hotel in Chicago in 1929, and another at Fisk University in 1930. In 1931, Douglas also completed a mural on Harriet Tubman for Bennett College in Greensboro, North Carolina.

In 1926, Douglas had married his high school love, Alta Mae Sawyer. In 1928, with the money that he realized from the sale of his work and from commissioned murals, he traveled to Paris with Alta and studied at the Académie Scandinave. While in Paris, he met with a fellow artist, **Palmer C. Hayden,** who facilitated his meeting with Henry Ossawa Tanner. Douglas returned to New York in 1929, and he soon received a commission under the auspices of the Public Works of Art Project, which was established in 1933 to fend for artists as part of a broad government policy to contain the devastating effects of the Great Depression. As a result of the blatant discrimination that they experienced at the hands of the Public Works of Art Project, African American artists founded the Harlem Artists Guild and elected Douglas as its first president. From this vantage position, Douglas was able to meet the acquaintance of several African American artists, critics, writers, poets, and performers who regularly congregated at Charles Alston's "306" studio.

Aaron's reputation as a muralist was secured by the four murals at the Countee Cullen Branch of the New York Public Library (now the Arthur Schomburg Center for Research in Black Culture), which he titled *Aspects of Negro Life.* Completed in 1934, each of the four panels was given a subtitle that explored an aspect of black cosmology, which was the main theme of the murals. The first panel, *The Negro in an African Setting,* explores the cadence of life in an African context—a context in which art, music, dance, performance, and rituals predominate. *From Slavery through the Reconstruction,* the second panel, historicizes the anxieties and tribulations of blacks who had to endure the inhuman ordeals of slavery, the euphoric relief occasioned by the Emancipation Proclamation, and the egregious sadism of the Ku Klux Klan.

In *Idyll of the Deep South,* Douglas depicts blacks engaged in quotidian activities: tilling the soil amid singing and dancing, and sharing a collective grief as they take care of the body of a lynched member. The fourth panel, *Song of the Towers,* extols the indomitability of the human spirit: narratives of migration from the South to the industrial North during World War I is juxtaposed with the devastating effects of the Great Depression in the early 1930s.

Douglas completed his master's degree at the Teachers College of Columbia University in 1944 and decided to move from teaching art as part-time instructor at Fisk, which he had been doing since 1937, to full-time professor. He would later become the chair of the art department and remain there until his retirement in 1966. He died on February 2, 1979, in Nashville, Tennessee.

Places to See Douglas's Work

Amon Carter Museum, Fort Worth, TX
Art Institute of Chicago, Chicago, IL
Corcoran Gallery of Art, Washington, DC
Fisk University Galleries, Nashville, TN
Howard University Art Collection, Washington, DC
Philadelphia Museum of Art, Philadelphia, PA
RISD Museum of Art, Providence, RI
Schomburg Center for Research in Black Culture, New York, NY
Spencer Museum of Art, University of Kansas, Lawrence, Kansas

Bibliography

Bearden, Romare, and Harry Henderson. *A History of African American Artists from 1792 to the Present.* New York: Pantheon Books, 1993.

Driskell, David C. *Two Centuries of Black American Art.* Los Angeles, CA: Los Angeles County Museum of Art, 1976.

Earle, Susan, ed. *Aaron Douglas: African American Modernist.* New Haven, CT: Yale University Press, 2007.

Kirschke, Amy Helene. *Aaron Douglas: Art, Race, and the Harlem Renaissance.* Jackson: University Press of Mississippi, 1995.

Lewis, Samella. *African-American Art and Artists.* Berkeley: University of California Press, 1994.

Myers, Aaron. "Douglas, Aaron." *Microsoft Encarta Reference Library 2002.* 2002 ed. Redmond, WA: Microsoft, 2001. CD-ROM.

Porter, James A. *Modern Negro Art.* Washington, DC: Howard University Press, 1992.

Powell, Richard J. *The Blues Aesthetic: Black Culture and Modernism.* Washington, DC: Washington Project for the Arts, 1989.

Schoener, Allon, ed. *Harlem on My Mind: Cultural Capital of Black America, 1900–1968.* New York: The New Press, 1995.

Smith, Jessie Carney, ed. *Images of Blacks in American Culture: A Reference Guide to Information Sources.* New York: Greenwood Press, 1988.

Watson, Steven. *The Harlem Renaissance: Hub of African American Culture, 1920–1930.* New York: Pantheon Books, 1995.

David Clyde Driskell (b. 1931), Painter, Printmaker, Curator, Scholar.

Six years before Driskell was born, Alain LeRoy Locke published his seminal work *The New Negro,* which enunciated a philosophical premise for the legitimacy of a black art that is unapologetic and autonomous. Locke's book, which was preceded by his writings in the March 1925 edition of the *Survey Graphic,* became the unofficial manifesto for the Harlem Renaissance, a movement that heralded, for the first time, the possibility of an art that celebrated perspectives that had been substantially neglected in American art history. As the Great Depression wracked the nation, the Harlem Renaissance petered out, although the passion that its flames lit continued to smolder in a variety of forms, including exhibitions that were promoted under the auspices of the Harmon Foundation. But it was James A. Porter's work, *Modern Negro Art,* which attempted to locate black art within the mainstream of American art.

The emergence of African American art as a viable field stems from the pioneering scholarship of Locke and Porter, and the advocacy and work of others —scholars and artists—including Evelyn Brown, **Romare Bearden,** Harry Henderson, Elton Fax, Edmund Barry Gaither, and Samella Lewis. But it was Driskell's singularity of purpose and zealousness that have given form and integrity to the field. In 1976, he curated the exhibition "Two Centuries of Black American Art" and wrote an accompanying catalog that focused more on historicizing black art. Driskell presented the exhibition in a way that gave the new discipline two of the key elements it needed most for growth: patronage and legitimacy. The exhibition, which would become a template for disseminating Driskell's commitment to the propagation of a hitherto neglected province of American art, laid the ground rules for the study and cultivation of a new field. "Driskell," Morrison writes, "did not so much discover the best-known African American artists as he did establish African American art as a legitimate and distinct field of study" (McGee 2006, 8).

Yet, when Driskell headed for Howard University in 1949, his interest lay in European history, not art. When his admission was formalized and Driskell had the opportunity to take a course in drawing in the first quarter of the 1951 academic year, an encounter with James Porter persuaded him to change his major to art beginning in 1952. It was not only Porter's advice that he took in 1952; he followed his own instinct and married Thelma G. Deloatch, a marriage that was blessed with two daughters—Daviryne Mari and Daphne Joyce. In 1953, Driskell received a full scholarship to study art at Howard University; he would become the department's star student who was favored, on account of his acuity, by almost all his professors. That same year, Driskell completed an art program at the Skowhegan School of Painting and Sculpture in Skowhegan, Maine, where the laissez-faire approach to teaching art was conducive to his temperament for multimedia, interdisciplinary explorations. Born on June 7, 1931, in Eatonton, Georgia, Driskell is the only son of the four children of George Washington Driskell, a Baptist minister, and Mary Lou Cloud Driskell. His parents were sharecroppers who cultivated cotton and grew vegetables near Polkville in the Appalachian Mountains of North Carolina, to

which they had moved when Driskell was young (McGee 2006, 15). In 1949, he graduated from Grahamtown High School in Forest City, North Carolina. During his elementary school days, he had acquired a reputation as a gifted young man who exhibited unusual ability to draw, on account of which he became the unofficial artist of his school. By the time he arrived at Howard, he was buoyed by a determination to succeed as the first in his family to attend college.

Howard University of the fifties boasted of some of the best African American scholars and pacesetters. In addition to Locke and Porter, there were James Vernon Herring, who founded Howard's Department of Art in 1922, served as its first chairman, and was instrumental in the establishment of the department's Barnett-Aden Gallery in 1943; and **Loïs Mailou Jones,** matriarch and professor at Howard for nearly five decades, from 1930 to 1977. At Howard, Driskell saw in Porter his future; he adored Porter and took him as his role model. Driskell wanted to be everything that Porter was: an articulate and well-dressed scholar, artist, and professor, the epitome of erudition and suaveness. Driskell felt that he was the anointed of Porter. "If there was ever a role model for me of what I wanted to be it was Professor James Porter. He dressed well, he spoke well; he was so knowledgeable about the subject. And when I went into the classroom to pursue the course he was teaching, called 'Modern Negro Art,' he used his own textbook" (Driskell, "My Inspirations").

The education that Driskell received at Howard was holistic; it prepared him to see art from diverse perspectives, which included art making, art history, curatorial work, and gallery practice—areas in which Driskell would establish his authority later. At Howard, he was exposed to African art through the prism of Alaine Locke, who had a strong collection of objects from the continent, the writings of Porter, and the paintings of Jones, one of the first African American artists to look to Africa for inspiration in their paintings. Howard's quest for quality instruction was balanced: it exposed its students to the best traditions of Western art at the same time that it promoted classical and modern African art. In 1950, Howard hosted an exhibition of Ben Enwonwu, the preeminent modern African artist of his time. In 1953, a major exhibition of classical African art, "African Negro Art," was opened at Howard (McGee 2006, 31). For Driskell, who was then a gallery assistant, these were epochal opportunities that broadened his education beyond studio and textbooks.

He graduated from Howard University in 1955 with a B.A. degree in art, followed with an M.F.A. from the Catholic University of America in 1962, while he served in the U.S. Army. From 1955 to 1962, he taught at Talladega College, Alabama. Intent on combining his interest in art history with his studio practice, Driskell pursued postgraduate work in art history at The Netherlands Institute for the History of Art at The Hague. From 1962 to 1966, he taught at Howard University before moving to Fisk University in Nashville, Tennessee, where, as successor to yet another legendary African American personage, **Aaron Douglas**, he served for 10 years as professor and chairman of the Department of Art. In 1977, he moved to University of Maryland, College Park, and served as chairman from 1978 to 1983. In 1995, the University of Maryland

bestowed on him the Distinguished Professor award in recognition of his sterling contributions to the field. In December 1998, he retired from teaching but has become more involved in his mission to use art as a platform for addressing cultural and sociopolitical imbalance. It is a mission that Driskell has embraced with a passion that is comparable to that of a priest:

> I feel that I have a calling, a priestly mission, so to speak. To tell the true story of my people, of the struggle of their artistry, from the time that my forebears left the continent of Africa, not of their own will but because they were forced migrants. I feel that this mission is so strong that I have to go into other parts of the world to tell that yes, African Americans have a glorious past . . . and our people have come through much to be where they are and what they are today, and this means that with that kind of tradition, African Americans have a glorious future.
>
> (Hidden Heritage: The Roots of Black American Painting [TV film, 1990]; quoted in Sussman)

Driskell's work as curator, advocate, historian, and Africanist, provides ample justification for this position. In 1970, he was at the University of Ife (now Obafemi Awolowo University) as visiting professor. This visit, which came a decade after Nigeria attained independence from Britain, followed in the tradition of some African American artists, including **Jacob Lawrence, Loïs Mailou Jones**, **John Thomas Biggers**, and **Melvin Eugene Edwards Jr.**, who visited African countries such as Nigeria and Ghana to gain insights about African art and culture. His art draws from Africa physically, philosophically, and spiritually. An avid gardener who believes in cultural regeneration, Driskell went back home to North Carolina in the eighties, collected a variety of bottles that his parents had buried, and brought them back to Maryland, where he reinstalled them in furtherance of the tradition of memorializing ancestors that is itself a carryover from Africa. His paintings and prints are inspired as much by his immersion in Western traditions of art-making as by Africa and nature. Driskell believes that the environment shapes our perception and interpretation of the world. His notion of creativity leans on the African concept in which nature combines with intuition and professionalism to initiate a creative path that is complementary to, rather than imitative of, nature.

Since his retirement from active teaching, Driskell has continued to work in the studio, working in a variety of media that include collage, prints, and water-based media. In October 2007, the David C. Driskell Center for the Study of the Visual Arts and Culture of African Americans and the African Diaspora, which was established in 2001 as an edifice to Driskell's legacy, opened an exhibition, "Five Decades of Printmaking by David C. Driskell." The exhibition, which features 75 of the artist's prints that date back to 1952, highlights Driskell's profile as a creative spirit.

The David C. Driskell Center is but one of the avenues through which Driskell's contributions to the visual culture of the African and African American environment are being institutionalized. His expertise as a scholar and artist has earned him recognition at national and international levels. He has, since 1977, worked with Camille and Bill Cosby as advisor and curator of their

collection. In 1997, he served as advisor to President William Jefferson Clinton in connection with the addition of the first piece of art by an African American artist to be added to the White House collection. In December 2000, President Clinton honored him with the National Humanities Medal in recognition of his seminal role as a visual ambassador for American art. In 2007, he was elected by the National Academy as a National Academician. Driskell dominates the literature on African American art, and has published more exhibition catalogs and books on the subject than most scholars in this field. In addition to curating major exhibitions, he has influenced generations of artists and scholars through his teaching, and has lectured extensively in numerous universities in the United States, Europe, South America, and Africa. Driskell who has an extensive collection of African, African American, Western, and Asian art, has also had numerous exhibitions of his work in addition to having his work in other collections. Recipient of nine honorary degrees, Driskell is professor emeritus of the University of Maryland.

Places to See Driskell's Work

High Museum of Art, Atlanta, GA
California African American Museum, Los Angeles, CA
Deforest Chapel, Talladega College, Talladega, AL
Private collections

Bibliography

Atkinson, J. Edward, ed. *Black Dimensions in Contemporary American Art.* New York: NAL Plume, 1971.

Bontemps, A. Alexander, ed. *Choosing: An Exhibit of Changing Perspectives in Modern Art and Art Criticism by Black Americans, 1925–1985.* Hampton, VA: Hampton University, 1985.

Campbell, Mary Schmidt. *Harlem Renaissance: Art of Black America.* New York: The Studio Museum and Harry N. Abrams, 1994.

Driskell, David C. "Art by Blacks: Its Vital Role in U.S. Culture." *Smithsonian Magazine* 7, no. 7 (October 1976): 86–93.

———. "Bibliographies in Afro-American Art." *American Quarterly* 30, no. 3 (1978): 374–94.

———. *David C. Driskell: A Survey.* College Park: The Art Gallery University of Maryland, 1980.

———. *Contemporary Visual Expressions.* Washington, DC: Smithsonian Institution Press, 1987.

———. *The Other Side of Color: African American Art in the Collection of Camille O. and William H. Cosby Jr.* San Francisco: Pomegranate, 2001.

———. "My Inspirations at Howard University/My Mentor, James A. Porter." Video clips from the Oral History Archive, National Visionary Leadership Project." http://www.visionaryproject.org/driskelldavid/ (accessed December 1, 2008).

Driskell, David C., ed. *African American Visual Aesthetics: A Postmodernist View.* Washington, DC: Smithsonian Institution Press, 1995.

Driskell, David C., and Earl J. Hooks.*The Afro-American Collection, Fisk University.* Nashville, TN: Fisk University, 1976.

Gips, Terry. *Narratives of African American Art and Identity, the David C. Driskell Collection.* Exhibition catalog. San Francisco: Pomegranate Communications, 1998.

Grantham, Tosha. "David Driskell: 'The Dean.'" *International Review of African American Art* 18, no. 1 (2001): 30.

Harris, Juliette. "Driskell and 'The Third Generation.'" *International Review of African American Art* 18, no. 2 (2001): 58.

James, Curtia, Patricia Failing, and Holland Cotter. "Beyond the Boundaries of Black Art." *Art Papers* 14, no. 4 (July–August 1990): 36–37.

King-Hammond, Leslie. "David C. Driskell: A Memoir of a Painter Cum Scholar." *International Review of African American Art* 14, no. 1 (1997): 4–9.

———. "David Driskell: Memoir of an Artist cum Scholar." *International Review of African American Art* 14, no. 1 (1997).

Langley, Jerry L. "David Driskell." *International Review of African American Art* 16, no. 2 (1999): 2–11.

Lewis, Samella. *African American Art & Artists.* Berkeley: University of California, 1990.

McGee, Julie L. *David C. Driskell: Artist and Scholar.* San Francisco: Pomegranate, 2006.

National Visionary Leadership Project. http://www.visionaryproject.com/NVLPmemberTier/index2.asp (accessed February 10, 2008).

Otfinoski, Steven. *African Americans in the Visual Arts.* New York: Facts on File, 2003.

Pitts, Terrance. "David C. Driskell Affirms African American Culture." *American Visions* 14 no. 1 (February–March 1999): 28–29.

Riggs, Thomas, ed. *St. James Guide to Black Artists.* Detroit, MI: St. James Press, 1997.

Robertson, Jack. *Twentieth-Century Artists on Art. An Index to Artists' Writings, Statements, and Interviews.* Boston: G. K. Hall, 1985.

Salzman, Jack, David Lionel Smith, and Cornel West, eds. *Encyclopedia of African American Culture and History.* New York: Macmillan Reference USA, 2001.

Sussman, Alison Carb. "David C. Driskell." Answers.comhttp://www.answers.com/topic/david-c-driskell (accessed February 10, 2008).

E

Melvin Eugene Edwards Jr. (b. 1937), Sculptor.

Mel Edwards has been consistent in thematically exploring slavery and its inescapable corollaries: disenfranchisement, disablement, incarceration, stigmatization, marginalization, and similar opprobrious conditions that have been visited upon African Americans and, inferentially, blacks in the Diaspora. His "Lynch Fragments" series was started in 1963—early in his professional career. He would work on this in creative spurts: from 1963 to 1967; in 1973; and since 1978. The total number of works produced in the series has been put at more than 200. All of the pieces, with only a handful of exceptions, are less than two feet in height. Each piece is meant to be hung on the wall to provoke the viewer to contemplate the metaphor and the symbolism that the work evinces. While the finished works exhibit individuality, a stylistic integrity that is quintessentially Edwardsque pervades the oeuvre. The lynch fragment series is often in relief format made of steel that is subdued to respect the creative temper of Edwards. Found objects—including nails, metal extrusions, machine parts, auto parts, ball bearings, horseshoes, and chains—are combined with steel to make an aesthetic statement and a monumental attestation to the bestiality of a condition in which blacks were victimized and hanged by a hateful and irascible mob from the dominant culture. According to Hughes et al. (1995, 232), in 1899, a total of 99 people, 87 of whom were blacks, were lynched. Hughes also writes that between 1890 and 1900, 1,217 cases of murder by mob action involving lynching, burning, shooting, or burning were recorded.

Edwards's use of found objects as accretions echo a similar practice that is commonplace among several African cultures in which art objects acquire their status through an accretive method. Among the Wee of Liberia, ferocious masks are built from an array of objects that include animal teeth, horns, bones, and man-made objects. In the Federal Democratic Republic of Congo, various *minkisi* power objects of the Yombe attest to the additive method of object construction; standing figures are fitted with spears or machetes, while an assortment of nails and blades are driven into them to activate their retributive or juridical power. To imply that Edwards was influenced in his creative solution to spatial problems, however, would be missing the point. Indeed, he made the transition from painting to sculpture because the latter offered him a more practical solution to the resolution of spatial problems.

Edwards's art reflects a deep-rooted philosophical affinity with Africa; it is an affinity that is underlined by the several trips that he made to the continent and the references to various African personages and syntax that can be seen in the titles of his works. This affinity was accentuated during his college days in California when he was shocked by the ignorance that masqueraded as scholarship: "[W]hy would I get in a university and have a teacher tell me Africa didn't have anything until Europeans came, and that happened to me one summer at U.S.C. when I took a history class, and I told him, well, you're wrong." In 1970, Edwards undertook his first of many visits to Africa, and visited Nigeria, Ghana, Togo, and Benin Republic. He instantly fell for in love with the pervasive bright colors that he encountered. Since then, he has visited other African countries and maintains contacts with several traditional and contemporary artists from the continent. His travel to Benin City in 1971, where he met the late Oba Akenzua II and traditional bronze casters Chief Omoregbe Inneh and Amos Nomayo, was for Edwards an affirmation of the centrality of Africa to his worldview.

The "Lynch Fragments" are but an aspect of the series of themes that Edwards has worked on intermittently. In 1970, he left the "Lynch Fragments" to work with barbed wire, which escalated the jarring poignancy of his social message. The installation for his exhibition at the Whitney Museum of American Art in 1970 featured installations that incorporated barbed wire into the theme. The "Rocker" series constitutes a complementary theme to Edwards's "Lynch Fragments." It was conceived when his "interest in kinetic sculpture and animated film sparked childhood memories of his Grandmother Cora's oak Mission rocking chair" (BookRags 2005).

The eldest of four children born to Thelmarie Felton and Melvin Eugene Edwards Sr., Melvin Edwards Jr. was born on May 4, 1937 in Houston, Texas. He began his elementary education in Texas in 1942. The family soon moved to Dayton, Ohio, in 1944, where Edwards attended Wogaman Elementary School and, in the following year, Irving Elementary School. In 1949, the family moved once again, this time back to Houston. At E. O. Smith Junior High School, Edwards continued his art studies with Sadie Melton. His father, for whom Edwards has tremendous admiration, was his greatest mentor—something of a superhero in the eyes of the budding artist: "My father could do anything if he put his mind to it. . . . Everything from mathematics to music came easy to him. . . . In our family we referred to him as smart, and philosophical" (Sims 9). The artist's grandfather was a carver and his father an art enthusiast who had in 1951 built Edwards his first easel. The senior Edwards's friend, George Gilbert who was an amateur artist, also assisted the young artist by recommending appropriate art materials and books for him to use (Sims 9). Edwards comes from a family of artists and athletes. His grandfather and father were carvers. In addition to his interest in art, the elder Edwards was also an athlete in his high school days in Texas, to which he had moved after World War I. Young Edwards's mother was a seamstress who taught her son how to sew. She too was an athlete: a member of her school's basketball team.

At Phyllis Wheatley Senior High School in 1952, Edwards combined art and sports: he joined the football and baseball teams that year and, in the

following year, attended art classes at the Museum of Fine Arts in Houston. Upon graduating from high school in 1955, Edwards moved to Los Angeles and entered the Los Angeles City College. In 1958, he was offered a scholarship to Los Angeles County Art Institute, where he studied for six months and took his first sculpture classes. With a football scholarship, Edwards headed for the University of Southern California in 1959. The following year, he married Karen Hamre, a painter, and they welcomed their first child, Ana, who would have a pair of twin sisters—Margit and Allma—five years later. By the time Edwards graduated with the B.F.A. degree from University of Southern California in 1965, he had participated in a number of exhibitions and established a storefront studio. With the help of George Baker who was a graduate student at USC, Edwards learned welding. By 1963, he produced his first "Lynch Fragment" series.

Melvin Edwards, *Tambo,* 1993. Welded Steel. 28⅛" x 25¼" x 22". The Newark Museum/Art Resource, NY.

Between 1964 and 1967, he taught in San Bernadino Valley College and the Chouinard Art Institute (now Cal Arts). He relocated to New York in 1967 and joined the faculty at the Orange County Community College. In 1970, he began teaching at the University of Connecticut, and received the National Endowment for the Arts Visual Artists Fellowship in 1971. In 1972, he joined the faculty at Rutgers University in New Jersey, from where he retired in 2002.

Edwards was influenced in his work as much by jazz music as by the sociopolitical cauldron that Los Angeles was in the 1960s. The momentum generated by the Civil Rights Movement resulted in a restiveness in Los Angeles, and Edwards became an active participant in history. African Americans staged demonstrations to register their revulsion at the unmitigated injustice that African Americans had to endure. This environment gave birth to the artist's "Lynch Fragments" series in 1963. In his personal life as in his work, Edwards is passionate about the African and African American condition. Rather than become involved in discussions about the merits and or demerits

of black art—debates that he considers merely academic and unproductive—Edward is committed to doing something tangible. This position is borne out of the conviction that there is no singular African or African American aesthetic. Edwards does not have patience for mere platitudes about art and the African American. Rather, he hankers after something structured, substantive, and institutional: something enduring, such as the establishment of major museums for African and African American art. Since 1998, he and his wife have established a second home in Senegal, where he spends time twice a year working with other African colleagues on projects that are meant to involve and benefit contemporary African artists. In 2001, Edwards was honored by the City University of New York's Brooklyn College with an honorary degree. In 2007, five of his "Lynch Fragment" series were shown at the Valencia Biennial, appropriately signifying the relevance of his art especially at a time that social events in America drew attention to the opprobrious presence of the noose.

Places to See Edwards's Work

Bethune Towers, 144th Street and Lenox Avenue, New York City, NY
CUNY Brooklyn College, New York, NY
Department of Motor Vehicles, Trenton, NJ
Herbert F. Johnson Museum, Cornell University, Ithaca, NY
Lafayette College of Pennsylvania, Easton, PA
Lafayette Gardens, Jersey City, NJ
Martin Luther King Promenade, San Diego, CA
Miami University Recreational Center, Oxford, OH
Morgan State University, Baltimore, MD
Mount Vernon Plaza, Columbus, OH
Rutgers University, Livingston College Student Center, New Brunswick, NJ
Thomas Jefferson Park, East Harlem, NY
U.S. Social Security Building, Federal Plaza, Jamaica, NY
Winston-Salem State University, Winston-Salem, NC

Bibliography

BookRags. "Melvin Edwards." 2005. http://www.bookrags.com/biography/melvin-edwards/ (accessed July 21, 2008).
Brenson, Michael. "Lynch Fragments." In *Melvin Edwards Sculpture: A Thirty-Year Retrospective 1963–1993*. Exhibition Catalogue. Edited by Lucinda Gedeon. Purchase: Neuberger Museum of Art, State University of New York at Purchase; Seattle: Distributed by the University of Washington Press, 1993.
Campbell, Mary Schmidt. "Melvin Edwards: Sculpture (1964–84)." Exhibition catalog. Paris: Maison de l'UNESCO, 1984.
Cortez, Jayne. "Three Poems: *Lynch Fragment I*"; "It Came"; "Ogun's Friend." In *Sulfur: A Literary Bi-Annual of the Whole Art*. Ypsilanti: Eastern Michigan University, 1992.
Gedeon, Lucinda H. *Melvin Edwards Sculpture: A Thirty-Year Retrospective 1963–1993*. Exhibition catalog. Purchase: Neuberger Museum of Art, State University

of New York at Purchase; Seattle: Distributed by the University of Washington Press, 1993.

Hines, Watson. "Mel Edwards" (interview). *International Review of African American Art* 7 (1987): 34–51.

Hughes, Langston, Milton Meltzer, C. Eric Lincoln, and Jon Michael Spence. *A Pictorial History of African Americans from 1619 to the Present*. 6th ed. New York: Crown Publishers, 1995.

Irbouh, Hamid. "Melving Edwards' Lynch Fragments: Negritude and the Battle for Civil Rights in America." *Ijele: Art eJournal of the African World* 1 (2000): 2.

Sims, Lowery Stokes. "Melvin Edwards: An Artist's Life and Philosophy." In *Melvin Edwards Sculpture: A Thirty-Year Retrospective 1963–1993*, edited by Lucinda H. Gedeon. Purchase: Neuberger Museum of Art, State University of New York at Purchase; Seattle: Distributed by the University of Washington Press, 1993.

Victor Ekpuk (b. 1964), Painter; Multimedia Artist.

Ekpuk's "Manuscript Series" offers the artist the platform to synthesize a confluence of traditional motifs and incorporate a plethora of idiographic elements, which he craftily ensconces in pouches of designs that appear to have affinity with a number of traditional African cultures. The creative template appears for the "Manuscript Series" appears standardized, although this accommodates variations in the size, placement, and color fields and the background design. Each piece is painted on a koranic board (*walaha*) using acrylic. Each board typically has a central, often rectangular containment within which the subject matter resides. This containment is further distinguished from the ambient field of interlaced designs through the use of color that throws the containment in relief. Those who are familiar with the traditional arts of Africa will feel at home with Ekpuk's deployment of motifs, concepts, and color strategies that combine to give the "Manuscript Series" their uniqueness. The various plank masks of the Bwa in Burkina Faso; the chevrons and lozenges that are favored among the numerous groups in the Federal Democratic Republic of Congo; the exquisite Togu Na house post designs among the Dogon of Mali: these are the constituents of the visual dictionary from which Ekpuk copiously borrows for this series. The subject matter of many of the series is extracted from myth, man, and nature: folkloric archetypes, cultural norms that favor man as the cunning prowler and sage, and the reptilian class of animals. Central to this is the *nsibidi*.

The koranic board that serves as the canvas is a freestanding slate with a copper-wired neck and a short, curved handle. The board serves as a portable instrument for the inscription of Islamic religious verses, and also as a didactic instrument in the hands of young kids who are learning the Arabic alphabet. The "Manuscript Series" has become Ekpuk's signature pack because of the uniqueness of the form, the flexibility that it offers, and the aesthetic resonance that it transmits. Equally important is the notion of the koranic board as

Victor Ekpuk. Photograph by Elsa Daniels. Courtesy of Victor Ekpuk.

symbolic of the visual syncretism that Ekpuk has continuously explored in his work. Using such a form as the koranic tablet is a natural progression, if Epuk's interest in appropriating traditional elements from African and Western sources is taken into account. He began using tablet as a surface in 1995, drawn to them by its enchanting form but more importantly by the potential that he saw in the tablet as a facilitator of two key elements: African spirituality, and literacy. Ekpuk's "Manuscript Series" is not about Islam. Rather, it is a fusion of his own creative forms and elements from *nsibidi.* In his work, Ekpuk strives to "manipulate the materials so the mystical essence of the board and that of *Nsibidi* signs are retained. The goal [is] to create contemporary sacred tablets whose verses tell our stories, hold our prayers and perhaps provide healing and inspiration to us" (Ekpuk, "Manuscript Series").

Born in Uyo, in Akwa Ibom (then South Eastern) State Nigeria in 1964, he was a child with prodigious talents: he placed first in a statewide annual festival of art and culture art competition in his second year at John Kirk Memorial (primary) School in Etinan. He was the star artist favored by most teachers, who employed him in creating maps and charts for the whole school. Ekpuk attended the University of Ife in Nigeria from 1984 and graduated with a bachelor's degree in fine art in 1989. At Ife, he came under the influence of some of Nigeria's foremost art teachers—Rowland Abiodun, Babatunde Lawal, Agbo Folarin, and Moyo Okediji. But the impetus for connecting poetry with linear mark-making came to him much earlier when, as a seven-year old, he saw the drawings of **Obiora Udechukwu** in *Labyrinths,* a collection of poems by the late Christopher Okigbo, arguably Africa's foremost poet and lyricist. At the end of his education at Ife, he had developed a fascination for extrapolating and redeploying indigenous African graphic motifs in his work. From Yoruba traditional patterns, Ekpuk shifted his attention to *nsibidi,* an indigenous ideographic text employed by distinctive regulatory societies among the Ejagham, Efik, Ibibio, and Igbo peoples of southeastern Nigeria. The more he read about *nsibidi,* the better he became appreciative of its significance as an indigenous codifier of note: "Having grown up within Ibibio culture, I had always known about nsibidi but I never thought of it as a form of literacy until I read about it again in college. Prior to this realization, I had believed the colonial history books that mine was an illiterate culture until the white missionaries arrived on our shores" (Ekpuk 2007). The thought of redressing this misconception gave him the impetus to appropriate *nsibidi.*

In 1990, he joined the staff of the *Daily Times of Nigeria,* one of the continent's dominant news organizations. His work as graphic illustrator and cartoonist further sharpened his design reflexes. Whereas graphic communication is paramount in the work of most newspaper illustrators, Ekpuk turned every

assignment for graphic illustration to works of art that are bejeweled by an intricate mesh of *nsibidi* designs. In 1998, Ekpuk quit the *Daily Times* and emigrated to Northern Virginia in the United States in 1999 with his wife and son, and set up studio. He has taken advantage of available facilities and opportunities to expand his repertoire of subjects that he references in his work. While he continues to explore traditional African motival elements, he has moved towards exploration of facial abstractions in playful and modes that recall African masks and an individuated color schema. His "Mbobo Series" exemplifies this new creative thrust. In all his work, the pervasiveness of draftsmanship is unmistakable—so much so that Ekpuk has had to confront the quandary of categorization. He concedes that it has become increasingly difficult to categorize himself simply as a painter. Ekpuk has capitalized on the advances offered by technology to create a new synergy for his art. The boundaries between painting and drawing have been neutralized by the computer and new applications, which promote multi-media explorations.

Ekpuk's residences include those at Brandeis University in Massachusetts, and the University of South Florida. He has had numerous solo exhibitions in places like the Nederlands, Republic of Benin, Nigeria, and the United States. He has also participated in several group exhibitions, including the 2003 exhibition on the legacy of the Afro Beat legend, Fela Anikulapo-Kuti, and the 2007 exhibition at the National Museum for African Art at the Smithsonian Institution in Washington, DC.

Places to See Ekpuk's Work

Gallerie 23, Amsterdam, The Netherlands
Joysmith Gallery, Memphis, TN
Newark Museum, Newark, NJ
Wertz Contemporary, Atlanta, GA

Bibliography

Adesokan, Akinwumi. "Victor Ekpuk." *Nka: Journal of Contemporary African Art*, no. 10 (Spring–Summer 1999): 68.

Adeyemi, Ester. "Zeitgenössische Kunst in Nigeria & Ghana." Verlagsprogramm, July 22, 2008. http://www.reinhardt.ch/default.aspx?code=01&id=347.

Auslander, Mark. "Trans/Scripts: The Art of Victor Ekpuk." Brandeis University, July 22, 2008. http://www.brandeis.edu/departments/anthro/assemblies/ekpuk.html.

Carlson, Amanda. "Songs of Ancient Moons," July 22, 2008. http://www.victorekpuk.com/.

Ekpuk, Victor. "My Source." *Glendora Review: African Quarterly on the Arts* 1 (May 1995): 2.

———. *WindSongs* (exhibition catalog). Lagos, Nigeria: French Cultural Center, 1995.

———. *Dream* (exhibition catalog). Lagos, Nigeria: Goethe Institut, 1996.

———. "Manuscript Series." 2007. http://www.victorekpuk.com (accessed December 2, 2008).

————. Personal correspondence with author, July 30, 2007.

Kreamer, Christine Mullen et al. *Inscribing Meaning: Writing and Graphic Systems in African Art*. Washington, DC: Smithsonian Institution, National Museum of African Art, 2007.

Okeke-Agulu, Chika, and John Picton. "Nationalism and the Art Rhetoric of Modernism in Nigeria: The Art of Uche Okeke and Demas Nwoko, 1960–1968." *African Arts* 39, no. 1 (Spring 2006): 26–37.

Ottenberg, Simon, ed. *The Nsukka Artists and Nigerian Contemporary Art*. Seattle: University of Washington Press and the National Museum of African Art, Smithsonian Institution, 2002.

Ottenberg, Simon. "Sources and Themes in the Art of Obiora Udechukwu." *African Arts* 35, no. 2 (Summer 2002): 30–43, 91–92.

Purpura, Allyson. "Reflections on Drawing from Within: The Art of Victor Ekpuk," July 22, 2008. http://www.victorekpuk.com/.

Okwui Enwezor (b. 1963), Poet, Critic, Curator, Publisher, Administrator.

Since the 1920s, when Alain Locke became the dominant figure that mobilized artists towards embracing a creative doctrine that was Africa-centric, considerable progress has been made in addressing the relevance of the African American aesthetic within the larger framework of American art. The emergence of a corps of African American scholars, curators, and critics, together with a steady rise in the tribe of African American artists who have attained national and international renown, are one of the indices by which progress can be measured. It is instructive not to conclude that progress in this fertile substratum, measured by whatever yardsticks, is synonymous with unstinted acknowledgment and recognition of African American art for reasons that pertain to the near-total control of exhibition spaces, with a corresponding dominance of critical and curatorial authorship by the mainstream cultural establishment—what bell hooks refers to as "the white-supremacist patriarchal colonizing mind-set" (hooks 1995).

While the African American aesthetic remains a contested project, contemporary African art and the contemporary art of the Black Diaspora remained, for a long time, completely marginalized. In the 1960s, some attempts were made to expose the United States to contemporary African art. Led by American patrons who had been on diplomatic or business missions to Africa, such attempts emanated from Washington, DC, and were fueled more by a copious dose of effusions than by any attempt at critical analysis of the new art. Until the mid-1990s, any reference to African art was generally interpreted to refer to the classical arts of the continent. In the United States, the prevalent mindset excluded the recognition that Africa had the capacity to produce any serious art worthy of contemplation or acknowledgment. Other than the journal, *African Arts*, there was no medium of substance devoted to the discourse on contemporary African art.

This was the brief background against which Okwui Enwezor's contribution to art in general, and to African and African art and the art of the Black Diaspora is discussed. He was born in Calabar, the capital of Nigeria's Akwa Ibom State, on October 23, 1963, to Igbo parents. His father owned a furniture business while his mother, a homemaker, became a contractor supplying foodstuff to schools after the Biafran war, which took place from 1967 to 1970. He attended Government College in Afikpo, Nigeria, from 1974 to 1979. In 1982, he moved to the United States, and in the following year, he enrolled at Jersey State City College, where he majored in political science and graduated in 1987.

It was in New York that Enwezor's interest in the arts was sparked by the deluge of activities to which he became exposed. This was where he began to nurse the pursuit of critical inquiry, which has become a hallmark of his career. As one who has been interested in

Okwui Enwezor. Courtesy of dele jegede.

poetry since his high school years, it was relatively easy for him to make the connection with the visual arts and become keenly interested in contemporary critical theory. Right from the beginning, Enwezor was quite clear about his mission, which he saw as residing in the interstices of three constructs: African, African American, and African Diasporic art. But he was aware of the qualitative difference and, correspondingly, the daunting challenge that working in these areas entailed.

For him, the 1980s was a period for the expansion not only of a field, but also for the invention of a discipline, but a discipline that does not stand outside of parameters of mainstream of intellectual enquiry insofar as the production of African artists and African American artists was concerned. According to him, there "is a qualitative difference between African and African American and Diasporic art, which influences the location of practice." The African American world, he acknowledges, is a crucial area of important reflection that requires critical analytical skills. Enwezor's challenge, then, was to construct a credible platform from which to reflect on key aspects of critical practice in which artists of African descent are working: being critical to the development of contemporary and modern African art, and modern and contemporary African American art. He addressed this challenge in the following manner:

> The intellectual challenge for me was how to imagine, engage, critique, reflect, and analyze critical production that is coming from Africa whether it is the so-called genre paintings from Zaire [FDR Congo] or the most conceptual of practices that artists may be making. But of course the art of African American world is just as crucial as an area of importance that

requires sophisticated analytical skills to engage. Africa is my field of engagement. And of course there is the broader field of African Diaspora. Within this space all these different entities come together to form a historical space within which African influence can be re-invented as a material with which to make a work of transcendental importance. I came into this field with a very clear agenda of reflecting on all those key three aspects of critical practice in which artists of African descent are working. And I wanted to pose the question: how can we deploy sophisticated tools of analysis in facing the challenges and in facing the conceptual issues that artists are going to face in a way that not only respects their field of operation but also to challenge them to other realms of engagement.

So this was for me the trajectory: not to curate but to produce an environment of serious reflection and critique. That may be through presentation of exhibitions; it may be through the art of writing. For me the art of writing is important because it is about visibility; it is about inscription; it is about historicization. We needed to develop the tools of historicizing what it is that happened. What I was after was fundamentally an archaeological practice. So my work in that sense took off as a critic, not as a curator. But I was obviously very interested in curating. But I didn't wait around for somebody to offer me the possibility; I went after it and created the arena.
(Enwezor 2008)

After Enwezor completed his degree in 1987, he did not entertain the notion of seeking employment. Instead, he became self-employed. Neither did he seek to go to graduate school. Rather, he directed his intellectual sight on self-education. In New York, he was fascinated by the efflorescence of creative enterprise in East Village. But he was shocked to find that there was a vacuum: there was nothing in the system onto which his own project could be grafted. "What struck me," said Enwezor, "was that in this amazing lively space, there was no existence of my own imaginary, which was the African imaginary" (Enwezor 2008). For him to be credible, he would need to reeducate himself. New York offered a suitable environment; its museums and art exhibitions offered Enwezor the opportunity that would be critical to the realization of his vision. While he immersed himself in the visual village, he continued to write and perform poetry. For sustainability, he did interior designs and printed T-shirts to supplement the stipends that he received from home. He went one step further and formed a think tank—a group named "Akadibia." "Aka" is an Igbo word for hand, while "Dibia" loosely means the diviner, a healer, a seer, or an intellectual.

Enwezor's group of friends comprised the photographer, Gregory Christopher; Nary Ward; Chim Nwabueze; and a former schoolmate from Government College, Afikpo in Nigeria, Ike Ude. Others such as Olu Oguibe, Salah Hassan, and **Odili Donald Odita** would eventually become active within the group, as was Skoto Agbahowa, whose outfit was arguably the first major gallery on contemporary African art in SoHo. They constituted the forum and locus of debate where critical theory was read, digested, and discussed. The idea was to act from within, rather than outside of, the scene.

Enwezor continued with his poetry and stepped up his critical writings on the art scene; he dispatched unsolicited essays to major art journals and was disappointed at being rejected by all. Added to Enwezor's dilemma was the absence of any infrastructure to support the focus of "Akadibia" on the art of Africa, African America, and the Black Diaspora. Enwezor was convinced that the best solution to the problem was to adopt a proactive approach; he decided to found a journal on contemporary African art.

In 1994, he successfully launched *Nka: Journal of Contemporary African Art* in order to address, as Enwezor stated in the maiden edition of the journal, "the pervasive absence in . . . highly policed [museum and gallery] environments, of art by contemporary African Artists" (Enwezor 1994). Furthermore: "Not only are the works of these artists . . . conspicuously absent from the museum and gallery environment, they've also been accorded little attention or significance in academic art historical practices, university curriculums, the print media, or other organs of such reportage" (Enwezor 1994). In 1994, Enwezor became a consultant to the Guggenheim Museum and, working with Danielle Tilkin and Octavio Zaya, cocurated a major contemporary African exhibition of photography.

Since then, Enwezor has moved from one project to another. Today, his accomplishments are a testament to his insight, doggedness, and intellectual clarity. It would seem that he, perhaps more than any other person in the last decade, has affected the critical and curatorial trajectory of contemporary African art in the United States. Through the projects that he has undertaken, the numerous exhibitions that he has curated, and the major publications that he has authored, Enwezor has demonstrated the artificiality of boundaries that imposed in relation to the critical analysis of works by artists of African ancestry. From 1996 to 1998, he was the Artistic Director of the Second Johannesburg Biennale. Between 2005 and 2007, he was also Artistic Director of the Second Biennial of Contemporary Art, Seville, Spain. Perhaps the pinnacle of his curatorial achievement was Documenta 11 in Kassel, Germany, of which he served as artistic director from 1998 to 2002. Among his many publications are *Reading the Contemporary: African Art from Theory to the Marketplace* (with Oguibe); *The Short Century: Independence and Liberation Movements in Africa*; and *Snap Judgments: New Positions in Contemporary African Photography*. He has contributed to numerous publications and journals, and has undertaken speaking engagements across the globe. In addition, Enwezor is the recipient of the International Art Critics Association Award, the Peter Norton Foundation Curatorial Award, and the College Art Association's Frank Jewett Mather Award for Distinction in Criticism, among others.

Enwezor works as dean of academic affairs and senior vice president at San Francisco Art Institute in California.

Major Curatorial and Artistic Directorship Projects by Enwezor

Archive Fever: Uses of the Document in Contemporary Art, International Center of
 Photography, New York, NY
Century City, Tate Modern, London

Cinco Continente: Biennale of Painting, Mexico City
David Goldblatt: Fifty One Years, Museum of Contemporary Art, Barcelona, Spain
Documenta 11, Kassel, Germany, 1998–2002 (artistic director)
Echigo-Tsumari Sculpture Biennale in Japan (cocurator)
Global Conceptualism, Queens Museum, New York and Walker Art Center, Minneapolis, MN
In/Sight: African Photographers, 1940–Present, Guggenheim Museum, New York, NY
Mirror's Edge, Bildmuseet, Umea
2nd Johannesburg Biennale, 1996–1998 (Artistic Director), Johannesburg, South Africa
The Short Century: Independence and Liberation Movements in Africa, 1945–1994, Museum Villa Stuck, Munich, Germany.
Snap Judgments: New Positions in Contemporary African Photography, International Center of Photography, New York, NY
Stan Douglas: Le Detroit, Art Institute of Chicago, Chicago, IL
The Unhomely: Phantom Scenes in Global Society, Centro Andalucia de Arte Contemporaneo, Seville, Spain

Bibliography

Allison, Peter, Okwui Enwezor, and Whitechapel Art Gallery. *David Adjaye: Making Public Buildings: Specificity, Customization, Imbrication.* London: Thames & Hudson, 2006.

Aquin, Stéphanie, ed. *Global Village: The 1960s.* Montreal: Montreal Museum of Fine Arts in association with Snoeck Publishers, 2003.

Basualdo, Carlos, ed. *William Kentridge: Tapestries.* Philadelphia: Philadelphia Museum of Art in association with Yale University Press, New Haven, CT, 2008.

Beauchamp-Byrd, Mora J., and M. Franklin Sirmans, ed. *Transforming the Crown: African, Asian and Caribbean Artists in Britain, 1966–1996.* New York: Franklin H. Williams Caribbean Cultural Center; African Diaspora Institute, 1997.

Bell, Clare, O. Enwezor, and D. Tilkin et al. *In/sight: African Photographers, 1940 to the Present.* New York: Guggenheim Museum; New York: Distributed by Harry N. Abrams, 1996.

Blazwick, Iwona, ed. *Century City: Art and Culture in the Modern Metropolis.* London: Tate Publishing, 2001.

Enwezor, Okwui. "Redrawing the Boundaries: Towards a New African Art Discourse." *Nka: Journal of Contemporary Afircan Art,* no. 1 (Fall–Winter 1994): 3.

———. *The Short Century: Independence and Liberation Movements in Africa, 1945–1994.* New York: Prestel, 2001.

———. *Experiments with Truth: Transitional Justice and the Processes of Truth and Reconciliation: Documenta 11, Platform 2.* Ostfildern-Ruit: Hatje Cantz, 2002.

———. *Under Siege, Four African Cities: Freetown, Johannesburg, Kinshasa, Lagos: Documenta 11, Platform 4.* Ostfildern-Ruit: Hatje Cantz, 2002.

———. *Creolite and Creolization: Documenta 11, Platform 3.* Ostfildern-Ruit: Hatje Cantz, 2003.

———. *Personal Affects: Power and Poetics in Contemporary South African Art.* New York: Museum for African Art, New York and Spier, Cape Town, 2004.

———. *Lorna Simpson*. New York: Harry N. Abrams in association with the American Federation of Arts, 2006.

———. *Snap Judgments: New Positions in Contemporary African Photography.* Göttingen: Steidl, 2006.

———. Interview by author. Oxford, Ohio, March 26, 2008.

Eshun, Kodwo, and A. Sagar, eds. *The Ghosts of Songs: The Film Art of the Black Audio Film Collective, 1982–1998.* Liverpool: Liverpool University Press: Foundation for Art and Creative Technology, 2007.

Freiman, Lisa D. *Maria Magdalena Campos-Pons: Everything is Separated by Water.* Indianapolis, IN: Indianapolis Museum of Art; New Haven, CT: Yale University Press, 2007.

hooks, bell. *Art on My Mind: Visual Politics.* New York: New Press; distributed by W. W. Norton, 1995.

Oguibe, Olu, and O. Enwezor. *Reading the Contemporary: African Art from Theory to the Marketplace.* London: Institute of International Visual Arts; Cambridge, MA: MIT Press, 1999.

Rondeau, James, Susanne Ghez, and Hamza Walker. *Thomas Hirschhorn: Jumbo Spoons and Big Cake. The Art Institute of Chicago: Flugplatz Welt/World Airport, the Renaissance Society at the University of Chicago.* Chicago, IL: Art Institute of Chicago, 2000.

Stimson, Blake, and G. Sholette. *Collectivism after Modernism: The Art of Social Imagination after 1945.* Minneapolis: University of Minnesota Press, 2007.

Lalla Assia Essaydi (b. 1956), Painter; Photographer; Installation Artist.

In her oeuvre, Lalla Assia Essaydi addresses several issues in numerous ways using a variety of media, which include photography, painting, video, film, and installation. At times, these issues are direct, unmistakable, and quite challenging. At other times, they are nuanced, subtle, and implied—issues that are detectable mainly by the discerning eye as a critical constituent of the artist's fabric of visual narrative. Central to the recurrent question around which Essaydi's work revolves are issues of identity, perception, location, and self-hood, with culture serving as the primary platform. Running parallel to these core concepts are the subliminal notions of space and thresholds; hierarchies and sexuality; aesthetics and feminism. In her work and statements, Essaydi reminds us of the centrality of culture to the creative process, and the essence of art in disrupting the notion of the previously colonized Other as less than Self.

In May 2003, Essaydi obtained her M.F.A. degree in photography and painting from the School of the Museum of Fine Arts at Tufts University in Boston, where she now lives and works. Within a short time after graduation, Essaydi's work received attention from a broad spectrum of the art world. She has had numerous one-person exhibitions and participated in an overwhelming number of shows across the country. Her work is in collections such as the Fries Museum in the Netherlands, the Kodak Museum, the Museum of Fine Arts in Boston, and the Columbus Museum of Art, among several others.

What is it that has catapulted a woman from a conservative African culture to prominence in the West? Why has the work of someone who grew up in an Islamic culture, with strict adherence to religious observances and cultural practices that are considered restrictive in the West, found favors in major galleries and museums? The answer lies, in part, in the introspection that being in exile conferred on Essaydi, and in the opportunity and access that going back to school in the United States furnished her. Living and working in the West, with the creative freedom that comes with it, gave Essaydi the opportunity to become more contemplative and appreciative of the centrality of culture to the creative process. It emboldened her to return to her childhood years in Morocco and scrutinize it anew. The resultant photographs, paintings, and installations that she produced constitute an exploration of the numerous insights gained through the totality of her experience as an international nomad and global citizen: an African artist living and working in the West, a Moroccan by birth, Arab by culture, Muslim by religion, and Saudi Arabian by marriage.

Essaydi was born in Marrakech, Morocco, the sixth child in a family of 11 children, six of whom are male. She grew up within a strict homestead, and was home-educated until she was 14. She grew up in Morocco at a time when emphasis on women's education was on turning them into successful housewives rather than giving them the necessary training that would turn them into career women or successful artists. Unlike her brothers, who excelled in the sciences, Essaydi always knew that her aptitude lay in the visual arts. She grew up admiring her father, Abdeljalil Ben Mohamed Essaydi, for whom painting was a hobby. To Essaydi, her father was the most wonderful painter that she ever met: indulgent, patient, and loving. The young, impressionable Essaydi was always fascinated by the magical transformation that occurred each time her father painted. A wall that was previously blank would, in a course of a month or two, become populated by fantastic landscapes with magical animals that became, for young Essaydi, the equivalent of Disneyland. Nothing would please her more than replicating her father's mesmerizing performance. Essaydi learned to associate the quality time that she spent with her father with making art which, over time, became her refuge. Whenever there was a problem, she would immerse herself in creating art. She grew to cherish this process and covet it as something unique, personal, and private. Essaydi associated the process with expressing the most private thought, exclusive and autobiographical.

Her mother took on the responsibility of grooming Essaydi to become a successful wife; the spiritual and creative side was nurtured by her father. Still, within her family circles, making art was not regarded as anything other than one of those fanciful indulgences, which a young girl like Essaydi would not be denied. The culture did not, at any rate, take kindly to women creating realistic art. So, Essaydi kept her art-making as a private indulgence. For the family, this was not a big deal.

After a very early marriage and the birth of two daughters, Essaydi went back to school. Between 1990 and 1994, she attended the L'Ecole de Beaux Arts in Paris, France, where she obtained her certificates: one in painting, and

Lalla Essaydi, left, gives an interview with public radio reporter Allison Young during the opening of an exhibit titled "Nazar, Photographs from the Arab World," in Houston, 2005. AP Photo/ Brett Coomer.

another in drawing. In 1999, she graduated with a B.F.A. degree from Tufts University. By the time she completed her M.F.A. in 2003, the artist had acquired the creative discipline and critical apparatuses that would allow her to make the best use of her status as a nomad in voluntary exile. From this position, Essaydi realized the implications of being caught in the interstices of two dominant cultures—Oriental and Occidental—and the imperative of reexamining her past as an essential aspect of transforming her present. She appreciates the contrasts that are inherent in these two cultures and constantly finds ways of mediating and synthesizing them through her work.

The titles of her solo exhibitions offer insights into the theme that Essaydi explores. These include "Converging Territories," "Transgressions," and "Embodiments." In her work, she confronts and attempts to rupture the Western notion of Orientalism, which fetishizes Arab women and sets them up as slave objects that fuel the lascivious imagination of Western artists. In her large paintings, some of which are between 9 and 10 feet, Essaydi appropriates the works of many known Western artists and substitutes hermaphrodites for the seductive but enervated image of the Arab woman that Western artists have perpetrated.

It is perhaps her photographs that have allowed her to more readily confront her paradoxical status as an artist and to attempt to resolve the seeming dichotomies that are an inevitable consequence of conflicting cultural and religious values prevalent in the two spaces that she is privileged to occupy. It is not

uncommon for others to question Essaydi's identity: Is she African? Is she African American? Is she Arab, Saudi, or simply an assimilated Western artist? To answer some of these conundrums, Essaydi decided to go back to her roots in Morocco—to reinvestigate and reconstruct the impact of the space of confinement that shaped her childhood years. The series of photographs that resulted from this project is nothing but cathartic. When she was growing up, she was confined within a house any time that she transgressed social norms.

There, she began working with women acquaintances with whom she grew up. In the series of photographs that she took at this site, the women would wear layers of cloths, mainly from Morocco and Saudi Arabia. Their bodies and the white veil (*haik*) that the women wear are then covered with Islamic calligraphic text that she had to train herself to learn, since this opportunity was available only to boys in schools. The women who are the subject of these photographs are Essaydi's family members, who are drawn into the project because they have experienced the same banishment. Essaydi transformed the house, now unoccupied and falling apart, into a makeshift studio, where she spends between four to six weeks with the women, numbering about 40, who lived together for the period. The artist's chose a space that used to be a man's room that women were forbidden to enter. The room would be covered completely with white cloth from floor to ceiling, after which it would be covered completely in calligraphic text, using hena

Although the resultant images are suffused with a mesmerizing aesthetic beauty, this was, for Essaydi, a secondary outcome. The process itself was much more important to her than the product. The significance, for example, of subverting cultural injunctions—using calligraphic text that was previously proscribed for women; asserting dominance over a room that was previously inaccessible to women; suffusing the *haik* with its own veil; and covering women's bodies with calligraphic text—all of these constitute an assertion of individualism and a bold reclamation of selfhood. This is at the African level. At the Western end, Essaydi seeks to confront the pejorative notion of the Arab woman as a wimpy, effeminate sexual object.

Her work and personal outlook constitute a philosophical intersection for competing ideas on race, culture, religion, and art across the Atlantic divide.

Places to See Essaydi's Work

British National Museum, London, UK
Brooks Museum of Art, Memphis, TN
Chicago Art Institute, Chicago, IL
Colorado Museum of Art, Boulder, CO
Columbus Museum of Art, Columbus, OH
Fries Museum, Leeuwarden, the Netherlands
The Kodak Museum, George Eastman House, Rochester, NY
Kresge Art Museum, East Lansing, MI
Longwood Center for the Visual Arts, Farmville, VA
Museum of Fine Arts, Boston, MA
Museum of Fine Arts, Houston, TX

Neuberger Museum of Art, New York, NY
New Britain Museum of American Art, New Britain, CT
Santa Barbara Museum of Art, Santa Barbara, CA
Williams College Museum of Art, Williamstown, MA

Bibliography

Brielmaier, Isolde. "Re-inventing the Spaces Within: The Images of Lalla Essaydi."
 Aperture 178 (2005): 20–25.
Carlson, Amanda. *Lalla Essaydi: Converging Territories.* New York: PowerHouse
 Books, 2005.
Denker, Susan. "Essaydi, Lalla Assia Moroccan Artist." *Nka,* no. 19 (Summer 2004):
 86–87.
Neismith, Robert. "Art's Winter Haven." *Art and Antiques* 29 (2006): 70–73.
Richmond, Susan. "Atlanta." *Art Papers* 29, no. 6 (November–December 2005):
 46–47.
Rosoff, Patricia. "New Britain Museum of American Art's New/Now Gallery/
 New Britain: Lalla Essaydi: Converging Territories." *Art New England* 28, no. 1
 (December 2006–January 2007): 23.
Whitley, Lauren. "Lalla Essaydi: Eloquent Cloth." *Fiberarts* 32, no. 4 (January–
 February 2006): 42–43.

F

Tolulope Filani (b. 1957), Sculptor.

Since the last decade of the twentieth century, the issue of emigration and self-exile by contemporary artists from Africa has received considerable amplification. Through a number of apparatuses, including critical exhibitions at national and international fora, insightful analyses of the works of some of these artists in respectable scholarly sources and the popular media, and exposure of a new breed of American students and patrons to the arts and artists of the African continent, a wider sector of the American society is becoming much more aware of, and receptive to, the works of African artists in voluntary exile in the United States. Among the artists who have benefitted from this development are **Ouattara Watts, Lalla Assia Essaydi, Wangechi Mutu, Obiora Udechukwu,** and **Wosene Worke Kosrof**. To this list must be added Tolu Filani, a sculptor and superb draftsman who emigrated to the United States from Nigeria with his family in 1996. His story exemplifies the time-worn attraction that the United States holds for creative minds of all manifestations from across the globe: an attraction that is predicated on the potentials that dreams of creative ebullience will be met so long as the dreamer has the resolve to dare. For Filani, his passionate dream, one that is yet to be fully realized, is to live the life of a full-time artist: to wake up and do nothing but think, make, and see art; to live and work in his studio, and to age and die right in his studio: "My prayer to God is that if and when I'm dead, I want to be found dead in my studio with a mallet or a spatula and somebody coming in saying, 'You know what: that old man is dead!' " (Filani 2008).

Filani's unabashed passion for his art has its roots in his childhood. Filani grew up finding that he had an unusual aptitude for creating and fixing things. A broken radio would provide him a good reason to apply his handyman's skills. He would fashion wearable objects like shirts and shoes from discarded paper. His insatiable appetite for creativity soon came to the attention of his father, who thought that his son had all the instincts for becoming an engineer. In colonial Nigeria, where British imperialism modeled engineering, medicine, and law as the three pivotal professions worth pursuing, it was understandable that the elder Filani would miss the diagnosis that his son might be an art prodigy. Born in Ado-Ekiti, Nigeria, on May 12, 1957 to Victoria Olabangbe and Jacob Ogunmoroti Filani of Ifaki-Ekiti, Tolu Filani is the last and only son of five children by Victoria, who died shortly after childbirth. Filani's mother

Toloupe Filani. Courtesy of Toloupe Filani.

was a successful businesswoman who traded in clothing items. His father rose to the top of his profession as a permanent secretary in the administration of the Western Nigerian government. The elder Filani ran a polygamous family that is, even by Nigerian standards, sizeable; he had five wives and more than 30 children.

Filani grew up all over Nigeria, the consequence of the intermittent transfers that his father had to endure as an administrator. As a result, his elementary education was in bits and pieces across several Western Nigerian towns and cities. But the signs of his precociousness remained unmistakable. In 1968, he became the first winner in a UNESCO-organized international children's art competition. At his high school, Doherty Memorial, Ijero, Filani surprised his principal by copying his photograph in pencil and presenting it to him. For a high school that had no art teacher, Filani's tepid drawing had a major impact: the principal instantly hired an art teacher. In turn, this spurred an unprecedented artistic explosion in the high school, with Filani at the vanguard. The fervid atmosphere catapulted him to national limelight, with appearances on national television. From 1976 to 1980, he attended Yaba College of Technology, earning the Ordinary National Diploma (OND) and the Higher National Diploma (HND) with a major in sculpture and a string of honors and awards. At Yaba College of Technology, Filani came under the influence of Isiaka Osunde and Yusuf Grillo, two of Nigeria's pioneering contemporary artists.

He won his first major commission, *Welcome to Nigeria*, in 1981. This is a larger-than-life sculpture of a Nigerian master drummer who, with a huge drum firmly propped between his strong legs, strumming the drum with his bare hands, much like it is done in major traditional ceremonies across the land. Situated strategically on the main access to the Murtala Mohammed International Airport in Ikeja, Lagos, this sculpture, one of very few public monuments in Lagos, is heraldic of the notion of African modernity as defined by the pioneer sculptor, Ben Enwonwu, whose *Sango* statue on the Marina in Lagos set the standard in that genre. Until Enwonwu's monumental piece, the tradition of public sculpture in modern Nigeria was nominal: a standing, two-piece sculpture of a black man in a subservient posture to a European soldier adorned Idumota, the main access to Lagos, which served as Nigeria's federal capital until 1992. What is known about Nigerian sculpture subsists in the classical tradition, popularized by votive figures, masks, house posts, and a plethora of figurative pieces that are expressive of the country's religious and aesthetic inclinations. Sculpture in the classical Nigerian sense was partly the physical manifestation of deeply spiritual essences, and partly symbolic of

status and wealth. The avenues for the appreciation of sculpture were numerous, but did not include the installation of public statues. Filani's *Welcome to Nigeria* therefore ranks as one of those modernist expressions that typify a new era.

In 1986, Filani secured a USAID sponsorship that enabled him to study at the University of Missouri in Columbia, where he obtained his master's degree in art education. He would eventually return to Nigeria, only to finally relocate to the United States permanently. In 2003, he obtained his Ph.D. in art education and took up appointment as chair of the Department of Art at South Carolina State University in Orangeburg. In all of this, the propelling force remains his art. As an émigré, Filani acknowledges the centrality of culture in the process of art-making. Yet, he believes that the art of the African artist and that of his or her African American counterpart is different only in so far as the prevailing cultures have mandated. The art of **Faith Ringgold, Jacob Lawrence,** and **Elizabeth Catlett** is, in that vein, similar to that of their African colleagues in the extent to which they reflect the sensibilities of their respective cultures and periods.

A committed art educator and chair of the Department of Art at South Carolina State University, Filani has participated in numerous exhibitions and is fluently expressive in a variety of two-dimensional and three-dimensional media.

Places to See Filani's Work

Cannon Adeyemi's Public Statue, Adeyemi College of Education, Ondo, Nigeria
Freestanding Public Statue of Eyo Masquerade, Lagos, Nigeria
Herbert Macaulay's Public Statue, Herbert Macaulay Street, Lagos, Nigeria
Ikoyi Club Anniversary Monument, Lagos, Nigeria
Public Statue of Tai Solarin, Lagos, Nigeria
Welcome to Nigeria Monument: Murtala Mohammed International Airport, Ikeja, Nigeria

Bibliography

Fall, N'goné, and J. L. Pivin, ed. *An Anthology of African Art: the Twentieth Century.* New York: D.A.P. Distributed Art Publishers; Paris: Revue Noir Editions, 2002.

Filani, Tolulope. Interview by author, July 6, 2008.

jegede, dele, ed. *Creative Dialogue: S.N.A. at 25.* Lagos: Society of Nigerian Artists, 1990.

Kelly, Bernice, and Janet Stanley. *Nigerian Artists: A Who's Who and Bibliography.* New York: Published for the National Museum of African Art Branch, Smithsonian Institution Libraries, Washington, DC [by] Hans Zell, 1993.

Kennedy, Jean. *New Currents, Ancient Rivers: Contemporary African Artists in a Generation of Change.* Washington, DC: Smithsonian Institution Press, 1992.

Nzegwu, Nkiru, ed. *Contemporary Textures, Multidimensionality in Nigerian Art.* Binghamton, NY: International Society for the Study of Africa, 1999.

G

Sam Gilliam (b. 1933), Painter.

Gilliam's reputation is built on his ability to push existing boundaries, challenge entrenched modes of creating art, and intuit a new format for narrating new paradigms. The seventh of eight children, Gilliam was born in Tupelo, Mississippi, on November 30, 1933. He was an infant when his father, Sam Gilliam, a railroad worker, and Estery, his mother who was a homemaker, relocated to Louisville, Kentucky. Gilliam's interest in art began early, and he received support and encouragement from his teachers in elementary school and at Central High School in Louisville, from which he graduated in 1951. That same year, he entered the University of Louisville, from where he graduated in 1955 with a B.A. in fine arts. In 1956, he joined the U.S. Army and served for two years. He began his graduate work at the University of Louisville in 1958 on part time and maintained a full-time daytime teaching job. He completed his M.A. in painting in 1961, which was also the time that his fiancée, Dorothy Butler (who had attended Ursuline College in Ohio and Tuskegee Institute in Alabama) had just completed her graduate studies at Columbia University, and secured a job at the *Washington Post*. In 1962, they married, and Gilliam, who had spent four years in Louisville as a teacher, moved to Washington.

In his formative, post-Louisville years in Washington, Gilliam took his time to associate with artists in the city and become invested in what the dominant trends were at that time. He established a studio, had an exhibition in Adams Morgan, and met with a number of notable artists who were established in Washington, including Robert Gates and Tom Downing, a member of the Washington Color School. Eventually, Gilliam became acquainted with Kenneth Noland and Howard Morris, two of the key exponents of the Washington Color School. This association, and the insights that Gilliam gained from his observations and active engagement at exhibitions, resulted in a conceptual shift and radical retooling. Gilliam abandoned figurative painting but also was careful to develop his own style, a challenging task given the caliber of artists in the field with established reputations. He began to question the rationale behind the process of making art in certain ways. This was the environment that radically altered the whole notion of painting as a contained entity in a fixed space.

In 1968, he initiated a major shift in the way that the canvas was handled: he freed it from the traditional frame and gave it unfettered existence. This liberating act produced a symphony of colors, as Gilliam attacked tens of yards of canvas, soaking them in acrylic, manipulating, folding, and reorienting them, and then leaving them to dry. His canvases hang from ceilings and are draped on walls in ways that accentuate lyrical interaction with their architectural environments. Gilliam's *Autumn Surf,* which he created in 1973 for the San Francisco Museum of Art, exemplifies the artist's success and creative power. It was 150 yards of color-saturated polypropylene that were arranged, hung from the ceiling, decked over beams, and draped over vertical supports. Upon setting his sight on this painting in Gilliam's studio in a building where he too had his own studio, Rockne Krebs, Gilliam's colleague and sculptor, was said to have exclaimed, "God! That's like a surf" (Forgey 1989). This singular departure from tradition became one of Gilliam's distinctive signatures. His ability to map a new aesthetic and orchestrate an enchanting rapport among yards of canvas that are transformed into color spectacles and the various environments in which they are fielded have stood Gilliam out as one of the dominant contemporary artists of the last half-century.

In the 1970s, Gilliam continued to explore an assortment of supports for his draped canvases, which ranged from sawhorses and screens to poles. He also experimented with the interaction of colors on various supports. He worked with translucent paints and tried an assortment of paint application options on the canvas: staining, folding, dripping, pouring, and splashing. He would pour colors onto a flat surface and leave it overnight to bleed and form new patterns. In a 1989 interview with Forgey, he described his response to the outcome of this new method as "the most important thing that started to happen, that I could paint and go away and overnight the surprise of the painting, the surprise of the identification with the painting would be formed." For him, this was an exciting way of producing a piece of work: exerting control over it in a way that allowed for accident and absence of control to produce unexpected effects. Beginning from 1977, Gilliam, who felt that working in huge dimensions of canvas had taken him away from the formality of Color Field painting, returned to painting with a series of black paintings. He also began incorporating collaged items to the surface of the canvas. He experimented with various dimensions and angles for generating relief and spatial recession on the canvas.

This was but one step from moving his work in a three-dimensional way, with the collaged paintings having an aesthetic partnership with metal surfaces and three-dimensional figurations. This, in a sense, was Gilliam's reaction to the protest that his work attracted in Atlanta; he surmised that this was connected with the way that people classified his work: primarily as cloth. "But the more that you could involve harder material, like stone, marble and other things, they'd lighten up on you. Finally, the next chance that I had to do a commission, I used all metal. And I figured out that the attitude toward metal is that it's very clean, it's very acceptable" (Forgey 1989). In time, Gilliam mastered the fusion of color and metal, and made a strong impression in designing three-dimensional pieces that are installed in exterior spaces. His 1996 work,

Helix, (anodized aluminum and steel) which is installed at La Guardia Airport, exemplifies the outcome of Gilliam's persistent research and explorations. This work testifies to the artist's ability to envision new platforms and enrich visual vocabulary. The nineties saw full realization of the fusion of colors and surfaces, including birch and steel, that are not generally associated with color fields.

Gilliam has been criticized in certain circles for producing art that did not account for black aesthetic or respond to issues that were a corollary of the Civil Rights Movement. This criticism, which should be understood within the context of Gilliam's emergence on the art scene in the 1960s, a time when a proprietary notion of art was embraced by an emerging class of African American artists who felt marginalized by mainstream art apparatuses, seemed to have little relevance to the platform from which Gilliam approached art making. For as long as there has been art, there has been the issue of distinctions, boundaries, and compartmentalization. Gilliam's aesthetic was concerned with bridging those boundaries: transcending them by developing a new language complete with its own syntax; his ability to reconfigure, adapt, and synthesize places him within the top echelon of contemporary artists without diminishing his cultural allegiance.

As the years wore on, Gilliam's experimentation continued. Whereas his initial canvases were saturated with colors that were applied in a variety of ways —thin, stained, transparent, diluted or impasto, for example—he later pared down colors severely and subordinated them to the integrity of his three-dimensional surface. With reduction of his color palette came a reduction in contrast and a greater relationship between color and support. By the turn of the century, Gilliam went back to medium-size work. In 2002, he produced "Slats," a new body of work that is relatively small-scaled that uses birch plywood to construct slats on which he poured and manipulated acrylic colors. In 2002, his exhibition at Marsha Mateyka Gallery in Washington revealed Gilliam's new interest in the application of single colors over plain rectangular surfaces in a way that suggested a new minimalism.

Gilliam began his career as a teacher and continued teaching even after he had built a name for himself and was self-sufficient. From 1962 to 1967, he taught in the Washington, DC, public school system and at Maryland Institute of Art from 1967 to 1982. Between 1964 and 1967, Gilliam also taught at Corcoran School of Art in Washington. In the 1980s, he taught at the University of Maryland and at Carnegie Mellon University. He has executed numerous commissions for public and private organizations and held numerous solo exhibitions in galleries, museums, and university campuses across the nation, and in countries such as Germany, Finland, South Korea, France, and Ireland. He was the recipient of a number of awards, including the National Endowment for the Arts grant, the Solomon Guggenheim Memorial Fellowship, and the Norman W. Harris Prize of the Art Institute of Chicago. In recognition of his seminal contributions to society, he has been conferred with eight honorary degrees from universities, including two from his alma mater, the University of Louisville (1980), which also named him its 2006 Alumnus of the Year.

Places to See Gilliam's Work

American Federation of Art Museum Collection, New York, NY
Art Institute of Chicago, Chicago, IL
Art Museum, Princeton University, Princeton, NJ
Ballinglen Arts Foundation, County Mayo, Ireland
Baltimore Museum of Art, Baltimore, MD
Cincinnati Museum of Art, Cincinnati, OH
Corcoran Gallery of Art, Washington, DC
David and Alfred Smart Museum, University of Chicago, Chicago, IL
Dayton Art Institute, Dayton, OH
Denver Art Museum, Denver, CO
Detroit Institute of Art, Detroit, MI
Elvehjem Museum of Art, Madison, WI
High Museum of Art, Atlanta, GA
Hirshhorn Museum and Sculpture Garden, Washington, DC
Howard University, Washington, DC
Indianapolis Museum of Art, Indianapolis, IN
J. B. Speed Art Museum, Louisville, KY
Louisiana Museum of Modern Art, Humlebaek, Denmark
Madison Art Center, Madison, WI
Metropolitan Museum of Art, New York, NY
Milwaukee Art Museum, Milwaukee, WI
Mississippi Museum of Art, Jackson, MI
Musee d'Art Moderne de la Ville de Paris, Paris, France
Museum Boymans—van Beuningen, Rotterdam, the Netherlands
Museum of African Art, Washington, DC
Museum of Art, Carnegie Institute, Pittsburgh, PA
Museum of Art, Fort Lauderdale, FL
Museum of Modern Art, New York, NY
National Collection of Fine Arts, Smithsonian Institution, Washington, DC
National Gallery of Art, Washington, DC
National Museum of American Art, Washington, DC
National Museum of Jamaica, Kingston, Jamaica
New Orleans Museum of Art, New Orleans, LA
Renwick Gallery, Washington, DC
Rockefeller Collection, New York, NY
Spencer Museum of Art, University of Kansas, Lawrence, KS
Studio Museum in Harlem, New York, NY
Szepmuveszeti Museum, Budapest, Hungary
Tate Gallery, London, England
University of Iowa, Iowa City, IA
University of Louisville, Louisville, KY
University of Michigan, Ann Arbor, MI
Virginia Museum of Fine Art, Richmond, VA
Walker Art Center, Minneapolis, MN
Whitney Museum of American Art, New York, NY

Bibliography

Binstock, Jonathan P. *Sam Gilliam: A Retrospective.* Berkeley: University of California Press; Washington, DC: Corcoran Gallery of Art, 2005.

Campbell, Mary Schmidt. *Red + Black to "D": Paintings by Sam Gilliam.* New York: Studio Museum in Harlem, 1982.

Driskell, David. *Contemporary Visual Expressions: The Art of Sam Gilliam, Martha Jackson-Jarvis, Keith Morrison, and William T. Williams.* Washington, DC: Smithsonian Institution Press, 1987.

Forgey, Benjamin. "Interview with Sam Gilliam," November 4–11, 1989. http://www.aaa.si.edu/collections/oralhistories/transcripts/gillia89.htm.

Hardy, Donald. "A House Built for Art." *International Review of African American Art* 17, no. 3 (2000): 25–37.

Perry, Regenia. *Free within Ourselves: African-American Artists in the Collection of the National Museum of American Art.* Washington, DC: National Museum of American Art, Smithsonian Institution in association with Pomegranate Artbooks, San Francisco, 1992.

Rose, Barbara. "Color Me Washington." *Art & Antiques* 30, no. 5 (May 2007): 56–61.

Speer, Richard. "Sam Gilliam." *ARTnews* 106, no. 6 (June 2007): 142.

Van Derzee, James, Owen Dodson, and Camille Billops. *Harlem Book of the Dead.* Dobbs Ferry, NY: Morgan & Morgan, 1978.

Wei, Lilly. "Living Color." *Art in America* 95, no. 4 (April 2007): 116–22.

H

Palmer C. Hayden (1890–1973), Painter.

Palmer C. Hayden, the name by which posterity has come to know Peyton Cole Hedgeman, knew as early as he could remember that he wanted to be an artist. But this knowing alone would not suffice to make him one, and Hayden recognized that. As a result, he lived a life that was dedicated to mastering the skills that were necessary for becoming a successful artist. As he entered the labor market early and worked in the circus, as he joined the U.S. Army and served as a private, and as he substituted as a mail career, Hayden always found the time and the money to devote to self-improvement in art. Yet, Hayden's art has attracted sympathy and unflattering criticism in equal measure. From James Porter, who took umbrage at Hayden's work because he believed it pandered to the depiction of blacks as minstrels, to **Aaron Douglas**, who felt that the Harmon Foundation (which supported black artists and gave Palmer his first major recognition) privileged any black artist whom they suspected of a modicum of talent, Hayden's work continues to attract attention (Leininger-Miller 2001). Bearden and Henderson offer a view as to why Hayden was the most misunderstood of all artists that emerged during the Harlem Renaissance: "His simplicity and single-mindedness were often interpreted as naiveté. His themes, which were for the most part imaginative projections of his unique experiences, were too often seen as a simple kind of folklore. His early life and adulthood required him to engage in the most arduous type of labor and led to his being referred to as a 'working man who also painted'" (1993).

In some of Hayden's figurative paintings, the characters appear to be a parody of the black persona: the skin is not just black, it is burnt; the lips are not just pronounced, they are heavy and bulky; the eyes are not just white, they glare with a burning stare when seen against the pitch-black pigment with which Hayden adorns them. In his 1930 painting *The Subway*, the central figure, the one that holds on to the pole and stares directly at the viewer, appears irredeemably vile and ferocious. When the skin color is not brutally emphasized, the figures are made bald and depicted in profile such that the lips assume mountainous proportions. *Nous Quatre à Paris* (1928–30) exemplifies this stylistic trait. A watercolor piece dominated by four black card players, all of whom appear distracted from both sides of the picture frame, *Nous Qautre à Paris* provides the perfect excuse for Hayden to profile his characters.

Set against a background in which two others are engaged playing billiards, this is a tight composition in which the artist's viewpoint appears to swoop in from above the eye level. Leininger-Miller (2001) suggests that this may be an imaginary portrait of Hayden and his group of African American artists, including possibly Claude McKay, **Hale Woodruff**, and Countee Cullen, who frequented Le Dôme, the favorite café of Americans in Paris in the 1920s. Leininger-Miller's quotation (2001, 84) of Hayden's reminiscences on this topic is apt: "Eric Walrond . . . we used to play cards together all night in the cafes in Paris. There's a part of the cafés there . . . set aside especially for people who want to play cards, not gambling but . . . checkers and chess . . . bélote is a French card game something like bridge . . . so we'd hang out there, Countee, another West Indian . . . , Dr. Dupré, all of them students."

In *The Janitor Who Paints* (1931), Hayden succeeds in packing into a very tight space information concerning the character of his subject. The janitor's pride is demonstrated in his spiffy appearance, which underlines the process of painting and elevates the profession to an echelon comparable to other major fields in which formal attire becomes a marker of status. The hand, which is large, somewhat coarse but steady, seems much more important than the painting itself. There are the other indices that attest to the janitor's self-worth: a stable family, as represented by a well-dressed mother and child at whose feet a snug cat continues with its gentle dreams. A broom shoots from the left side of the painter and rests against the wall, its upward thrust balanced by a dangling duster. When viewed against the trash bin at the lower right corner, the inference is clear: the janitor is framed by all the tools of his profession, but he is not defined by it. Rather, the painting, which he works on with unflinching concentration, brings on the sparkle, which the seated woman radiates. The alarm clock in the painting indicates the importance of the equipment in the life of a janitor, who has to be alert in the discharge of his duties and be aware of the possibility that packages might be delivered at certain times (Bearden and Henderson 1993).

The Janitor Who Paints was one of two such paintings that Hayden did after he had been dismissed from his job in the post office for absenteeism. The first one, which is compositionally indistinguishable from the latter, has one major difference: the characterization of the janitor. With a bald head and an eye that pops when seen against the janitor's black skin and a jutting forehead, the figure retains a macabre mien, one that led to Hayden being criticized for lampooning blacks. A very shy individual who found it easier to work alone and take on janitorial and other jobs for his upkeep, he would meet another black artist, Cloyd Boykin from Virginia, who worked as a janitor. This association buoyed Hayden's confidence and gave him the assurance that they were kindred spirits, someone with similar experiences and tribulations. According to Bearden and Henderson (1993), this painting was meant to symbolize Boykin. Hayden painted it to protest the insensitivity of people who never recognized his talent as an artist, preferring to call him a janitor instead.

The fifth in a family of 10 children, Palmer C. Hayden was born in Widewater, Virginia, on January 15, 1890, to James Hedgeman, a freed slave, and Nancy Belle Cole. As a boy, Hayden, who nursed an ambition of becoming a

fiddle player, was timorous, although he derived immense pleasure in the attention that his art brought him in school. He left home at age 17 for Washington, DC, and lived with his aunt and started life as a worker taking on whatever circumstance pushed his way: as errand boy for a drugstore; a circus worker with Ringling Brothers Circus, for which he drew posters, cartoons, and portraits for publicity purposes; a porter at Coney Island in New York; a member of a sledgehammer gang; and a sandhog in a shaft in New York for the Catskill water conduit (Bearden and Henderson 1993). In 1911, he responded to an advertisement and sought to enlist in the army. This, he believed, would provide a reprieve from the capricious job situation that he had to endure. A recommendation that was reluctantly given to him by the clerk at the shaft where Hayden worked turned out to bear a name different from that by which he was known: Peyton C. Hedgeman. He realized this at the recruiting station and was too frightened to do anything about the name change. The artist thus assumed a new identity: Palmer C. Hayden, private in the all-black Company A, 24th Infantry Regiment. He served on the islands of Panay, Negros, Luzon, and Corregidor in the Philippines. He was assigned to the cartography unit by his superiors upon seeing his drawings of fellow soldiers and of the Filipino people and their environment (Leininger-Miller 2001).

After his discharge in San Francisco in 1914, he went back to Washington, DC. Upon the outbreak of World War I in Europe, Hayden enlisted at West Point where a detachment of black cavalrymen was stationed as a part of the 10th Cavalry. As he had done in the Philippines earlier, Hayden again continued to draw, to the admiration of his fellow soldiers. In 1920, Hayden was discharged from the army. During that summer, he enrolled in a six-week summer art course at Columbia University. He worked as a mail carrier for five years, but was eventually dismissed because he grew increasingly protective of spending his daytime working on his art, to the detriment of his employment. He took up employment as a janitor cleaning the studio of Victor Pérard, a painting teacher at Cooper Union, whose advice and instructional assistance gave Hayden a significant fillip. A chance meeting with Alice Miller Dike, a single prosperous woman in her sixties and daughter of a woolen mills business mogul, proved to be epochal in the life of Hayden. He also received support from Asa Grant Randall, founder of the Commonwealth Art Colony, whom he worked for in exchange for art instruction. In April 1926, Hayden had done enough work to have a solo exhibition at the Civic Club.

With encouragement from Dike, he entered some paintings for the inaugural Harmon Foundation exhibition of 1926. His commitment to art was handsomely rewarded when his landscape, *Schooners*, won the Foundation's first prize for Distinguished Achievement in Fine Arts: a gold medal and $400. With an additional $3,000 in support from Dike, Hayden sailed to France in March 1927. Although he spent five years in Paris, Hayden decided against subjecting himself to any formal tutelage, preferring instead to work on his own. He met with **Henry Ossawa Tanner**, who encouraged him and gave him some hints about how to survive in Paris. He also met with prominent African American artists and scholars such as Alain Locke, Hale Woodruff, and Claude McKay.

He maintained contact with the Harmon Foundation, particularly as his resources dwindled and he found that he needed additional funding. In 1932, he finally returned to New York.

He worked for the Harmon Foundation and the Works Progress Administration (WPA), doing easel paintings at home. He married Miriam Hoffman in 1940, resigned from the WPA, and set his sight on fulfilling a dream that he had nursed since he was a child: painting a series on John Henry, whom he thought was a mythical folk hero, until he learned that there indeed was "a strong African-American worker named John Henry, who in 1870–71 had actually helped build the mile-long Big Bend Tunnel on the Chesapeake and Ohio Railroad on the Greenbriar River, near White Sulphur Springs" (Bearden and Henderson 1993). Hayden's series on John Henry remains perhaps some of his most significant works because it essentializes, for Hayden, the resilience and steely resolve of African Americans. Palmer Hayden died on February 18, 1973.

Places to See Hayden's Work

Evans-Tibbs Collections.
Hampton University Museum, Hampton, VA
Metropolitan Museum of Art, New York, NY
Museum of African American Art, Los Angeles, CA
National Gallery of Art, Washington, DC
Smithsonian American Art Museum, Washington, DC

Bibliography

Bearden, Romare, and Harry Henderson. *A History of African-American Artists from 1792 to the Present.* New York: Pantheon Books, 1993.

Driskell, David. *Palmer Hayden: The John Henry Series and Paintings Reflecting the Theme of Afro-American Folklore.* Nashville, TN: Art Gallery, Fisk University, 1970.

———. *Two Centuries of Black American Art.* Los Angeles: Los Angeles County Museum of Art; New York: Knopf, 1976.

Gordon, Allan. *Echoes of Our Past: The Narrative Artistry of Palmer C. Hayden.* Los Angeles: Museum of African American Art, 1988.

Hanks, Eric. "Journey from the Crossroads: Palmer Hayden's Right Turn." *International Review of African American Art* 16, no. 1 (1999): 30–41.

Hills, Patricia, and Melissa Renn. *Syncopated Rhythms: 20th Century African American Art from the George and Joyce Wein Collection.* Boston: Boston University Art Gallery, 2005.

Leininger-Miller, Theresa. *New Negro Artists in Paris: African American Painters and Sculptors in the City of Light, 1922–1934.* New Brunswick, NJ: Rutgers University Press, 2001.

Lewis, Samella. *African American Art and Artists.* Berkeley: University of California Press, 2003.

Livingston, Jane, and John Beardsley. *Black Folk Art in America, 1930–1980.* Jackson: University of Mississippi, Center for the Study of Southern Culture, 1982.

Ott, John. "Labored Stereotypes." *American Art* 22, no. 1 (Spring 2008): 102–15.

Perry, Regenia A. *Free within Ourselves: African-American Artists in the Collection of the National Museum of American Art.* Washington, DC: National Museum of American Art, Smithsonian Institution in association with Pomegranate Artbooks, San Francisco, 1992.

Porter, James Amos. *Modern Negro Art.* New York: The Dryden Press, 1943.

Powell, Richard J. *Black Art and Culture in the 20th Century.* New York: Thames & Hudson, 1997.

Sims, Lowery Stokes. "African-American Artists' Passionate Visions." *American Visions* 9, no. 2 (April–May 1994): 20.

Studio Museum in Harlem. *Harlem Renaissance: Art of Black America.* New York: The Studio Museum in Harlem; New York: Harry N. Abrams, 1987.

George Hughes (b. 1962), Painter, Performing Artist, Poet.

Looking at the paintings of George Hughes, one may come to the conclusion that the artist is unhinged professionally. Considering the amount of energy that his large canvases exude, the emotional bleeding that they portray, and the sheer pulverization and seemingly chaotic atmosphere that his subject matter endures, Hughes appears to relish the recklessness that the process itself demands. When one speaks of subject matter, one does so in a very loose sense simply because, for Hughes, there is no attempt at working in a premeditated fashion. His paintings emerge; they make themselves manifest in much the same way that sound floats from the strummed strings of a master guitarist. Of course, it is possible over time to begin to categorize the images that tend to recur in Hughes's paintings: robotized essences; militarized subjects; athletes; energized African masks in contemporary costumes and sometimes with psychedelic attitudes; cars that are beaten, battered, bleeding, or burned. Those who are familiar with African art may break into some bemused smile upon recognizing familiar personages—the Kifwebe, and the Nkisi, both from the Democratic Republic of Congo—now transformed into modern characters by Hughes, become much more maniacal and ferocious in their makeover. For his Western colleagues, the plethora of mechanized stars and armored personages tends to constitute an acknowledgement of Hughes's duality and immersion in the African and African American worlds. In this regard, Hughes's canvases constitute a synthesis of the cultural sensibilities that continue to shape his work.

His paintings do not reference any specific artist, living or dead. Perhaps **Jean-Michel Basquiat**, more than any other artist, comes to mind when one regards Hughes's work. The artist has acknowledged his respect for Robert Rauschenberg and Jimi Hendrix. Adding Hendrix, the phenomenal American musical idol who died suddenly in 1970, to the list of artists who have influenced Hughes the most reveals the artist's creative pulse: a certain restlessness, energy, vive, and exploratory spirit are common traits among these artists. Most of them seem deliberately antagonistic to spatial order, and are suffused with playful inscriptions that goad the viewer to ascribe meanings or construct

motives. The artist is unabashedly eclectic and refuses to be pinned down either by single ideas or people's expectation of what he is supposed to do: "I am motivated by curiosity to visually explore and interpret the human predicament in relation to historical and current issues of political and social significance. I seek to express these themes with symbolic and metaphoric imagery borrowed from various subjects and cultural sources" (Hughes 2005). He neither favors labels nor embraces movements, although he regards all such manifestations with respect. He attributes whatever detectable influence in his work to his own study of Western, Asian, and African cultures, and the experiences that he has garnered growing up in his native Ghana and studying, teaching, and exhibiting in the United States.

In his studio where he tackles subjects as they float through his canvas, capturing them without any premeditation, Hughes comes across as one possessed of an impulsive, creative spirit. For him, the process of creating art becomes cathartic; it turns him into a medium that exists to do the bidding of the deities, very much like what obtains in Ghana, where practiced spiritualists, completely swathed in white kaolin and bedecked with powerful charms and amulets, prance about in the public arena, dancing to the frenzied beat of drums with unusual agility that confirms their spiritual prowess. This notion of the artist as a medium that responds to cosmic dictates tends to be in accord with Hughes's search for visual equilibrium in his work. He views culture with a cosmic eye, and has an interest in allowing his imagination to be fertilized by universal principles of culture. Hughes acknowledges that his work has grown from the formative period in which he was interested primarily in the immediacy of visual images, to the current phase in which he seeks to transcend the cultural mind, which he perceives as standing between us and our individuality. Hughes's objective is to continue to infuse his work with the streams of insights that cultures offer, and to "utilize processes, themes and knowledge of universal significance" in a way that allows him to reach a wider audience and avoid the taint of parochialism (Hughes 2005).

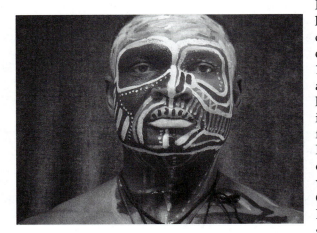

George Hughes. Courtesy of Cecilia Hughes.

Born in Accra, Ghana, in 1962, Hughes grew up in Sekondi, where he had his elementary and secondary education. Although Hughes obtained an M.A. in art education in 1992 from the University of Science and Technology, Kumasi, where he had graduated in 1989 with a B.A. in painting and drawing, he did not feel fulfilled economically. In 1991, Hughes went to London in search of adventure and worked as a visiting lecturer at Queen Mary's College in Basingstoke, England. In London, he met an American sculptor, Jayne Elizabeth, whom he would eventually marry. He went

back to Ghana before finally moving to Toledo, Ohio, with his wife in 1994. Hughes attributes his relocation to the United States to volition, economics, and fate. The economic aspect pertains to the status of Ghana in the late 1980s and early 1990s. Although Ghana was the first sub-Saharan African country to attain independence from colonial domination in 1957, a series of military coup d'états interrupted the country's economic growth. In 1993, Jerry Rawlings's presidency ushered in Ghana's fourth republic in 36 years. In 2001, Hughes obtained his M.F.A. in painting and drawing from Bowling Green State University in Ohio.

That same year, he moved to the University of Oklahoma to teach painting. Between 1999 and 2000, he taught part-time drawing at Bowling Green State University. He has taken part in numerous group exhibitions and had many solo shows in the United States, England, Ghana, Germany, and the Netherlands. His laurels include the 1995 Gumbacher Award for Excellence in painting, the 1996 First Award in the Toledo Area Artists 78th Annual Exhibition at the Toledo Museum of Art, and Best of Show in the Arts Commission of Greater Toledo Roots of Diversity exhibition.

Hughes adopts a layered approach to art making, employing mixed media that include acrylics, oils, photographs, and any objects or techniques that will get his message across. Tactility of the surface becomes an essential aspect of his work. In addition to image dismemberment that appears to be a standard stylistic given, his work relies on dripping paint, scratchy painterliness, and irrational juxtaposition of emblems to provoke a jarring sense of discomfort in the viewer. In a series of paintings that focused on motorized contraptions, one can catch a glimpse of what remains of certain popular cars, Lincoln, Mercedes, and Rolls Royce among them. The cars appear to exude en emotional pathos akin to what a severely outmatched boxer might look like after a particularly disastrous outing. In one particular painting, the remnants of a car appears to plead for emergency intervention from the viewer; its eyes are gouged, the nose crumpled, and the denture in shambles. Ross has attributed the artist's interest in painting disabled cars to the fact that growing up in Ghana, the artist's father was involved in about 10 car accidents (Ross 2001). As to the graffiti that Hughes employs, there is no specific effort to ascribe embedded meanings to them. He writes them partly on the spur of the moment, but perhaps more relatedly because this provides an outcome for him to express one aspect of his creative persona that is not often on display—poetry.

Although fully comfortable in his role as professor in an American university, Hughes does not place too much stock on the impact of his status as an artist in voluntary exile. He acknowledges that although being away from Ghana has given him the freedom to create art in isolation from the artistic genres of Ghana and Africa, he has not abandoned the dynamics of the African psyche. Hughes has evolved a personal style with an individuated philosophy, which is a synthesis of his African upbringing and Western education. Because he values his individualism over imposition of order or adherence to specificity, Hughes does not honor commissions. Equally, he resents the tendency to typecast or compartmentalize an artist on the basis of social expectations. In

this respect, he affirms his individuality over any collective stereotyping of the African artist who is expected to produce work that accords with certain preconceived notions.

Places to See Hughes's Work

Private collections in the United States

Bibliography

Hughes, George. Personal correspondence with author, September 2005.

Kasfir, Sidney. "Museums and Contemporary African Art: Some Questions for Curators." *African Arts* 35, no. 4 (Winter 2002): 9–87.

Nelson, Robert S. "The Map of Art History." *Art Bulletin* 79, no. 1 (March 1997): 28–40.

Posnansky, Merrick. "In Support of Contemporary Art." *African Arts* 19, no. 1 (November 1985): 8–10.

Ross, Doran. "George Hughes." *African Arts* 34, no. 1 (Spring 2001): 50.

Stanley, Janet. "Three Contemporary Ethiopians." *African Arts* 26, no. 1 (January 1993): 76–77.

Richard Howard Hunt (1935–), Sculptor, Printmaker, Installation Artist.

Hunt's sculptures are inimitable for their organic tenderness. They are produced in a style that is itself a testament to the power of the artist to dominate his material and create a gracious union between two seemingly incompatible elements: mineral and vegetable. In swooning motion, tendrils shoot in various directions, coiling in empathetic snoots seemingly oblivious of their encasement in bronze or welded metals. Michael Brenson, in a 1989 review of Hunt, describes his *Flyaway* as a "figure with arms outstretched in horror [that] is also a dove in flight." Titles of some of Hunt's projects reveal his love for growth and efflorescence; nature and space: *Nature's Palette* (at Kalamazoo College in Michigan); *Freeform* (Chicago, Illinois); *Spatial Interactions* (Chattanooga, Tennessee); *Growing Orbit* (FMC Corporation, Chicago); *Meander* (Lake Forest, Illinois); and *Organic Construction* (Chicago).

Hunt grew up mastering the ability to fuse elements from the two worlds of the visual arts and biological sciences that he cherishes. While he was involved in the visual arts, he took it for granted but paid particular attention to biological sciences and to history. These traits permeate Hunt's oeuvre, making it holistic and individuated. Brenson's observation of the way that Hunt tempers history with art is apt. Noting that his sculptures are imbued with "classical and narrative references," Brenson further adds that "Hunt is not after total newness. He wants to balance new and old, industry and the hand, transformation and memory. This is apparent in the way he takes a hard modern material like Cor-ten steel and makes it seem as elastic as wax" (1989). Although Hunt's renown seems to privilege his sculptures, his

lithographs are equally assertive; they are poetic abstractions that constitute perhaps sympathetic equivalents to his sculptures.

Hunt was born in Chicago on September 12, 1935, to Victoria Inez Henderson Hunt, who worked as a librarian and beautician, and Cleo Hunt, a barber. During the Great Depression, Cleo Hunt, who was born in Georgia, came to Chicago, where he met Victoria Henderson who was from Tennessee, and they got married. Hunt and his younger sister Marian grew up in the South Side of Chicago; when he was about age 11, his parents moved to Galesburg, Illinois, although he spent most of his time in the city of Chicago. As a child, he developed an interest in music on account of his mother's activities in that field; he would follow his mother to her voice lessons and watch her sing as a soloist in local churches and choirs. Hunt's interest in art began early; every space—the floor, the walls, paper—was a ground, which he used as a support for his crayon drawings. At age 12, he was enrolled in the Junior School of the Art Institute of Chicago, thus beginning the relationship of a lifetime. He attended Englewood High School while he continued with his art classes at the Art Institute. He became fascinated with forms when he worked in a zoological laboratory of the University of Chicago. The insights that he gained while working at the laboratory regarding the biological transformations that animals undergo were internalized and would be splayed out into his lithographic and metal forms as the years advanced. Additional source of inspiration was the Chicago Field Museum, which he frequented with his mother, and where he had seen African art.

Hunt's prodigious talents were noticed by all who were privileged to be around him, and his junior high school sculpture teacher, Nelli Barr, was instrumental in spurring him to see local shows and meet artists. At age 15, he turned his father's basement into a personal studio where he began to model in clay. In 1953, he began his studies at the Art Institute of Chicago, studied sculpture and lithography, and declared a major in art education. He was greatly inspired by the work of David Smith and Julio Gonzales, whom he considers one of the unsung artists of his time. At the 1953 exhibition "Sculpture of the Twentieth Century," which was held at the Art Institute, Hunt was exposed to the welded metals of Gonzales and decided to explore the medium further on his own. Within two years, he had mastered the welding torch and developed a more intuitive and personal approach to welded metal, one that leaned heavily on the use of discarded materials, mostly dysfunctional automobile parts, which he salvaged from the junkyard. The newfound method of welded metal offered Hunt greater creative latitude, as it allowed him to undertake creative adventures that were difficult to contemplate using the traditional modeling and carving method, which was the main approach that the Art Institute taught. Welded metal buoyed his determination to soar in space—to draw in space, literally—using a three-dimensional medium. Welding, soldering, and using metals to create sculpture through an additive method that was neither clay nor plaster offered exciting prospects for him. By the time he was 20, Hunt had mastered this new medium all on his own, and had begun to create sculptures that earned him accolades at local art fairs and exhibitions. His break came early in his life: in 1956, during his

third year at the Art Institute, he won the top award at the annual Vicinity Show that the Art Institute sponsored. This generated further interest in the art establishment and led to a New York art dealer offering him an exhibition. His work, *Arachne,* was included by the Art Institute in the American Exhibition; the Museum of Modern Art purchased it for its collection. For a 20 year-old artist who was still in college, this was a substantial recognition. *Arachne,* as Jane Addams Allen describes it, "was made of recycled junk; its bulging eyes had originally been motorcycle head lamps; its gaping torso came from parts of cars. Inspired by the direct metal sculpture of Julio Gonzalez, Picasso's contemporary, Mr. Hunt had taught himself to weld during his first year at art school" (Allen 1985). He began to draw the attention of patrons with Arnold Merrit purchasing and donating his work to the Art Institute (Barrie 1979).

Hunt graduated from the Art Institute in 1957 and won a fellowship, which he used to travel to Europe in the summer of that year. He visited England, France, Spain, and Italy, spending considerable time in Florence. He became fascinated with casting, which he had not had the opportunity to explore prior to this time. In Rome, he met and married Betty Scott, his first wife, and both of them returned to Chicago in 1958. That same year, he was drafted into the army and went to Fort Leonard Wood, Missouri, from where he was posted to Fort Sam Houston in San Antonio, Texas, as an army artist. Upon his discharge in the summer of 1960, he took an appointment with the University of Illinois, and also with the Art Institute of Chicago. Later, he accepted a full-time employment at the University of Illinois and taught there for two years before deciding to quit and focus full time on his studio practice (Barrie 1979).

The year 1967 was a milestone in Hunt's professional direction. This was when he began his first commissioned sculpture, *Play,* which was so large that he had to work on it outside of his studio with the assistance of additional men and equipment. *Play* initiated the second phase of Hunt's career: that of public commissions. Outside sculpture has its own dynamic and produced new creative directions that are at times external to the artist's original conception. As Hunt has observed in one of his artist's statements, there are distinctions between studio work and that done for public consumption. While in the studio, the artist uses the tools—the hammer and the torch—to beat ideas into shape and turn concepts that are frozen in time into viable physical presences, outside sculptures generate external dialogue with the environment, patrons, and other constituencies. Hunt writes: "Public sculpture responds to the dynamics of a community, or of those in it, who have a use for sculpture. It is this aspect of use, of utility, that gives public sculpture its vital and lively place in the public mind." This clarity is a critical factor in the artist's phenomenal rise. This was when he began to focus exclusively on public commissions. Today, Hunt's works are an unmistakable presence at major public domains in many states—Illinois, California, Texas, Florida, Missouri, South Carolina, and Tennessee, among others—as well as in Washington, DC. One of his most impressive public sculptures is *I Have Been to the Mountain,* which is a welded Cor-ten interactive and commemorative three-part memorial in Memphis,

Tennessee, in honor of Martin Luther King, who was assassinated in the city. In 1971, in recognition of his eminent status, the Museum of Modern Art gave him a retrospective exhibition.

Places to See Hunt's Work

Albright-Knox Art Gallery, Buffalo, NY
Art Institute of Chicago, Chicago, IL
Cincinnati Art Museum, Cincinnati, OH
Cleveland Museum of Art, Cleveland, OH
Fogg Art Museum, Harvard University Art Museum, Cambridge, MA
The Hirshhorn Museum and Sculpture Garden, Washington, DC
Los Angeles County Museum, Los Angeles, CA
Metropolitan Museum of Art, New York, NY
Miami University Art Museum, Oxford, OH
Museum of Fine Arts, Boston, MA
Museum of Modern Art, New York, NY
Museum of the Twentieth Century, Vienna, Switzerland
National Gallery, Washington, DC
National Museum of American Art, Washington, DC
National Museum of Israel, Jerusalem, Israel
Nelson-Atkins Museum, Kansas City, MO
New Jersey State Museum, Trenton, NJ
New York Public Library, New York, NY
Studio Museum in Harlem, New York, NY
Whitney Museum of American Art, New York, NY
Wichita Art Museum, Wichita, KS

Bibliography

Allen, Jane A. "A Very Private Artist Seeks a Very Public Art." *Washington Times,* January 1985.http://www.procuniarworkshop.com/art-reference/jane-addams-allen-a-very-private-artist-seeks-a-very-public.html (accessed January 19, 2008).
Ashton, Dore. *Modern American Sculpture.* New York: Harry N. Abrams, 1968.
Barrie, Dennis. "Oral History Interview with Richard Hunt," March 2, 1979.
Brenson, Michael. "Richard Hunt at Dorsky Gallery 1989." April 1989. http://www.procuniarworkshop.com/art-reference/michael-brenson-richard-hunt-at-dorsky-gallery.html (accessed January 19, 2008).
Contemporary Art: Acquisitions, 1959–1961. Foreword by Gordon M. Smith. Buffalo, NY: Buffalo Fine Arts Academy, Albright-Knox Art Gallery, 1961, 10, 55.
Dover, Cedric. *American Negro Art.* Greenwich, CT: New York Graphic Society, 1960.
Kramer, H. "Richard Hunt Exhibition at Alan Gallery." *Nation,* March 23, 1963. http://www.procuniarworkshop.com/art-reference/hilton-kramer-the-nation-march.html.

Moss, Robert F. "Saturday Review: The Arts in Black America." http://www.procuniarworkshop.com/art-reference/robert-f-moss-saturday-review-the-arts-in-black-america.html (accessed January 19, 2008).

Museum of Modern Art, *The Sculpture of Richard Hunt*. The Museum of Modern Art. Exhibition catalog. New York: The Museum of Modern Art, 1971.

J

William H. Johnson (1901–1970), Painter.

William H. Johnson knew adversity; he was born into it, and his entire life reflected various degrees of adversity. His triumph occurred because of his ability to confront adversity: to work through it, confront it, and, in spite of it, produce masterpieces that speak about the indomitability of the human spirit.

Johnson was born in Florence, South Carolina, on March 18, 1901, to Alice Johnson, a black woman with native American ancestry, and a popular white father who cared little about young Johnson's upbringing. Faced with an economic and social dilemma, Alice reconsidered her options. The result was her marriage to an African American man. The marriage was blessed with four children—two boys and two girls (Bearden and Henderson 1993, 185). Another account of Johnson's family suggests that while miscegenation was rampant because women who worked as domestic hands—and Alice was one of them —were often subjected to unwanted sexual harassment by their white employers (Powell, *Homecoming*, 5). While Johnson was the only one of the five children with distinctive wavy hair and light skin, Powell suggests that his racial features could be attributed to the possibility that Johnson inherited part of his mother's American-Indian ancestry. What mattered, ultimately, was that Johnson's distinctive racial features exposed him to uncomplimentary whispers from neighbors and painful taunts from his schoolmates, all of which had an adverse effect on his social disposition (Powell, *Homecoming*, 5).

Adversity soon struck after Alice remarried. Johnson's stepfather suffered an accident, and the resulting disability shifted the burden of raising the family on the shoulders of Alice, who took on a variety of household jobs in order to cater for the family. Thus, at an early age, Johnson was steeled by adversity, as he had to assume his own share of responsibility at an early age: taking care of his younger siblings and working on the farms during the seasons. These harsh conditions would explain Johnson's limited education, for he eventually dropped out of school, although not before his teachers had noted his talent in art.

In 1918, Johnson headed for New York in company of his uncle. He endured the harshness of weather and work to earn sufficient money to send to his mother, and to enroll at the National Academy of Design in 1921. He proved to be a fast learner and came under the influence of Charles W. Hawthorne, who recognized the need to give Johnson the critical financial support without

which he might quickly exhaust himself. Between 1923 and 1925, Hawthorne offered Johnson some scholarship that relieved the young artist of the burden of tuition and sustenance. At the National Academy of Design, Johnson excelled and won major prizes: the Cannon Prize (1924; 1926) and the Hallgarten Prize (1925). Hawthorne then embarked on a fund-raising campaign in order to send Johnson abroad for additional studies. In this endeavor, Hawthorne secured the endorsement of George Luks, who contributed $600 of the $1,000 goal. With that, Johnson set for Paris in 1926 and showed interest in the work of Paul Gauguin, for whose subject-matter, comprising mainly of Tahitian people, Johnson had an affinity.

No doubt excited by the change and tempo that he saw in the new art world in which he found himself, Johnson declared that he had become a "primitive," a declaration that has been interpreted variously by artists and scholars. For example, Bearden and Henderson indicate that the declaration is made by "a sensitive man whose inner life lay outside a culture that imposed on him strict requirements on how he should behave and even paint" (187). Powell (*Homecoming*, xx) believes that the declaration is a claim "of just how he felt as an artist of color living in Nordic Europe." In France, Johnson took interest in Chaim Soutine's wildly expressive paintings and modeled his own approach after Soutine's. Johnson moved to Cagnes-sur-Mer in southeastern France to explore the neighborhood and improve on his style. In the first half of the twentieth century, France was a popular destination for many black artists, including **Henry Ossawa Tanner**, who felt that the country offered many more opportunities to acquire professional education in a country that was the center of creative ebullience. Additionally, many African American artists and writers who traveled to France felt that the racial tension there was relatively inconsequential. In Paris, Johnson was excited to have met Henry Tanner, who gave him encouragement. The two exhibitions that Johnson had in France—in 1927 and in the winter of 1928–29—were quite disappointing for the artist.

In 1929, Johnson fell in love with Holcha Krake, a Danish weaver he met at Cagnes-sur-Mer and would marry a year later. For the next several weeks, Johnson traveled to European art centers in company of his new love and her family. He returned to New York in November 1929 and entered some paintings for the Harmon Foundation exhibition of 1930 at which he won the first prize. For the first time since 1926 hen he left for France, Johnson reunited with his mother in Florence. It was a homecoming that had a bittersweet tinge to it. He exhibited some of the canvases that he took with him at the local YMCA where his mother continued to work, and the local newspaper, the *Florence Morning News,* celebrated Johnson's return with a short article. But Johnson was soon reminded of the prevalence of racism in Florence and the South in particular when he was arrested and jailed by the police for painting a ramshackle building—the Jacobia Hotel.

In 1932, Johnson settled with Holcha in Odense, Denmark. He traveled in Europe with her and painted the Nordic landscape. They also traveled to Tunisia in Africa where Johnson felt at home among the Arabs. Six years later, Johnson returned to New York with Krake, but both were dodged by a cold

reception and lack of patronage. He was in a United States that was still strug-
gling to recover from the devastating effects of the Great Depression. Besides,
the dynamics of patronage for African American artists had changed from
what Johnson was accustomed to; he felt suddenly out of professional rel-
evance. Powell refers to this phenomenon as Johnson's invisibility, and addu-
ces a number of factors, including the artist's stylistic eclecticism and the
vicissitudes of life, for this condition. There is no doubt that adversity was
Johnson's shadow: at times invisible, and at other times strong and apparent.

In the face of such difficulties, Johnson remained unwavering in his commit-
ment to his art. He produced a body of work that remains perhaps some of the
most impulsive and genuinely cathartic manifestations of American moder-
nity. His work gave visual presence to his claim of being a "primitive." John-
son's power lies in his ability to work in a variety of styles that are united by
his fiercely individualistic temperament. He produced paintings that captured
the soul of his times and the innate spirituality of the environment in which he
lived. From Cagnes-sur-Mer, through Scandinavian landscapes, and on to the
United States in the twilight of his life, Johnson's paintings capture the acute-
ness of his sensibility at the same time that they reflect his control of the
medium. The landscapes that he painted in Kerterminde in the early 1930s
show the brutal frankness of his mood, which ranged from the broody to the
tempestuous and the lyrically abstract. Later in life, the swirl and convulsive-
ness of his style would be succeeded by a flat placidity that bordered on a cul-
tivated naiveté. His paintings *Going to Church* (1940–41), *Mount Calvary* (1944),
and *Lamentation* (1944) exemplify this manifestation.

In 1944, Holcha Krake died of breast cancer, and Johnson was devastated. He
returned to Denmark and lived for a while with his in-laws while living a Spar-
tan existence. He began to manifest signs of severe health deterioration. He
was diagnosed with paresis and repatriated to the United States later in 1947.
In December of that year, he was admitted to Central Islip State Hospital in
Long Island, New York, where he remained until his death on April 13, 1970.

Places to See Johnson's Work

Amon Carter Museum, Fort Worth, TX
Howard University Art Museum, Washington, DC
Museum of Modern Art, New York, NY
Ogden Museum of Southern Art, University of New Orleans, New Orleans, LA
Smithsonian American Art Museum, Washington, DC
Smithsonian Archives of American Art, Washington, DC

Bibliography

Bearden, Romare, and Harry Henderson. *A History of African American Artists:
From 1792 to the Present.* New York: Pantheon Books, 1993.
Campbell, Mary Schmidt. *Harlem Renaissance: Art of Black America.* New York: The
Studio Museum in Harlem; New York: Harry N. Abrams, 1987.
Ogden Museum of Southern Art. "Treasures from the Amistad Collection," July 23,
2008. http://www.tfaoi.com/aa/3aa/3aa21.htm.

Powell, Richard J. *Homecoming: The Art and Life of William H. Johnson.* Washington, DC: National Museum of American Art, Smithsonian Institution; New York: Rizzoli, 1991.

———. " 'In My Family of Primitiveness and Tradition': William H. Johnson's Jesus and the Three Marys." *American Art* 5 (Fall 1991): 20–33.

———. *The Life and Art of William H. Johnson.* Video recording. Wilton, CT: Reading & O' Reilly, 1991.

———. *Black Art: A Cultural History.* London: Thames and Hudson, 2002.

Smithsonian American Art Museum. "Collections and Exhibitions," July 23, 2008. http://americanart.si.edu/collections/interact/slideshow/johnson.cfm.

Turner, Steve. *William H. Johnson: Truth Be Told.* Los Angeles: Seven Arts Publishing; Seattle: Distributed by the University of Washington Press, 1998.

University of South Carolina. "William H. Johnson Civil War Letters," July 23, 2008. http://www.sc.edu/library/socar/uscs/1995/whjohn95.html.

Loïs Mailou Jones (1905–1998), Painter, Educator, Designer, Illustrator.

By the time she was barely 20 years old, Loïs Mailou Jones had acquired remarkable maturity and skills in her drawings and designs. Her superb draftsmanship and command of a variety of media—charcoal, pen and ink, watercolor, and tempera among these—ranked her among the most talented in her era. The awards and scholarships that she attracted remain proof that Loïs Mailou Jones was an exceptional artist. But it was her parents who first noted young Jones's gift and provided the incentive that was to culminate in the choice of art as a career. Growing up, her parents provided her with a rich supply of drawing and painting materials: color pencils, crayons, and paint; at only seven years old, she received her first set of watercolor (Benjamin 1994, 5). They also enrolled her at the High School of Practical Arts, which gave her a very strong grounding in the fundamentals of art. Jones was the recipient of four successive scholarships, with the attendant privilege of after-school studies on weekdays and Saturdays at the Museum of Fine Arts from 1919 to 1923.

Loïs Mailou Jones was born in Cambridge, Massachusetts, on November 3, 1905, the younger of two children, to Thomas Vreeland Jones and Carolyn Dorinda Jones. (Her brother, John Wesley Jones, was born in 1896.) Her parents had migrated to Cambridge from Paterson, New Jersey, in 1896 in search of social improvement. Her father was an ambitious person who supplemented his work as office superintendent with attendance at night classes at Suffolk Law School, graduating in 1915 with a degree in law at the age of 40 (Benjamin 1994, 4). With the new degree came a new social status: Thomas Vreeland Jones, now a lawyer, delved into real estate, and became a notable member of his society. With the employment of Carolyn Jones as a cosmetologist, the Joneses had worked their way into the upper echelon of the black society in Cambridge.

Her career spanned three quarters of a century. During this time, Jones received a solid education within and outside of formal academies in the

United States and France. She lived through the Harlem Renaissance and witnessed various "isms" in the art world. Yet, she perceived, taught, and produced art on her own terms. Her art is a reflection of the humanist values that she espoused. Throughout her extensive travels in the United States, Europe, and Africa, Jones demonstrated in her art an affinity with the poor and the downtrodden, and used her paintings to highlight those edifying aspects of a people's culture. A painter, watercolorist, and textile designer, Jones's work demonstrates grit, superb draftsmanship, and mastery of media that came from her exposure to a variety of techniques and an innate ability to absorb, synthesize, and individualize. At the age of 17, Jones had her first solo exhibition on Martha's Vineyard. This would be a precursor to major events that would follow. From 1923 to 1927, she studied at the School of the Museum of Fine Arts in Boston with a major in design. She combined her studies at the School of the Museum of Fine Arts with evening studies at the Boston Normal Art School, which later metamorphosed into the Massachusetts College of Art. In 1927, she graduated from the School of the Museum of Fine Arts, Boston and earned a certificate from the Boston Normal Art School. With this, she launched her career as an independent textile designer and recorded success designing for the F.A. Foster Company and also for Schumacher's of New York. But, she soon realized, it was not the best way for an artist who was intent on making a name for herself; she would have to devise ways of avoiding being consigned to the anonymous precinct of fabric designers whose designs are often associated to the company or organization that handles the mass production and marketing.

In 1928, Jones began her career as art teacher at the Palmer Memorial Institute, a junior college in Sedalia, North Carolina. In 1930, she was recruited to join the faculty at Howard University in Washington, DC, by James Vernon Herring, founding chairperson of the institution's Department of Art. For the next 47 years until her retirement in May 1977, Jones taught at Howard University and contributed substantially to giving credence to the aspirations of generations of art students, and establishing a legacy as a profound artist who used her art to inspire, enlighten, and document. From 1937 to 1938, Jones studied at the Académie Julian in Paris on a General Education Board fellowship. There, she came under the influence of Pierre Montezin, Jules Adler, G. Maury, and Joseph Bergès and entered a prolific period of her professional career. The influence of her stay in Paris can be seen in the numerous paintings that she did, including *Le Petit Déjeuner, Paris* (1937); *Le Moulin De Fretin, Pas-de-Calais, France* (1938); and *Jardin de Cluny, Paris,* (1938); all of which are suffused with the familiar painterly abandon that characterized the open-air approach that impressionists had successfully established earlier. Some of the paintings that Jones did at this time recall Paul Cezanne in their cubist flavor, albeit in a soft and somewhat romantic tempo. In *Le Modèl, Paris* (1938), Jones adopts a limited palette in modeling a male model sitting on a stool. In this piece, Jones is more concerned with the gestalt appeal than with details. In applying broad swaths of paint to construct a three-dimensional figure on canvas, Jones approximates some of the basic intuitions of cubism. Jones's

one-year sojourn in Paris was a productive year during which she produced more than 40 paintings.

Her painting *Les Fetiches* (1938) is significant in that it reveals the crossroads that Jones straddled at this time in her career. The painting recalls the dilemma that was spawned by the Western world, which attempted to proclaim its acknowledgment of the legitimacy of African art but continued to deny authorship to individual artists at the same time that it persisted in applying pejorative labels to objects and pieces from Africa. It is important to note that the title *Les Fetiches,* was a reflection of the prevalent mode of typifying objects from Africa during this period. Jones's painting, which is a composite of masks that include a Kifwebe mask of the Songye people in the Federal Democratic Republic of Congo on the lower left, and a dominant face mask that recalls the kpelie mask of the Senufo people in Cote D'Ivoire, approximates the spirit of the times. It was a time when many African Americans, spurred by Alain Locke's passionate advocacy, began to look to Africa as a source of creative replenishment. Jones's abiding interest in Africa was amply rewarded when, in 1970, she traveled to 11 West and Central African countries, including Nigeria, Cote D'Ivoire, FDR Congo, and Ghana.

In 1953, Jones married Louis Vergniaud Pierre-Noël, a Haitian designer whom she had met two decades earlier at Columbia University where Jones had taken some summer courses. In the words of Benjamin (1994, 77), "Jones's marriage to Pierre-Noël transformed both her life and her art. From the summer of 1954 through 1969, annual trips to her husband's homeland, Haiti, expanded her vision and experience." With her marriage to Pierre-Noël, Jones added Haiti to France as countries that she would visit intermittently, drawing and painting each time she visited. Her painting style oscillated between a Postimpressionist palette, in which colors were freely applied, and a calm, meditated, and simplified approach in which figures and objects are carefully delineated through the use of sharp angularities and silhouetted fields of design. She favored this latter approach in many of the paintings of scenes, landscapes, market sites, and people in Haiti that she painted. Falling within this category are *Market, Haiti* (1960); *Les Vendeuses de Tissus* (1961); *Street Vendors, Haiti* (1978); and *The Water Carriers, Haiti* (1985). Her 1970 trip to several African countries resulted in some of the most spectacular post-African tour paintings that Jones did. In *Dahomey* (1971), Jones reveals her knack for simple but effective design as she appropriates some of the cultural icons from the classical designs of the people of the Republic of Benin. Perhaps the most elegant summation of her African tour is her 1979 *Sudanesia*, in which the kanaga masks of the Dogon peoples of Mali are reduced to geometric fields of design dominated by primary and neutral colors.

From her first exhibition at Martha's Vineyard in 1923, and for the rest of her professional life, Jones continued to work and exhibit. Soon after her appointment at Howard University in 1930, Jones began her quest for professional recognition by taking part in the 1930 Harmon Foundation exhibition at which she received an honorary mention. She would go on to have numerous solo exhibitions in major venues across the country. She would also have solo and group exhibitions at international venues in France, Brazil, Japan, Haiti, and

Hong Kong, among others. In the course of her career, Jones received numerous awards and honors for her landscape and watercolor paintings. In 1954, she received the Diplôme et Décoration de l'Ordre National "Honneur et Mérite au Grade de Chevalier" from the Haitian government and in 1980, she was one of ten African American artists who were honored in a ceremony at the White House by President Jimmy Carter for their outstanding achievement in the arts. She was a recipient of honorary degrees from Massachusetts College of Art, Boston, Howard University, Colorado State Christian University, and Suffolk University, Boston.

Loïs Mailou Jones died on June 9, 1998. Among her notable students are **Elizabeth Catlett** and **David Clyde Driskell**, who, in a 1998 tribute to Jones, wrote: "Although she considered herself first and foremost an American artist, she understood and graciously accepted the role affectionately bestowed upon her as 'Queen Mother' of African-American art."

Places to See Jones's Work

Hirshhorn Museum and Sculpture Garden, Washington, DC
Howard University Art Collection, Washington, DC
Metropolitan Museum of Art, New York, NY
Museum of Fine Arts, Boston, MA
Museum of the National Center of Afro American Artists, Boston, MA
National Museum of American Art, Washington, DC
National Museum of Women in the Arts, Washington, DC
National Palace, Port-au-Prince, Haiti
National Portrait Gallery, Washington, DC
Phillips Collection, Washington, DC
University Art Museum, Albany, NY

Bibliography

Adamson, Lynda G. *Notable Women in American History: A Guide to Recommended Biographies and Autobiographies.* Westport, CT: Greenwood Press, 1999.
Bearden, Romare, and Harry Henderson. *A History of African-American Artists from 1792 to the Present.* New York: Pantheon Books, 1993.
Benjamin, Tritobia Hayes. *The Life and Art of Loïs Mailou Jones.* San Francisco: Pomegranate Artbooks, 1994.
———. "A Passionate Life in Art." *International Review of African American Art* 15, no. 2 (1998): 39–42.
Driskell, David C. "Loïs Mailou Jones (1905–1998)." *American Art* 12, no. 3 (Autumn 1998): 86–88.
Gaither, E. B. "Introduction." In *Reflective Moments.* Boston, MA: Museum of Fine Arts, 1973.
Henkes, Robert. *The Art of Black American Women: Works of Twenty-Four Artists of the Twentieth Century.* Jefferson, NC: McFarland, 1993.
Hills, Patricia. *Syncopated Rhythms: 20th-Century African American Art from George and Joyce Wein Collection.* Boston, MA: Boston University Art Gallery, 2005.

Martin, Elizabeth. *Female Gazes: Seventy-Five Women Artists.* Toronto: Second Story Press, 1997.

Perry, Regenia. *Free within Ourselves: African-American Artists in the Collection of the National Museum of American Art.* Washington, DC: National Museum of American Art, Smithsonian Institution in association with Pomegranate Books, San Francisco, 1992.

Schmidt-Campbell, M., D. C. Driskell, and D. W. Ryan. *Harlem Renaissance: Art of Black America.* New York: Studio Museum and Harry N. Abrams, 1987.

K

Wosene Worke Kosrof (b. 1950), Painter.

Kosrof's paintings, which are often fields of abstract configurations painted in acrylic on linen, evoke dazzling, bejeweled agglomeration of signs and symbols. There is probably little profit in trying to decipher their meanings, since they are not meant to be accessed literally. Since the 1980s, when he decided to focus on the exploration of the visual energy and aesthetic beauty of Amharic, one of Ethiopia's major modern languages, Wosene Kosrof has developed a personal repertoire of alphabets, symbols, and inscriptions that are the visual equivalents of jazz music and poetic chants. Amharic, one of Africa's written systems, was derived from Ge'ez, the ancient Ethiopian language into which the Bible was translated around the fourth century AD, and which is today the ceremonial language of the Ethiopian Church. Its use, which Kosrof has continued to develop, complements the Ethiopian concept of "wax and gold," with wax symbolizing the figurative manifestation of a fugitive concept, which is gold. Breaking up the Amharic ideograms into a complex jumble of multi-nuanced palettes dominated by green, orange, black, and white hues is Kosrof's major preoccupation. For him, the Amharic is more than a compendium of alphabets; it is alive, animate, and cooperative. For Kosrof, the Amharic encompasses the real and the imaginary; it encapsulates cultural and intellectual ethos and validates his own status as an immigrant whose sojourn in the United States has enabled him to discover the essence of his own wax and gold: his heritage.

Kosrof was born in 1950 in the Addis Ababa district of Arat Kilo, a center for traditional art movement and a thriving commune for many of Ethiopia's poets, artisans, costume makers, and traditional musicians. He was raised by a single mother, Worke Woldegebrael. Woldegebrael, who very much desired that Kosrof would become a medical doctor. In Ethiopia, being an artist was considered a calling with substantial amount of spiritual power but with little assurances for economic self-sufficiency, something that Kosrof's mother did not particularly favor. While artisanship and general craftsmanship was a traditional trade, Woldegebrael desired more than a routine pastime for her son. For a single mother who very much wanted her son to succeed, art was not considered as something serious. In this regard, Woldegebrael's perception reflected the societal reaction in Ethiopia to Western education, which placed the arts on a relatively low social rung.

Wosene Worke Kosrof, *Inside the Museum of African Art,* 1990 (acrylic on canvas). © Indianapolis Museum of Art, USA, James E. Roberts Fund/The Bridgeman Art Library.

Kosrof attended the Haile Selassie First Day School in Addis Ababa. At the completion of high school, his brother, Mulatu Kosrof, who recognized the young Kosrof's talent in drawing and painting, encouraged him to apply to the School of Fine Arts in Addis Ababa. In 1967, he entered the School of Fine Arts in Addis Ababa and graduated in 1972 with specialization in painting. Established in 1957, the School of Fine Arts ranks as one of the continent's foremost institutions where students were exposed to art-making methodologies fashioned after Western models. The institution was brimming with some of the best contemporary artists in the country who had studied abroad and returned home to initiate a new tradition of modernism: Tadesse Gizaw, Abdurahman Sherif, and Bisrat Bekele. Two of the most influential of the faculty at the Addis Ababa School of Fine Arts were Gebre Kristos Desta (1932–81) and **Skunder Boghossian** (1937–2003). Desta, an abstract expressionist and poet who studied art in Cologne, Germany from 1957 to 1961 before he joined the faculty in Addis Ababa in 1963 was Kosrof's advisor and mentor. Boghossian, who was also on the faculty at Addis Ababa when Kosrof began his studies in 1967, had studied and taught in Paris for nearly a decade before returning to Ethiopia in 1966. In 1972, Boghossian left for Howard University in the United States, where Kosrof would again meet him.

Kosrof's earliest exposure to calligraphy started during his Addis Ababa years when he began to study "lettering" with Yegezu Bisrat. This was when he also began to focus on incorporating Ethiopian religious icons into his work. Political developments in Ethiopia in the early seventies necessitated the artist's decision to go into voluntary exile. In 1974, Haile Selassie, who had ruled Ethiopia as an imperial monarch since 1930, was toppled in a bloody military coup d'état. His successor, Mengistu Haile Mariam, unleashed a reign of terror on those he perceived as counter-revolutionaries. This was the atmosphere that led to the departure of a many members of the intelligentsia in Ethiopia. After traveling through some African countries—Kenya, Ghana, Nigeria, and Senegal—Kosrof arrived in the United States in 1978 and settled within a large population of Ethiopian exiles in Washington, DC. That same year, he enrolled at Howard University for the M.F.A. in painting as Ford Foundation Talent Scholar.

At Howard, Kosrof studied with the legendary **Loïs Mailou Jones** and received professional advice and direction from his mentor, **Jeff Donaldson**. Although Kosrof had succumbed to the mesmerizing allure of Duke Ellington's music the first time he heard it in Ethiopia in 1973, he had to live the experience to fully grasp and appreciate African American culture, and to become contemplative of the impact of African culture in his work. At Howard, he was exposed to a cream of African American artists, including

Ed Love, James Phillip, and **Charles Wilbert White**. But it was Donaldson who insisted that Kosrof needed to dig deep into his own Ethiopian heritage to find meaning and character in his art. Donaldson told Kosrof to "go home," which stunned and confused Kosrof, since he had just left Ethiopia for Washington, DC. But Donaldson's admonition was meant not to be taken literally, but rather to be taken metaphorically; Kosrof must learn to dig into his own cultural heritage in order to evolve a personal aesthetic. In this, Donaldson, who was familiar with the immense potentials that Ethiopian culture could offer, urged Kosrof to deemphasize his preoccupation with biblical subjects—Virgin Mary, the saints, and all other ecclesiastical matter: "Donaldson urged Wosene to abandon the traditional scrolls that portrayed the saints. 'Don't worry about the saints, just leave them alone. . . . Just think about the writing . . . explore what the writing does,' Donaldson advised" (Johnson 2005). This was the origin of Kosrof's exploration of Amharic calligraphy.

Kennedy (1992, 125) has observed that the use of calligraphic shapes, a fascination with religious mysticism, and the incorporation of Coptic symbols are some of the distinctive characteristics of the works of many Ethiopian artists. Kennedy goes further to suggest that some of these tendencies are also present in the work of some Sudanese artists. In Ethiopia, where the Coptic religion once held sway and Emperor Haile Selassie claimed to be a direct descendant of the queen of Sheba and King Solomon, the Amharic language becomes one of the agencies through which Kosrof leverages his connection with "home."

Places to See Kosrof's Work

Birmingham Museum of Art, Birmingham, AL
City Museum of Addis Ababa, Ethiopia
Fowler Museum, UCLA, Los Angeles, CA
Indianapolis Museum of Art, Indianapolis, IN
National Museum of African Art, Smithsonian Institution, Washington, DC
National Museum of Art, Addis Ababa, Ethiopia
Neuberger Museum of Art, Purchase, NY
Newark Museum, Newark, NJ
Samuel P. Harn Museum, University of Florida, Gainesville, FL
Völkerkunde Museum, Zürich, Switzerland

Bibliography

Deliss, Clémentine. "Returning the Curve: Africa 95, Teng, and 'Seven Stories.'" *African Arts* 29, no. 3; special issue, africa 95 (Summer 1996): 37–96.
Hardin, Kris. "Inaugural Exhibitions: National Museum of African Art." *African Arts* 21, no. 3 (May 1987): 72–73.
Hassan, Salah, and Achamyeleh Debela. "Addis Ababa Connections: The Making of the Modern Ethiopian Art Movement." In *Seven Stories about Modern Art in Africa*, edited by Clementine Deliss, 127–249. New York: Flammarion, 1996.
Herney, Elizabeth, ed. *Ethiopian Passages: Contemporary Art from the Diaspora*. Washington, DC: National Museum of African Art, Smithsonian Institution, 2003.

Johnson, Eloise. "Wosene Worke Kosrof: The Color of Words." New Orleans, LA: Stella Jones Gallery, 2005. An exhibition brochure.

Kennedy, Jean. "Wosene Kosrof of Ethiopia." *African Arts* 20, no. 3 (May 1987): 64–89.

———. *New Currents, Ancient Rivers: Contemporary African Artists in a Generation of Change.* Washington, DC: Smithsonian Institution Press, 1992.

Kreamder, Christine Mullen. "Graffiti Magic: Wosene Kosrof." *African Arts* 21, no. 3 (May 1988): 73–75.

Mann, Griffith C. *Art of Ethiopia.* London: Sam Fogg, 2005.

Owerka, Carolyn. "Contemporary African Art." *African Arts* 18, no. 2 (February 1985): 78.

Stanley, Janet. "Three Contemporary Ethiopians." *African Arts* 26, no. 1 (January 1993): 76–77.

Warburg Institute. *Proceedings of the First International Conference on the History of Ethiopian Art.* London: The Warburg Institute of the University of London, October 21–22, 1986.

Marcia Kure (b. 1970), Painter; Performance Artist.

There is an unmistakable poetic elegance in the work of Marcia Kure. Whether it is rendered in graphite, acrylic, oil, or mixed media, Kure's work is a distillation of a frugal but haunting aesthetic that strips her subject of all extraneousness, allowing the viewer to scrutinize the irreducible work. Kure's work emanates from a well-digested aesthetic, one that packs into every piece of work, experiences that emanate from her education and from a cultural background that is more totalizing than average even in Nigeria, her home country, where people are minimally bilingual and exposure to multiple cultures is a given.

Marcia Wok Kure's education was atypical. Her father, General Y. Y. Kure, was a member of the military junta that ruled Nigeria in the 1980s and the 1990s. His job as a soldier required that the family be constantly on the move, spending an average of two and a half years in each station. Consequently, Kure spent her early years moving from one major Nigerian city to another—Benin, Jos, Ibadan, Port Harcourt, Enugu, and Kano among others. In the process, the artist acquired a panoramic view of the cultural mosaic that gives Nigeria its national texture. The second of five children—three girls and two boys—Kure was born on July 22, 1970, in the ancient city of Kano, a major center for Islamic learning. Her family's ancestral home is in Kurmin Musa, in Southern Zaria of Kaduna State. Her people, the Jama'a, are non-Muslims in a state that is predominantly Islamic. Kure acknowledges the tension that her place of birth and her family's religious orientation engendered: "In Nigeria, where religious affiliation means everything, we belong to the Christian minorities in the North, yet the rest of Nigeria lumps us together with the Islamic Hausa perhaps because the lingua franca for all of Northern Nigeria is Hausa" (Aas 1998).

Her late mother, Ladidi Mary Kure was a strong-willed independent thinker, a connoisseur with a taste for fashion and still-life paintings, and one who

shaped the aesthetic taste of Kure. Mary earned two degrees—a B.S. in education and a master's degree in guidance and counseling. Strict and pragmatic, the artist's father was a cabinet member in the Babangida military administration until he retired to his village in the 1990s to begin life as a missionary with a quest for ministering young adult males. Y. Y. Kure is a lover of nature and photographer who encourages his children to cultivate the habit of documenting passages in their lives. Kure draws inspiration from her mother's assertiveness and adores her father's personality and zest for life.

From 1982 to 1987, she attended the Command Secondary School in Jos, the same year that she gained admission to the University of Nigeria, Nsukka, with the intent of majoring in nutrition and dietetics. Not particularly satisfied with her major, she strayed into art and would have probably graduated in biology but for the intervention of one of her professors, **Obiora Udechukwu**, who encouraged her to cultivate excellence in whatever she was involved in. Kure graduated from the University of Nigeria in 1994 with a B.A. in painting. In 1995, after serving in the National Youth Service Corps, she went to Germany. There, she began developing a form that would become her creative hallmark: the emaciated, primordial cave personality. This was the first indication that Kure's creative scope is global. Over the years, Kure's cave figures have gained weight and acquired more accoutrements just as Kure has moved them into new environments and morphed them into all manner of forms ranging from vegetal anthropomorphic vaginas to fully militarized Hitlerian figures. In 1996, she enrolled at the University of Nigeria, Nsukka, for her M.F.A. degree in painting. She transferred to Ahmadu Bello University, Zaria in 1999, before she moved to the United States for residency.

Kure's art is steeped in a doctrinal belief that is antipathetic to all forms of hegemonic practice. In 2000, she staged a performance at the Goethe Institute in Lagos, Nigeria. She had seven women dress in burqua, which is the veil worn by women as part of Islamic culture. As the audience sat in expectation of a performance, the women in burqua strolled in, mingled with the audience, and engaged them: the performance had started unbeknownst to the audience. This interaction among the veiled and the spectator was meant to challenge common assumptions about women, identity, and religious preferences. The performance was Kure's way of drawing attention to the imperturbable air that enveloped Lagos even as parts of the Islamic north were under tremendous siege as a result of religious riots that characterized life in that part of Nigeria. Kure had lost an uncle to one of the religious riots in Zaria as Christians were attacked and slaughtered by Islamic militants. Her Lagos performance ended with each of those wearing the burqua unveiling herself, often to the consternation of the audience who realized that

Marcia Wok Kure. Courtesy of Chika Okeke-Agulu.

by preventing eye contact, the burqua had prejudiced their opinion of its wearer.

Perhaps more than other artists of her generation, Kure has been eclectic in terms of the sources that she draws upon for her creative work. She is a student of African history and references Nkrumah's political ideology of "sankofa," which pertains to the recuperation of those cultural ideals that appear threatened by the colonial encounter. In embracing and fashioning this ideology into an artistic credo, Kure drew on multiple sources: her exposure to multiple cultural experiences while growing up; her interaction with scholars and artists of the uli school at the University of Nigeria in Nsukka; her disenchantment with the religious and political disenfranchisement of African women; and the disturbing power relations between the West and the African continent. Kure's work employs a variegated panoply of icons and concepts, including adinkra and kente designs of the Akan in Ghana, nsibidi alphabets of the Efik in Nigeria, uli designs of the Igbo of Nigeria, and the emaciated cave icons that have become stylistic signifiers for Kure. Her interest in global issues is complemented by her sensitivity to personal tragedies or social upheavals: "The stick-like frame of the figures of rock art in my work represents man as he was before he became an inventor, and afterwards as well. It does, in a way, suggest contemporary humanity starved of all its conscience and emotions; [they recall] images from Biafra, Somalia and Nazi Germany" (Aas 1998, 22).

When her mother died in 1997, Kure poured her grief onto a 5' × 4' triptych titled *Mother,* in which she envelops the canvases in a fugitive color fields of grids that recall African woven textiles onto which pockets of cave figures are stitched. The triptych was the ultimate memorial to an admired mother. Kure explains the emotional outpour: "I remembered her as a strong woman. I imagined her in her last and dying moments, a frail flower . . . a strong baobab. In the triptych, *Mother,* I could see her spirit dissolving in the air, in the earth; her spirit fluttering like a little twig in the whirlwind, moving, leaving (jegede 2000, 22).

Kure has had a number of residencies: at the University of South Florida in 1997; at Iwalewa House in Bayreuth, Germany, in 1998, and in Atlanta in 1999. That year, she was involved in a joint execution of a mural that was commissioned by the City of Langenhagen in Germany. Since 2000, she has resided in the United States, and has had a thriving career as a practicing artist. Married to Chika Okeke-Agulu, an art historian and artist, she combines motherhood with full-time professional practice. In 2001, she was commissioned by three UN agencies—UNCBD, UNFCCC, and UNCCD—to create a calendar. She has participated in numerous group exhibitions nationally and internationally and had solo exhibitions in Nigeria, Germany, the Netherlands, and the United States.

Places to See Kure's Work

Gallery Art Korner, The Hague, the Netherlands
Lisa-Dent Gallery, San Francisco, CA
Newark Museum, Newark, NJ

Bibliography

Aas, Norbert, ed. *Iwalewa Forum 1/98: Working Papers in African Art and Culture.* Bayreuth: Iwalewa Haus, Universitat Bayreuth, 1998.

Adams, Sarah. "Marcia Kure." *Nka: Journal of Contemporary African Art* (New York) 18 (2003): 80–83.

jegede, dele. *Women to Women: Weaving Cultures, Shaping History.* Terre Haute: University Art Gallery, Indiana State University, 2000.

Ogbechie, Sylvester. "Zaria Art Society and the Uli Movement, Nigeria." In *An Anthology of African Art: The Twentieth Century,* edited by N'Gone Fall and Jean Loup Pivin, 249. New York: DAP/Distributed Art Publishers, 2002.

Oguibe, Olu. "Beyond Visual Pleasures: A Brief Reflection on the Work of Contemporary African Women Artists." In *Gendered Visions: The Art of Contemporary African Women Artists,* edited by Salah Hassan, 63–72. Trenton, NJ: Africa World Press, 1997.

Okeke, Chika. "Black President: The Art and Legacy of Fela Anikulapo-Kuti." *Nka: Journal of Contemporary African Art* 19 (Spring 2004): 90.

Onuzulike, Ozioma. "Marcia Kure: Not Just a Cloth." *Nka: Journal of Contemporary African Art* (New York) 15 (2001): 85.

L

Jacob Lawrence (1917–2000), Painter.

The life, work, and times of Jacob Lawrence are a testimony to the heroic determination of a man who pursued his passion with tenacity and unparalleled gusto, and who prevailed mightily in the end. Growing up during the Great Depression in a country with what is now generally acknowledged as a shameful history of racist and discriminatory practices, and an art establishment that regarded works by African American artists with contempt and condescension, Jacob Lawrence used his art as an instrument of enlightenment, one that told the story of Africa America and the Black Diaspora with uncanny elegance and consummate skill. Jacob Lawrence was born in Atlantic City, New Jersey, on September 7, 1917, to Jacob Armstead Lawrence, from South Carolina, and Rose Lee Lawrence, who was from Virginia.

During World War I, both Lawrence the elder and Rose Lee had joined thousands of African Americans who were migrating north in search of better conditions of living. The senior Lawrence moved with his wife to Easton, Pennsylvania, where they had two more children, Geraldine and William. Lawrence the senior worked irregular hours as chef on the railroad car while his wife worked as a domestic staffer. The times were hard, and both parents soon went their respective ways. Around 1930, Rose Lee moved to New York with her three children, and went on welfare. The pressure of working all day to fend for the family led to the children being sent to an after-school place. Lawrence was at first assigned to a graduate student from Columbia University, Charles Alston, who operated from the basement of the 135th Street branch of the public library. Later, when Alston moved to the Utopia Children's Settlement house in Harlem, Lawrence moved with him. There, Lawrence was exposed to a variety of arts and crafts ideas. In addition to learning to do leather and woodwork, he became involved with painting and developed a passion for color, which would become one of the hallmarks of his creative presence. Lawrence would later explain that he had no idea that this early encounter with the creative world was art: "It was something I just liked to do. . . . I never even thought of being a professional artist at that time. I didn't even know what it was about. . . . But it was beyond my experience. I never saw an art gallery until I was about eighteen years of age. . . . So my experience was almost like something I liked to do. I liked to color. And this was it"

(Greene 1968). Under the watchful and sympathetic guidance of Alston, Lawrence developed his skills as a colorist and gained appreciable mastery of composition and pattern making.

The career of Lawrence was shaped by situations and circumstances that were beyond his grasp or understanding. He was born during World War I and in the full course of the Great Migration, a child of the Harlem Renaissance who was barely a teenager when the Depression occurred. Yet, each of these major events had an impact, directly or obliquely, on Lawrence and contributed to his emergence as an American painter of consequence. The Great Migration, one of the themes on which Lawrence would later focus his creative energy, began in 1916 and continued through 1918. Spurred by a combination of economic, social, and political factors, the Great Migration actuated one of the greatest population shifts involving African Americans, who moved in the thousands from the rural South to the industrial North. The impact of World War I, which stemmed the inflow of European emigrants, combined with the involvement of the United States in the war in 1917 to exacerbate the shortage of labor, which was by then already acute.

For Lawrence and his family, the Depression of 1929 made a tough life even grimmer. But events would later show Lawrence as a beneficiary of one of the agencies that were created as part of the recovery strategies that President Franklin D. Roosevelt put in place to alleviate the devastating impact of the Great Depression. The Works Progress Administration, which was established in 1935, followed the short-lived Public Works of Art Project, which recognized only a handful of African American artists, including **Aaron Douglas** and **Palmer C. Hayden**, in a list of 3,500 artists. It is inconceivable, as Bearden and Henderson (1993, 293) have pointed out, to fully fathom the Depression without reference to the socially relevant work of Jacob Lawrence. By the time he started high school, Lawrence had become so thoroughly engrossed in the art-making process that opting out of high school, which he did after only two years, was perhaps the most plausible option, given the prevailing social upheaval at that time and the tenuousness of the his family's economic condition. A direct consequence of this decision was that Lawrence, with no formal qualification, became a casual employee with no fixed employment. The only steady recourse that he had was to art. In due course, Alston introduced Lawrence to Augusta Savage to take free art classes at the Harlem Community Art Center at 125th Street and Lenox Avenue in New York.·

With exposure to an influential company of African American artists, writers, and other critical minds in the black community in Alston's apartment at 306 143rd Street, New York, and at other forums, Lawrence developed interest in the history and accomplishments of black people. He was particularly enchanted by the passion for, and knowledge of, black history that Charles Seifert demonstrated. Although fondly called "Professor," Seifert was a successful New York contractor who was born in Barbados and developed a prodigious interest in African history, which he shared with audiences during his annual lecture series. As Lawrence plunged into reading, he became fascinated by the riveting heroics of Toussaint Louverture, the Haitian revolutionary who, through his exploits against slavery and military

maneuvers in the late eighteenth and early nineteenth centuries, established himself as a leader of incomparable status.

Alston contributed to the nurturing of Lawrence as a young man and gave him all the encouragement that he needed because he saw in Lawrence a special talent waiting to be fertilized, not taught. Early in his creative life, Lawrence developed and settled on a stylistic form that favored the application of flat colors and the adoption of a narrative approach. He has held tenaciously to this style regardless of the numerous shifts and fads that the art arena has endured over the years. In successfully withstanding these waves and sticking to his own unique style, Lawrence's lack of formal art education may have been a factor. Although he briefly attended the American Artists School with the aid of a scholarship that Alston helped attract, Lawrence did not stay there for long; the economic pulls on him were too strong to permit the devotion that was called for.

While Alston successfully mentored the young Lawrence, Augusta Savage gave him the support and guidance that would eventuate in the artist's creative growth and professional maturation. It was through Savage's auspices that Lawrence enrolled in the WPA as an artist. This provided a major financial comfort and allowed him to fully devote himself to making art. His engagement on the WPA came with supply of art materials and a steady weekly stipend of about $26. Although Lawrence was with the WPA for only 18 months, it was long enough for him to make an impact on the cultural establishment: his suite of 41 pictorial narratives on Toussaint Louverture brought him critical recognition when they were exhibited at the Baltimore Museum of Art in 1939. This exhibition launched his career and earned him three Julius Rosenwald Fund fellowships. He continued with other series by focusing intently on significant epochs in American history through other series: "Frederick Douglas," "Harriet Tubman," and "John Brown."

With the freedom to paint came opportunities to interact with other artists and become exposed to discussions on social and cultural issues affecting the African American populace, which were a constant feature at the meetings that were held in Alston's 306 apartment. Lawrence mingled with a group of artists, writers, and others, including the sculptor, Henry "Mike" Bannarn, **Romare Bearden,** Ronald Joseph, **Aaron Douglas**, Ralph Ellison, Langston Hughes, and Claude McKay. During this time, Lawrence met another artist, a young lady who was also involved in the Harlem art scene: Gwendolyn Knight. Born in Barbados, she migrated to the United States with her parents and studied art for one year at Howard University before leaving. Gwendolyn Knight and Lawrence were married in 1941, which turned out to be an auspicious year. It coincided with Lawrence's second Rosenwald award, which called for him to go to New Orleans, which he had chosen as a study site for his next creative project. While in New Orleans, Edith Halpert requested to be his agent. Although Lawrence admitted that he was too naïve at that time to recognize the significance of being represented by such a major dealer, it was a professional relationship that launched Lawrence to national limelight. Through Halpert's Downtown Gallery, the Migration series, which consisted of 60 pieces, were jointly purchased by the Phillips Memorial Gallery in

Washington, DC, and the Museum of Modern Art. The former had the odd numbers while the latter had the even. But 1941 was also the year that the Japanese bombed Pearl Harbor, an act that forced the United States into World War II. In 1943, Lawrence joined the U.S. Coast Guard.

Lawrence favored thematic paintings using a variety of water-based media—acrylic, egg tempera, gouache, and casein—on paper. His aversion for oil stemmed from his early exposure to art, when he developed a preference for working in two-dimensional media with poster color as the preferred medium. Just as he never veered from the narrative approach to art that he developed early, Lawrence simply did not see the need to experiment with other media or stray far from the two-dimensional form. His interest in the history and accomplishments of blacks, which he began exploring with his series on Toussaint Louverture, continued through the Migration series and carried through his entire oeuvre. His understanding of the significance of history informed his penchant for working in series; he believed that there was so much to say visually that could not be contained within one panel. Most of his series run into tens of panels. For example, the Toussaint Louverture suite (1938) was comprised of 41 panels, while the Harlem series (1942–43) consisted of 30. While most of his series focused on the history and social life of blacks, his *Struggle: From the History of the American People,* which he did between 1955 and 1956, was made up of 30 panels. Most of his panels are quite small and average about 24" × 15". A characteristic of these bodies of work is numbering. Each painting is given a caption, which is sometimes explicatory or descriptive, while each body of work is serially numbered.

In 1945, Lawrence left the Coast Guard, where he had served as a steward's mate in a segregated military. His postwar experience was marked by a nervous breakdown, for which he voluntarily checked himself into Hillside psychiatric hospital in New York for a successful treatment in 1949. Characteristically, Lawrence turned his 10-month hospitalization into a visual record in his "Hospital" series. In 1946, Lawrence received a Guggenheim Fellowship that enabled him to work on the War series, which is now at the Whitney Museum. Shortly thereafter, he was invited by Josef Albers to teach at Black Mountain College in North Carolina. This was the beginning of a teaching career that saw Lawrence teach in such institutions as the Skowhegan School of Sculpture and Painting in Maine, Pratt Institute in Brooklyn, Brandeis University in Massachusetts, New School for Social Research in New York, and California State College at Hayward. In 1971, he accepted an offer of full professorship at the University of Washington in Seattle, a position that he held until he retired in 1983. Lawrence traveled to Nigeria on two occasions: in 1962, and 1964 for eight months. His experience there led to the "Nigeria" series, eight panels in which he showed his fascination with the quotidian life in Africa's most populous nation.

After his retirement, Lawrence continued to create art, including his series on "Theatre," (1984–85); "Community," (1989); and "New York in Transit," his last public work, an enormous mosaic mural which he designed in 1997 but was installed in 2001 at the Times Square–42nd Street subway station in New York. Beginning in 1941 when, at 24, his work entered major national

collections, Lawrence earned national accolades and international recognition in more ways than most American artists. In addition to being collected by most museums with numerous national and international exhibitions, Lawrence also won the respect and recognition of distinguished national organizations and august professional establishments. These include the National Institute of Arts and Letters, which conferred him with its national award in 1953; the National Academy of Design, which made him a member in 1977; and the American Academy of Arts and Letters, which honored him in 1983 with membership. Among the 20 honorary doctorates that he received were those from Harvard in 1995 and Yale in 1986. Jacob Lawrence died in Seattle, Washington, on June 9, 2000.

Places to See Lawrence's Work

Art Institute of Chicago, Chicago, IL
Brooklyn Museum, Brooklyn, NY
Cleveland Museum of Art, Cleveland, OH
Dallas Museum of Art, Dallas, TX
Fine Arts Museum of San Francisco, San Francisco, CA
Harvard University Museums, Cambridge, MA
High Museum of Art, Atlanta, GA
Hirshhorn Museum and Sculpture Garden, Washington, DC
Howard University Art Collection, Washington, DC
Indianapolis Museum of Art, Indianapolis, IN
Metropolitan Museum of Art, New York, NY
Museum of Fine Arts, Boston, MA
Museum of Modern Art, New York, NY
National Gallery of Art, Washington, DC
North Carolina Museum of Art, Raleigh, NC
Philadelphia Museum, Philadelphia, PA
Smithsonian American Art Museum, Washington, DC
Whitney Museum of American Art, New York, NY

Bibliography

Babcock, Grover. *Jacob Lawrence: An Intimate Portrait.* Video recording. Chicago, IL: Public Media Home Vision, 1993.

Bearden, Romare, and Harry Henderson. *A History of African American Artists from 1792 to the Present.* New York: Pantheon Books, 1993.

Brown, Milton Wolf. *Jacob Lawrence.* New York: Whitney Museum of American Art, 1974.

Carroll, Valinda. "Samella Lewis' Catlett Collection at the Hampton University Museum." *International Review of African American Art* 21, no. 1 (2006): 59–61.

Driskell, David C. *Two Centuries of Black American Art.* Los Angeles, CA: Los Angeles County Museum of Art, 1976.

Duggleby, John. *Story Painter: The Life of Jacob Lawrence.* San Francisco, CA: Chronicle Books, 1998.

Greene, Carroll. "Oral History Interview with Jacob Lawrence, October 26, 1968." Smithsonian Archive of American Art. http://www.aaa.si.edu/collections/oralhistories/transcripts/lawren68.htm.

Hills, Patricia. *Syncopated Rhythms: 20th-Century African American Art from the George and Joyce Wein Collection.* Boston, MA: Boston Art Gallery; Seattle: Distributed by University of Washington Press, 2005.

Irwing, David. *Jacob Lawrence: The Glory of Expression.* Chappaqua, NY: L&S Video Enterprises, 1998.

Lewis, Samella. *African-American Art and Artists.* Berkeley: University of California Press, 1994.

Nesbett, Peter T. *Jacob Lawrence: Paintings, Drawings, and Murals (1935–1999): A Cataloge Raisonné.* Seattle: University of Washington Press in association with Jacob Lawrence Catalogue Raisonné Project, 2000.

Perry, Regenia. *Free within Ourselves: African-American Artists in the Collection of the National Museum of American Art.* Washington, DC: National Museum of American Art, Smithsonian Institution in association with Pomegranate Artbooks, San Francisco, 1992.

Powell, Richard. *Jacob Lawrence.* New York: Rizzoli, 1992.

Turner, Elizabeth Hutton, ed. *Jacob Lawrence: The Migration Series.* Washington, DC: Rappahannock Press, 1993.

Wheat, Ellen Harkins. *Jacob Lawrence, American Painter.* Seattle: University of Washington Press in association with the Seattle Art Museum, 1986.

Norman Lewis (1909–1979), Painter.

In the throes of the Great Depression, Norman Lewis, then working in a figurative style, did some pieces that were as typical as they were predictable. They typified the social malaise and economic doldrums that the nation was experiencing—conditions that Dorothea Lange summarily captured for posterity in photography, with her *Migrant Mother* of 1936. Lewis's figurative work of that period was predictable in the sense that, for black artists who believed that theirs was a state of permanent economic depression, the social imperative was that art should be used as a mechanism for conveying the prevailing mood of social class in a visual language that everybody could understand and relate to. In essence, this meant the privileging of realism or figurative art as a style amongst the majority of black artists. Two of Norman Lewis's pieces exemplify this notion: *Untitled (Despondent)* of 1933, and *Yellow Hat* (1936).

Executed in watercolor on paper, *Untitled (Despondent)* portrays a seated man, perhaps of decent means judging by his sartorial taste, who appears battered and crushed, perhaps by the economic situation. It is difficult to guess to what racial class this figure belongs: his face is obscured by his elegant hat. With his right arm tucked firmly into the inner pocket of his long coat, Lewis's subject sits at an angle that emphasizes the broodiness of his state. Against a dark background that is intercepted by the diagonals of the bench on which the man leans, there could not have been a more decent portrait of languor.

Three years after this watercolor piece, Lewis painted *Yellow Hat*. As in *Untitled*, the face of the female figure is hidden by a yellow hat, which is tilted to the right such that it is nearly touching the lady's right shoulder. Unlike *Untitled*, we are able to ascertain that this figure is a black woman, based on the skin pigmentation. One can surmise upon reading the posture of the figure that the lady is in a pensive state. Again, Lewis gives us a picture of someone who, whatever her affliction, has poise and elegance.

Until the outbreak of World War II, Lewis would be preoccupied with the typical and predictable, including the portrayal of the struggle by black Americans to deal with an uneven and discriminatory social condition. In a way, *Yellow Hat* anticipates a stylistic shift; the employment of flat, angular planes hints at the artist's exploration of cubist language. It would be only a matter of time before the full transition to abstraction was completed. By the middle of the 1940s, Lewis's work had undergone a radical transformation. *Jazz Musicians* of 1948, for example, recalls Wilfredo Lam's *The Jungle*, in which a playful forest of anthropomorphic forms appears to be having a serious conference.

Norman Lewis came to art and dominated it on his own terms. The middle child in a family of three brothers, Lewis was born in Harlem, New York, on July 23, 1909, to parents of Caribbean ancestry. His father, Wilfred Lewis came from Bermuda, as did his mother, Diana Lewis. While in Bermuda, Wilfred worked as a fisherman, while Diana owned a bakery (Bearden and Henderson 1993). In New York, Wilfred Lewis secured employment as a stevedore supervisor on the docks. Lewis grew up in Harlem in a household that gave its children a sense of pride in their Caribbean ancestry. As a young boy, Lewis showed an independent, curious mind and a talent for creativity, two elements that would sustain him later in life. While his mother encouraged him in his pursuit of intellectual and creative enquiries, it soon became apparent that both parents placed a higher premium on the musical talents of Saul, his brother. A violinist, Saul would eventually own his own band and would play with Count Basie before giving it up altogether to become a detective because concertos and classical music was not a profitable means of earning a living for blacks at the time.

Lewis must have been discouraged further by his father's insistence that his son was wasting his time by pursuing a white man's profession. According to Lewis,

> I always wanted to be an artist, you know, the drawings that children make in the street and stuff like that. I remember coming home and I said to my father that I wanted to be an artist and he said this is a white man's profession. It is a starving profession. He never encouraged me, but musically they forced my brother's becoming a violinist and he was good. And yet visually they couldn't understand my desire to be a painter, you know, which I pursued on my own.
>
> (Ghent 1968)

Lewis, who felt inferior about the notion of becoming an artist, reacted by withdrawing to himself and learning to do things by himself. In high school, he was interested in commercial art but was frustrated but not daunted by

the lack of encouragement that he received. From his parents' perspective, school was more about personal growth and intellectual development—about the wholesome development of the human persona—than about making money. Lewis grew up in a Harlem that was then a predominantly white community. He attended a high school where his commitment to reading stood him apart from many of his fellow students, most of whom were white, and learned of racial discrimination firsthand. "[A]fter high school suddenly I found with all my ability that I couldn't get a job as they could get a job after school. And slowly it dawns on you, it is a kind of rude awakening that you are not part of this system you know" (Smithsonian Oral Histories).

Lewis was enterprising and bore his disappointment with equanimity. He sold newspapers and delivered groceries. From the incomes that he earned, he lived a relatively more comfortable than life than most kids his age. When he was about 20 years old, he secured a job as a freighter and became a seaman. For about three years, he set sail to South America and visited places like Bolivia, St. Thomas, and Jamaica. Sailing for weeks and seeing nothing but the sea, misty grays and the color of water, and finally coming ashore to the sight of murky and muddy water had an impression on Lewis; it was an impression that he would eventually channel into some of his paintings later in life. He got into gambling—played poker and bet on horse racing—and made some money, which he invested in art history books and materials. Eventually, Lewis would have a well-stocked library of books, which he read dutifully, and from which he copied often.

When he returned from his South American trip, Lewis picked up a job as a presser with Haig Kasebian, an Armenian neighborhood tailor. In the process, he learned to sew. This was where he came across Augusta Savage, who gave him access to her sculpture studio, which was in the basement of Kasebian's tailoring and dry cleaning outfit. While Lewis's self-education gave him the incentive to pursue art, it also constituted a hindrance to his personal growth much later, as his inability to fully digest and contextualize the knowledge that he had acquired through his extensive readings placed him at odds with art teachers and students in real-life situations. Arguments often broke out between him and Savage on issues pertaining to art:

> What he had learned through his self-education did not always agree with what Savage taught. As they got better acquainted, they argued more, often violently, for Savage, often imperious, would brook no challenge. They argued, Lewis said, "because occasionally I would ask questions that she didn't answer to my satisfaction, and we used to get into arguments about what she was doing . . . like, well, she's not a sculptor, she's a modeler in clay and a sculptor cuts stone, which she never did. But thank heaven for her! Because she afforded me the opportunity to get started."
> (Bearden and Henderson 1993)

Although Lewis spent about two years with her, Savage never dictated to him what to do or how to do it. This laissez-faire approach stimulated Lewis, who immersed himself in painting. Savage was crucial to Lewis's professional education, for she allowed him access to her studio; and the bouts of

arguments that ensued between her and Lewis must have served to elucidate Lewis's understanding of art. At Savage's place, Lewis met a number of black poets, writers, and musicians: Roland Hayes (who had become a world-renowned tenor by the second half of the twentieth century), and literary personages such as Countee Cullen, Claude McKay, and Carl Van Vechten. Soon, Lewis received a sponsorship from Robert and Lydia Minor to study art at the John Reed Club Art School, with Raphael Soyer as his teacher. Again, his insecurity prevented him from capitalizing on the opportunity, although he had an exhibition with the John Reed Club in 1933. He went on to take up appointment as an art teacher at the Works Progress Administration when it was established in 1935. As he taught, he continued with his self-education.

He was active in union activities and kept the company of many of the Abstract Expressionist artists as they began to formulate their approach to art making. His advocacy in the Harlem Artists Guild yielded some modicum of success in bringing black and white artists together to subscribe to the ideals of the WPA project. He was the first president of Spiral, an association that was formed in the summer of 1963 to work toward empowering African American artists in claiming their own territory in a society that insisted on constantly marginalizing them. Spiral, which had such artists as **Romare Bearden**, **Hale Woodruff**, Alvin Hollingsworth, and **Emma Amos** among its members, disbanded in 1965. In reaction to the blatant discrimination that he experienced, Lewis rationalized that picketing, rather than art, was a better platform for addressing social malaise. He became drawn to the Abstract Expressionist movement and attended its meetings at Studio 35, the only African American artist to be so involved. Through this forum, he became acquainted with prominent members: David Smith, Ad Reinhardt, Mark Tobey, and Richard Lippold. As he had done previously, Lewis adapted and became introspective; he studied such artists as Claude Monet and J. M. W. Turner as he began to channel his thoughts towards nonrepresentational art. This process also led, in a way, to self-imposed isolation, brightened even if only temporarily by his invitation, in 1946, by Marian Willard, owner of the Willard Gallery which had successfully hosted Willem de Kooning's exhibition in the previous year. For 15 years—from 1949, when he had his first solo exhibition, to 1964, when he left—Lewis was one of the prominent Abstract Expressionists on the Willard Gallery stable. During this time, he held six sole exhibitions—in 1950, 1951, 1952, 1954, 1957, and 1961 (June Kelley Gallery 2008).

By 1952, Lewis's work had started to attract a long-overdue recognition by the media. By this time, his style of painting has completely moved away from the figurative engagement of the 1930s. A gentle and mesmerizing air pervades most of his post–World War II paintings, giving them a misty, poetic dignity. While outlines of teeming crowds are still discernable in some of his paintings, such as *Harlem Turns White* (1955), and *Arrival and Departure* (1963), the overall integrity of his paintings convey deep emotionality that serves to sits on the other end of the Abstract Expressionist pole, which is dominated by a powerful processual bravura. In 1955, Lewis's painting, *Migrating Birds,* won the star prize at the Pittsburgh International Exhibition at the Carnegie Institute.

Neither this prize nor his nine solo exhibitions at the Willard Gallery lifted Lewis's status, as collectors and museums continually ignored him. In turn, this fueled his pessimism and contributed further to his isolation. Bearden and Henderson (1993) provides a succinct summary of a situation in which Lewis found it difficult to accept that the Abstract Expressionist movement did not favor all artists equally. Lewis "felt that his contribution—drawing on nature for his inspiration—had been as significant and important as that of any of the Abstract Expressionist pioneers. He had come to believe that because many of the leading Abstract Expressionists considered him their artistic equal, everyone would."

By the 1970s, Lewis experienced an artistic resuscitation: he received grants from the Mark Rothko Foundation (1972), the National Endowment for the Arts (1972), and the Guggenheim Foundation (1975). From 1972 to 1979, he taught at The Art Students League in New York and was able to travel and enjoy some modicum of professional validation for his contributions. On August 27, 1979, Norman Lewis died.

Places to See Lewis's Work

Addison Gallery of American Art, Andover, MA
Dayton Art Institute, Dayton, OH
Jack S. Blanton Museum of Art, University of Texas, Austin, TX
Metropolitan Museum of Art, New York, NY
Museum of Modern Art, New York, NY

Bibliography

Bearden, Romare, and Harry Henderson. *A History of African American Artists from 1792 to the Present*. New York: Pantheon Books, 1993.

Cederholm, Theresa Dickason. *Afro-American Artists: A Bio-bibliographical Directory*. Boston, MA: Trustees of the Boston Public Library, 1973.

Craven, David. *Norman Leis: Black Paintings, 1946–1977*. New York: Studio Museum in Harlem, 1998.

Driskell, David. *The Other Side of Color: African American Art in the Collection of Camille O. and William H. Cosby, Jr.* San Francisco: Pomegranate, 2001.

Fine, Elsa Honig. *The Afro-American Artist: A Search for Identity*. New York: Hacker Art Books, 1982.

Ghent, Henri. "Oral History Interview with Norman Lewis, 1968 July 14." Smithsonian Archives of American Art, 1968. http://www.aaa.si.edu/collections/oralhistories/transcripts/lewis68.htm (accessed January 9, 2009).

Glueck, Grace. "Art Review: Shades of Meaning from a Black Modernist." *New York Times*, April 17, 1998, 38.

Hayes, J. M. "The Words Behind the Pictures." *International Review of African American Art* 21, no. 4. (2007): 22–24.

Igoe, Lynn. *Two Hundred Fifty Years of Afro-American Art: An Annotated Bibliography*. New York: Bowker, 1981.

Kenkeleba Gallery. *Norman Lewis: From the Harlem Renaissance to Abstraction*. New York: The Gallery, 1989. An exhibition catalog.

Kimmelman, Michael. "Art in Review." *New York Times*, November 12, 1993, 22.

Landau, Ellen G. *Reading Abstract Expressionism: Context and Critique*. New Haven, CT: Yale, 2005.

June Kelly Gallery. "Norman Lewis." July 20, 2008. http://www.junekellygallery .com/artists/lewis.htm.

Schomburg Center for Research in Black Culture. *Black New York Artists of the 20th Century*. New York: Schomburg Center for Research in Black Culture, 1998. An exhibition catalog.

Turner, Grady T. "Norman Lewis at June Kelly, Bill Hodges and the Studio Museum." *Art in America* 87, no. 1 (January 1999): 104.

Zimmer, William. "Art: The Color Black: On the Painter's Canvas and in the World." *New York Times*, May 30, 1999, 14.

Glenn Ligon (b. 1960), Painter, Printmaker, Multimedia Artist.

Glenn Ligon's work is, in a subtle but declarative way, autobiographical. Working as a multimedia artist using printmaking, photography, neon, installation, and video, Ligon imbues his work with insights gained from his encounters with text and literature, of which he is fond, and his reading of social, racial, and life experiences. The phrases or lines that Ligon appropriates for his art are adapted from established sources that range from nineteenth-century slave posters to contemporary literature and popular culture. Thelma Golden puts it succinctly when she writes that Ligon's work "is an inspired collision of autobiography and self-portraiture working through race, culture, gender, sexuality, and nation" (Golden 1998, 39). The connection between his work and literature, and the resultant interface between painting and prose, reveals his voracious appetite for reading.

There are stark poetry and nuanced cadences in his work, which engage at the same time that they cajole and jolt. The ideas that inform his work are borrowed from a variety of sources that include such artists as Willem de Kooning, Andy Warhol, Robert Mapplethorpe, the comedian and actor Richard Pryor, and writers such as Zora Neale Hurston and James Baldwin. From the plethora of sources at his disposal, Ligon extrapolates, appropriates, and creates something that reflects his own creative temperament and individuality. In 1997, he created two larger-than-life images of himself in which he wears a white, long-sleeve shirt atop a dark pair of jeans and a nondescript pair of snickers and stands at ease, his gaze fixed on the viewer. While the first is titled *Self-Portrait Exaggerating My Black Features*, the second is titled *Self-Portrait Exaggerating My White Features*. Inspired by Adrian Piper's 1981 drawing *Self-Portrait Exaggerating My Negroid Features*, Ligon's work poses a conceptual rather than visual challenge. A casual glance at this pair of works suggests that they are identical. But the titles indicate otherwise. This ploy invites the viewer to pry closer at the pair: to find out which features accentuate what racial features. On closer scrutiny, the viewer comes back with the same verdict: the pieces are identical. The only difference is in the titles.

Glenn Ligon wearing a leather jacket, New York City, 1998. Photo by John Jonas Gruen/Hulton Archive/Getty Images.

"Self-Portrait" dares the viewer to look beyond the two-dimensionality of the work and attempt to fathom its intentionality. In a way, the work attempts to initiate a dialogue with the viewer and intellectualize the extent to which the choices that we make, the impressions that we have, and the conclusions that we arrive at are influenced by the context of presentation and the baggage of assumptions or prejudices that individuals bear. A subtext of this work implicates race and social profiling. A fully clothed male figure may not prick our inquisitiveness until we read the caption.

The underlying theme of Ligon's work is the critique of his own identity and an affirmation of selfhood. As an African American, Ligon falls within the minority rank. As an artist and a gay black man, Ligon understandably filters the world through a lens trained on self, history, text, and context. He excavates African American history, updates it, and inserts himself into the emerging product such that the viewer experiences a deceptive déjà vu. His suite of 1993 prints, *Runaways,* are simulacra of retrofitted nineteenth-century slave posters with designs that replicate the authenticity of those inglorious flyers documenting the searing scars of slavery. In *Slave Narratives,* another series of prints produced in 1993, Ligon cases himself in the text of a poster as "A Negro who was sent to be educated amongst white people in the year 1966 when only about six years of age and has continued to fraternize with them to the present time."

Ligon was born in the Bronx, New York, in 1960. In 1980, he attended the Rhode Island School of Design for two years and, in 1985, obtained the B.A. degree from Wesleyan University in Middletown, Connecticut. In 1985, Ligon participated in the Whitney Museum Independent Study Program in New York. Although he has veered into multiple media, Ligon started as an abstract expressionist painter. In an interview with Byron Kim (Tannenbaum 1997, 51) Ligon explains that he moved away from painting because it was too delimiting for him to express all he wanted to say. This dilemma prompted him to move toward direct quotation of texts. Although Ligon did not abandon painting, he came up with an expanded format, one that accommodated his penchant for texts, which he began to incorporate into his work. For him, words have a charming potency: they metamorphose into pictures and initiate a tension between form and meaning. "That's what's interesting to me. The

paintings are about the desire to communicate and a certain pessimism about the possibility of doing that. I know that the texts I use are not iconographic, but they do exist outside of my paintings; they are available to be read. Making a painting, for me, is akin to making a film adaptation of a text: it's just one possible way out of many" (Tannenbaum 1997, 51).

From painting to prints, installation, and neon sculptures, the manipulation of words is a central strategy in Ligon's work. Such rapport with words gained him recognition in the early nineties. From Zora Neale Hurston's 1928 *How it Feels To Be Colored Me*, Ligon came up with his 1991 piece, *Untitled (I Feel Most Colored When I Am Thrown Against a Sharp White Background)*, a piece that was done with oilstick and gesso on panel. This phrase is repeated until the white surface, which measures 80" × 30", is filled up with black pigment, a good part of which is smudgy and flaky. This process adds to the symbolic and meta-phoric significance of the work. As Meyer has rightly observed, (Tannenbaum 1997, 13) "The resulting pictures set up a series of dialogues between visibility and erasure, between naming of color and its painterly absence on the canvas, and between the 'black space' of the stenciled letters and the 'white space' into which they increasingly bleed." Beginning in 1994, Ligon produced *A Feast of Scraps*, a family photo album into which he inserted homoerotic pictures, with captions that are as facetious as they are revelatory of his sexual orientation.

Since 1982 when he was curatorial intern at the Studio Museum in Harlem with a National Endowment for the Arts award, Ligon has won fellowships, grants, awards, and residences. These include the 2003 John Simon Guggen-heim Memorial Foundation Fellowship, the 1998 ArtPace International Artists-in-Residence Program in San Antonio, Texas, and the 1997 Joan Mitch-ell Foundation Grant. He has had a string of solo exhibitions at places like the Hirshhorn Museum and Sculpture Garden in Washington, DC; the Studio Museum in Harlem; the Brooklyn Museum of Art, Brooklyn, New York; the Institute of Contemporary Art, University of Pennsylvania; St. Louis Art Museum in Missouri; and the Dia Center for the Arts in New York. He has par-ticipated at the Whitney Biennial; the Venice Biennale; Documenta; and Kwangju Biennale. His work is in major collections.

Places to See Ligon's Work

Baltimore Museum of Art, Baltimore, MD
Bohen Foundation, New York, NY
Carnegie Museum of Art, Pittsburgh, PA
Des Moines Art Center, Des Moines, IA
Detroit Institute of Arts, Detroit, MI
High Museum of Art, Atlanta, GA
Hirshhorn Museum and Sculpture Garden, Washington, DC
Museum of Fine Arts, Boston, MA
Museum of Modern Art, New York, NY
Peter Norton Family Foundation, Santa Monica, CA
Philadelphia Museum of Art, Philadelphia, PA
San Francisco Museum of Modern Art, San Francisco, CA

Wadsworth Atheneum, Hartford, CT
Walker Art Center, Minneapolis, MN
Whitney Museum of American Art, New York, NY

Bibliography

Carrier, David. "10th Biennale, Sydney." *Burlington Magazine* 138, no. 1123 (October 1996): 714–15.

Connor, Kimberly Rae. "To Disembark: The Slave Narrative Tradition." *African American Review* 30, no. 1 (Spring 1996): 35–57.

Cotter, Holland. "Stories about Race, Politics, and Himself." *New York Times*, December 2, 1998, 48–49.

Firstenberg, Lauri. "Neo-Archival and Textual Strategies: An Interview with Glenn Ligon." *Art Journal* 60, no. 1 (Spring 2001): 42–47.

Golden, Thelma. "Everynight." In *Unbecoming.* Philadelphia, PA: Institute of Contemporary Art, 1998.

Koestenbaum, Wayne. "Color Me Glenn." In *Coloring.* Minneapolis, MN: Walker Art Center, 2001.

Meyer, Richard. "Borrowed Voices: Glenn Ligon and the Force of Language." Queer Cultural Center, July 23, 2008. http://www.queerculturalcenter.org /Pages/Ligon/LigonEssay.html.

Tannenbaum, Judith. *Glenn Ligon: Unbecoming.* Philadelphia, PA: Institute of Contemporary Art, University of Pennsylvania, 1997.

Tomlinson, Glenn C., and R. Corpus. "A Selection of Works by African American Artists in the Philadelphia Museum of Art." *Philadelphia Museum of Art Bulletin* 90, no. 382/383 (Winter 1995): 1–47.

Tucker, Sara. "Introduction to 'Annotations,'" July 23, 2008. http://www .diacenter.org/ligon/intro.html.

Cynthia Lockhart (b. 1952), Fashion Designer, Quilt Maker, Fiber Artist.

Cynthia Lockhart grew into art. As a child, her earliest memories were about her desire for self-expression through the agency of what she would later identify as fashion. Her obsession with looks and appearances started with a fascination with dolls. While most children were content to play with dolls, perhaps for their cuddliness and the sense of companionship that they offered, Lockhart preoccupied herself with reconstructing her dolls. She would change the clothes on the doll; the original fabrics were never good enough, and she had to invent her own design for the dolls. She would wrap the head, make additional little knots here and add a touch of fabric there. This was her own remake of her mother's role as a model. Each time her mother practiced modeling, Lockhart would go with her to her practice sessions and see her try on an assortment of outfits. Gerri was always impeccably dressed, while George's sartorial taste complemented his wife's. For Lockhart, this was a nurturing environment, one that registered in her subconscious the penchant for elegance and individualized aesthetics.

Lockhart was born in Cincinnati, Ohio, on December 4, 1952, the younger of two daughters. Her father, George Reid worked at General Electric all his adult life until he retired. Her mother, Gerri Reid, worked as a state employment services supervisor and was a fashion aficionado who used her dress to make social statements. At Columbian elementary school in Cincinnati, Lockhart found out that her teachers were fond of her on account of her precociousness in art. She attended Woodward Junior and High School, from where she graduated in 1970. In the 1970s, Cincinnati was a tumultuous arena on account of social inequality and racial prejudice that pervaded the city. The Civil Rights Movement provided a fresh burst of liberation and empowerment and allowed African Americans to scream for all to hear those thoughts that they had harbored within the confines of their homestead but dared not give free expression to for fear

Cynthia Lockhart. Courtesy of dele jegede.

of persecution. Embracing Africana became a popular index of selfhood. For Lockhart, who is light-skinned, the 1970s was also a time of cultural conflict. At a time when the popular slogan was based on the imperative that African Americans loudly proclaim their blackness, Lockhart found herself in a conundrum as a result of her fair skin. During the riots in Cincinnati, Lockhart's parents were apprehensive that, because of her skin color, their daughter might be shot at. For this reason, she was always prevented from sitting upright anytime she rode in the car with her parents.

In high school, it became apparent to most that Lockhart's future would be tied to the arts. She sang, learned to sew, embraced the Beatles, learned to play the guitar, expanded her creative vista, and became fascinated with traveling and learning of other cultures. Her fascination with reconfiguring the appearance of her dolls took a more personalized form of expressiveness: she turned the attention to herself. In school, Lockhart turned herself into a moving piece of art on account of her mode of dressing: white go-go boots and Beatles hairstyle became her standard fashion statement. For teachers and her schoolmates alike, Lockhart became the standard by which personal expression was measured. In 1970, Lockhart enrolled at the University of Cincinnati; she graduated in 1975 with a B.A. in fashion design and earned the M.A. in design in 1999. Thereafter, she moved to New York, where she worked for over a decade as a fashion designer where she handled portfolios for major design organizations in addition to pursuing her own work as a fashion designer. Her designs in New York focused on apparels and accessories, which drew attention on account of their unique, individualized designs. She designed for major names in the industry, including Koos van der Akker, Nicole Accessories, Andrea Gayle, Oggi Ltd, and Leslie J. New York, at the same time that she maintained

her own clients, among which were Neiman Marcus, Macy's, Barney's, and Saks Fifth Avenue. Predictably, the city of New York proved to be relentless, even unforgiving, with most of Lockhart's work tied to the massive corporate machine that thrived more on business names than on the identification and recognition of individual designers. Following the stock market crash of 1987, Lockhart moved back to Cincinnati and took up appointment with the University of Cincinnati, where she is professor of professional practice.

Lockhart approached quilt making not from the traditional format that recalls the powerful narratives of Harriet Powers or the contemporary minimalist designs of some of the quilters of Gee's Bend in Alabama. Her quilts reflect a fashion designer's sensitivity to fabrics and accessories. Coming into quilting from a fashion designer's background, Lockhart's early quilts were redolent with a formalistic attitude that came from a strict adherence to the syntax of design. *Shades of Black and White*, for example, appropriates black-and-white design elements from the "bogolanfini" mud textiles of the Bamana in Mali, which is then adorned with cowry shells and a dash of silky add-ons. Within a rectangular frame, this piece bears relatively little affinity with traditional quilts. She has moved away from the muted fabrics of her early quilts and has become one of the leading exponents of a new genre of quilting, one that privileges intuitive exuberance colors and organic shapes over rigid formalism.

Belonging in this genre is *Venice*, which won a merit award at the 2001 Museum of Science and Industry exhibition in Chicago. Designed from a collage comprising an admixture of textile pieces, quill, bone, and leather, *Venice* typifies Lockhart's penchant for curvilinearity and burst of associated, harmonious colors. In 2004, she produced *Journey to Freedom*, which was her first quilt story. It was done in response to a call by the Freedom Center in Cincinnati. Lockhart decided to tell the story of runaway slaves by avoiding the characterization of familiar slaves. Rather, she opted for using the quilt to narrate the ordeal of those unheralded and unidentified slaves. The quilt, which is built on a curvilinear ground that has a celebratory joyousness, features two slaves in profile standing on the lower right corner and pointing towards the North Star as they contemplate freedom. Lockhart produced it after researching the topic, and after completing an inordinate amount of sketches. It is meant to be the first in a four-part series in which the same concept—freedom—is explored in stages, with the last piece in the series culminating in slaves crossing the Mason-Dixon line to freedom. Lockhart's quilts are distinguished by their pulsating colors, which simulate the vivaciousness of her African ancestry, and by their irregular, organic shapes. In her 2006 piece, *Jazz On My Mind*, Lockhart asserts her claim to her ancestry by appropriating the improvisational approach that jazz popularized: "Based on my ancestors; struggles, celebrations, creative survival skills, my own personal witness and love of music, I have a lot to say about the art of Jazz. . . . The quilt . . . takes into consideration a Creole blend of the authentic New Orleans Jazz, Bebop, and Swing revelations of a Jazz culture" (Mazloomi 2007, 86).

Ghada Amer, *Red Drips,* 1999. Acrylic embroidery and gel medium on canvas. © 2009 Artists Rights Society (ARS), New York/ADAGP, Paris and Art Resource, NY.

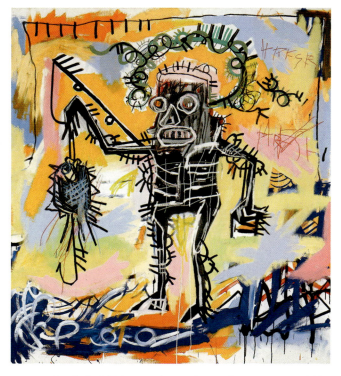

Jean-Michel Basquiat, *Untitled,* 1981. Acrylic and pencil on canvas, 198 cm x 173 cm. © 2009 The Estate of Jean-Michael Basquiat/ADAGP, Paris/ARS, New York and [Baque d'images, ADAGP / Art Resource, NYBanque d'Images, ADAGP/Art Resource, NY.

A 60′ x 13′ mural by Romare Bearden is displayed in the Gateway Center subway station in downtown Pittsburgh, 2008. The mural, titled *Pittsburgh Recollections,* was installed in 1984. AP Photo/Gene J. Puskar.

John Biggers, *Jubilee: Ghana Harvest Festival, 1959–63.* Tempera and acrylic on canvas. © Museum of Fine Arts, Houston, Texas. Museum purchase with funds provided by Duke Energy/The Bridgeman Art Library.

Elizabeth Catlett, *Mother and Child,* 1959. Lithograph. © The Granger Collection, New York.

Achamyele Debela, *Song for Africa,* 1990. Courtesy of Achamyele Debela.

Melvin Edwards, *Resolved,* 1986. Welded steel, from the Lynch Fragments series. Estate of Gertrude Weinstock Simpson. © The Newark Museum/Art Resource, NY.

Wosene Kosrof, *Inside the Museum of African Art,* 1990. Acrylic on canvas. © Indianapolis Museum of Art, James E. Roberts Fund/The Bridgeman Art Library.

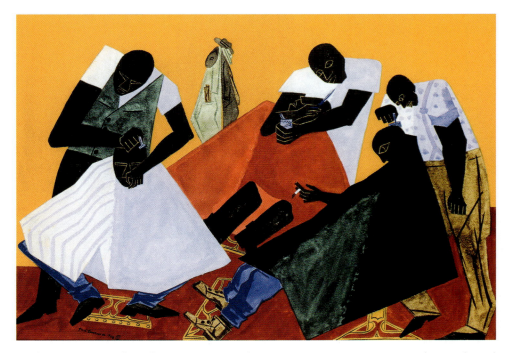

Jacob Lawrence, *Barber Shop,* 1946. Gouache on paper, 21⅛″ x 29⅜″. © The Jacob and Gwendolyn Lawrence Foundation, Seattle/Artists Rights Society (ARS), New York and Art Resource, NY.

Glenn Ligon, *Untitled (There is a consciousness we all have . . .)*, 1988. Synthetic polymer paint and pencil on two sheets of paper, 30″ × 44¾″. Gift of Jan Christiaan Braun in honor of Agnes Gund (298.2000). © The Museum of Modern Art/Licensed by SCALA/Art Resource, NY.

Wangechi Mutu, *Yo Mama*, 2003. Cut-and-pasted printed paper, cut-and-pasted pressure-sensitive synthetic polymer sheet, synthetic polymer paint, and pencil with glitter on two sheets of painted paper; overall: 59⅛″ × 85″ (150.2 cm × 215.9 cm). © The Museum of Modern Art/Licensed by SCALA/Art Resource, NY.

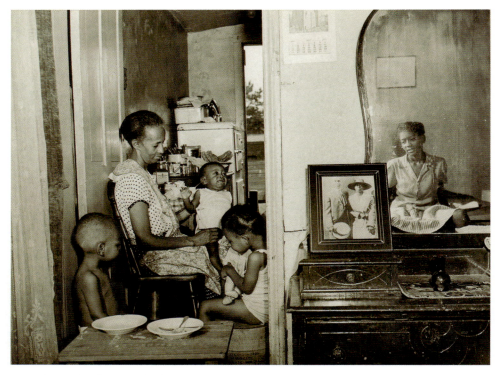

A Gordon Parks photograph of Ella Watson sitting with three children and, on the right, reflected in a mirror, her adopted daughter. New York, 1942. Courtesy of the Library of Congress.

Faith Ringgold, *Tar Beach 2,* 1990. Quilt, silk, 66″ x 64½″ (167.6 cm x 163.8 cm). © The Philadelphia Museum of Art/Art Resource, NY.

Visitors view a textile work in progress by Aminah Brenda Lynn Robinson at the National Underground Railroad Freedom Center in Cincinnati, 2005. Begun in 1968, the work shows the history of the Atlantic slave trade. AP Photo/Al Behrman.

Lorna Simpson, *Untitled (Two Necklines)*. Part of an exhibit at the National Gallery of Art in Washington, DC, 2005. AP Photo/National Gallery of Art.

Obiora Udechukwu, *Where Something Stands* (Detail). Courtesy of Obiora Udechukwu.

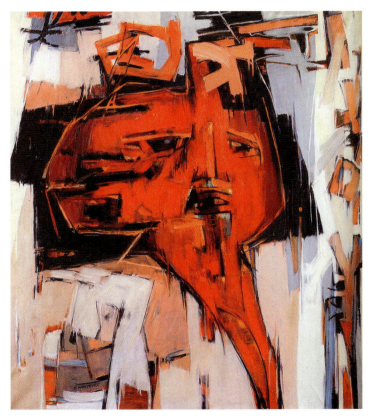

Hale Woodruff, *Ancestral Memory,* mid-twentieth century. © Estate of Hale Woodruff/Elnora, Inc.; Courtesy of Michael Rosenfeld Gallery, LLC, New York, NY.

Places to See Lockhart's Work

Cincinnati Art Museum, Cincinnati, OH
Frederick Douglass School, Cincinnati, OH
NAACP, Cincinnati, OH
Private collections
Springer School & Center, Cincinnati, OH
United Methodist Church, Cincinnati, OH

Bibliography

Benberry, Cuesta. *A Piece of My Soul: Quilts by Black Arkansans*. Fayetteville: University of Arkansas Press, 2000.

Cameron, Dan. *Dancing at the Louvre: Faith Ringgold's French Collection and Other Story Quilts*. New York: New Museum of Contemporary Art; Berkeley: University of California Press, 1998.

Glueck, Grace. Review of "Make a Joyful Noise unto the Lord." *New York Times*, January 30, 2004, E27.

Herlinger, Chris. Review of "Narrative Quilts." *Washington Post*, February 2, 2004, B9.

Imami-Paydar, Niloo. *Stitch by Stitch: A Quilt Potpourri*. Indianapolis, IN: Indianapolis Museum of Art. 1996.

Jacobs, Joseph. *A World of Their Own: Twentieth Century African Folk Art*. Newark, NJ: Newark Museum, 1995.

Mayr, Bill. Review of "Quilts: Materials, Innovation Matter in Museum Exhibit." *Columbus Dispatch*, June 15, 2008, E–E2.

Mazloomi, Carolyn L. *Spirits of the Cloth: Contemporary African-American Quilts*. New York : Clarkson Potter/Publishers, 1998.

———. *Textural Rhythms: Quilting the Jazz Tradition*. Westchester, OH: Paper Moon Publishing, 2007.

———. *Quilting African American Women's History: Our Challenges, Creativity, and Champions*. Westchester, OH: Paper Moon Publishing, 2008.

Mazloomi, Carolyn L., and Patricia C. Pongracz. *Threads of Faith*. New York: The Gallery at the American Bible Society, 2004.

Pearce, Sara. Review of "A Quilt That Sings." *Cincinnati Enquirer*, February 19, 2006, D–D4.

———. Review of "Catch the Northern Highlights." *Cincinnati Enquirer*, July 18, 2008, E12.

Pritchard, Gayle. *Uncommon Threads: Ohio's Art Quilt Revolution*. Athens: Ohio University Press, 2006.

M

(Frank E.) Toby Martin II (b. 1955), Sculptor.

Frank E. T. Martin, who goes by Toby Martin, sees art as a powerful medium because of its power to assert boundaries at the same time that it defines them. As a sculptor with interest in engineering and metaphysics, Martin has a consuming passion for exploring the relationship between these two domains. His sculptures characteristically occupy two spaces: physical and metaphysical. In this, Martin draws as much inspiration from science as he draws from Africa. He copiously references the Dogon of Mali, whose schematized sculptures, which date to the thirteenth century, provide Martin with the spiritual link on which to anchor his creative dogma. Martin's sculptures are not merely extrusions that interrupt the space that they occupy; they are also, from the artist's standpoint, testimonials to a higher being and physical manifestations of the spirit and philosophy that engendered them.

Generations of African Americans have visited the African continent. In his crusade for the construction of a philosophical basis on which African Americans could anchor their creative work during the Harlem Renaissance, Alain Locke emphasized the essence of drawing upon the arts of Africa, which is the ancestral home of African Americans. **Loïs Mailou Jones**, Kofi Bailey, **Jacob Lawrence**, **John Thomas Biggers**, **Melvin Eugene Edwards**, and **Faith Ringgold** are among several African American artists who have visited Africa. In channeling Dogon culture as the spiritual base for his sculptures, Martin follows a line of distinguished artists who have taken advantage of the continent's cultural wealth. The Dogon in particular rank among African cultures that, for good or ill, have gained favorable attention from the West. Since 1948, when the French anthropologist Marcel Griaule published *Conversations with Ogotemmeli,* scholars have been engaged in reconstructing the interpretations that have been ascribed to Dogon belief systems. Martin's interest was provoked by the tantalizing web of mythological and metaphysical relationships between the secular and the spiritual domains in Dogon world. In the Bandiagara escarpments where the Dogon live in Mali, Martin would seek to grasp the philosophical constructs that undergird the elegant, schematized sculptures that date back to the fifteenth century, when the Dogon supplanted the Tellem in present-day Mali. Much more important to Martin is the integrative essence of art among the Dogon: the way they are steeped in cycles of rituals that are meant to appease the earth and assuage malevolent forces.

Frank E. T. Martin II. Courtesy of Toby Martin.

Martin's steel sculptures may symbolize the pulse of a culture preoccupied with technology and materialism. But they are also edifices to a truth that can be grasped only when the viewer is sufficiently endowed to understand their irreducible spiritual signification.

Martin is drawn to Mali because he sees a connection between art and spirituality that transcends the quotidian and embraces the sublime and the spiritual: life beyond this physical earth. In this sense, he asserts that his work becomes a transformative union between art and ceremony; spirituality and secrecy. Martin is interested in rupturing, to the extent possible, the layering of secrecy, which subsists in governmental establishments and in churches. He wants to create sculptures that exude his vision of a union between the spiritual and the secular. In the quest to achieve this goal and bring art to the people, Africa becomes a veritable source. In this context, Martin becomes the Hogon: the divinity and spiritual dispenser among the Dogon of Mali. Interacting with Dogon elders, observing their rituals, and understudying the connection between their art and life are insights that imbue Martin's sculptures with the philosophical and deeper truth that he so much hankers after. In Martin's world, the layering of aesthetics is cultural, whereas spiritual transformation takes place at the level of faith, which permeates all layers of cultural aesthetics. Thus, the religious affiliation of a person is immaterial, just as racial, gender, or sexual orientation play only marginal roles.

Toby Martin was born on December 20, 1951, in Fort Lauderdale, Florida. His mother Laura Martin was one of the three major influences on him while he was growing up. She worked in multiple areas of education. A singer, cultural organizer, and restauranteur who had taught music and chorus at Blanch Ely High School in Pompano while Martin was in elementary school, Laura Martin went on to become assistant principal in Fort Lauderdale. She loved operas and concerts and gave Martin an early exposure to the arts. The second influence on Martin was his grandfather, James Bryant Sr., who operated a junkyard in Jacksonville, Florida. It was at Bryant Sr.'s junkyard that Martin was first exposed to the alluring power of metals; it was there that he first experienced exposure to a diversity of materials. Bryant Sr. was into recycling in Jacksonville during the mid-fifties. Martin would go to his grandfather's junkyard with his cousin and watch his grandfather cut cars, break metals and steel and iron, which he sold. Martin's fascination began with the festival of fireworks that issued from his grandfather's torches at the yard. The third influence on young Martin was the church. He was raised a Catholic and attended St. Thomas Aquinas High School in Fort Lauderdale. The combination of these three main sources—his mother, his grandfather, and the church

—shaped Martin's professional course and stimulated his interest in finding spiritual equilibrium through his art.

After high school, he attended Southern University in 1969, where he met Beverly, his future wife. He transferred to Morehouse College, Atlanta in 1972 and graduated in 1976 with a B.A. degree in fine arts and a major in sculpture. Between 1976 and 1986, he worked full time in varying capacities—fabricator of sculptures, designer draftsman, and engineering illustrator and designer—for various companies. He attended Georgia State University for his graduate degree and graduated in 1986 with an M.F.A. in sculpture. Since 1987, Martin has taught as a professor in Spelman College, Atlanta. He has received and executed commissions from many sources, including the Bureau of Cultural Affairs for the city of Atlanta; Environmental Sculpture for the Corporation for Olympic Development; and the Metropolitan Atlanta Rapid Transit Authority. He has had numerous solo and group shows and participated in conferences throughout the country and in places such as England, the Netherlands, and France.

Places to See Martin's Work

Commission for Perkerson Park, Atlanta, GA

Commission for the Bureau of Cultural Affairs, Atlanta, GA

Environmental Sculpture: Corporation for Olympic Development, Atlanta, GA (1996)

Florida A&M University, Tallahassee, FL

Frederick Humphries Science & Research Center, Florida Agricultural and Mechanical University, Tallahassee, FL

Metropolitan Atlanta Rapid Transit Authority, Atlanta, GA

Our Lady of Lourdes Catholic Church, Atlanta, GA

Bibliography

Coleman, Floyd. "African American Art Then and Now: Some Personal Reflections." *American Art* 17, no. 1 (Spring 2003): 23–25.

Emory University. *Emory Chairs Project.* Atlanta, GA: Emory University Publications, 2004.

Firstenberg, Lauri. "Perverse Anthropology: The Photomontage of Wangechi Mutu." In *Looking Both Ways: Art of the Contemporary African Diaspora,* edited by Laurie Ann Farrell. New York: Museum for African Art; Gent: Snoeck, 2003.

Hill, J. Newton. "African Artists in America." *African Arts* 11, no. 3 (April 1978): 84–85.

Leininger-Miller, Theresa A. *New Negro Artists in Paris: African American Painters and Sculptors in the City of Light, 1922–1934.* New Brunswick, NJ: Rutgers University Press, 2001.

Martin, Toby. *Form v. Thought.* Atlanta, GA: Little Sculptors Library, 1994.

Otfinoski, Steven. *African Americans in the Visual Arts.* New York: Facts on File, 2003.

Thomas, Trevor. "Artists Africans and Installation." *Parnassus* 12, no. 1 (January 1940): 32–36.

Carolyn Mazloomi (b. 1948), Quilt Maker, Cultural Activist, Author.

Carolyn Mazloomi has, in a span of two decades, become one of the best-known quilt artists in the nation. Since 1983, when she had her first exhibition at the Oakland Museum of Art in California, she has had about 50 solo exhibitions and participated in twice as many. Her solo exhibitions have been seen across many university campuses, in several galleries and museums nationwide, and internationally in England, China, and Belgium, among others. She has curated some of the most notable exhibitions on quilt, coedited a book and authored two others—*Spirits of the Cloth* (1998) and *Threads of Faith* (2004). In the course of her work as artist, curator, and author, Mazloomi has also acquired a reputation as a catalyst and organizer who has created a platform for rallying many African American practitioners of quilt against what she perceived as the potential danger of becoming stereotyped by the emerging scholarship in this area.

Yet, with her exhibitions and publications having had significant influence among scholars and collectors, Mazloomi often demonstratively proclaims that she is not a scholar; and only recently, after having won national and international acclaim, has she begun to feel comfortable with her classification as an artist. Mazloomi's position owes as much to her modesty and education as to her suspicion of scholars and critics. She came into art not through any formal exposure to art, but through a chance encounter with a piece of quilt; that encounter would forever change her career.

Mazloomi was born on August 22, 1948, and grew up in the Deep South—in Baton Rouge, Louisiana—during segregation. She was raised by her aunt, Oriana, who showered her with love and nurtured her interest in reading. By the time she was six, she had attained a remarkable fluency in reading. This, combined with the irreplaceable love of her Aunt Oriana, the one who truly cared for and loved her and who would sacrifice anything for her happiness, helped Mazloomi cope with the harsh racial environment of her childhood. The only thing that was as important to Mazloomi as her reading was Aunt Oriana. During her elementary education at Greenville Elementary, and her years at McKinely High and Capital High, her interest in reading, science, and especially mathematics, grew. By the time she graduated from Capital High in 1965, Mazloomi had participated in, and garnered laurels at many science fairs across the region, including one in Dallas, Texas, in 1964. She dreamed solely of becoming involved in aviation or medicine; the arts were a distant, almost nonexistent notion.

In 1977, Mazloomi graduated from Northrop University with a B.S. in airframe power plant engineering. Three years later, she obtained her Ph.D. in aerospace engineering from the University of Southern California (USC). With her specialized education, Mazloomi gained employment at Northrop Aircraft Industry; from there, she moved to Lockheed and worked as an engineer in research and development between 1976 and 1985. The turning point came when, as a student at USC, she went to the World Trade Market in Dallas where she saw a traditional quilt in one of the commercial stores and became

so fascinated that she determined there and then to teach herself quilt making and embrace it as a hobby. Over the years, as her involvement in traditional quilt making deepened, she became disenchanted by the limitations that the form imposed on her desire for self-expression. With its predictable rote and a heavy reliance on stitching together pastiches of other people's recycled ideas, quilt blocks lost their initial dazzle and, for Mazloomi, became boring and oppressively repetitive. While skills and techniques are a *sine qua non* in creating quilts, Mazloomi realized that they should be only a means, and not ends in themselves. She reasoned that repetitive floral designs and appliquéd memorabilia become memorable and outstanding as works of art only to the extent that their creation is anchored on a personal, passionately soulful and emotive platform. The urge to take ownership of her own designs—to become more self-expressive and spontaneous—led her in a new direction.

Carolyn Mazloomi. Courtesy of Chas E. Martin.

In 1986, she founded the Women of Color Quilters Network (WCQN), with a membership that is now at 1,500 located in several countries across the globe. The establishment of this organization provides an insight into the fierce individualism and social activism that inform Mazloomi's work. As an African American who grew up in the Deep South, her sensitivity to what she perceives as insipient stereotyping that scholars have foisted upon the public in the course of studying patchwork quilt provided the necessary fillip for the establishment of WCQN. She chafed at what she saw as the exploitation of poor rural quilters by collectors and scholars. In considering Mazloomi's impact and contributions to the arts, cognizance must be taken of her social activism on a global scale, and her empowerment of African and African American quilters, many of whom had felt marginalized, isolated, and vulnerable to exploitation by collectors. The emergence of this engineer-turned-artist is attributable in part to an inquisitive spirit, an insatiable, almost maniacal determination to self-educate, a robust business acumen, and a strong aversion for social injustice and exploitation of women. For example, while she started patchwork quilt on her own and mastered the craft even as she continued her studies at USC, she quickly realized that her chances of success would be considerably enhanced if she could turn her quilts into unique, one-of-a-kind pieces.

The need to move away from traditional patchwork quilt led Mazloomi to a search for style, in the course of which she realized that working on those things that she felt passionate about would give her work soul and substance.

Music, especially jazz music, emerged as one of a number of things that Mazloomi was passionate about. This explains the recourse to musical rapture in her work. In *Midnight Jazz* (2004), three inordinately tall figures do battle with music, with emphasis clearly placed on the musical instruments: a piano, a bass guitar, and a trumpet. From *Getting Dizzy* (2004), which pays homage to Dizzy Gillespie, to *What's Love Got to Do With It* (2005), an apparent reference to Tina Turner, admired by Mazloomi for overcoming domestic violence to establish her niche in the music industry, the discovery of music gave Mazloomi the necessary incentive to become much more personal in her quilts. Another recurrent theme in her work pertains to women's rights. In *A Peacekeeper's Gift* (2005), she addresses the negative impact that UN peacekeepers had on the security of women in places like Sierra Leone, Democratic Republic of Congo, and Sudan. *The Veil* (2005) draws attention to the burqa, which became synonymous with the Taliban's brutality against women in Afghanistan. Mazloomi has exhibited extensively at national and international spaces. including a 1995 international quilt exhibition that she curated in Beijing, China, as part of the UN Conference for Women.

Places to See Mazloomi's Work

Amistad Research Center, New Orleans, LA
Bank of America, New York, NY
Birmingham Civil Rights Institute, Birmingham, AL
Cincinnati Bell Telephone, Cincinnati, OH
Cleveland Public Library, Cleveland, OH
Coca-Cola Company, Atlanta, GA
Exxon, Houston, TX
Frauen in der Einen, Nuremberg, Germany
IBM, New York, NY
Indianapolis Museum of Art, Indianapolis, IN
Lewis and Clark College, Godfrey, IL
Manchester Craftsmen's Guild, Pittsburgh, PA
Museum of Art and Design, New York, NY
Museum of the American West, Los Angeles, CA
National Afro-American Museum, Wilberforce, OH
National Civil Rights Museum, Memphis, TN
National Underground Railroad Freedom Center Museum, Cincinnati, OH
New Jersey Historical Society, Newark, NJ
Phillip Morris Inc., New York, NY
Quilters' Hall of Fame Museum, Madison, IN
Rocky Mountain Quilt Museum, Denver, CO
Smithsonian American Art Museum Renwick Gallery, Washington, DC
Toyota Corporation, Los Angeles, CA
Wadsworth Athenaeum Museum, Hartford, CT
World Bank, Washington, DC
Private collections

Bibliography

Arnett, Paul. *Souls Grown Deep: African American Vernacular Art of the South.* Atlanta, GA: Tinwood Books in association with the Schomburg Center for Research in Black Culture, the New York Public Library, New York, 2000.

Benberry, Cuesta. *A Piece of My Soul: Quilts by Black Arkansans.* Fayetteville: University of Arkansas Press, 2000.

Cameron, Dan. *Dancing at the Louvre: Faith Ringgold's French Collection and Other Story Quilts.* New York: New Museum of Contemporary Art; Berkeley: University of California Press, 1998.

Cubbs, Joanne. "Interview with Carolyn Mazloomi," September 17 and 30, 2002. Smithsonian Archives of American Art, July 24, 2008. http://www.aaa.si.edu/collections/oralhistories/transcripts/mazloo02.htm.

Imami-Paydar, Niloo. *Stitch by Stitch: A Quilt Potpourri.* Indianapolis, IN: Indianapolis Museum of Art, 1996.

Jacobs, Joseph. *A World of Their Own: Twentieth Century African Fold Art.* Newark, NJ: Newark Museum, 1995.

Jefferies, Tamara. "Going Under: Artists and the Healing Power of Artmaking." *International Review of African American Art* 16, no. 4 (1999): 2–15.

Mazloomi, Carolyn L. *Spirits of the Cloth: Contemporary African-American Quilts.* New York: Clarkson Potter/Publishers, 1998.

———. *Quilting African American Women's History: Our Challenges, Creativity, and Champions.* Westchester, OH: Paper Moon Publishing, 2007.

———. *Textural Rhythms: Quilting the Jazz Tradition.* Westchester, OH: Paper Moon Publishing, 2007.

Pongracz, Patricia C., ed. *Threads of Faith: Recent Works from the Women of Color Quilters Network.* New York: Gallery of the American Bible Society, 2004.

Tobin, Jacqueline. *Hidden in Plain View: The Secret Story of Quilts and the Underground Railroad.* New York: Anchor Books, 2000.

Wahlman, Maude. *Signs and Symbols: African Images in African American Quilts.* Atlanta, GA: Tinwood Books, 2001.

Julie Mehretu (b. 1970), Painter.

At a glance, Julie Mehretu's work conjures a visual symphony in which an assortment of lines—geometric, organic, curvilinear—collide with, or are superposed on, shapes, textures, inscriptions, dots, and hatches. Almost always, an aerial scenario is suggested: wide vistas are laid out akin to a city grid seen from outer space. Mehretu's paintings evoke urban chaos in which shapes, lines, and colors are fragmented and placed in oppositional relationships that are held together by a tight sense of design and masterly control of space. Mehretu's visual orchestra is arranged in grids and layers, all of which are in dialogue moderated or, more appropriately, conducted by the artist. In their abstracted form, Mehretu has developed and individuated semiotics for simulating panoramic vignettes of urban geography or social landscape.

Layers of colors are arranged in broad spans, elegant swooshes, or delicate fragrances that ultimate serve as visual accompaniments to the forest of lines and shapes that coalesce on the canvas. She provides the raison d'être for her work:

> I have chosen to work with many types of different built environments—airports, large arenas, amphiteaters, churches, malls, mosques, city squares—generally, places that hold large numbers of people and operate internally, like a city. I am interested in the larger metaphoric potential of these types of places. For example, international airports have become the central hubs for a new type of circulatory system in a global cityscape; at the same time, they operate like mini-cities, complete with shopping, eating, sleeping, exercise, and civic facilities. (Fogle and Ilesanmi 2003)

This new visual language of abstraction, one in which numerous layers of potential realities are suggested and eviscerated, has drawn attention to the work of this artist, who has contributed significantly to our understanding of the creative sacraments that gird her work with her eloquent statements and interviews. Mehretu positions her work within a crossroads of identity, one that employs abstracted vignettes as a metaphor for the multiple sources that inform her individuality. While her work evokes the site of an architect's studio, in which a creative child has been let loose cutting and rearranging blue prints of airports, stadia, and city arteries and enhancing them with strips of translucent colors that are constitutive of a new geocentric order, Mehretu ascribes her work to the process of layering or delineation that is encoded in mapping: "Part of my work is about mapping. I like the idea that everything fits into a structure with a map or an architectural plan, but part of it is also about mapping who I am. . . . My parents come from such historically opposing points of ethnicity: Polish Jew; French; English; Lynchburg, Virginian; Amharic, Tigre and Eritrean, but somehow they came together to make me" (Sirmans 2001).

Mehretu, the eldest of three children, was born on November 28, 1970, in Addis Ababa, Ethiopia. Her sister Neeshan, was born in 1972, while her brother David was born in 1975. Her mother, Doree E. Mehretu, a white American from Alabama, is a Montessori teacher, while her father, Assefa Mehretu, originally from Ethiopia, is a professor of economic geography at Michigan State University. Mehretu's creative impulse owes as much to the family flair for education as to the artistic temperament of her grandmothers: one was into traditional Ethiopian crafts, while the other was a sculptor and painter in the western tradition. Mehretu's maternal great aunt and mother's sister are painters. Growing up within a family with such an admixture of cultural values provided the initial fillip for Mehretu to find her own creative path. With both parents fully invested in education, Mehretu's early years in Montessori served as a catalyst. Her education in Ethiopia—at the Good Shepherd elementary school—was interrupted when Mehretu's parents left Addis Ababa in 1977 and moved to East Lansing, Michigan. There, she completed her elementary school and attended Hannah Middle School in 1981. Mehretu then spent a year, 1984–85, at Mount Pleasant High School in Harare, Zimbabwe, after which she returned to East Lansing High School (in 1985), completing her high

school education in 1988. From 1990 to 1991, she attended University of Cheik Anta Diop in Dakar, Senegal, before moving to Kalamazoo College, Michigan, where she received her B.A. degree in 1992. For the next three years, Mehretu waited tables in New York and continued to paint what she believed were uninspired paintings. She then attended Rhode Island School of Design, graduating with M.F.A. honors in 1997.

Two of the key group exhibitions that catapulted her to national attention occurred in 2000: the "Greater New York" exhibition at P.S. 1 in Contemporary Art Center in New York, and the "Freestyle" at the Studio Museum in Harlem, New York. In 2001, she had two solo exhibitions—at The Project in New York, and at Art Pace in San Antonio. What has earned Mehretu considerable attention has been the originality of her work, which advances abstraction in a new direction. Added to this is the employment of a new creative semiotics that aptly captures Mehretu's trajectory on race, culture, migration, and identity. In 2003, Mehretu had a residency at the Walker Art Center in Minneapolis, during which she worked with her brother David, and organized 30 youngsters of East African descent to participate in interactive sessions that undertook ethnographic excavation of cultural identity using a variety of media, including photography, journals, and audio recording. In 2007, as part of a grand scheme to rehabilitate the cultural life of the city, the Detroit Institute of Arts commissioned Mehretu to create a new body of work for its galleries. During her monthlong residency, she worked with 40 art students from public high schools in the city to produce "City Sittings," a new body of work that was meant to compliment the Diego Rivera frescoes in the Institute's galleries. In these two instances—Walker and Detroit—Mehretu has consciously adopted a proselytization mechanism that is aimed at spreading the visual gospel of the excavation of individual and corporate identities.

Mehretu has had numerous solo exhibitions since she made her professional debut in 1995, across the country and in South Africa and London, with an even greater participation in group exhibitions in countries like Australia, Spain, Denmark, England, Germany, Italy, and Japan among others. She has received numerous grants and residencies, including a residency at the Walker Art Center, Minneapolis; the MacArthur fellowship; and the American Art Award of the Whitney Museum of Art.

Places to See Mehretu's Work

Brooklyn Museum, Brooklyn, NY
Carnegie Museum of Art, Pittsburgh, PA
Contemporary Museum, Honolulu, HI
Detroit Institute of Arts, Detroit, MI
Minneapolis Institute of Arts, Minneapolis, MN
Museum of Fine Arts, Boston, MA
Museum of Fine Arts, Houston, TX
Museum of Modern Art, New York, NY
National Gallery of Art, Smithsonian Institution, Washington, DC
New Museum of Contemporary Art, New York, NY

Philadelphia Museum of Art, Philadelphia, PA
San Francisco Museum of Modern Art, San Francisco, CA
Studio Museum in Harlem, New York, NY
Virginia Museum of Fine Arts, Richmond, VA
Walker Art Center, Minneapolis, MN
Whitney Museum of American Art, New York, NY

Bibliography

Chua, Lawrence. *Julie Mehretu.* Leon, Spain: Museo de Arte Contemporaneo de Castilla y Leon, 2007.

Cotter, Holland. "Glenn Brown, Julie Mehretu, Peter Rostovsky." *New York Times,* June 23, 2000.

De Zegher, Catherine. *Julie Mehretu: Drawings.* New York: Rizzoli, 2007.

Firstenberg, Lauri. "Painting Platforms in NY." *Flash Art* 35, no. 227 (November–December 2002): 70–75.

Fogle, Douglas. *Painting at the Edge of the World.* Minneapolis, MN: Walker Art Center, 2001.

Fogle, Douglas, and O. Ilesanmi. *Julie Mehretu: Drawing into Painting.* Minneapolis, MN: Walker Art Center, 2003.

Golden, Thelma, H. Walker, and D. Hunt. *Freestyle.* New York: Studio Museum in Harlem, 2001.

Harney, Elizabeth. *Ethiopian Passages: Contemporary Art from the Diaspora.* Washington, DC: National Museum of African Art, Smithsonian Institution, 2003.

Hoptman, Laura. "Crosstown Traffic." *Frieze* 54 (September 2000): 104–7.

Iles, Chrissie, Shamim Momin, and Debra Singer. *Whitney Biennial 2004.* New York: Whitney Museum of American Art and Harry N. Abrams, 2004.

Njami, Simon, ed. *Africa Remix: Contemporary Art of a Continent.* Ostfildern-Ruit: Hatje Cantz, 2004.

Sirmans, Franklin. "Mapping a New, and Urgent, History of the World." *New York Times,* December 9, 2001, 41.

Archibald Motley (1891–1981), Painter.

Motley grew up in a predominantly white environment in Chicago, one in which he and his nephew Willard, who would later write *Knock on Any Door,* felt very comfortable. His was the only black family living in a white neighborhood of about a three-mile radius. His father, Archibald Motley Sr., ran a merchandise store in New Orleans, where he married Mary Huff, a teacher. On October 7, 1891, Archibald Motley was born, one of two children. His sister was Flossie, whose son, Willard, would provide considerable help to Motley later in life as he faced health problems. Soon after, his parents came under pressure from white competition to leave New Orleans. They eventually settled in a comfortable white neighborhood on West 60th Street in Chicago (Bearden and Henderson 1993, 147). Motley Sr. operated a buffet Pullman car as a railroad porter. While that had exposed the Motleys to a different social

class, it also denied Motley the opportunity of becoming fully enculturated into the black stratum of the society during his childhood.

When he was in fifth grade, for example, he would go over to a poolroom near the school to observe blacks who were the main patrons. "There was nothing but colored men there. The owner was colored. I used to sit there and study them and I found they had such a peculiar and such a wonderful sense of humor, and the way they said things, and the way they talked, the way that they expressed themselves, you'd just die laughing. I used to make sketches even when I was a kid then" (Barrie 1978). Soon, Motley found other places near his home—churches, gambling houses, dance halls, skating rinks and movie houses—where he was able to do some sketches. Although Motley may have grown up in a white neighborhood, he was not immune from the supremacist disposition of the dominant society. For example, the paintings of club scenes, which he did when he was in Paris in 1929, was derived from a series of sketches of blacks—from Senegal, Martinique, or North America— who patronized the café. Yet, there is often the assumption that the subjects in the painting are African Americans. For Motley, who felt as comfortable among whites as he did among his people, and an artist who continually acknowledged the substantial help that he received from his white instructors, administrators, and patrons, he was far more accommodating than most of his peers on matters of race. This does not mean that he was less sensitive to racial injustice. On two separate occasions—one in Atlanta, Georgia, where he was subjected to the indignity of a white streetcar operator, and the other in Paris, France, where some African Americans called him "Nigger"—Motley's instinct for confronting racial bigotry nearly came to the fore.

Motley appeared to have spent the rest of his adult life compensating for his childhood. First, while he was in elementary school, he found the space and time to observe the cultural mannerisms of his people. Later as he found his voice and style as an artist, he became fascinated with exploring the distinctive characteristics of people in general, but all the while privileging blacks. He attended an elementary school where art was a nominal subject. However, he received encouragement from some of his teachers, who showed interest in his work even at such an early stage. Motley had no illusion that he was going to study art. In high school, he stood apart from many of his schoolmates on account of his versatility in producing several posters and school announcements for the bulletin board. With a one-year scholarship from his father's friend Frank Gunsaulus, who had tried unsuccessfully to recruit Motley to study architecture at the Armour Institute (now Illinois Institute of Technology), he entered the Art Institute of Chicago in 1914, where he developed an interest in composition: "I found composition got so intriguing, so very interesting to compose something in your mind, your imagination and build it up and make something out of it. . . . I'd start first making small pencil sketches in a small sketchbook and usually for one painting . . . I make from thirty-five to forty pencil sketches until I get the thing arranged just the way I want it" (Barrie 1978). At the Art Institute, Motley won merit award not only in composition but also in portrait painting.

By the time Motley graduated from the Art Institute in 1918, he had fully developed the key concepts and principles—of portraiture and compositions that express behavioral characteristics of his people—which would become pivotal to his emergence and contribute to his stylistic uniqueness. It was a style that Karl Buehr, his professor, implored him to keep because it would be beneficial to him later. Motley made a deal with Buehr; it was a deal that he never broke. He was opportuned in the summer of 1917 to travel extensively on trains with his father when he secured a vacation job as a porter. He did some sketches and started painting. In 1924, Motley married Edith Granzo, a German American high school sweetheart who lived in Motley's neighborhood. Their only child, Archie, was born in 1931.

Motley derived inspiration from a number of sources: the old masters, especially the seventeenth-century Flemish painter, Frans Hals; George Bellows, who shot to limelight early in the twentieth century on account of the compelling flair with which he captured urban scenes in New York; John Sloan, a member of The Eight, or the Ashcan School, noted for its portrayal of candid urban scenes in Philadelphia; and Karl Buehr, Motley's instructor at the Art Institute. What emerged in Motley's paintings is his keen interest in people: his people. He was intrigued with shades of skin pigmentation among black people, which is exemplified by *Octoroon* (1928), one of many paintings that he did on the subtle differentiations in the skin of blacks. Many of his paintings focused on street scenes and club environments in which artificial light combine with his depiction of jazz music to portray a class of blacks that stood in sharp difference to the unflattering representation that was favored by the mainstream culture.

Two genres characterize Motley's oeuvre: portraiture and scenes. A 1924 portrait that he did of his grandmother, *Mending Socks,* typifies Motley's grasp of portraiture and composition. His paternal grandmother, Emily, was a domestic slave in the Craighead family in Tennessee who treated her with dignity and humaneness, buying her good clothes and giving her education comparable to that of eighth grade (Barrie 1978). The oval painting in the upper left hand corner of Motley's *Mending Socks* was the same prized painting of his grandmother's mistress, which was given to her when she was freed. In *Nightlife,* a 1943 oil on canvas, Motley depicts a social nightlife in which the animated crowd is having an exciting time. The notion behind his portrayal of well-dressed African Americans in a joyous mood represents a deliberate attempt at recuperating the battered image of blacks who, as Motley wrote, have been depicted "as the ignorant, southern, 'darky,' to be portrayed on canvas as something humorous; an old southern black Negro gulping a large piece of watermelon: one with a banjo on his knee, possibly a 'crapshoote' or a cotton-picker or a chicken thief" (Bearden and Henderson 1993, 152).

In the 1920s, while the Harlem Renaissance was at its peak and the Harmon Foundation, which had been established in 1922 by a white real estate developer William E. Harmon, continued with its efforts at recognizing the achievements of African American artists. Motley's work came to regional attention during this time as he received critical reviews at a number of exhibitions in which he participated in Chicago. Through the personal interest and support

of Robert B. Harsche, director of the Art Institute, Motley's *Mending Socks* was entered into a 1927 exhibition in Newark Museum, New Jersey, where it won the "most popular" prize (Bearden and Henderson 1993, 150). In 1928, his painting won a gold medal award at the year's Harmon Foundation exhibition. But it was his 1928 solo exhibition in New Galleries, New York, that catapulted him to national limelight. Of the 26 paintings that George Hellman took in for the show, 22 were sold. This gave him the financial buoyancy needed to leave his part-time work as a handyman and devote himself exclusively to his paintings. Motley's highly successful exhibition was the first solo show in New York since **Henry Ossawa Tanner**. The following year, he won a Guggenheim Foundation Award, which enabled him to travel to Paris for one year. Upon his return from France, he was employed as artist at the Public Works of Art Project, where he later became a supervisor.

In 1945, he suffered a depression that was triggered by the death of his wife. As part of his recovery efforts, he worked with other artists in a large factory and spent some time with his nephew Willard in Cuernavaca, Mexico. Motley eventually returned to easel painting and was among 10 African American artists who were recognized by President Jimmy Carter in 1980. He died on January 16, 1981.

Places to See Motley's Work

Ackland Art Museum, University of North Carolina at Chapel Hill, Chapel Hill, NC
Art Institute of Chicago, Chicago, IL
DuSable Museum of African American History, Chicago, IL
Hampton University Museum, Hampton, VA
Howard University Gallery of Art, Washington, DC
New York Public Library, New York, NY
Southside Community Center, Chicago, IL
Western Illinois University Art Gallery and Museum, Macomb, IL

Bibliography

Bailey, David A., and Richard J. Powell. *Rhapsodies in Black: Art of the Harlem Renaissance.* London: Hayward Gallery, the Institute of International Visual Arts; Berkeley: University of California Press, 1997.

Barrie, Dennis. "Oral History Interview with Archibald Motley at His Home in Chicago, Illinois," January 23, 1978. Smithsonian Oral Histories. http://www.aaa.si.edu/collections/oralhistories/transcripts/motley78.htm (accessed December 6, 2008).

Bearden, Romare, and Harry Henderson. *A History of African-American Artists from 1792 to the Present.* New York: Pantheon Books, 1993.

Craven, Wayne. "An Awakening." *American Art* 11 (1997): 42–44.

Harris, Michael D. *Colored Pictures: Race and Visual Representation.* Chapel Hill: University of North Carolina Press, 2003.

Huggins, Nathan Irvin. *Voices from the Harlem Renaissance.* New York: Oxford University Press, 1995.

Jacobson, Jacob Z., ed. *Art of Today, Chicago, 1933*. Chicago, IL: L. M. Stein, 1933.

James, Curtia. "Archibald J. Motley, Jr., at the High Museum at Georgia Pacific Center." *Art in America* 81 (1993): 116–17.

Leininger-Miller, Theresa A. *New Negro Artists in Paris: African American Painters and Sculptors in the City of Light, 1922–1934*. New Brunswick, NJ: Rutgers University Press, 2001.

Mooney, Amy M. *Archibald J. Motley Jr.* San Francisco, CA: Pomegranate, 2004.

Powell, Richard J. "Art of the Harlem Renaissance." *American Art Review* 10 (1998): 132–37.

Robinson, Jontyle Theresa, and Wendy Greenhouse. *The Art of Archibald J. Motley, Jr.* Chicago, IL: Chicago Historical Society, 1991.

Wangechi Mutu (b. 1972), Sculptor, Collagist, Installation Artist.

Based in New York, Mutu has become the toast of the art establishment not on account of her sculptures, but solely on the strength of her collage and assemblage pieces, which employ cutouts from glitzy magazines and splotches of acrylic and sumi ink on Mylar to produce phantasmagoric anthropomorphic forms that mutate at the command of the artist. What transpires is a mesmerizing visual hybridity, which reflects the confluence of cultural and continental influences in the artist's work.

Mutu, who lives in the Bedford-Stuyvesant neighborhood of Brooklyn, New York, was born in 1972 into the Kikuyu nation and raised in Nairobi, Kenya, by a middle-class family. Her father, Mutu wa Gethoi, is a research professor in Nairobi. Her mother, Wambura Mutu, is a retired nurse and midwife who also lives in Nairobi. In 1992, Mutu came to the United States with her parents. For a while, her father was a visiting professor at Marquette University, Michigan State University, and the University of Florida in Gainesville, where he taught African literature in the fall of 2002. In Nairobi, Mutu attended a private Catholic school and worked for a while as a graphic designer. In 1989, she left Kenya for England, where she attended an international boarding school. In 1996, she graduated from Cooper Union for the Advancement of the Arts and Science in New York with a B.F.A. degree. In 2000, Mutu earned her M.F.A. degree from the School of Art at Yale University, with a major in sculpture.

Although her drawings, collage pieces, and installation art have secured her reputation as an immigrant artist, sculpture provides the artist with the nuggets of ideas that have coalesced into a colossal success. Growing up in Kenya, the artist received advice and support from Richard Leakey, a conservationist, paleoanthropologist and erstwhile director of the National Museum of Kenya, whose expeditions have led to successful fossil finds on the African continent. Leakey, who was active in Kenyan social and political life, had seen the young Mutu act on stage in Nairobi and encouraged her to apply to the school in Wales that his daughter had attended. Additionally, Leakey encouraged Mutu's desire to become an artist.

As a student in New York, Mutu combined anthropology and cultural studies with fine art. She was fascinated by the way that anthropology became a gateway for dissecting and analyzing the historical and material culture of other groups. At Cooper, Mutu began to make sculptures that played to the incredulous naïveté of many of her peers in class whose critiques were colored by the stereotypical notion that every sculpture from the African continent must look like those that are popularized in museum holdings, exhibition catalogs, and other publications that romanticize the continent. Mutu's response to such oversimplified perceptions was to make irreverent, tongue-in-cheek objects that played up to the credulity of her fellow students (Firstenberg 2003, 143). Using found objects—bottles, tar, feathers, cowrie shells, and knick-knacks—Mutu would make "African" objects that faked the patina and encrustations that are associated with "authentic" African art. Along this line, Mutu constructed large apparels and three-dimensional adornments that were meant to be worn, just like those African objects that are seen in ethnographic publications. To play up her irreverent response to the general assumption of Edenic Africa, the objects thus manufactured by Mutu were photographed, bathed in dramatic lights, and positioned against pristine backgrounds that accentuated their assumed awesomeness.

Although Mutu's art is radically different from the classical African sculptures that spurred her saucy three-dimensional objects, the artist's inspiration comes from the continent. Included in *ARTnews* 2004 trendsetters list of 25 movers, shakers, and makers, Mutu uses photomontage in an audacious way that emphasizes an indebtedness to her African upbringing and an acknowledgment of the empowering culture of the West. For her, the notion of the artist in Africa conjures a different paradigm from the prevalent idea of the Western artist. Studying in the United States and living in an environment where creative minds could interact with the purpose of mapping out trajectories for developing their art provided Mutu with the incentive to combine the best of the two cultures that she has been privileged to experience. From Africa, Mutu borrows from the Makonde, a group that is found in Tanzania, Mozambique, and Malawi, whose sinuously intertwined sculptures of *shetani*, or spirit figures, are interwoven into a labyrinthine configuration that is not dissimilar to Mutu's fantastic and biomorphic works. Mutu draws from the fascinating folktales that she had heard in Lamu, Kenya, where she had worked earlier, and also from her mother and grandmother. The folktales, like *shetani* figures, are ethereal characters who transgress norms and transcend borders. They move from the abode of the dead to interact with and mediate the affairs of the living. Mutu's collage works are, at some level, a replication of the ideals that inform African folktales and the *shetani* sculptures of East Africa.

In 1992, she witnessed a protest in Kenya by a group of mothers who were clamoring for the release of their teenage children who were being held for political reasons. In a gesture that was meant to invoke the power of women and emphasize the shamelessness and corruption of people in power, the women stripped themselves bare in public. The idea of the power of the female body that is expressed in this demonstration was one of the lessons that Mutu

has appropriated and processed. Her work exemplifies the confluence of African and Euro-American ideals and practices. In 2001, shortly after leaving graduate school and forced to adapt in the absence of resources to produce three-dimensional work, she began using ink, pen, and colors to create her "Pin-Up Series," in which she transformed female bodies into a festival of unimaginable colors and apparitional beauties organized on a calendrical format. There is one caveat: every one of the female figures bears the scars of the ravages of war and the brutalizing effect of political turmoil that Sierra Leone and Liberia experienced until recently. Mutu's intent was clear: "I wanted you to walk up to [the series] assuming you were going to see these pretty, interestingly posed females. It takes people some time to see that every single one of them has some trauma or alteration that is severe and aggressive" (Kerr 2004, 29).

Mutu obsesses over the use of women in her work. The female body has, perhaps recalling her Kenyan experience, become an essential tool that is manipulated, mutilated, transformed, and camouflaged to draw attention to a number of social and economic issues. In her interview with Lauri Firstenberg, Mutu explains the recourse to the creative mode: "Camouflage and mutation are big themes in my work, but the idea I'm most enamored with is the notion that transformation can help us to transcend our predicament. . . . The language of body alteration is a powerful inspiration. I think part of my interest in this comes from being an immigrant." Mutu's collages feed on figures of women cannibalized from glossy publications, pornographic magazines, *National Geographic,* and other sources. She dismembers the photographs and reconstitutes them, mixing the disparate assemblage with acrylic and ink, which are exploded to conjure an extraterrestrial planet in which women with skin full of blotches grow horns, hair, or other contrivances, strut on delicate platforms constructed of beautified and elegant mushrooms, and pose on prosthethic limbs. Their lips are succulently grotesque, their eyes bulbous and inordinately spaced, or small and inconsequential, while juiced-up models with tantalizing poses harbor afflictions that can be gleaned only on up-close inspection. The female body is the object of Mutu's focus because she believes that, more than their male counterparts, females bear the emblems and cultural notations of their people.

Mutu has had an impressive success, judging by the fact that since 2003, she has had numerous solo exhibitions at important exhibition spaces that include the San Francisco Museum of Modern Art, Miami Art Museum, Art Pace in San Antonio, Texas, and Jamaica Center for the Arts and Learning in New York. She has also participated in innumerable list of group exhibitions nationally and internationally.

Places to See Mutu's Work

Altoids Collection, New Museum of Contemporary Art, New York, NY
Blanton Museum of Art, University of Texas at Austin, Austin, TX
Judith Rothschild Foundation, Museum of Modern Art, New York, NY
Miami Art Museum, Miami, FL

Museum of Contemporary Art, Chicago, IL
Museum of Contemporary Art, Los Angeles, CA
Museum of Modern Art, Judith Rothschild Foundation, New York, NY
Museum of Modern Art, New York, NY
Saatchi Collection, London, UK
San Francisco Museum of Modern Art, San Francisco, CA
Studio Museum in Harlem, New York, NY
Whitney Museum of American Art, New York, NY

Bibliography

Blum, Kelly, and Annette Carlozzi DiMeo. *Blanton Museum of Art: American Art Since 1900*. Austin: University of Texas at Austin, 2006.

Cotter, Holland. "Feminist Art Finally Takes Center Stage." *New York Times*, January 29, 2007, E 1.

Cox, Lorraine Morales. "Transformed Bodies, Colonial Wounds & Ethnographic Tropes: Wangechi Mutu." *N.Paradoxa: International Feminist Art Journal* 21 (January 2008): 67–75.

de La Forterie, Maud. "Africa Remix Continental." *Art Actuel* 38 (May–June 2005): 47–50.

Firstenberg, Lauri. "Perverse Anthropology: The Photomontage of Wangechi Mutu." In *Looking Both Ways: Art of the Contemporary African Diaspora*, edited by Laurie Ann Farrell, 137–43. New York: Museum for African Art; Gent: Snoeck, 2003.

Heartney, Eleanor. *Art & Today*. London: Phaidon Press, 2008.

Kelly, Kevin. "Reward for Creative Touch." *Daily Nation* (Kenya), July 25, 2004.

Kerr, Merrily. "Extreme Makeovers." *Art on Paper* 8, no. 6 (July–August 2004):, 28–29.

Pollack, Barbara. "Panic Room." *Time Out New York*, January 13–19, 55–56.

N

Barbara Nesin (b. 1951), Painter, Multimedia Artist.

Barbara Nesin is a painter, collagist, and educationist whose life and work are comprised of diverse elements and fractions that challenge our standard embracement of the diversity trope. Growing up in the boroughs of New York City, where she was born on January 5, 1951, Barbara was taught by her art-loving parents to be colorblind and not privilege race over individuality. An only child of a Haitian "mulatto" mother who was conscious of her racial status, and to a father, an Ashkenazi (European) Jew who had a progressive political bent and a passion for social activism, Nesin was socialized into a life in which art played an important role. Although her parents were not professional artists, they delighted in exercising their drawing skills with the sketches of people that they made. They nurtured Nesin's passion for art from an early age through such display of enthusiasm and skills, and by taking her to museums, plays, and classical music. Given her exposure to art books at home and to her father's modest collection, which included a portfolio of William Blake's color prints, it did not take long before Nesin began to see herself as an artist and a teacher.

At age 14, she lost her father, and her mother was hospitalized. She relocated to Maine where she lived with her father's brother and his family of seven children. Although the high school that Nesin attended in Maine did not have an art program, this did not deter her from achieving her goal of pursuing it at the college level. In 1975, she graduated from Pratt Institute with a B.F.A. degree, in addition to receiving certification as an art teacher. But her dream of gaining employment as an art teacher in New York City was dashed by a hiring freeze because of a budget shortfall. Finding a job eventually would lead Nesin to the banking sector, where she began employment initially as a stopgap, but ended up earning an M.B.A. and eventually becoming a vice president of a major bank. While the financial compensation was good, Nesin felt disconnected from art, which created a void that she began to worry about. In 1994, at age 43, she enrolled at Indiana State University and graduated with an M.F.A. in 1996.

As a multimedia artist, Nesin's work focuses on issues of diversity, religious syncretism, and multiculturalism, which approximate the sums of her life's experiences. Notions of "metissage," a political strategy that is meant to affirm the uniqueness of the individual experience and to establish a bulwark against

Barbara Nesin, 1997. Courtesy of Barbara Nesin.

dominance and oppression, constitute the thematic undercurrents for her work. Her art is located in the spaces between the compartments occupied by the standard categories that the field often employs: American; African American; Black; Jewish; Haitian; and Minority. Nesin's strength lies in attempting to synthesize in her work seemingly divergent streams of religious, social, and artistic thought and processes. As Haitian American of Jewish descent, Nesin empathizes in her work with the physical, spiritual, and abstract notions that she embodies. She draws from her Haitian culture because Haiti exemplifies the paradox that Nesin hankers after in her work. The first black nation to declare its independence from European domination in 1804, Haiti's history as a nation, with the bouts of subjugation that it has experienced at the hands of Euro-American powers, has parallels with the experience of blacks in the Diaspora, and of African Americans in the pre- and post–civil rights era. The demonization of Haiti by the West, which began as a reprisal for the country's audacious assertion of sovereignty, has become internalized by most Haitians in a way that seems to cast a damper on the country's psyche.

In Nesin's "Ayiti Cherie (Dear Haiti)" series, she attempts to resuscitate the nostalgic innocence that she experienced as a prepubescent girl who, during her one-year stay in the country in the hey days of the "Papa Doc" Francois Duvalier dictatorship, was ensconced by a protective mother who invoked the awesome symbolism of the American flag, which she placed on the porch to warn any of the terrorizing political gangs to keep their distance. Nesin's firsthand experience in Haiti, her mother's native country, was complemented by the emotional epiphany that she had at her uncle's funeral ceremony, which resonated with her so profoundly that she decided to study the Jewish faith. Realizing that she could be black and Jewish was a liberating experience, one that she has continued to explore in her works. Her research into world religions becomes one of the tools that she employs in pushing a new advocacy for globalism and multiculturalism. As a means of deconstructing her identity, she committed herself to understanding the basic tenets of some religious faiths—Haitian, African, European, Native American, and Judaic. A 1998 trip to France, where she saw tapestries on the conversion of Jews to Christianity, whetted her appetite to dig into the history of the Jews in Spain, the Spanish Inquisition, and their expulsion from that country in 1492. In studying Voudou, the Creole religion of Haiti, she came to the realization that although Hollywood has contributed to the trivialization of this religion, it is a religion with connections to African, Christian, Jewish, Islamic, and Native American elements, with pervasive impact on the culture as a whole.

Most of her work is an exploration of the visual, spiritual, and ideological connections between Haitian and Jewish traditions, using mixed media.

Places to See Nesin's Work

Private collections in the United States

Bibliography

Benson, LeGrace. "Arts of Haiti Research Project." XX International Congress of the Latin American Studies Association, Guadalajara, Mexico, April 1997 (Ithaca, NY: Arts of Haiti Research Project).

———. "Ketuba for Agwe: A Selection of Paintings by Barbara Nesin." Paper presented at Kosanba Colloquium V, Nova Southeastern University, Fort Lauderdale, FL, June 2003.

Heath, Jennifer. "Multicultural Images." *Boulder Planet,* Boulder, CO, March 19, 1997, 4C.

Houlberg, Marilyn. "Sirens and Snakes: Water Spirits in the Arts of Haitian Vodou." *African Arts* 29, no. 2, special issue, *Arts of Vodou* (Spring 1996): 30–35.

McAuliffe, Shena. "Culture Collage: Collector and Artist Join in Pasting Worlds Together." *Rocky Mountain Bullhorn,* Fort Collins, CO, April 2001, 16.

Nesin, Barbara. "The Cultural Content of Haitian Art." *Anales del Caribe* 14–15. (Havana: Centro de Estudios del Caribe/Casa de las Americas, 1995): 259–66.

———. "Teaching Diversity Through Art." In *Collage.* Fort Collins, CO: Colorado Art Education Association, Spring 1998.

———. "Haiti." In *Esther's Legacy: Celebrating Purim around the World,* edited by Barbara Vinick. Waltham, MA: Haddassah International Research Institute on Jewish Women at Brandeis University, 2002, 45.

Pérez y Mena, Andrés I. "Cuban Santería, Haitian Vodun, Puerto Rican Spiritualism: A Multiculturalist Inquiry into Syncretism." *Journal for the Scientific Study of Religion* 37, no. 1 (March 1998): 15–27.

Reid, Graeme. "Exhibit Draws on Turbulent Heritage." *Tribune Star,* February 5, 1995, B3.

Thompson, Robert Farris. "Tap-Tap, Fula-Fula, Kíá-Kíá: The Haitian Bus in Atlantic Perspective." *African Arts* 29, no. 2, special issue, *Arts of Vodou* (Spring 1996): 36–45.

O

Odili Donald Odita (b. 1966), Painter.

The paintings of Odili Donald Odita are structured such that they can theoretically cover endless spans of space and still maintain an aesthetic integrity and a compelling wholeness. In the abstract configurations that have become Odita's distinctive creative signature, bands of colors, often sharp, angular, chevron, or distorted rhombus are sent in trajectories that are sometimes poetic and at other times mesmerizing. The palette, arranged often to conjure a mood, is as important to the finished work as it is in suggesting moods or evoking notions. They recall landscapes and geographies of a different sort: those that are summoned forth through the power of imagination and execution. What is Odita's work about? In an interview that was widely distributed in conjunction with the installation of his work at the Contemporary Arts Center in Cincinnati in 2007, he provides an answer: "My work entails abstract designs that come from painting. I am dealing with patterns and designs that come from African textiles, but it also refers to geography—to landscapes. The paintings are often called internal geographies. . . . In a certain sense they are my internalization of Africa—this landscape space that I was born in but haven't lived in a large part of my life."

Odita typifies the new generation of contemporary black artists—the first generation of African Americans whose parents migrated to the United States in search of a golden fleece. He was born in Enugu, a coal city on the east of the Niger River in Nigeria on February 18, 1966, to Chinyere Florence Odita and Emmanuel Odita, one of the first generation of contemporary Nigerian artists to emerge on the art scene in the 1960s, the decade that Nigeria attained independence from Britain. On January 15, 1966, a military coup had toppled the federal government of Nigeria. Within a few months, this resulted in a pogrom in the northern part of the country, leading to the massacre of thousands of Igbo men, women, and children, Odita's kinsmen. Later that year, shortly before the 1967 civil war that erupted following the secessionist bid of Biafra, the Odita family fled Nigeria with six-month old Odita. The oldest of four children—two brothers and a sister—Odita grew up in Columbus, Ohio; his father, who earned his doctorate degree in art history from Indiana University, is professor of art history at Ohio State University.

Odita grew up with exposure to comic books, the television, cartoons, and video games. Equally, he grew up African; specifically, a Nigerian of Igbo

ancestry. He was surrounded by the art produced by his father, as well as the artifacts and elements of material culture from the Igbo nation. While he lived American, he breathed Nigerian, in an American household that practiced the African concept of extended family where family became redefined to include members of the same ethnic, national, or continental affiliation. Odita drew his creative inspiration from his father, in whose studio he spent much of his spare time drawing away and working as an assistant. There, he had full access to his father's library of art history and became familiar with key trends and movements in art at an early age. Through the interviews that his father had with artists, Odita became familiar with some artists. From his mother, Odita learned about the preeminence of culture in shaping one's understanding of a people's history. His mother, who loves shopping and collecting antiques, would take young Odita along during her shopping trips to flea markets. At a young age, Odita became exposed to an important aspect of American culture and became aware of colors and design through objects and other cultural paraphernalia. The cumulative impact of this socialization process is what has provided Odita with the philosophical rationale for his work. In a January 2008 interview with this author, Odita declared: "I've always been interested in a kind of art that is engaged intellectually and intelligently with abstraction and with the history of Western painting. I also know that I come from a history that is intrinsically African, and I am strongly interested in promoting and working through that fact."

Odita had his elementary school education in the Upper Arlington City School District school system and attended Upper Arlington High School from 1980 to 1984. He attended Ohio State University, majored in painting, and graduated with distinction in 1988. In 1990, he obtained the M.F.A. degree from Bennington College in Vermont. He moved to New York soon after and met two other Nigerians—**Okwui Enwezor** and Olu Oguibe—whose thoughts and activities would have a significant impact on the direction of his work. Enwezor, who founded *Nka: Journal of Contemporary African Art* early in the 1990s, would rise to become perhaps the foremost influence on global art in the last quarter of the twentieth century. In addition to a string of groundbreaking publications, Enwezor was the artistic director of the 2nd Johannesburg Biennale in 1996–97, and Documenta 11 in Kassel, Germany, from 1998–2002. Oguibe, professor of art and art history at the University of Connecticut, has been a dominant force whose writings and curatorial work brought considerable attention to the work and social conditions of contemporary artists, especially those of dual ancestry, in the United States. The ensuing conversations and debates that this encounter engendered gave Odita new perspectives into the art-making process. He ventured into installation and computer-aided designs and, for a while, stopped painting.

Although he grew up American, his work is embedded in issues that use his African heritage as an effective leverage to draw attention to the ubiquitousness of the twin issues that continue to plague American society: race and gender. Some of the work that he did shortly after leaving graduate school show his connectedness with the two cultures that have shaped his persona: African and American. Using wallpaper, house paint, and Plexiglas, Odita produced a

series of work that employed photocopies as a metaphor for the loss of individuality, which occurs in a world that is continually dominated by technology and mass reproduction. From his standpoint, the multiplicity of images that the medium facilitates captures the notion of distance from an original point, something that has applicability to his social status. In the exchange that photocopies foster, new value regimes emerge, and the feasibility of new permutations is enhanced. The wallpaper is a signifier for visual terminality: it is the culmination, in the estimation of Odita, of all that Western tradition of painting has to offer—"a system repeating itself, creating a fabric." In addition to this mélange of sources for creating visual images, Odita became interested in the electronic medium: computer screen savers and television test band patterns suggested new modes of transmitting visual impulses that bypassed the canvas. This led Odita to stop painting from 1994 to 1997, during which he went into conceptual work and explored electronic images among other media.

When he came back into painting in 1997, he went fully into the abstract field, in which panoramic color fields suggest the rupturing of space. While Odita's new paintings are limited by the physicality of the space they inhabit, they are conceptually interminable: they can be used as wraparounds, which evokes the notion of the wallpaper but in a different context. Rather than signify the end of an engagement, they initiate it. A project that exemplifies this reengagement with painting was *Flow*, his 2007 installation at the Contemporary Arts Center in Cincinnati, Ohio. Using a palette of 112 colors, Odita's abstract field of jarring points, intersecting angles, and complementary bands envelope the freestanding walls of Kaplan Hall of the Contemporary Arts Center in ways that evoke moods and suggest playful interactivity with patrons.

In addition to his work as a painter and installation artist, Odita has curated a number of shows and contributed to numerous publications. The list of solo and group exhibitions in which he has participated is respectable, just as are the venues in which the shows took place. He has had solo exhibitions in cities that include New York, Atlanta, St. Louis, Cincinnati, and San Francisco, and in countries such as Canada, Switzerland, Austria, Belgium, and Germany. Odita has won many awards, including the Louis Comfort Tiffany Foundation Grant (2007); the Thami Mnyele Residency Foundation Grant for African Artists in Amsterdam, The Netherlands (2004); the Reithalle Artist Residency in St. Gallen, Switzerland (1999); and the Joan Mitchell Foundation Grant for Painting and Sculpture, New York (2001). Odita is associate professor of art at Tyler School of Art, Temple University, Philadelphia.

Places to See Odita's Work

American Council on Education, Washington, DC
Birmingham Museum of Art, Birmingham, AL
Miami Art Museum, Miami, FL
Studio Museum of Harlem, New York, NY

Bibliography

Amor, Monica, and Okwui Enwezor. "Liminalities: Discussions on the Global and the Local. *Art Journal* 57, no. 4 (Winter 1998): 28–49.

Bester, Rory, and Lauri Firstenberg. "African Experiences." *Flash Art (International Edition)* 33, no. 210 (January–February 2000): 68–70.

Carrier, David. "A Fiction of Authenticity." *Art Forum* 43, no. 7 (March 2004): 188.

Cotter, Holland. "Material and Matter." *New York Times,* March 9, 2001.

Cullum, Jerry. "No-Frills Cultural Comment." *Atlanta Journal-Constitution,* March 5, 2006.

Espinosa de los Monteros, Santiago. "Five Continents & One City." *Art Nexus,* no. 39 (February–April 2001): 108–10.

Hughes, Jeffrey. "A Fiction of Authenticity." *Flash Art International* 36, no. 233 (November–December 2003): 44.

Maine, Stephen. "Odili Donald Odita at Florence Lynch." *Art in America* 93, no. 6 (June/July 2005): 183–84.

Murray, Derek. "New York Scene." *International Review of African American Art* 18, no. 2 (2001): 54–56.

Odili Donald Odita Web site. http://www.odilidonaldodita.com/statements/index.html (accessed March 12, 2008).

Oguibe, Olu. "Finding a Place: Nigerian Artists in the Contemporary Art World." *Art Journal* 58, no. 2 (Summer 1999): 30–41.

Pollack, Barbara. "The Newest Avant-Garde." *Art News* 100, no. 4 (April 2001): 124–29.

Kolade Adekunle Oshinowo (b. 1948), Painter.

Oshinowo's paintings celebrate life: the mundane and the neglected, the benighted and the celebrated. His theme, the one that he has devoted his life-long career to exploring and exploiting, is life. Of all African artists of the last quarter of the twentieth century, perhaps no one paid as much attention to the vibrant, colorful efflorescence that defines Africa. It is understandable that Oshinowo would be the self-appointed apostle of the status of the marginalized and the embattled. Living and working in Lagos, Nigeria's mega-city and arguably one of the world's most fascinating cities, all the elements that could excite and animate any socially committed artist are present. During the colonial era in Nigeria, Lagos was a modest but dazzling city, one that served as the seat of colonial power and became, for generations of Nigerians, the El Dorado. As Nigerians flocked to Lagos in the eighteenth century, so also did others from the West African subregion. As these joined the Portuguese and Dutch traders, Lagos soon became a burgeoning commercial trading outpost and, after the 1820s, an active participant in the slave trade. In the 1960s, the decade that Nigeria attained independence from British colonial dominance, the population of Lagos was less than 250,000. Today, the city has experienced unprecedented exponential, albeit uncontrolled, growth that puts the population conservatively at 10 million.

Oshinowo's subject matter is drawn largely from Lagos and its sprawling suburbs, which offer an exciting study in contrasts. It is a space where affluence is flaunted brazenly in the midst of poverty. The city has a thriving population of young, energetic hustlers and hardworking but underprivileged adult population of men and women who meander effortlessly within the constantly stalled Lagos traffic, hawking an assortment of wares that range from negligees to pieces of furniture. The markets are exciting sites for Oshinowo precisely because of the endless mosaic of colors that they present. With their children fastened onto their backs in the hot and humid weather of Lagos, market women engage in the task of enticing potential customers to the articles that they sell, which often range from fruits and vegetables to roasted corn. With their horns as an accessory, newspaper vendors tend to shout themselves shrill as they proudly market the day's news. A tribe of motorbike porters known popularly as "okada" weave their way in traffic, sometimes carrying an astonishing number of passengers who clutch firmly but dangerously to their luggage. These are the favorite subjects that Oshinowo paints.

His experience in the United States has only confirmed his firm conviction that art is a product of the culture and the political economy within which it is produced. He is mesmerized by the colors that are emblematic of the African environment. "I have ideas running in my head based on what I see on the streets: the lifestyle and the interactivity. Fish hawkers in groups with their trays balanced precariously on their heads, untouched. Ceremonies involving gorgeously dressed women; social parties with women's colorful head ties; colors; 'obas' and chiefs bedecked in their royal regalia; pageantry." These are the sources of Oshinowo's canvases. He also acknowledges that the Nigerian environment is not only about the radiance of colors. There is perhaps as much ugliness as there is beauty, especially on the streets of Lagos, where the absence of social services has made the dumping of all manner of detritus on the streets a regular sight. For the socially inclined artist, there are additional dimensions of ugliness, including issues of child labor and inadequate care of widows, the abandonment of senior citizens, and the neglect of the disabled, that are ingrained in the system. His paintings are a summation of a stream of experiences concerned with the spiritual, social, and emotional realms.

If he were to permanently relocate to the United States, he is convinced that his paintings would still reflect the degree of indebtedness to his parent culture; they will still express the same sensibility that only the African environment is capable of fostering. When he attended the Dak'Art Biennal in Dakar, Senegal, in 2006 and 2008, he was impressed by the elegance of the women who were clad in their billowing, colorful "boubous." What he identified with was the naturalness with which people conducted their business. On the other hand, Oshinowo believes that American art, which is also a reflection of American culture, environment, and sensibility, presents a sharp contrast. What struck him on his visit to the United States was the relative absence of colors and sparkle. While acknowledging that his travels within the country may have been incomplete to warrant a conclusive declaration on the vibrancy of the American social and physical environment, his first impressions were that America exists in shades of gray. The inspiration to paint is, within this

context, dampened. Where are the open markets? There are no streets populated with a smorgasbord of people pursuing a myriad of tasks? The generally monochromatic field of colors that characterizes dressing preferences in the United States stands in sharp contrast to the familiar java print that is heavily favored in Africa.

In terms of style, Oshinowo could be brusque. He could also be figuratively narrative. His paintings that highlight Nigeria's cultural heritage—paintings in which popular images of classical African art ranging from "ibeji" carvings to "gelede" masks are incorporated—tend to favor a tactility that recalls the accretion and patina for which the pieces are known. He oscillates between abstracted fields in which objects are reduced to geometric shapes and bands of colors, and idealized scenes that capture a frozen moment in the life of a rural Nigerian village. In all of his paintings, Oshinowo comes across as a painter that furiously struggles to capture every aspect of his country's cultural, social, political, and religious life before they are altered for good.

Kolade Oshinowo was born in Ibadan, Nigeria, on February 6, 1948. This sprawling Yoruba city was at that time Africa's third-largest city, after Cairo and Johannesburg. Today, it is Nigeria's third-largest city, after Lagos and Kano. Oshinowo's father, Ladipo Shittu Oshinowo, was an education officer in the civil service of the then Western Region of Nigeria. His mother, Janet Adeoti Oshinowo, was a trader. He grew up in a polygamous family; his father had four wives and a full house of children: 17 in total. While being raised in a polygamous family had its disadvantages, including the absence of quality time with his father, it also inculcated in him an appreciation of diversity and tolerance. A home that had no less than 15 siblings at any given time demanded a level of adjustment. His father was a disciplinarian who insisted that all of his children must be educated. His own version of education, however, precluded the arts, for which the elder Oshinowo had a low tolerance. Rather, he was interested in having his children grow up either as engineers, lawyers, or doctors. This would eventually create a friction between Oshinowo and his father.

In 1963, his father withdrew him from Macjob Grammar School, Abeokuta, and enrolled him in Ibadan Grammar School, Ibadan, with a view to having him become more exposed to the sciences. Fortunately for Oshinowo, it was at Ibadan Grammar School that he discovered his apathy for the sciences and found that he had an unusual flair for art. He became the favorite student of the school's art teacher, who encouraged him to enter the 1966 All-African Schools Painting competition, which was organized in Tanzania. Oshinowo won the star prize. After graduation, he worked as a bank clerk in Ile-Ife, where his manager, who had seen his private drawings, insisted that his future was not in banking but in art. In 1968, he gained admission to study art at the Ahmadu Bello University in Zaria, which was one of the country's two main art institutions. He graduated in 1972 and, after teaching for a brief period at King's College, joined the faculty at the Yaba College of Technology, where he taught until he retired in 2008. Since he started exhibiting professionally in 1973, Oshinowo, who since 2005 has served as president of the Society of Nigerian Artists, has held nearly two dozen solo exhibitions and ninety-five

group exhibitions in various countries, including Great Britain, Italy, Ghana, Cuba, and Russia. Among the numerous awards that he has won are the World Council Award of Diploma in Monterrey, Mexico, and the National Productivity Order of Merit Award.

Places to See Oshinowo's Work

Didi Museum, Lagos, Nigeria
Economic Commission for Africa, Addis Ababa, Ethiopia
Lagos University Library, University of Lagos, Lagos, Nigeria
National Council for Arts and Culture, Lagos, Nigeria
National Gallery of Art, Abuja, Nigeria
National Museum, Lagos, Nigeria
Obafemi Awolowo University, Ile-Ife, Nigeria
United Bank for Africa, Lagos, Nigeria
Yaba College of Technology, Lagos, Nigeria

Bibliography

Campbell, Bolaji. "Colour Attitudes: A Critique of Seven Nigerian Painters." *Kurio Africana: Journal of Art and Criticism* (Ile-Ife) 1, no. 2 (1989): 42–51.
———. "Kolade Oshinowo's *Drummer Series:* A Critical Appraisal." B.A. thesis, University of Ife, Ile-Ife.
jegede, dele, ed. *Offerings from the Gods.* Exhibition catalog. Lagos: Society of Nigerian Artists, 1985.
———. *Creative Dialogue: S.N.A. at 25.* Lagos: Society of Nigerian Artists, 1990.
Mydrim Gallery. *Art for Life: An Exhibition of Paintings by Kolade Oshinowo.* Exhibition catalog. Lagos: Mydrim Gallery, 2006.
National Museum. *My People.* Exhibition catalog. Lagos: National Museum, 1984.
Oguibe, Olu, and O. Enwenzor. *Reading the Contemporary: African Art from Theory to the Marketplace.* London: Institute of International Visual Arts; Cambridge, MA: MIT Press, 1999.
Ottenberg, Simon, ed. *The Nsukka Artists and Nigerian Contemporary Art.* Washington, DC: Smithsonian National Museum of African Art in association with University of Washington Press, Seattle, 2002.
Pruitt, Sharon Yvette. "Perspectives in the Study of Nigerian Kuntu Art: A Traditionalist Style in Contemporary Visual Expression." Ph.D. diss., Ohio State University, 1985.

P

Gordon Alexander Parks (1912–2006), Photographer, Composer, Film Director, Poet, Author.

"When the doors of promise open, the trick is to quickly walk through them. . . . Racism is still around, but I'm not about to let it destroy me. Too much grave digging is going on, and firing anger at each other only keeps up the digging. If we would only remember the needs of our past, perhaps we could anticipate those of our future" (Parks 1997, 13). While Parks may have quickly walked through doors of promise, it must be noted that he worked hard and endured considerable hardship for the opportunity to reach those doors. Through perseverance and application of intuitive and cultivated talents, Parks made sure that he chose a path that led to the doors of promise.

He was born on a farm in Fort Scott, Kansas, on November 30, 1912, to Andrew Jackson Parks and Sarah Parks. The youngest of 15 children, his mother died while he was only 15, but not before she had fortified him with lessons that more than compensated for his lack of access to formal education. With all his brothers and sisters gone, Parks was soon sent to St. Paul, Minnesota, to live with one of his sisters. But his relationship with his brother-in-law was less than cordial. One night, not long after he arrived in St. Paul, his brother-in-law threw him out into a minus-30-degree temperature. That would mark the beginning of a journey that would take Parks into the arts and lead him to a creatively fecund life that spanned music, film, painting, and photography. In order to survive the night in St. Paul, a city that he barely knew before he was thrown out, Parks spent the night riding the streetcars that plied St. Paul and Minneapolis. As the years wore on, Parks discovered that being far from Kansas did not diminish the incidents of racism, intolerance, prejudice, and sheer ignorance.

In the integrated high school that he attended in St. Paul, Parks's white high school teacher, Miss McClintock, embodied all of these vices. She asked her black students not to even think of going to college, as this would amount to a waste of their families' money: regardless of their education, they would only end up as porters and maids. Like many students of his ilk, Parks never finished high school. But at Princeton University on the occasion of the conferment of an honorary doctorate degree on Parks—his 45th honorary doctorate —the artist wished that Miss McClintock would have been there. Although his teacher's bigotry demoralized many of her students while it galvanized a

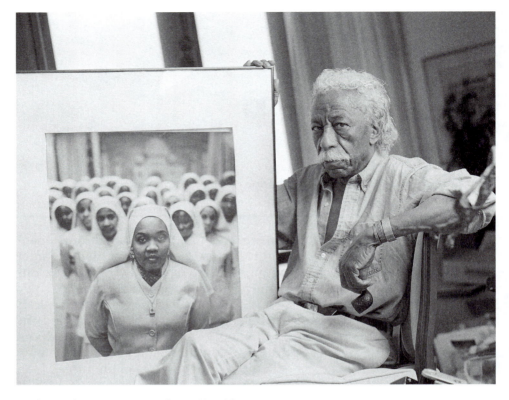

Gordon Parks, 1999. © Douglas Kirkland/CORBIS.

few, Parks gave McClintock the benefit of the doubt: "She wasn't an evil person; she really believed what she was saying" (PDOnline 2007).

Early in his life, Parks decided that the best weapon for fighting racism, oppression, and morbid prejudice would be the camera and the pen. In 1938, he purchased his first camera, a Voightlander Brilliant, at a pawnshop in Seattle, Washington. When he took the film for processing in Minneapolis, he could not unload it from the camera, since he had no idea how to do so; somebody had helped him load it. His first pictures were so stunning that he soon received his first exhibition. Before he purchased his camera, Parks had eked a living by doing a variety of jobs: as a piano player in a brothel; as a dishwasher in a restaurant; and as a waiter on the transcontinental train that ran between St. Paul and Chicago (Parks 1997, 28). The choice of using the camera came through two avenues. First, in a magazine that was left on the train where he was working as a waiter, he had come upon pictures of downbeaten and despondent migrant workers roaming about in the wake of the Great Depression. The pictures were taken by documentary photographers, including Dorothea Lange and Ben Shahn, who worked at the Farm Security Administration (FSA) Historical Section, one of the projects that Franklin Delano Roosevelt had established to document social life in the 1930s and early 1940s. He was greatly fascinated by the impact the medium could have on

readers. Second, Parks had watched Norman Alley's newsreel that showed the attack on an American gunboat by Japanese warplanes.

In 1933, Parks married his first love, Sally Alvis. In 1934, they had Gordon Jr., followed by a daughter, Toni, in 1937. The marriage ended in divorce in 1961. Parks would eventually have two more marriages—to Elizabeth Campbell from 1962 to 1973, and to Genevieve Young from 1973 to 1979. He begged his way to Madeline Murphy's upscale fashion store in St. Paul in 1940 out of desperation, having lost his job and with no steady source of income to support his family. That marked his foray into fashion photography. Among those who were impressed with Parks's photographs, which went on display in the store's windows, was Marva Louis, wife of Joe Louis, the acclaimed champion boxer. With her encouragement, Parks went to Chicago, where his work on the plight of the downtrodden black population in the city's south side earned him a Julius Rosenwald Fellowship—the first for any photographer.

In 1942, Parks moved to Washington, DC, to begin his fellowship at the FSA with Roy Stryker. He was immensely pleased at the opportunity to work with Stryker at FSA—the same organization that employed those photographers whose magazine images had triggered his interest in photography. But it did not take long before Parks realized the pervasiveness of racism. His first major picture in Washington was that of an African American janitor standing before a large American flag, broom in one hand, and mop in the other. The photograph was christened *American Gothic,* after Grant Wood's 1930 painting of the same title. In 1943, following the abolishment of the FSA, Parks became one of the photographers that Stryker took with him to the Office of War Information (OWI), into which the FSA had been fused. The stint at OWI was based on assignments. Yet, Parks needed something regular. As he had learned to do, he took the plunge and went after key establishments even when he knew that the possibility of being rejected on account of his race were always high. From 1944 until 1948, Parks's fashion photographs graced the pages of *Vogue.*

His tenure at *Life* magazine from 1948 to 1972 brought Parks's creative skills to the attention of millions of readers. Having cracked the seemingly impenetrable doors at *Life* by boldly asking for a job, Parks secured appointment purely on the strength of his portfolio. While at *Life,* he covered seemingly oppositional assignments: affluence and poverty, fashion and gangsterism. His photo essay on gang wars in Harlem, which was published in *Life,* was redolent with pathos and creativity that sets it in contrast with the subtle, poetic radiance of his fashion photographs. The alternation between extremes would become one of Parks's strengths as a creative professional. From frighteningly beautiful landscapes to deathly rooms, simple folks in rural settings to jazz musicians, Parks knew how to leverage the power of the lens for maximum effect. It was through his 1961 photographic essay in *Life* that the ordeal of Flavio da Silva, a Brazilian child in Catacumba, near Rio de Janeiro, who was ravaged by illness and poverty, became a rallying cause for the nation— a rally that saved and rehabilitated poor da Silva. From poverty, Parks turned to celebrity. His photographs of eminent personalities such as Muhammad Ali, Langston Hughes, Alexander Calder, Ingrid Bergman, Aaron Copland, and Alberto Giacometti strive to capture the character of his subjects.

In the 1969, Parks directed and produced the film *The Learning Tree*, which was based on his 1963 autobiographical novel with the same title. Prior to that, he had directed *Flavio* (1964), *Diary of a Harlem Family* (1968), and *The World of Piri Thomas* (1968). With *The Learning Tree*, Parks became the first African American director and producer of a major film in Hollywood. His 1971 film *Shaft* was a critical and box office success. Other directed films—*Shaft's Big Score, Leadbelly*, and *Supercops*—followed, with his last film coming in 1985 with *Odyssey*. In addition to his directorial work, Parks was also a composer, poet, and author of novels, memoirs, and poetry. Gordon Parks died on March 7, 2006.

Places to See Phelps's Work

Gordon Parks Center for Culture and Diversity, Fort Scott, KS
Leonard H. Axe Library Digital Collections, Pittsburg State University,
 Pittsburg, KS

Bibliography

Berry, S. L. *Gordon Parks.* New York: Chelsea House, 1991.
Capa, Cornell, ed. *The Concerned Photographer.* New York: Grossman Publishers, 1972.
Danska, Herbert. *Gordon Parks.* New York: T. Y. Crowell, 1971.
Monaco, James. "The Black Film and the Black Image." In *American Film Now,* edited by James Monaco, 185–213. New York: Oxford University Press, 1979..
Parks, Gordon. *The Learning Tree.* New York: Harper and Row, 1963.
———. *Whispers of Intimate Things.* New York: Viking Press, 1971.
Parks, Gordon. *Eye Music: New Images by Gordon Parks.* Exhibition catalog. New York: Alex Rosenberg Gallery, 1979.
———. *Half Past Autumn: A Retrospective.* Boston: Little, Brown and Company, 1997.
PDOnline. "Gordon Parks." http://www.pdngallery.com/legends/parks/intro _set.shtml (accessed July 24, 2008).
Shepard, Thomas. "Gordon Parks: Beyond the Black Film." In *Cineaste Interviews: On the Art and Politics of the Cinema,* edited by Dan Georgakas and Lenny Rubenstein, 173–80. Chicago: Lake View Press, 1983.
Stryker, Roy E., and Nancy Wood. *In this Proud Land: America, 1935–1943.* Boston: New York Graphic Society, 1973.
Tidyman, Ernest. *Shaft.* New York: Macmillan, 1970.

Thomas Phelps (b. 1939), Installation Artist.

Thomas Phelps's education deviated from the usual trajectory followed by those who are privileged to receive formal instruction in academic institutions. He was raised by a single mother in Cincinnati in an era when racism was normative and the idea of accounting for the cultural heritage of the black

person in the cultural narrative of the United States was immaterial. As an installation artist, Phelps's work is governed more by intuition and a strong, innate propensity to resolve compositional issues through a process of simultaneous assemblage and deconstruction. Phelps's creative instinct responds to an inner clock and a visual stimulus that shuns the contemplative and exploratory prerequisites associated with many artists. Phelps's conceptual approach to art making is more impulsive than intellectualized, more improvisational than methodical. Growing up in Cincinnati in the 1940s, Phelps was not disenchanted by the nonexistence of any art that referenced his ancestry. At school and in the city, art was defined through reference to Western aesthetics. He would learn later that his yearning for creative expression embraced an affinity with the spiritual and the deeply personal—something that he found in the work of a number of self-trained artists within and outside of Cincinnati.

Thomas Phelps was the younger of two boys born to Woodrow Phelps and Mary Blake Phelps on June 2, 1939, in Cincinnati. On account of his father not being always available to cater to the needs of the family, the responsibility of raising Phelps and his brother devolved on Mary. The absence of his father worsened an already dire family situation, leading to Phelps taking up employment at a local bakery immediately after he graduated from Robert A. Taft High School in 1959. His talents as a potential artist were noticed early at Porter Junior High School in Cincinnati, where his art teacher mentored him and encouraged in nursing his creative interests. In his senior year in high school, Phelps was one of three students who won the Scholastic Art Awards for 1959, a feat that came with scholarship to attend the Cincinnati Art Academy. Phelps enrolled in 1961, having deferred his admission for one year in order to work. When he eventually registered, he could only study on a part-time basis; the responsibility of catering for himself and his family severely discouraged any inclinations to study art full time. For the next seven years, he worked a number of jobs in Cincinnati, including serving as a cement mason apprentice, before securing permanent employment in the U.S. Postal Service, where he worked for 31 years before retiring in 1997.

With the assurance of steady employment that his work provided, Phelps enjoyed the opportunity to further explore his interest in art. In 1989, the Dallas Museum of Art organized the seminal exhibition "Black Art Ancestral Legacy: the African Impulse in African American Art." The publication that accompanied the show validated Phelps's instinct and became a catalyst for leveraging new aesthetic engagements in the community. Together with three others—Gail Gaither (owner of Third World Art Gallery in Cincinnati), Jimi Jones, and Ken Leslie—Phelps in 1989 formed a group that became known in Cincinnati as the "Neo-Ancestralists." The group, which also had other artists with diverse interests and specialties—in theater, music, poetry, and the visual arts—expressed interest in creating an environment in Cincinnati in which the African creative temper is resuscitated and presented as a platform for energizing the community and, in particular, for promoting artistic resurgence.

The group was intent on addressing the cultural inertia in Cincinnati by conveying in their art what Ipori Lasana refers to as "the inner shine" of African Americans through artistic engagements that replicate the multicultural and

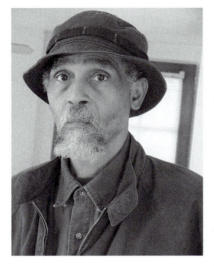

Thomas Phelps. Courtesy of dele jegede.

performance-oriented aspects of African art. From 1991 to 2001, the three founding members of the Neo-Ancestralists had their studio in The Arts Consortium, an organization that was established in 1972 and that served as the cynosure for all activities in the creative and performing arts. In an undated manuscript that is written by Ikechukwu Okafor-Newsum, which Phelps made available to me, Lasana further contended that "[a] multiplicity of African symbols and American images superimposed on found objects such as old doors, religious relics, white baby dolls, and empty potato chip bags are representative of a new direction African American artists are exploring" (Okafor-Newsum n.d.).

Phelps's creative impetus derives from the work of a number of artists, including two Haitians: the self-taught painter Hector Hippolite, and the sculptor Georges Liautaud. But the most immediate and more pervasive influence is ascribed to another Cincinnati assemblage and installation aficionado, James Batchelor, whose environmental work and installations on his property on Walnut Hills are an astonishing draw for the community. Batchelor combines an admirable knack for organic effervescence with an eye for an art that celebrates a powerful folksiness. His yard stands as a lofty testament to the power of imagination and recycling: a discarded bathtub becomes an abode for a thriving colony of collard greens, while peppers announce their triumphal emergence through the empty space left by what used to be the seat of a disused white plastic chair. A mound with an assortment of yard ornaments competes with, and complements a whimsical arrangement of plastic horses around a tree, with an old Lakers signage standing next to a stop sign, all of which are within a field of plants and creeping tendrils.

Phelps's installations are concerned with making manifest a spirituality that is fugitive and ungraspable. In his 1995 installation *Baptism,* the face of an altar boy is covered with an exquisite Igbo mask, Agbogho mmwo, which symbolizes the youthful gracefulness and beauty of Igbo young female. Within the context in which Phelps deploys it, this mask is transformed into a Catholic emblem with an African source. Thus, it symbolizes a religious syncretism in which the dominance of an indigenous and individuated spiritualism becomes unmistakable. What makes this installation even more enigmatic is that upon closer scrutiny, the altar figure is a dressed-up mannequin. A 2005 installation by Phelps, *Weapons of War Fetish,* features an elaborate shrine, at the center of which is a small ironing board with an assault rifle that is wrapped with white strips of cloth in a way that turns the rifle into an art object. The installation contains an inscription, "Here lies a deceased weapon of war; may they all rest, rest in peace." In Phelps's words, which was published in a brochure that accompanied the exhibition, "S.O.SArt," that was held at the Mockbee at Central Parkway in 2005, his installation "deals with the pervasive presence of the

military industrial complex in the domestic domain as well as the field of battle; this military effort supports and produces passive and aggressive weapons of war, propaganda, monetary gain."

In his installations, Phelps makes the connection between a primordial root that acknowledges and honors African spirituality, and the cultures of black Americans, especially in the southern belt. Phelps's installations challenge our preoccupation with categories and compartments. His installation, which celebrates amalgamation and compositeness, also incorporates photographs of sites, symbols, and persons that he constantly takes. In his statement, Phelps acknowledges his preoccupation with narrating the human condition, and with using art to refocus our attention away from the mundane to the pragmatic: "My work concerns itself with 'The Human Condition' as I perceive it. Be it social, political, psychological, mystical, moral, or environmental. Be it local or universal in scope. Using a wide range of materials to compliment the diversified expressive manner of a single soul and spirit we accomplish the greater effect and response: staying in touch with the reality of life."

Phelps, who is married with two sons and one daughter, lives and works in Cincinnati. He has had numerous exhibitions and continues to create installations that pursue the cultural dialog between African and African American creative cultures.

Places to See Phelps's Work

Cincinnati Bell Telephone, Cincinnati, OH.
Arts Consortium of Cincinnati, Cincinnati, OH
Frank W. Hale, Jr. Black Cultural Center, Ohio State University, Columbus, OH
Phelps works in transitional installations; most of his work is either in private collections or dismembered after installation.

Bibliography

Berger, Maurice. "Are Art Museums Racist?" *Art in America* 78, no 9 (September 1990): 68–77.

Hambrick, Jennifer. "Exposing 50 Years of Columbus: Kojo Kamau." In *Short North Gazetter*, 18–20. Columbus, OH: Columbus Art Community, August 2006.

Okafor-Newsum, Ikechukwu. "The Art of Thomas R. Phelps, Kenneth Leslie and Jimi Jones." *Soulstirrers: Black Art and the Neo-Ancestral Impulse in Cincinnati.* Undated manuscript.

Sampson, Michael L. *Innervisions: Individuality and Creativity among Ohio Artists of African Descent.* Exhibition catalog. Cincinnati, OH: National Afro-American Museum and Cultural Center, 1998.

Horace Pippin (1888–1945), Painter.

Based on the significance of his contributions to the creative wealth of the nation, Horace Pippin is typically cited, and deservingly so, as an extraordinary artist. The aesthetic quality of his work, which is rich and alluring,

combines with the exceptional context within which he produced his art to caution us on the futility or inappropriateness of broad categories and compartments—"naïve," "folk," "self-taught," "outsider," "intuitive," and others—into which artists are forced.

Horace Pippin's paintings are deeply personal and evocative reconstructions and renditions of his own stories, observations, aspirations, sensibilities, and reaction to events, personalities, places, and nature. These, as Bearden and Henderson (1993, 346–47) have observed, are some of the peculiarities of artists who make art on their own without the routines and strictures that are often a corollary of their exposure to formal art-making methods and processes. Bearden and Henderson have deduced that artists like Pippin share certain perceptual and stylistic characteristics. They tend to come from an economically disadvantaged social class, take to making art at a late stage in their life, and produce art that resonates with a high level of emotional rather than analytical rationalization or conceptual energy. In the case of Pippin, the intensity and honesty of his work, and the disabilities that he overcame to achieve his goal, attest to his deep love for art and his persevering quest to find an outlet for pent-up emotion.

Pippin was born in 1888 in West Chester, Pennsylvania, to Harriet Pippin (who has also been identified by other sources as Christie), a single mother who relocated to Goshen, New York when Pippin was just seven years old in order to move closer to family members and eke a living. Pippin's interest in art manifested itself quite early. He made art in school, drew biblical subjects, and won accolades and considerable attention for his effort. But after his eighth-grade education, it was difficult for Pippin to secure any respectable or sustaining employment. From age 14, he tried his hands at a variety of employments: as a farm boy, a woodcutter, and a loader at a furniture store. Eventually, he secured employment as a hotel porter, a position that he kept for seven years, relinquishing it only in 1911 upon the death of his mother.

Pippin was working as a crater of household goods in Patterson, New Jersey, in 1917 when the United States entered World War I. He enlisted and became a soldier in the 15th Infantry, which later became the all-black 369th Infantry when it became subsumed under the French command. Pippin emerged as a squadron leader in the infantry. On the war front, he sustained an injury to his right arm when a German sniper hit him on the shoulder. The injury that he sustained to his right arm would create a modicum of discomfort for him, especially after he was discharged from the army in 1919. Upon his discharge, he returned to West Chester, where, with the support of his family and the community, he faced the difficult task of easing back into civil society. In 1920, he married Jennie Ora Featherstone Wade. While the marriage lifted his spirit and gave him comfort, it also aggravated his frustrations. The damage to his right hand adversely affected his contributions to the economic fortune of his new family. The torrent of emotion that he experienced proved to be quite overwhelming. His reminiscences on the war and the desire to find an outlet for the welter of images and thoughts that flooded his mind led him back to art. He began by assembling disused cigar boxes with an attempt at creating something fanciful out of them. Not satisfied with the outcome, he in

1925 began applying red-hot iron implements on wood panels to create images. This was the beginning of his professional art career.

It was excruciating for him to work with a seriously injured hand. Eventually, his persistence paid off; through constant practice and use, he gradually regained use of his right arm to a point where he was able to hold the brush. He plunged into work although his effort did not produce prodigious outcome, given his penchant for details and the slow process that came with working with a damaged hand. He began with using a heated poker to burn preconceived ideas onto a flat surface, a process that required patience, skill, and painstaking manipulation. By 1931, he made his first significant oil painting, *The End of the War: Starting Home.* This painting, which catalogs aspects of his war experience, took him about three years to complete. It features the surrender of a group of German soldiers who are arranged in various positions in a field that suggests the brutality ravages of war, but in a fashion that clearly reveals Pippin's mastery of design and composition. Deeply entrenched in the center of the painting against a forested background, a soldier raises his two hands in a surrender posture. Attributes of the ugliness of war, which are suggested with a sky that is bursting with explosives and a plane that is plucked from the air, extend to the frame of the painting, which Pippin adorned with grenades, helmets, tanks, and bombs. By the end of 1931, Pippin had done three more paintings, all of which continued his visual essay on his war experience.

Pippin's paintings are done with a deep passion for truth: his own truth. There is a certain ambience in many of his paintings, particularly those that deal with his war experience, that evoke a serene spirituality. Contrary to popular notions of the self-tutored artists who cared not about perspectives and other elements of art, Pippin has a strong sense of structure and design. Indeed, his work does not fall within the so-called "naïve" category, which is supposed to be marked by a primitive intuitiveness that we often associate with the work of children. Rather, Pippin was a sophisticated master narrator who was very selective in his choice of imageries and the color scheme that he believed would accentuate delivery of penetration, empathy, and pungency—elements that are central to his oeuvre. For example, in a painting like *West Chester Court House,* which he did in 1940, we see an artist with an acute and penetrating insight about composition, symmetry, balance, and contrast. His handling of the low walls that fence the statue and the lawn is critical to spatial organization. The darker hues that Pippin used for the lawn effectively initiate depth at the same time that they suggest the relative distance between the court house and the lamp posts and the tree, which are the closest objects. His proclivity for details and sense of patriotism can be seen in the distinctiveness of the flags on the lawn, just as his interest in minute and local details can be seen in the fire hydrant, and the statue on a white pedestal. While he painted war scenarios and social scenes, especially those that commemorate his love of West Chester, Pippin also did some still lifes and religious paintings. In the early 1940s, he produced three versions of *The Holy Mountain,* which reveal his deep religious conviction. In the first version of the painting, a varied population of animals and humans are gathered in the foreground of the

painting, sharing a blissful and serene time and looking straight, as if on command, at the onlooker. While the three versions share common thematic threads, they are distinguished by progressive simplification in the composition and elimination of certain elements. In making this series, Pippin wanted to visually capture the peace that is alluded to in the Bible, but which was an increasingly elusive notion during the months immediately following World War II, when the third and last version of *The Holy Mountain* was painted. In the artist's note that he offered regarding this series, Pippin cited spiritual inspiration as the sole impetus: "Isaiah XI, the 6th verse to the 10th gave me the picture, and to think that all the animals that kill the weak ones will dwell together, like the wolf will dwell with the lamb, and the leopard shall lie down with the kid and calf and the young lion and the fatling together" (Bearden and Henderson 1993, 367).

By the mid-1930s, Pippin began a number of portrait paintings, including that of his wife and that of the local deputy sheriff of Downingtown Legion post. A notable portrait, which he did in 1940, is that of Christian Brinton, an Asianist and art critic who, in 1937, had located Pippin and organized an exhibition of his works at the West Chester Community Center. It was through Brinton's introduction that Pippin's work became widely disseminated, purchased, and included in the Museum of Modern Art exhibition, "Masters of Popular Painting—Artists of the People," which featured, among others, Henri Rousseau, Edward Hicks, and Joseph Pickett (Bearden and Henderson 1993, 362). In 1940, Albert C. Barnes became an enthusiastic promoter of Pippin's work, having chanced upon it at the art dealer Robert Carlen's gallery. Barnes wrote the introduction to the exhibition catalog and brought Pippin considerable patronage. Pippin was exposed to the Barnes collection of modern art, and offered an incentive to enroll for professional art classes. Although Pippin obliged Barnes and spent a few weeks, it did not take long for him to discover that he simply did not have the temperance for having someone else teach him how art should be made.

With exposure came recognition and financial comfort, although Pippin remained unimpressed by such materialistic trappings. He only tolerated museums and collectors and preferred the company of his Bible. At home, his wife became ill and had to be committed to the Norristown State Hospital in 1944. Pippin continued painting a variety of subjects, including richly nuanced flowers and still lifes. Although he attained fame later in life, Pippin remained troubled by the dissonance between his spiritual world and the social reality that he experienced. On July 6, 1946, he died of a stroke.

Places to See Pippin's Work

Allen Memorial Art Museum at Oberlin College, Oberlin, OH
Art Institute of Chicago, Chicago, IL
Butler Institute of American Art, Youngstown, OH
Fine Arts Museums of San Francisco, San Francisco, CA
Hirshhorn Museums and Sculpture Garden, Washington, DC
Metropolitan Museum of Art, New York, NY

National Gallery of Art, Washington, DC
Pennsylvania Academy of the Fine Arts, Philadelphia, PA
Philadelphia Museum of Art, Philadelphia, PA
Smithsonian American Art Museum, Washington, DC

Bibliography

Bearden, Romare. "The Negro Artist and Modern Art." *Opportunity*, December 1934, 371–72.

———. *Horace Pippin: The Phillips Collection.* Exhibition catalog. Washington, DC: Phillips Collection, 1976.

Bearden, Romare, and Harry Henderson. *Six Black Masters of American Art.* Garden City, NY: Zenith Books, Doubleday, 1972.

———. *A History of African-American Artists from 1792 to the Present.* New York: Pantheon Books, 1993.

Irving, David. *Horace Pippin: There Will Be Peace.* Video recording. Chappaqua, NY: L&S Video, 1998.

Porter, James A. *Modern Negro Art.* Washington, DC: Howard University Press, 1992.

Powell, Richard J. *The Blues Aesthetic: Black Culture and Modernism.* Washington, DC: Washington Project for the Arts, 1989.

———. "Re-Creating American History" and "Biblical and Spiritual Motifs." In *I Tell My Heart: The Art of Horace Pippin*, edited by Judith Stein, 70–81, 124–35. New York: Universe, 1993.

Roberts, John W. "Horace Pippin and the African American Vernacular." *Cultural Critique*, no. 41 (Winter 1999): 5–36.

Rodman, Selden. *Horace Pippin, a Negro Painter in America.* New York: Quadrangle Press, 1947.

Sirmans, Meredith. "Collecting the Work of Black Artists." *Black American Literature Forum* 19, no. 1 (Spring 1985): 40–41.

Stein, Judith, ed.. *I Tell My Heart: The Art of Horace Pippin.* New York: Universe, 1993.

Szeemann, Harald. *Self-Taught Artists of the 20th Century: An American Anthology.* San Francisco, CA: Chronicle Books, 1998.

West, Cornel. "Horace Pippin's Challenge to Art Criticism." In *I Tell My Heart: The Art of Horace Pippin*, edited by Judith Stein. New York: Universe, 1993.

Ellen Jean Price (b. 1955), Printmaker.

Ellen Price's prints are jarring in their deceptive simplicity. The subject matter is the cause: a pair of African American men in suits that recall Harlemite dandies of the 1930s stare at the viewer. That would be a fair presumption to make upon gazing at the print. But such a presumption may be misleading or totally misplaced. The two figures in the print may, for all that Price cares, be the same person that is repeated with tonal gradations that change the value of the two

images. From the glimpse that Price permits the viewer, the figures are those of men, tightly cropped with half of the face shown right from the tip of the nose to the bust. The head is totally edited out of the picture, as are the ears and the eyes. Price's refusal to grant the viewer the privilege of the gaze—to unmask the subject—is one of the creative devices that she employs to address the recrudescent issue of blatant discrimination, what she refers to as coded racism. In yet another print, Price reveals the cropped face of what appears to be a female figure in profile, with only the left ear and cheek. The figure occupies a sizeable portion of the left part of the picture plane, with the other half featuring a DNA band and a twig. One of Price's characteristics is the ability to ensconce her work in a field of symbolic and allusive imageries that allow for multiple meanings. Is the figure in this print a female? Is the figure Caucasian, or African American? To what period in American history can this figure be ascribed? These are aspects of the incipient elusiveness that gives Price's prints their enigmatic presence. Yet race, racism, and identity provide the dominant cultural matrix that sustains Price's work.

Price's own personal experience gave her the materials that constitute the focal point of her work as a printmaker. She was born to middle-class parents on April 26, 1955, in St. Albans in southeast Queens, New York City. When her parents first moved to the neighborhood, it was comprised of a mixed population. Within a short span of time, the situation changed, and the population became almost wholly black. Price grew up in an environment that encouraged the exploration of individual creative fantasies. As a child, she would go to the Museum of Modern Art and Central Park with her older sister, Lucy, who was more science-oriented. Her father, Wilson Price, was an engineer while her mother, Anna Price, who had attended the Art Students League, was an art teacher on Long Island prior to her marriage in 1952. It was a gutsy, heroic move at that time, spurred no doubt by love, but within a climate that brooked no empathy for interracial marriage, which was illegal in much of

Ellen Jean Price. Courtesy of Thomas Featherstone.

the United States. Price's understanding of the incipience of racism initially came through her father's experience. Her enterprising father was routinely frustrated and disillusioned at the disdainful attitude of potential employers who would show interest in hiring him upon seeing his resume only to reject him once he showed up for the job. The American society in which Price's father grew up in the fifties had no incentives for African Americans who showed enterprise and were determined to challenge their subaltern social standing.

For Price, the jarring ubiquitousness of racism came in the sixth grade when her friends in the predominantly black community that they lived in began to question her identity: is she black? Is she white? Affirming her blackness always doused such inquisitiveness, and

quelled pent-up desire for adversarial action were she to turn out Caucasian. "My parents were political progressives. . . . We were in a community where we felt comfortable. But as I started going out on my own in junior high and high school more, I became aware of the fact that everyone didn't see me as being part of their community" (Price 2007). As a self-defense mechanism, young Price became focused on fitting in; she began carrying her own copy of the autobiography of Malcolm X.

Price left high school a semester early in 1971 and, feeling that she was not ready for college yet, decided to do something different; going to an art school became an attractive option. Her experience at the Art Students League, which she attended in 1974, and where she took life-drawing classes for a reasonable monthly fee, proved to be stimulating and rewarding. There was something enchanting about showing up at the place in the morning and finding that the model was there. Price became deeply involved in the process, which provided a much-needed platform for subsequent engagements in art at other institutions. From 1974 to 1976, Price studied at Hunter College, New York. In 1977, she began her studies at Brooklyn College, also in New York, and graduated summa cum laude in 1980. Although she failed to fully grasp it at that time, her years at Hunter were extremely helpful in exposing her to conceptual and abstract notions of art. Coming from the Art Students League, where she had received a strong grounding in figuration, her Hunter experience gave her an understanding of the multi-nuanced dimensions that art harbors. It was a highly motivated Price that left Hunter for Brooklyn, which had a more structured approach to art-making. In 1977, she was involved in an accident as she drove to New Mexico. In 1978, her father died. The combination of these factors—her admission to Brooklyn, her accident, and the loss of her father—gave Price a new reality that led to a more focused commitment to art.

Her contact with printmaking began at Brooklyn. In 1983, she began graduate work at Indiana University in Bloomington and graduated in 1986. While at Indiana, she began to realize the cumulating benefit of her long exposure to art: she was accepted into a juried show at first try, won a purchase prize, and sold some pieces. In addition to being influenced by some of her peers in graduate school, who brought new ideas and techniques to class, the life and experiences of Adrian Piper gave Price the necessary incentive to focus on identity. The first time that Price read Piper, she felt the need to make her life the topic of her work. The environment in which she also studied played into Price's understanding of text and context. Bloomington is in the flat plains of the Midwest, in the cornfields of Indiana that has earned notoriety as a bastion of the Ku Klux Klan. In 1987, Price secured an appointment at Miami University and moved to Oxford, Ohio, with Tom Featherstone, whom she had married the previous year.

Price decided to focus on identity because race has become symptomatic of her inner ruminations and unverbalized anguish. Her approach was to veil her work in garbs that would reveal depth of meanings only to those with levels of discernment. You would have to know Price deeply to be able to read her work, which makes use of photographs of members of her family. Inserting the photographs of her parents into her work in a faint disguise accords with her own

quiet but formidable way of dealing with race. In this, Price places a premium on being reverential and personal, even if evasive. She also uses pruned or dislocated plant forms. Her materials come from family albums. In cleaning out her grandmother's house, she chanced upon a treasure trove of old family photographs, an album of the Price family that goes back some generations. The exercise itself brought Price in direct contact with aspects of her history. Her paternal grandparents—Rhodes and Mazie Price—bought a brownstone house in Harlem in 1925. Her uncle, Sam, who had a pharmacology degree and served in World War II, was never able to reconcile himself with the undignified treatment that he received as a black GI in the segregate army. The cumulative impact of her history fueled Price's compunction for drawing, and for resolving in print the seething angst that she felt toward an insensitive society.

The first body of work that was based on the family albums comprised full figures. Price arrived at veiling, cropping, or mythologizing the figures by accident. At the copier where she had taken the photographs, Price was having difficulty in enlarging her copies from which she intended to work. As the copier help tried to show Price how to operate the machine, a tiny, wrongly cropped piece that she had earlier discarded caught her eye. She rescued the piece from the trash and realized that she had just found the appropriate format in which to give visual expression to her innermost thoughts. The family album opened Price's eyes to the role that miscegenation played in American life. As has been amply demonstrated by **Lorna Simpson** and **Glenn Ligon** among other artists, photographs and family are a rich field that is capable of providing invaluable cultural artifacts that artists could effectively mine. Price has invested considerable effort in collecting photographs and family albums, which become her passport into history. The picture of her grandfather as a young man (who died in 1935); elegant pictures of her aunts in tastefully stylish hats; Uncle Sam's pictures when he was young: these have become priceless collections and powerful tools in Price's quest for a society in which the potency and divisiveness that are a corollary of any considerations of gender, race, and racism will dissipate. She has earned grants and fellowships and participated in major national exhibitions.

Places to See Price's Work

Allen Hite Art Collection, University of Louisville, Louisville, KY
The Boston Printmakers, Boston, MA
The Brockton Art Museum, Brockton, MA
Cincinnati Art Museum, Cincinnati, OH
CUNY Graduate Center, New York, NY
Sheldon Memorial Art Gallery, University of Nebraska, Lincoln, NE
3M Corporation, Minneapolis, MN
University of Wisconsin-Madison, Special Collections Library, Madison, WI

Bibliography

Bearden, Romare, and Harry Henderson. *A History of African-American Artists from 1792 to the Present.* New York: Pantheon Books, 1993.

Berger, Maurice. "Are Art Museums Racist?" *Art in America* 78, no 9 (September 1990): 68–77.

Brodsky, Judith. "Some Notes on Women Printmakers." *Art Journal* 35, no. 4 (Summer 1976): 374–77.

Finney, Henry C. "Mediating Claims to Artistry: Social Stratification in a Local Visual Arts Community. *Sociological Forum* 8, no. 3 (September 1993): 403–31.

Hall, Robert L. *Gathered Visions: Selected Works by African American Women Artists.* Washington, DC: Anacostia Museum, Smithsonian Institution, 1992.

Masur, Louis P. " 'Pictures Have Now Become a Necessity': The Use of Images in American History Textbooks." *Journal of American History* 84, no. 4 (March 1998): 1409–424.

Porter, James A. *Modern Negro Art* Washington, DC: Howard University Press, 1992.

Powell, Richard J. *The Blues Aesthetic: Black Culture and Modernism.* Washington, DC: Washington Project for the Arts, 1989.

———. "Re-Creating American History" and "Biblical and Spiritual Motifs." In *I Tell My Heart: The Art of Horace Pippin,* 70–81, 124–35. New York: Universe, 1993.

Price, Ellen Jean. Interview by author, Oxford, OH, February 18, 2007.

Roberts, John W. "Horace Pippin and the African American Vernacular." *Cultural Critique,* no. 41 (Winter 1999): 5–36.

Sirmans, Meredith. "Collecting the Work of Black Artists." *Black American Literature Forum* 19, no. 1 (Spring 1985): 40–41.

Martin Puryear (b. 1941), Sculptor.

Discussions about art often oscillate around boundaries, with artists defined by style, school, or concept. Compartments are routinely created for the purpose of containment or assignment of labels. The notion of dichotomies or distinctions is invoked to discuss or analyze strata: high art vs. kitsch; is it art, or simply craft? Yet another category, one which is yet to be fully tackled, pertains to race, with the widespread perception that African Americans are customarily edited out of dominant texts while their inclusion in major national exhibitions is influenced more by the desire to quell potential criticism about inequality than by any desire to allow the quality of work to be the primary determinant. In his work and professional approach, Puryear appears to have placed himself outside of the politics of being. There is a consensus that his work transcends artificial boundaries or the polemics of art and craft. A sculptor of immense skills and profound aesthetic insights, Puryear has earned a reputation for producing works that have a universal appeal; works that are appreciated for their sheer artistry and craftsmanship. Princenthal (1992, 34) is quite direct when she writes, "Puryear's art is not contentious or politically partisan." She further contends: "Wary in the extreme of being pigeonholed, and of critical attention generally, Puryear nurtures a degree of inner disjunction. For all its composure, his work keeps a number of oppositions in tension and expresses a penchant for the kind of controlled upheaval that has also

governed his life" (34). In the words of Koplos (2001, 75), "Puryear's art in general, cannot be identified with a movement or message, a theory or even an image. His sculptures evoke the summary viewpoint of Archibald MacLeish's famous 'Ars Poetica,' that 'A poem should not mean/But be.' Puryear's sculpture does not mean, it just is."

Puryear has always enjoyed being intimately involved with the creative process: with the dexterity and skills entailed in craftsmanship. He was born on May 23, 1941, in Washington, DC, to Reginald, a retired post office supervisor, and Martina, who retired as a public grade school teacher. At an early age, Puryear showed interest in art and literature, a combination that would eventually determine the direction of his professional career. Ever since he won a scholarship at a children's art school when he was in elementary school, the urge to build, to construct and manually assemble, has been irrepressible. It was this urge that saw him try his hands at constructing whatever he needed: furniture, canoe, and guitar. He combined his interest in art with a love for reading, and paid particular attention to wildlife. As a young man, he nursed the ambition to become a wildlife illustrator with interest in ornithology and zoology and a particular fondness for falconry.

When Puryear entered Catholic University in Washington in 1958, his intent was to major in biology. In his junior year, he declared a major in art, with painting as the favored specialty. As he grew in his studies, his views about art, and in particular his initial preference for representational art over abstraction changed. This turnaround occurred as a result of the influence of Nell Sonneman, described by Benezra (1991, 14) as Puryear's most important instructor at Catholic University. Sonneman tried to purge Puryear of his obsession with detailed figuration and open his mind to grasping the essence of objects. It was Sonneman who directed Puryear to embrace the possibility of ideas and structures rather than depict physical appearances. The notion of nonobjectivity was no doubt a challenge for Puryear at this level of his education, and it would not be until his sojourn in Sierra Leone that the idea would begin to take root. When Puryear graduated in painting in 1963, his immediate goal was to travel and explore the world on his own.

Between 1964 and 1966, he was in Segbwema, Sierra Leone, as a Peace Corps member in Africa where he taught biology, English, French, and, on occasion, art at a mission school. In Sierra Leone, away from Sonneman's prodding and exposed to new challenges and opportunities, Puryear broadened his creative vista. He studied with the craftspeople—weavers, dyers, and potters—of Segbwema and learned carpentry and joinery from local carpenters who were conditioned to working without much dependency on fancy tools and motorized equipment. At the end of his stay in Sierra Leone, Puryear's interest in and respect for craftsmanship had grown. Additionally, he also learned something about the philosophy that sustained the skills and techniques of his Sierra Leonean carpenters. "In more traditional, more slowly evolving societies, there is always a downplaying of the craftsmen's ego. You spend time learning, in an almost menial way, initially, from an acknowledged authority, and you only earn the right to be an artist, with anything personal to invest in the work, through mastery" (Benezra 1991, 16).

At the completion of his tour in Sierra Leone in 1966, Puryear left for Stockholm having secured admission to the Swedish Royal Academy of Art to study printmaking. A Scandinavian-American Foundation fellowship in 1967 enabled him to indulge in the study of printmaking during the day and, in his spare time, explore the tools and techniques of cabinetry. His pursuit of this interest led him to the workshop of a master woodworker, James Krenov, who gave Puryear insights into the essence of materials. His stint with Krenov underlined for him the place of skills and craftsmanship, just as it placed considerable value on the sheer joy that is derivable from being fully involved in the process of making art. In a way, Puryear's relationship with Krenov recalls a similar experience that he had with Sonneman: both would be a part of a mediatory process on the path to a slow and incremental, yet decidedly individualized learning. While in Stockholm, Puryear took part in the Annual Exhibition of the Swedish Royal Academy of Art (in 1967 and 1968). In addition to participating in the 1968 Stockholm Biennial, Puryear also had his first solo exhibition and attended the Venice Biennale before returning to the United States.

Puryear continued his education in 1969 by entering Yale University's graduate program to study sculpture. There, he studied with key faculty, including Al Held and James Rosati, and became familiar with such visiting faculty as Richard Serra and Robert Morris. He must have received additional insights on the arts of African peoples when he took a course with Robert Farris Thompson, the renowned Africanist who taught courses on African art and the arts of the Black Diaspora at Yale. From Yale, Puryear availed himself of the opportunity to reconnect with contemporary American art by visiting SoHo and began to reacquaint himself with minimalism. After he graduated from Yale in 1971, Puryear joined the faculty at Fisk University in Nashville, Tennessee, in 1971, but left in 1973, the same year that he established his studio in Brooklyn, New York. Between 1974 and 1978, Puryear taught at the University of Maryland, College Park. This was a period of maturation and professional fecundity for Puryear. He received many important grants, including one from the National Endowment for the Arts, which galvanized his culminated in projects and exhibitions that established him not just as an artist or a sculptor, but as somebody with a deeply philosophical approach to the process of making art.

It became apparent, from the body of work that Puryear began to produce at this time, that his interest in a hands-on approach to learning, a willingness to immerse himself in other cultures, an appetite for understanding basic tools, mechanics, and processes that are involved in woodworking, and his single-minded pursuit of supplemental learning had finally begun to produce the desired goals. Having fully internalized the lessons learned from formal and informal sources—from Sonneman, the Sierra Leonean carpenters and artisans, Krenov, his mentors at Yale, and the art scene in Europe and the United States—Puryear began to make art on his own terms. His sculptures reveal no specific affinity with race or subject matter, although it is possible for inferences to be made on the basis of suggested shapes or forms. Puryear has finally mastered the art of investing his work, and not his person, with prestige and

aura. The notion of individualism seems to be at variance with the process and craftsmanship that have become the hallmark of his oeuvre. Jonathan Crary (1979, 28) offers an evaluation of Puryear's work:

> He maintains the stance of both an artisan and a carver who pares down his material to a formal core, but the work he produces demands to be confronted outside of conventional sculptural terms. A no-nonsense craftsman's esthetic is applied to the creation of ambiguous, multivalent objects that resist analytic categorization. His art is an experience of an extraordinary refinement bordering on a kind of mannerism, yet it generates a confluence of meanings and effects coinciding with, and going beyond, its own lyricism and stylishness.

In 1977, Puryear suffered a setback as his studio in Brooklyn was gutted by fire and most of his work was destroyed. In 1978, he moved to Chicago and began teaching at the University of Illinois at Chicago. Puryear's work could be evasive and ambiguous, as in his 1978 *Self*, a painted, 5'9", heavy-looking conical object that rests firmly on a base and projects a slight bulge on one side, thus giving the impression, simultaneously, of stability and movement. Made of cedar and mahogany, *Self* is built on a hollow shell and covered with thin layers of painted cedar. The range of ideas that Puryear tackles in his work is astonishingly wide and conceptual. From his yurt with the title *Where the Heart Is (Sleeping Mews)* to a 100-foot-high pole that is made from tree, or his series of enigmatic and poetic constructs that define specificity (such as his *Lever #1*, *Lever #2*, and *Pride's Cross*), Puryear's sculptures exude a pride that is based on the personality of the materials and the elegance of their assertion. His work projects a disciplined frugality that complements the character or status of each piece. One of his most daring concepts is *Bodark Arc*, an outdoor project that was completed in 1982 for the 392-foot-diameter Nathan Manilow Sculpture Garden on the Chicago campus of Governors State University.

By the time that Puryear had his first solo exhibition at David McKee Gallery in 1987, he had established a reputation as a craftsman with an uncanny sensitivity for the organic temperance of his wood. An example is his 1996 *Ladder for Booker T. Washington*, a 36-foot-tall ash ladder that starts on a 2-foot-wide base and meanders its way to a tapering end, where it narrows to mere inches. Puryear has received numerous awards and grants, including a Louis Comfort Tiffany Grant, a John S. Guggenheim Memorial Foundation Grant, the Francis J. Greenburger Foundation Award, the John. D. and Catherine T. MacArthur Foundation Fellowship, and the Skowhegan Prize for sculpture. In 1989, as the U.S. representative at the Sao Paulo Bienal, Puryear won the Grand Prize for his sculptures. In 1992, he was elected to the American Academy and Institute of Arts and Letters, while Yale University honored him in 1994 with an honorary doctorate. On the occasion of the major retrospective of his work at the Museum of Modern Art from November 2007 to January 2008, Puryear proffered a statement about his work that is succinct and instructive: "The ideas that give rise to a work can be quite diffuse, so I would describe my usual working process as a kind of distillation—trying to make coherence out of

things that can seem contradictory. . . . The most interesting art for me retains a flickering quality, where opposed ideas can be held in tense coexsistence" (Elderfield and Auping 2007).

Places to See Puryear's Work

Art Institute of Chicago, Chicago, IL
Artpark, Lewiston, NY
Baltimore Museum of Art, Baltimore, MD
Chevy Chase Garden Park, Bethesda, MD
Chicago O'Hare Transit Line, River Road Station, Chicago, IL
City University of New York, York College, Jamaica, NY
Corcoran Gallery of Art, Washington, DC
Dallas Museum of Art, Dallas, TX
Gettysburg College, Gettysburg, PA
Governors State University, The Nathan Manilow Sculpture Park, University Park, IL
Hirshhorn Museum and Sculpture Garden, Washington, DC
Joslyn Art Museum, Omaha, NE
Museum of Modern Art, New York, NY
National Gallery of Art, Washington, DC
Panza di Biumo Collection, Milan, Italy
Philadelphia Museum of Art, Philadelphia, PA
Port Authority of Allegheny County, Penn Park Station, Pittsburgh, PA
San Diego Museum of Contemporary Art, San Diego, CA
Seattle Art Museum, Seattle, WA
National Oceanic and Atmospheric Administration, Western Regional Center, Seattle, WA
Solomon R. Guggenheim Museum, New York, NY
St. Louis Art Museum, St Louis, MO
Truland Systems Corporation, Arlington, VA
U.S. Customs House, New York, NY
Walker Art Center, Minneapolis Sculpture Garden, Minneapolis, MN
Whitney Museum of American Art, New York, NY

Bibliography

Allen, Terry Y. "The Unconventional Eye." *Amherst Magazine,* Summer 1990, 14–17.

Benezra, Neal David. *Martin Puryear.* London: Thames and Hudson; Chicago, IL: Art Institute, 1991.

Berger, Laurel. "In Their Sights." *ARTnews* 96 (March 1997): 94–100.

Bois, Yve-Alain. "La Pensée Sauvage." *Art in America* 73, no. 4 (April 1985): 178–98.

Castro, Jan Garden. "Martin Puryear: The Call of History." *Sculpture* (Washington, DC) 17, no. 10 (December 1998): 16–21.

Cotter, Holland. "A Bland Biennial." *Art in America* 77, no. 9 (September 1989): 81–87.

Crary, Jonathan. "Martin Puryear's Sculpture." *Artforum* 18, no. 2 (October 1979): 28–31.

Crutchfield, Margo A. *Martin Puryear.* Richmond: Virginia Museum of Fine Arts, 2001.

Danto, Arthur C. "Tilted Ash." *Nation,* December 31, 2007. http://www.thenation.com/doc/20071231/danto.

Elderfield, John, and Michael Auping, *Martin Puryear.* New York: The Museum of Modern Art, 2007.

Haber, John. "Taking Modernism to the Woodshed," July 25, 2008. http://www.haberarts.com/puryear.htm, http://www.moma.org/exhibitions/exhibitions.php?id=3961).

Kirshner, Judith Russi. "Martin Puryear in the American grain." *Artforum International* 30 (December 1991): 58–63.

Koplos, Janet. "Martin Puryear's 'Ars Poetica.'" *Art in America,* December 2001, 75–79.

Princenthal, Nancy. "Institution's Disciplinarian." *Art in America,* January 1990, 131–36, 181.

———. "Martin Puryear." *American Craft* 52, no. 1 (February/March 1992): 34–36, 66.

Smith, Roberta. "Humanity's Ascent, in Three Dimensions." *New York Times,* November 2, 2007. http://www.nytimes.com/2007/11/02/arts/design/02pury.html.

R

Faith Ringgold (b. 1930), Painter, Sculptor, Quilter, Performance Artist.

Faith Ringgold was born in New York on October 8, 1930, to Andrew Lois Jones Sr. and Willi Posey Jones, the most influential person in her life. At age 12, her family moved to Sugar Hill in Harlem, where Ringgold grew up. Her paternal and maternal families had moved to New York from Florida during the Great Migration in the second decade of the twentieth century, when thousands of African Americans thronged to New York in search of greener pastures. It was a migration that **Jacob Lawrence** has eloquently memorialized in his paintings. Ringgold is the youngest of three children in the homestead: Barbara, her sister, and Andrew, the eldest, who died in 1961, forcing Ringgold to terminate her first trip to Europe. Because Ringgold was ravaged with chronic asthma as a child, she missed out on her kindergarten years and was jealously and prudently sheltered by a doting mother during the first years of her elementary education. Ringgold's asthma drew her closer to her mother, who exposed her to colors and design by furnishing her with crayons and other materials. Willi Posey Jones, a seamstress and fashion designer and artist in her own right, taught Ringgold the art of sewing and of making quilts, an art form that her own grandmother had practiced as a slave. In Ringgold's hands, and with the active collaboration of her mother, quilt making was transformed from what used to be regarded as craft to high art. Her mother introduced Ringgold to the use of fabric, and thus paved the way for the artist's painted quilts that have become a hallmark of her creative achievement.

Ringgold attended Morris High School in the Bronx and graduated in 1948. That year, she enrolled at City College in New York. Her initial desire to enroll as a fine arts student was thwarted by a City College bylaw that precluded women from certain fields of study, apparently in pursuit of the patriarchal notion that assigned students to disciplines on the basis of gender. That was how she ended up in the School of Education, where she declared a major in art and a minor in art education. Her interest in art, regardless of the prescriptive approach that City College adopted, was apparently not negotiable. Ringgold's enthusiasm for art and the facility that she has acquired in fabric working and quilt making at that point surpassed that of an average freshman art major. Still, it did not shield her from acerbic critiques and insensitive admonitions.

While in college, an incident occurred that would have a major impact on her determination to pursue art as a career. Ringgold had turned in a two-dimensional assignment, the subject matter of which was mountains. Apparently, the professor was not convinced that Ringgold knew what mountains were, or how to draw them. He asked her to write the subject matter down. "Does this mean you don't think I can draw? I plan to be an artist." That was Ringgold assuring her skeptical professor, who responded, "I don't see any indication that you can" (Farrington 2004, 4). Ringgold has not only proved that she could draw, but she has contributed significantly to the expansion of the language of art, and to the demolition of hegemonic boundaries that have held imagination in check and highlighted the distinctions between high art and craft. Ringgold draws strength from a deep, personal conviction that a person can transcend his or her limitations and achieve lofty goals once there is the willpower and resolve. The mantra, "If One Can Anyone Can; All You Gotta Do is Try," is emblazoned on her Web site, featuring a girl in flight.

Faith Ringgold sits before her quilt called "Tar Beach" in her New York City studio, 1993. AP Photo/Kathy Willens.

In 1950, while still in college, Ringgold married her high school friend, Robert Earl Wallace, a jazz musician. Although four years later the marriage had been annulled, it produced two children—Michele Faith Wallace and Barbara Faith Wallace—both of whom were born in 1952. With two young children, a B.S. degree in 1955, followed by an M.A. in art from City College in 1959, the 1950s was a productive decade for Ringgold. But it was in the 1960s that her career as an artist took off. This was when Ringgold, in response to the various sociopolitical stimuli around her, embraced a path that would shape her into the phenomenal activist and creative force that she would eventually become. For African American artists, the sixties was a period of struggle. The Spiral, which comprised a number of African American artists, including **Romare Bearden**, **Hale Woodruff**, Charles Alston, **Norman Lewis**, and **Emma Amos**, struggled to revisit the issue of black identity in the visual arts in a racialzed America. It was the decade of the Civil Rights Movement, undoubtedly the greatest catalyst for the constellation of cultural,

political, literary and artistic movements that sprang up during this period. The Black Art Movement, Black Power, the Black Panthers, and Africobra were all involved, in varying degrees, in asserting the unassailable rights of blacks in a society that had become comfortable with placing them in a subaltern position.

The combination of these factors exerted a palpable influence of Ringgold. In 1962, she married Burdette Ringgold and put in placed a plan to carve a career for herself as a professional artist. Her first political paintings as well as her first mature painting style whose contents were influenced by the writings of James Baldwin and Amiri Baraka, have been dated to this period (Hill 1998, 28). Some of her seminal works during this period, which she categorizes under "American People Series," include *U.S. Postage Stamp Commemorating the Advent of Black Power, The Flag is Bleeding,* and *Die,* all of which were painted in 1967. Their sheer size (the first two are 72" × 96", while the last is 72" × 144") attests to the bravura of the artist: she appeared to be driven by an insatiable urge to make a statement, and was not willing to make it quietly. The subject matter is as powerful as the dimensions that they command. *U.S. Postage Stamp* features two bands on the picture plane, each of which is populated by 50 faces, about 10 percent of which are black. Written diagonally across in black is the inscription, "Black Power." But the subtext, one which the viewer would have to work hard to decipher, is the phrase, "White Power," which is written in white, but in such a way that the viewer would have to squint to pick out. This is the power of Ringgold's art: the ability to challenge through a recourse to layering that elevates the intellectual and protestant nature of her work. *The Flag is Bleeding* and *Die* both highlight the unspeakable psychological assault that people, regardless of race, suffer when the die is cast and people are forced to take recourse to all strategies in order to preserve their dignity. As Lucy Lippard has written, *Die* "appalled many of its viewers. For some the harshness of its style was unacceptable; for others its political subject matter made it taboo. For the artist, it was a turning point that led her back to 'the shores of darkness'" (Studio Museum in Harlem 1984, 22).

Beginning in the 1970s, Ringgold adopted a method of hanging her paintings that would have a significant impact on her ability to work on a large scale and ship them effortlessly. On a visit to Amsterdam in 1972, she had seen at the Rijksmuseum, some Tibetan Buddhist *thangkas,* which were pieces of designs hung loosely on wooden pegs (Farrington 2004, 40). The adoption of this format also inspired the artist's further exploration of quilted forms. Just like the *thangkas* that she had seen in Amsterdam, in 1972, Ringgold began producing works with decorative fabric borders sewn on them. Posey, Ringgold's mother, became an active collaborator in this new venture; it was a collaboration that led to a series of pieces that focused on portraits of the residents of Harlem, the neighborhood in which she grew up, and continued until Posey's death in 1981. During this period, Ringgold worked on the "Feminist Series" and produced lush, richly nuanced landscapes that combined acrylic or oil on unframed canvas with embroidered fabric edges. After her mother's death, the artist continued with this new form, which blossomed into story quilts that combined visual narratives with text, often with stories that are loaded with

social commentaries, personal vignettes, or political implications. Her piece *Who's Afraid of Aunt Jemima?* exemplifies the stylistic thrust of her quilts of this period. These story quilts provide the right platform for Ringgold to give her art the critical edge and potency as she tackles sundry issues ranging from stereotypes to archetypes. Perhaps the most popular of story quilts is *Tar Beach*, which adopts an aerial view that is in tandem with the story of the young, third-grader Harlemite's dream to transcend the barriers imposed by her location and status.

From her penetrating critique of the objectification and subjugation of the African American female in her "Slave Rape" series, which she began early in the 1970s, Ringgold moved the into performance realm and employed fabrics and other accouterments to produce freestanding soft sculptures and masked assemblages. The series lent themselves to a multiplicity of engagements, something that recalls the amorphousness of boundaries in African cultures, for which Ringgold has shown respect and appreciation. Her 1976 installation performance *The Wake and Resurrection of The Bicentennial Negro* which was commemorative of the 200th anniversary of the United States, employed masked dancers to narrate the vicissitudes and triumphs of Buba, the central character, who symbolized the connections between African communities and their ancestors (Gouma-Peterson 1998, 40). The opportunity for Ringgold to experience the fervor and spectacle of art in an African setting came in the following year, when she attended the Second World Black and African Festival of Arts and Culture, FESTAC 77, in Lagos, Nigeria. In 1985, Ringgold was appointed full professor in the visual art department at the University of California, San Diego.

In the last decade of the twentieth century, Ringgold embarked on a quest to internationalize her quilt stories. She traveled to France and constructed narratives that bring together African American characters and key French modernists, including Picasso and Matisse, whose works she generously references. For over four decades, Ringgold has been a constant and powerful feature of the American and international art scene. In the process, she has made a strong impact in ways that underline the agency of art in shaping political and social agendas. Appropriately, she has been rewarded with major exhibitions and in venues that would have been unimaginable four decades ago. She has won major national and international awards—more than 75 at the last count—that include 15 honorary Doctor of Fine Arts degrees, the National Endowment for the Arts, the La Napoule Foundation Award for Painting in France, and the John Simon Guggenheim Memorial Foundation Fellowship for Painting. Ringgold, who is author of several children's books and a firm believer in the power of one's imagination and dream, has risen to become a remarkable cultural icon and political activist. Through innovative approach to art making and a refusal to be influenced by uncomplimentary criticism, she has become one of the dominant artists on the American scene. Through her books, which focus on children and her work that explore her sociocultural interests, global confluences, and historical connections, Ringgold's art has become an extension of her quest for respect, empowerment, gender and racial equality. She has championed the exposure of an endemic discriminatory practice in the

culture sector and worked on boosting access to major exhibition spaces for African American artists.

Places to See Ringgold's Work

Baltimore Museum, Baltimore, MD
Chase Manhattan Collection, New York, NY
High Museum of Art, Atlanta, GA
Metropolitan Museum of Art, New York, NY
Museum of Fine Arts, Boston, MA
Museum of Modern Art, New York, NY
National Museum of American Art, Washington, DC
Newark Museum, Newark, NJ
Philadelphia Museum of Art, Philadelphia, PA
Phoenix Art Museum, Phoenix, AZ
Solomon R. Guggenheim Museum, New York, NY
Spencer Museum of Art, Lawrence, KS
St. Louis Art Museum, St. Louis, MO
Studio Museum in Harlem, New York, NY
Williams College Museum of Art, Williamstown, MA

Bibliography

Baraka, Amiri. "Faith." *Black American Literature Forum* 19, no. 1 (Spring 1985): 12–13.

Farrington, L. *Faith Ringgold.* San Francisco, CA: Pomegranate, 2004.

Freeman, Linda. *Talking to Faith Ringgold.* New York: Crown Publishers, 1996.

Gouma-Peterson, Thalia. "Faith Ringgold's Journey." In *Dancing at the Louvre: Faith Ringgold's French Collection and Other Story Quilts,* edited by Dan Cameron. New York: New Museum of Contemporary Art; Berkeley: University of California Press, 1998.

Hill, Patrick Cody. "The Castration of Memphis Cody: Race, Gender and Nationalist Iconography in the Flag Art of Faith Ringgold." In *Dancing at the Louvre: Faith Ringgold's French Collection and Other Story Quilts,* edited by Dan Cameron. New York: New Museum of Contemporary Art; Berkeley: University of California Press, 1998.

Irving, David. *Faith Ringgold: The Last Story Quilt.* Video recording. Chicago: Home Vision, 1991.

Lippard, Lucy R. "Beyond the Pale: Ringgold's Black Light Series." In *Faith Ringgold: Twenty Years of Painting, Sculpture and Performance (1963–1983).* New York: Studio Museum in Harlem, 1984.

McGovern, Cynthia. "Quilted Dreams Inspired by Faith Ringgold." *Arts & Activities* 143, no. 3 (April 2008): 30–67.

Millman, Joyce. "Faith Ringgold's Quilts and Picturebooks: Comparisons and Contributions." *Children's Literature in Education* 36, no. 4 (December 2005): 381–93.

Ringgold, Faith. *We Flew over the Bridge: Memoirs of Faith Ringgold.* Boston: Little, Brown, 1995.

Ringgold, Faith, Linda Freeman, and Nancy Roucher. *Talking to Faith Ringgold.* New York: Crown Publishers, 1996.

Ringgold, Faith, and J. Withers. "Faith Ringgold: Art." *Feminist Studies* 6, no. 1 (Spring 1980): 207–11.

Studio Museum in Harlem. *Faith Ringgold: Twenty Years of Painting, Sculpture, and Performance.* New York: Studio Museum in Harlem, 1984.

Tribe, Tania C. "Visual Narrative and the Harlem Renaissance." *Word & Image* 23, no. 4 (October–December 2007): 391–413.

Turner, R. *Faith Ringgold.* Boston: Little, Brown, 1993.

Aminah Brenda Lynn Robinson (b. 1940), Painter, Multimedia and Installation Artist.

Aminah Brenda Lynn Robinson's work is inseparable from the totality of her life experience. It is all that she has grown up with, and all that has shaped her worldview as an African American woman who grew up in Columbus, Ohio, and has lived all of her productive, professional life there. Her work extols history, recognizes people, affirms traditions, and celebrates past and present communities. The total body of work that Robinson has created in over four decades of professional life has been estimated to be more than 20,000. The works defy being compartmentalized into one neat category, since Robinson is a very eclectic artist who has a capacity to combine materials and produce pieces that bridge traditional media boundaries. Many of her works are huge assemblages—over 20 feet—that take years to complete and use found objects and items such as ties, buttons, and textiles that generous neighbors constantly donate. These works are a visual encyclopedia of Robinson's insatiable quest to preserve memory; they are about the stories that she was told when she was growing up, about the people whom she met and those that she did not, and the travels that she undertook. Her art is both spiritual and cathartic; it is wrapped up in layers of narratives, each of which reveals Robinson's use of art to document, inform, celebrate, and inspire.

Brenda Lynn Robinson, one of three daughters, was born on February 18, 1940. She grew up in Poindexter Village, on the east side of Columbus, Ohio. Poindexter, one of the earliest housing projects in the country, was preceded by Blackberry Patch, a farmland on the outskirts of the town, about which Robinson learned from Alvin Zimmerman. As a young girl Robinson delighted in listening to fascinating stories that her uncle, Zimmerman, told her. These stories had a strong grip on her memory and provided her with much of the seemingly inexhaustible reservoir of materials that she has continued to draw upon as a professional artist. In addition to stories that she heard from Zimmerman, Robinson also derived great pleasure in listening to stories pertaining to her family ancestry that her great aunt, Cornelia Johnson, told her. A former slave who once lived in Sapelo Island in Georgia before migrating to Columbus, "Big Annie," as Johnson was affectionately called, shared with Robinson firsthand accounts of stories of slavery and helped Robinson grasp the

devastating consequences of the Middle Passage, which occurred between the fifteenth and nineteenth centuries when European traded in human cargo.

On the coast of West Africa, European traders captured and purchased Africans whom they shackled and transported across oceans, eventually selling them into slavery in North America, South America, and the Caribbean. Estimates vary, but the number of Africans who were forcibly removed and sold into slavery, including those who died during the journeys, has been put at between 15 and 30 million. Learning about this condition from her aunt jolted Robinson, who avidly jotted and sketched them in her sketchbook; the experience has continued to shape her work.

Aminah Robinson in Columbus, Ohio, 2003. AP Photo/Will Shilling.

Robinson grew up in a family in which creativity was nurtured. Her mother Helen Elizabeth Zimmerman Robinson, taught her daughter the spinning, weaving, sewing, button, and needlework skills that have given her work its distinctive character. Her father Leroy Edward Jones, who worked as a custodian for almost three decades in the Columbus public school system, imbued young Robinson with a passion for creativity. He created objects from cloth, leather, and wood and gave his daughter the "hogmawg" recipe, a combination of Elmer's glue, hog grease, paint, and wood putty that Robinson has continued to use in her work. He instilled in his daughter a love for books and, using paper and cloth, made small books for Robinson. He told his daughter fascinating stories and assisted her early in life to see art as inseparable from living. Her father nurtured in Robinson the capacity to recall and interpret visual experiences, techniques that have become the hallmark of her creative life.

Robinson grew up with art. She began doing art as early as age three, and frequently stole out of the house through the bathroom window for the opportunity to paint and draw at Beatty Recreation Center, which was across the street. She showed outstanding ability in art in high school and, after graduating in 1957, she enrolled at the Columbus Art School (now Columbus College of Art and Design) and graduated cum laude in 1960. Persuaded by her father, Robinson later attended Ohio State University, where she studied English and philosophy. While still at school, Robinson also worked at the Columbus Public Library, where her exposure to art books broadened her interest in archival materials on extant and existing communities in Columbus, and important historical, political, and cultural personages. This experience proved useful to Robinson later in her professional career.

In 1964, Robinson met and married Charles Robinson, a staff sergeant in the Air Force and a veteran of the Korean War. Her husband's postings saw them at various locations: Idaho, Nebraska, Mississippi, and later Puerto Rico, where she spent considerable amount of time doing sketches of her San Juan neighborhood. Robinson's allegiance to her native Columbus would seep

through in the work that she did at this time. She admits doing two bodies of work everywhere she has been: one of the place visited, the other of Columbus, a community to which she remains indebted. The marriage ended in divorce and, with her son Sydney, who was born in Mississippi, Robinson returned to Columbus in 1971 and experienced considerable difficulty in securing employment. She went in and out of welfare and eventually accepted an employment offer from the Columbus Recreation and Parks Department and moved from her parents' place to her own house, a place that has, over the years, become a creative shrine to Robinson's accretive and adaptive creative spirit.

Robinson works in pleats and volumes. Her creative style defies easy compartmentalization. She combines letters and textual narratives with a kaleidoscope of other objects: wood, leaves, twigs, bark, handmade paper, cloth, paint, an assortment of buttons, thread, graphite, beads, pastel, ink, graphite, puppets, and "RagGonNon," a piece that rags on and on, and "takes her years to research and create and . . . takes on a life of its own through powerful references to the past, present, and future" (Genshaft 2002, 16). Robinson's work has often been described as folksy, implying an art that is made by "folks" with no formal art education, who depend mainly on intuition rather than an art whose creation is based on the application of elements of art and principles of design. But Robinson's work is based on a thematized principle that revolves around the notion of community and culture, memory, redemption, and affirmation. Robinson works in an endless circle, with one idea begetting several others. As a result, her house, which also doubles as a studio, oozes with a plethora of items, including her RagMud Collection and Folk Quilt Series, which are in 10 volumes with each volume going from A to Z. These series come up in various forms, sculpted books, popup books, and fabulous, sometimes comical three-dimensional figures with distended, exaggerated features.

In 1979, Robinson traveled to Africa and visited Nigeria, Kenya, Ethiopia, Senegal, and Egypt. In Egypt, an Arab Sheik and tour guide told Robinson that her name was Aminah. Upon her return to Columbus, she narrated this event to her father. To her surprise, her father informed her that her grandmother's name was Aminah. Since 1980, Robinson's work has attracted critical attention by cultural establishments. Between 1979 and 1991, she was the recipient of four Ohio Arts Council individual artist grants. In the summer of 1998, she traveled to Israel and visited Jerusalem, Tel Aviv, and the artist's colony at Ein Hod, among other places. The result was a body of work—*Sacred Pages: Journey through the Holy Land, 1998–2002*—that documents her experiences, the people she met, the places she visited, and the three religions, Christianity, Islam, and Judaism, that she encountered. Robinson has held exhibitions at major museums and galleries nation-wide, and is the recipient of major awards, including the Ohio Governor's Award for the Visual Arts (1983), an honorary doctor of fine arts degree from the Ohio Dominican College, Columbus (2002) and the prestigious John D. and Catherine T. MacArthur Foundation grant (2004).

Places to See Robinson's Work

Columbus Metropolitan Library, Columbus, OH
Columbus Museum of Art, Columbus, OH
Huntington National Bank, Ashland, OH
JP Morgan Chase Art Collection, New York, NY
Newark Museum, Newark, NJ
Otterbein College, Westerville, OH
Private collections
Richmond Art Museum, Richmond, IN
Robert J. Shiffler Foundation, Columbus, OH
Southern Ohio Museum, Portsmouth, OH
Wexner Center for the Arts, Ohio State University, Columbus, OH

Bibliography

Anney Bonney Video. *A Brief Introduction to the Art of Aminah Brenda Lynn Robinson.* Video recording. Columbus, OH: Anney Bonney, 2002.

Bauer, Marilyn. "Center's Artist Choice Rooted to Ohio: Aminah Robinson Mixes Materials and Colors and Gives Life to Stories of Freedom." *Cincinnati Enquirer,* August 1, 2003. http://www.enquirer.com/editions/2003/08/01/tem_frilede01artist.html.

Chenfield, Mimi Brodsky. "Amina Robinson: One Artist's Ties to Folk-Life and Folk Art." *Clarion* 14 (1989): 54–60.

Columbus Museum of Art. *Symphonic Poem: The Art of Aminah Branda Lynn Robinson.* Columbus, OH: Columbus Museum of Art in association with Harry N. Abrams, 2002.

Genshaft, Carole Miller. "A Different Walk." In *Symphonic Poem: The Art of Aminah Branda Lynn Robinson,* 13–25. Columbus, OH: Columbus Museum of Art in association with Harry N. Abrams, 2002.

Goldstein, Jami. "Columbus Artist Aminah Robinson's Work Featured in Chilean Exhibition." http://www.oac.state.oh.us/news_mgmt/default.asp?intArticleId=143.

Robinson, Aminah Brenda Lynn. *A Street Called Home.* New York: Harcourt Publishers, 1997.

Starr, Ann. "Genius at Work: Inside Aminah Robinson's World." *Columbus Monthly,* September 2005, 51–56.

S

Betye Irene Saar (b. 1926), Assemblage and Installation Artist, Printmaker.

As matriarch on the American art scene, Betye Saar has seen and lived much of the art that she conjures through her assemblages and installations. The oldest of three children, Saar was born to Jefferson and Beatrice Parson Brown in Los Angeles on July 30, 1926, of African, Irish, Native American, Creole, German, and Scottish heritage. She grew up during the Great Depression and experienced the loss of her father, to whom she was very close. The family's resilience, adaptability, support, and hands-on approach to life assisted in mitigating the impact of the hardship. With the death of her husband, Beatrice became the sole provider for her family, as a result of which she moved the family to her maternal great aunt, Hattie Parson, and her husband, Robert Keys, in Pasadena, California (Carpenter 2003, 4). Living in Pasadena, Saar was exposed to a nurturing environment, sensitized to issues of race and social classification, and encouraged to embrace diversity of religious practices. The cumulative impact of such socialization process fertilized Saar's imagination and provided an initial grounding in what would eventually develop into a creative philosophy that extols pluralism. After attending Pasadena College, Saar studied at the University of California, Los Angeles (UCLA) from 1947 to 1949 and graduated with a B.A. degree.

Saar grew up fashioning things with hands. During the Depression, when things were tight, the family survived by making things for each other. Coming from a home where craftsmanship was an honored pastime—her mother was a seamstress and her grandmother a quilt maker—it seemed quite natural that Saar would embrace cobbling things together. One of the influences on her as a youngster was the Watts Towers, a one-person permanent structure that was constructed over a three-decade period, from 1921 to 1954, by Simon Rodia, an Italian immigrant. Using found objects that included porcelain and bottle shards, rods, steel pipes, and wire mesh, Rodia's inspirational work has since become a national landmark. Saar saw the Towers take shape over a period of time as she paid visits to her grandmother, who lived in Watts. Walking to the market along the railroad tracks, Saar was privileged to see the Rodia project as it developed. She recalls her memory of Rodia and impression of the times:

> He [Rodia] had a big car and he would see these piles of rubble and he would go through it. . . . And he put these steel structures up and covered

them in cement and pressed shards of ceramics, of plates, I've seen corn cobs in there, I've seen tools. It's like, the cement is wet, what can we put in here? I think that was the beginning of me becoming an assemblagist or recycler.

(Montagne 2006)

Upon graduating from UCLA in 1949, Saar began her career as a social worker while she continued as an interior designer and created enamel jewelry, which she had learned through her association with Curtis Tann, a fabric designer and enamel jewelry artist with whom he established a cottage business in the early 1950s (Carpenter 2003, 6). In 1952, she was married to Richard Saar, a ceramist and conservator, and a year later, the couple welcomed their first daughter, Lezley. They would eventually end up with two more: Alison (b. 1956), and Tracye (b. 1961). Lezley and Alison are established visual artists, while Tracye is a writer. Establishing a family meant a change of routine: Saar left her social work and focused more on her enamel jewelry and greeting card designs. With the birth of Alison, the family moved to Relondo Beach and Saar decided to pursue a career in teaching. Between 1959 and 1962, she enrolled in graduate studies at California State University in Long Beach with an interior design focus. While at Long Beach, Saar took a number of courses in printmaking that would inflect the trajectory of her career. She fell so much in love with printmaking that it became her favored medium of expression in the early 1960s.

In a series of prints that she made in the sixties, Saar began to play with frames, compartments within which she embedded found objects, old photographs, occult and metaphysical symbols. The primary trigger for this was the work of Joseph Cornell that she saw at a 1967 exhibition at the Pasadena Museum of Art. Cornell's assemblage pieces framed a surrealistic world for Saar in the way that objects—text, images, found items—were brilliantly put together in a receptacle that signified a world inhabited by multiple spirits and essences. For much of the sixties, Saar's work focused on empowering a smorgasbord of items within a contained environment. In her 1967 *Omen,* for example, Saar explores her interest in the metaphysical world by creating three longitudinal registers, two of which sit atop a short, horizontal compartment within which four canisters of organic materials are housed. Titles of some of her works—*Mystic Window for Leo* (1966); *View from the Sorcerer's Window* (1966); *View from the Palmist Window* (1966); and *Black Phrenology* (1967) —often provide indications of Saar's interest in the mystical, the occult, the metaphysical, and voodoo systems of thought.

Betye Saar, 1999. Photograph by Jimi Giannatti. Courtesy of Michael Rosenfeld Gallery, LLC, New York, NY.

After her divorce in 1968, Saar took up appointment at the Inner City Cultural Center in Los Angeles, where she worked as a costume designer, an experience that would prove to be beneficial to her career later as she ploughed the insights that she gained in her work for theater to her art, giving the encasements for her design a three-dimensional status. The ultimate piece that catapulted Saar to national limelight is her 1972 *Liberation of Aunt Jemima*. It was created in response to an invitation sent to artists by a community arts center in Berkeley, California, for artists to produce works about their hero or heroine. Saar confirmed in her 2002 interview with Lyn Kienholz and Rohini Talalla that—based on the volume of copyright requests that is handled by the University of California, Berkeley Art Museum which owns the piece—*Liberation of Aunt Jemima* is unquestionably her most popular work. In this work, Saar appropriates a figure that bears the burden of servitude, institutionalized mockery, and disrespect for African American personhood and turns it into an empowered icon. This piece packs symbols of enfranchisement—the raised fist of the Black Power era, the shotgun, and the penetrating gaze that is made more menacing by the unambiguous blackness of the figure. Gone is the domiciled and reverential nanny of yore. What decades of protestation and rhetoric could not achieve, *Liberation of Aunt Jemima* did in a visual language so laden with symbols that it confronts and challenges its viewers. A quarter of a century after *Liberation of Aunt Jemima* was first created, Saar revisited it and recycled its iconic power with the primary aim of quelling what she perceives as the negative power of the work of a new generation of African American artists who tap into the reservoir of black imageries to provoke a renewed confrontation between the oppressor and the oppressed.

Saar did not start focusing on the black condition until the Civil Rights Movement had drawn international attention to the plight of blacks in the United States. While the 1965 Watts riots had energized the black cultural community and jarred the conscience of many, the shocking television images of African Americans terrorized by agents of white administration during the civil rights marches, and the eventual assassination of Martin Luther King, spurred Saar into focusing her art on racial injustice. She began by collecting derogatory images alongside other materials, which she would eventually reprocess into her art.

Saar's work reflects her personal approach and philosophy to life; it reifies her belief about spirituality and universalism. While the materials for her assemblages are drawn from several sources, including African, Mexican, and Far Eastern cultures, Saar's primary objective is a critique of those aspects that essentialize cultural or political divergences or accentuate commonalities. In her 1989 freestanding mixed-media *House of Ancient Memory*, for example, Saar assembles objects from disparate climates and constructs a red, pyramidal wooden structure on a table in a way that suggests a mini throne. The process of art making is itself a ritual for Saar: collecting the object, harnessing its residual energy, transforming, and empowering anew. This transformation is a central concept of Saar's work. Whether the work is made of natural or manufactured objects—a twig, rocks, feathers, teeth, faded photographs, plastic toys, ribbons, and buttons—Saar ritualizes them very much in a way that

the *nganga* of the Kongo consecrates a power object, the *nkisi*, in order to unleash its full energy.

Saar, who has enjoyed a productive life, continues to produce a new body of work and participate in major exhibitions, the most recent being her 2005 traveling exhibition, *Betye Saar: Extending the Frozen Moment*, which was organized by the University of Michigan Museum of Art. Her awards and honors are numerous and include two National Endowments for the Arts Awards (in 1974 and 1984). She is the recipient of a 1990 J. Paul Getty Fund for the Visual Arts Fellowship; a 1991 John Simon Guggenheim Memorial Foundation Award; and a 1992 John Vander Zee Award. She has been awarded honorary doctorate degrees by Otis/Parsons Institute in Los Angeles; the San Francisco Art Institute in California; and the Massachusetts College of Art in Boston. Together with John Otterbridge, Saar represented the United States at the 22nd Sao Pãulo Biennial in Brazil.

Places to See Saar's Work

Herbert F. Johnson Museum of Art, Cornell University, Ithaca, NY
High Museum of Art, Atlanta, GA
Hirshhorn Museum and Sculpture Garden, Smithsonian Institution, Washington, DC
Los Angeles County Museum, Los Angeles, CA
Metropolitan Museum of Art, New York, NY
Museum of Fine Arts, Boston, MA
National Museum of American Art, Washington, DC
Newark Museum, Newark, NJ
New Jersey State Museum, Newark, NJ
Oakland Museum, Oakland, CA
Palmer Museum of Art, Pennsylvania State University, University Park, PA
Pennsylvania Academy of the Fine Arts, Philadelphia, PA
Studio Museum in Harlem, New York, NY
Tacoma Art Museum, Tacoma, WA
Walker Art Center, Minneapolis, MN
Whitney Museum of American Art, New York, NY

Bibliography

Belserene, E. P. "Betye Saar: Building Art." *Essence* 21, no. 1 (May 1990): 80.
Bryant, Eric. " 'L.A. Object'." *ARTnews* 106, no. 1 (January 2007): 133.
Carpenter, Jane H., and B. Saar. *Betye Saar*. San Francisco: Pomegranate, 2003.
Carroll, K. L. "Mojotech—Betye Saar." *School Arts* 89, no. 9 (May 1990): 25.
Dallow, Jessica, and B. Matilsky. *Family Legacies: The Art of Betye, Lezley, and Alison Saar*. Seattle and London: Ackland Art Museum, University of North Carolina at Chapel Hill, in association with University of Washington Press, 2005.
Leimbach, Dulcie. "Opening Up the Windows onto Artist's Life and Work." *New York Times* 148, no. 51521 (May 13, 1999): G12.
Montagne, Renee. "Life Is a Collage for Artist Betye Saar." National Public Radio interview. http://www.npr.org/templates/story/story.php?storyid=6688207

Owusu-Ansah, Edward K. "Betye Saar: Extending the Frozen Moment." *Library Journal* 131, no. 2 (February 1, 2006): 76–77.

Reilly, Maura. "Betye Saar at Michael Rosenfeld." *Art in America* 87, no. 2 (February 1999): 112.

S.M. "Betye Saar." *ARTnews* 93, no. 8 (October 1994): 193.

Shattuck, Kathryn. "The Artist Who Made a Tougher Aunt Jemima Hasn't Softened with Age." *New York Times* 155, no. 53700 (September 12, 2006). http://www.nytimes.com/2006/09/12/arts/design/12saar.html?_r=1&scp=1&sq=artist%20who%20made%20a%20tougher%20aunt%20jemima&st=cse

Walter, Virginia A. "Multiculturalism Meets Multimedia." *Book Links* 8, no. 3 (January 1999): 58.

John Tarrell Scott (1940–2007), Sculptor, Printmaker, Installation Artist.

In a series of woodcut prints that he did between 2000 and 2003, and published in a catalog that accompanied his 2005 solo exhibition, John Scott captured New Orleans and its sprawling poetic dissonance. In this series, Scott's monochromatic prints capture the bravura and assertive hauteur of New Orleans in ways that are anticipatory of the deadly arrival of Hurricane Katrina two full years later (Powell 2005, 126–36). Even the titles of some of the prints—*Storm's Coming* and *Dangerous,* for example—appear to predict the impending doom that would descend on the Big Easy, the city that Scott lived for and died longing to return to. Four of the woodcuts are devoted to Louis "Satchmo" Armstrong, the quintessential jazz musician who died in 1971. Armstrong elevated improvisation to a higher creative level, something that resonated with Scott, whose work is a celebration of the improvisational vibrancy that energizes jazz. Scott was devoted to exploring the philosophical and ancestral link between art and music more as a way of maintaining connection with his African ancestry than as an attempt at visually representing music.

The Louis prints capture the effervescent mood of the musician. *So Prove It* is a pastiche of colors, prints, effaced words, and more prints that are spat on a crooning Louis Armstrong. The improvisation that Scott is enamored of becomes reified in this print. In *Louis #4,* Armstrong cuddles his famous instrument, the trumpet, and smiles broadly. One can almost hear the raspy mumblings and sweet vocalization that gave Armstrong his unique identity. But perhaps the most visceral of the Louis prints is *Old Louis,* which is a close-up of the musician. Scott's gut-wrenching woodcut pulsates with palpable energy: eyes bulging, lips tightly clasped around the trumpet, the musician's furrowed burrows complement the facial sinews in proclaiming the musicality of the piece. This print epitomizes Scott's search for a continuum between art and music. It may be the medium; it may be the subject matter. But Scott's dexterity and intimate reading of New Orleans accounts for what is clearly an apocalyptic rendition of the city: the chaotic ambience is rendered more potent by the absence of human beings and a sprawling amalgam of dysfunctional urbanity. The stop signs, which struggle to proclaim their message now appear, in

retrospect, like metaphors for the impending calamity that would render the city comatose.

Shortly before the arrival of Hurricane Katrina in New Orleans in August 2005, Scott evacuated and headed for Houston. That would be the last time that the artist would see his beloved city; he died in Houston on September 1, 2007. Born in 1940 in Gentilly, New Orleans and raised in the Lower Ninth Ward, the largest and most popular of the city's 17 wards, John Terrell Scott was one of five children who were raised by Thomas and Mary Mable Holmes Scott to think creatively and develop a practical, hands-on approach to fashioning things. The Scotts were a very poor family. But all of them were exposed to object-making: drawing and emulating their mother, who had a third-grade education but fortified them with courage and dared them to dream. Following the motivation that his mother gave him, Scott decided early in life that he would be an artist, although in New Orleans of 1958, this declaration made him look preposterous: a poor young man committing to a life of perpetual impoverishment. Scott's father, Thomas, was a chef in a number of hotels who taught his son carpentry. His devotion to work and service to others would later inspire some of Scott's pieces, including *Third World Banquet Table*, a series of large drawings that highlighted the paradox of a man who, in the words of Scott, "set many banquets for many people, but [who] was never invited to sit down" (Powell 2005, 14).

Scott attended Locket Elementary School and Booker T. Washington High School, graduating in 1958. At these schools, the skills that he had acquired at home were further developed in the art classes that he was enrolled in. He became active in designing sets for his school's theater productions, and was fully involved in constructing floats for the popular Mardi Gras festivals in New Orleans (Powell 2005, 22). In 1958, Scott gained admission to Xavier University of Louisiana, a historically black Roman Catholic institution, where he continued to pursue his interest in art, and where he came under the tutelage of Sister Mary Lurana Neely, painter Numa Rousseve, and sculptor Frank Hayden. His admittance to Xavier was particularly remarkable for Scott in that it became a testimony to the perceptiveness of his mother who placed considerable stock on the power of individuals to transcend their perceived limitations and attain set objectives. While his education at Xavier exposed him to a variety of media, the city of New Orleans taught him to develop an enduring appreciation and respect for craftsmanship: "I think of the carpenters, the brick layers, the plasters, the wrought iron works, and realize that a lot of these people that built this city with their hands are people that are ancestrally related to me" (Powell 2005, 16).

Upon graduating from Xavier University, Scott heeded the advice of his professors and enrolled at Michigan State University in 1963 for the M.F.A. program. At Michigan, Scott focused on printmaking and sculpture, and gained from the experiences and creative mentorship of Robert Weil, sculptor, and Charles Pollock, painter and printmaker. In 1965, he was offered a job at his alma mater. That same year, Scott married Anna Rita Smith, his girl friend of many years; the marriage was blessed with five children. The transition from student to professor in the same institution was at once gratifying and

challenging for Scott. Drawing from the words of wisdom that his mother had imbued him with, he immediately set about developing an individuated pedagogy and a philosophical platform for his creative work: "When I got out of graduate school and began teaching, I was looking for a continuum, something to connect my art to that of other African-American artists. It dawned on me that in the visual arts African-American artists have no continuum" (Scott 2006). Jazz provided this critical link with the ancestral home. By studying the music of people like Miles Davis, Charles Mingus, Duke Ellington, and Thelonious Monk, Scott realized that the best approach to visually capture the élan vital to jazz is not to represent it. Rather, it is to understand the philosophical basis that sustains its creation. It is this zest, this ability of jazz musicians to compose and perform in a holistic and contemporaneous fashion that Scott attempts to capture and transmit in his work. This is what he refers to as spherical thinking, a catholic embracement of ideas and concepts and an ability to invest them with visual presence.

His sculptures exude a colorful joie de vivre that asserts this visual and musical synergy. They are poetic, frugal, and economical; as poignant as they are scintillating. His aluminum sculptures wear a musical garb, painted as they are in a variety of gay colors that transform the medium from the traditional, shimmery, and often noncommittal state to funky entities that exude a jazzy air. Some of the pieces that he created in the 1980s—*Snake Charmer's Wisp, Storyville Starter Cord with Thorns,* and *Diddlie Bow,* which were fashioned from wood and other media—combine this exuberant form with a whimsical playfulness. In 1976, he contributed significantly to the hugely successful Ninth National/International Sculpture Conference in New Orleans. Nearly a decade later, in 1984, he put his talent to work in the design and execution of the thematic installation for the huge, Afro-American Pavilion for the Louisiana World Exposition. The installation, *I've Known Rivers,* appropriated architectural elements from Africa to create a pavilion that consisted of "exhibit spaces, activity areas, a theater designated to resemble the hold of a ship used to transport slaves, and a centralized, thirty-foot-diameter 'ceremonial area'" (Powell 2005, 28).

Scott maintained an unbroken relationship with his city of birth. Outside of his graduate education, the artist lived, studied, and taught in New Orleans all his life. In spite of his prodigious creativity, he remained the artist who personified the spirit of New Orleans: its cuisine, its music, and its assimilative approach to life. Not until 1984 did he have his first solo exhibition outside of New Orleans —at the Harris/Brown Gallery—as a result of which he became more widely known and received a commission for a public sculpture, *Stoney Brook Dance,* at Ruggles Street Station in Boston. This opened the avenue for more public works, including his 1990 *Ocean Song,* which consists of a cluster of polished steel mini obelisks at the Audubon Institute in New Orleans. Between *Didlie Bow Series,* his first solo show at the Harris/Brown Gallery in 1984, and *Circle Dance,* his last at the New Orleans Museum in 2005, Scott had no less than 18 other shows, 50 percent of which were held in New Orleans.

He was the recipient of numerous awards in recognition of his distinguished status. These include an honorary doctor of humane letters from Tulane

University; the honorary doctor of humanities, Michigan State University, East Lansing, Michigan; Outstanding Art Contributor Award, National Conference of Artists; Certificate of Merit from New Orleans Mayor Marc Morial; Certificate of Special Congressional Recognition for Service to the Community from Congressman William Jefferson, and the Bush Excellence in Teaching Award (1991–92) at Xavier University, New Orleans. In June 1992, he received the highly coveted John D. and Catherine T. MacArthur Foundation award. With this, Scott was able to acquire a dream studio, where he was able to "play" with a variety of materials and experiment with an assortment of ideas. In 2006, Scott underwent two lung transplants for pulmonary fibrosis, a procedure from which he eventually died.

Places to See Scott's Work

American Jazz Museum, Kansas City, MO
Convention Center Building, Philadelphia, PA
Louisiana State University School of Journalism, Baton Rouge, LA
New Orleans Museum of Art, New Orleans, LA
Ruggles Street Station, Boston, MA
Tulane University School of Law, New Orleans, LA
University of Houston, Houston, TX
Uptown Secondline, 1515 Poydras Building, New Orleans, LA

Bibliography

Bayne, M. G. "State of the Art in New Orleans." *International Review of African American Art* 20, no. 4 (2006): 36–38.
Cotter, Holland. "John T. Scott, 67, New Orleans Sculptor." *New York Times*, September 4, 2007. http://www.lexisnexis.com.proxy.lib.muohio.edu/us/lnacademic/auth/checkbrowser.do?ipcounter=1&cookieState=0&rand=0.16508241747841057&bhcp=1 (accessed July 25, 2008).
Morejon, Nancy. "Melvin Edwards: The World of a Marvelous Artist." *Black Scholar* 24, no. 1 (Winter 1994): 47.
Powell, Richard J. *Circle Dance: The Art of John T. Scott.* New Orleans, LA: New Orleans Museum of Art; Jackson: University Press of Mississippi, 2005.
Scott, John. "MacArthur Fellow John Scott Reflects on His Art." *Black Collegian Online*, 2006. http://www.black-collegian.com/issues/2ndsem06/scott2006-2nd.shtml (accessed January 9, 2009).

Thomas Eugene Shaw Jr. (b. 1947), Painter, Printmaker.

Influenced by the German Expressionists, Thomas Shaw's prints are usually large, forceful, and rigorous; prints with a masculinity that may not have been deliberate, but that constitute an unmistakable and appropriate visual evocation of the social violence that the artist has seen and consistently explored. His black-and-white drawings and woodcuts are generally large, with heights

ranging between five and seven feet, and widths that range between two and four feet. The bold, expressionistic bravura of his drawings and woodcuts combine with a stark, highly contrasty appeal to accentuate the searing grittiness of his subject matter. Yet, Shaw is always reluctant to lay claim to being a printmaker primarily because of his reluctance to tamper with the intimacy and directness of drawing, or to compromise the rawness and elegance of the process, which employing a variety of technology-enhanced approaches does. Shaw attends as many printmaking workshops as his schedule permits, but abstains from getting drawn into the science of printmaking, which he sees as facilitating an indirect bypass of the human figure: "Whenever I go into these print workshops and everybody is going digital and they're going into these chemically inclined things, I have no interest in that because it is just too messy; it's too methodical. That takes something out of the flow of drawing for me because I'm all about drawing. I don't really consider myself a real printmaker" (Shaw 2007).

Shaw's statement belies his astute mastery of the medium, and the extent to which he is able to manipulate drawing and sublimate it to specified ends. The ease with which he draws—the immense pleasure that he derives from the process—is apparent in the power that his work exudes. Shaw grew into art, literally. Born on August 28, 1947, Thomas Eugene Shaw Jr. is one of 10 children: six sisters and three brothers. His father, Thomas Eugene Shaw Sr., was born in McDonald, Georgia. Before he retired to South Campbellsville, Ohio, the elder Shaw worked as a master chef at Mike Fink's riverboat restaurant in Cincinnati. Prior to moving to the north with the family in the late forties, the elder Shaw was a sharecropper who dropped out of school with a ninth-grade education. While his father attached greater value to hard, physical work, Shaw's mother, Alberta Ellis Shaw appreciated the subtleties associated with the creative process. She is a gospel singer who taught herself to sing at age three. By climbing on stools and a ladder, she learned how to play keyboards, organ, and piano.

In addition to encouraging him to follow his creative instincts, Alberta also instilled in Shaw the necessity for transparency and forthrightness. As a kid in Garfield Elementary School in Cincinnati, Shaw had once picked up the drawing of a cowboy and took it home to his mother, claiming that he did it. The incredulous Alberta instantly sat Shaw down and asked him to draw it again. Of course, he was unable to; it did not matter. The humiliating episode had driven home to young Shaw the main lesson: telling lies yields no profit. Still, Shaw was inseparable from art, more so when he saw the attention that his school teachers lavished on two slightly older kids in his school who had demonstrated some drawing aptitude. In elementary school, Shaw became an unapologetic admirer of Watson and Rayfield, two students whom he thought of as having prodigious talents. In particular Rayfield's ability to draw birds captivated him. Here was Rayfield, an African American boy who was so poor that he could not afford art materials and resorted to using drawing impressive downtown market scenes on cardboard using shoe polish. Out of admiration for the talents of these two students, teachers in the school had picked up collections to assist them as they began to pursue studying art in college. These

Thomas Shaw Jr. Courtesy of dele jegede.

events had such a tremendous impact on young Shaw's imagination that he could not visualize pursuing any cause other than art. He secretly wished for a day when teachers would pick up collections to help him pay for art school.

By the time he was in third grade, Shaw believed that something happened, although he did not have the capacity at that time to analyze it: he knew that he had become quite adept at drawing. He could mix colors without being taught, and could draw whatever he set his eyes upon with relative effortlessness. He grew so confident of his ability that he began to challenge anyone in the school, black and white, who claimed to be an artist to open drawing contests. A member of the crowd would pick the subject matter and the students would respond. Time and again, Shaw would end up the winner with bragging rights: "I'd send them crying." This was also the time that Shaw met Mrs. Cash, his teacher who provided such unstinted encouragement that he knew that there was no going back on becoming an artist. Mrs. Cash had chanced upon Shaw in class with a drawing that he claimed that he did. In a way that was reminiscent of his mother's reaction to the cowboy drawing episode, the teacher gave Shaw a double-size paper and told him to repeat the exercise right there in the class. This time, Shaw responded with pride: he made a drawing right before Mrs. Cash in a way that showed convincingly that he indeed was the one that did the first drawing. Although he was not enrolled in an art class at the time, Mrs. Cash gave him his first assignment of producing a large mural on the classroom walls. At the completion of the task, his teacher invited the school principal and other teachers for a formal unveiling. The teacher also invited two other guests to the school: Shaw's parents. They could not have been more proud of their son. Again, as the school had done earlier in the case of Watson and Rayfield, they did a fund-raising for Shaw.

Shaw attended Heinold Junior High School in Cincinnati in 1961, from where he moved to Hughes High School in 1964. From 1966 to 1970, he attended the Art Academy of Cincinnati and majored in painting and printmaking. While there, he worked in the hospital during his spare time, first at the laundry, where he was fired for doing more drawing than laundry. He moved to the morgue, which he enjoyed because the quiet of the environment was conducive to his creative growth. The hospital commissioned him to produce one-of-a-kind March of Dimes posters. To his astonishment, the posters were disappearing with the same speed that they were put up in the hospital. He later learned that they were being stolen by one of the workers in the hospital, Jackie, who fell in love with the posters. He married her.

His work is done in a series that explore topics ranging from the sociopolitical environment to self-portraits that explore his spirituality. Beginning in 1989, he began a series of woodcut prints and drawings that were focused on

what he called the "Malcolm X Paradox." This was his response to a spate of social ills that afflicted urban communities and left a particularly scorching effect on Cincinnati. Shaw attributed this phenomenon to the intrusiveness of television and its corrosive impact on the sacrosanctity of personal space and individual privacy. With the pervasiveness of talk shows and breaking news, television implanted its presence in the psyche of the nation and gave gangs, drug abuse, and drive-by shooting some visibility. Armed with a camcorder, Shaw would go out to interview his subjects and enrich his creative interpretation with the insights provided through such firsthand encounters. The outcome of his approach was a body of work that became so personal and cathartic that he was extremely reluctant to exhibit them.

In 2003, Shaw did a large woodcut, *Makes Me Want to Holler Through Both of My Hands*—a piece that places a screaming figure in the left foreground, with a police officer chasing a young African American man in the distance. This was Shaw's response to the 2001 incident in Cincinnati in which a police officer shot and killed unarmed Timothy Thomas, who was holding his sagging pants as he fled from a team of police officers. His death led to the Cincinnati Riots of 2001 and magnified the enormity of Shaw's subject matter. One of his recent pieces is *The Drive-By*, a 2006 woodcut in which a man wearing dreadlocks turns his large, expansive back to the viewer, revealing a handgun that is tucked in the lower ridge of his frocks. He is holding his dead child, whose lifeless hands dangle while blood continues to spatter the ground on which he kneels. How do you forgive when your child has just been felled by the bullets from a sanguine gangster's gun?

In 2006, Shaw was admitted to the hospital, from where he was moved to a nursing facility as a result of an infection that he suffered after a surgery. The experience led him to work on a series of self-portraits in which he tackles the intractable and deeply personal issue of spirituality. The ensuing series are as much about his spirituality as they are about his medical history. In *Self-Portrait: Dialysis Chronicles*," a 2007 ink on paper, Shaw's health scare is depicted with an assortment of tubes cursing in and out of his body while he lays propped up on a hospital bed. The drawing spots a rectangular heart that has since become the visual element that emblematizes the power of faith and the efficacy of modern medicine.

He has held solo exhibitions at major galleries in Ohio, Indiana, Wisconsin, South Carolina, West Virginia, and New York, among others. His works are in private and public collections across the country.

Places to See Shaw's Work

Akron Museum of Art, Akron, OH
Cairo University, Cairo, Egypt
Chase Manhattan Bank, New York, NY
Cincinnati Art Museum, Cincinnati, OH
High Museum of Art, Atlanta, GA
Houston Museum of Fine Art, Houston, TX
Huntington Museum, Huntington, VA

Kyoto Community House, Kyoto, Japan
Rolling Stone Press, Atlanta, GA
Sheldon Swope Museum, Terre Haute, IN

Bibliography

Artworks. "Thom Shaw: A Choice of Weapon II." *Artsworkscincinnati*, July 24, 2008. http://www.artworkscincinnati.org/gallery/show_thom_shaw.shtml.
Bonner, Earnest. "Collecting Limited Edition Prints." *International Review of African American Art* 4, no. 4 (1998): 9.
Mitchell, Leatha Simmons. "Grief Recycled." *International Review of African American Art* 15, no. 2 (1998): 2–17.
Rife Gallery. *New Horizons*. Exhibition catalog. Portsmouth, OH: Southern Ohio Museum, 2007.
Shaw, Thomas Eugene, Jr. Interview by author, Cincinnati, OH, October 7, 2007.
Studio Museum in Harlem. *The Hale Woodruff Memorial Exhibition: Curator's Choice*. Exhibition catalog. New York: Studio Museum in Harlem, 1994.
Suzanna Terrill Gallery. "Friends' Small Works." Review. *City Beat* 8, no. 4 (2001).

Lorna Simpson (b. 1960), Photographer, Filmmaker, Installation Artist.

Lorna Simpson uses a number of creative devices in her work to provoke the viewer into becoming personally invested in reading her work: scrutinizing them, assigning meanings, and attempting to make sense of some of the works, which are often evasive and open-ended. Simpson's photographs employ familiar strategies—including repetition, text, and ambiguity—to woo viewers and then befuddle them. Many of the images are repeated, often with imperceptible gestural nuances. Words are used to suggest possibilities to the viewer, but without confirming any conclusions. Ambiguity, a pervasive technique, is in the texts, which are a common feature of many of her early pieces; it is reinforced by the denial of familiarity or identification of the subjects who are often effaced (backs are turned to the viewer, faces are cropped, body types are deemphasized), while the decodification that is suggested by the combination of figure and text may frustrate the viewer or add to the obfuscation of the piece. Some may ask, "Why bother?" Is not the purpose of art to facilitate enjoyment? Besides, what happened to personality? Why are we prevented from reading the mood of Simpson's subjects, whose faces are never quite revealed?

Simpson's work, which is approached from a conceptual rather than from a traditional figurative angle, minimizes those attributes that may appeal to viewers without necessarily challenging them. In this regard, her work is enigmatic and elusive; it leaves you scrambling to decode meanings and ascribe motives. Simpson was interested in persuading viewers to abandon the comfort zone within which they have been socialized into contemplating photographs. The notion of conceptual photography developed when she was in

Lorna Simpson sitting on floor in her studio in front of her installation "Wigs." Photo by Ted Thai/Time Life Pictures/Getty Images.

graduate school at the University of California, San Diego (UCSD), where she received an M.F.A. degree in 1985 with a focus on conceptual photography. At UCSD, Simpson came under the influence of conceptual artists David and Eleanor Antin, both of whom were professors with an active creative profile. Eleanor was among those who pioneered performance art, and her influence as a filmmaker and installation artist has grown since 1975, when she began teaching at UCSD. A poet, critic, and extemporaneous performer, David was known for his embracement of conceptual poetry and improvisational "talk poems," which were performed at exhibition sites. At UCSD, Simpson was a contemporary of another major artist, Carrie Mae Weems, who graduated in 1984.

The only child of middle-class parents, Simpson was born in 1960 in the Crown Heights area of New York and grew up in Queens. Her father was a social worker, and her mother worked as a secretary in a hospital. She grew up as a privileged child in a household where art was appreciated. As a child, she was intrigued by the abstract and minimalist art with which her parents adorned their home; these constituted her earliest introduction to the visual arts. She attended the High School of Art and Design, where she was involved in the arts: she played the violin and was into ballet. But she realized early, at the age of 12, that as much as she loved performing, she preferred the role of observer (Golden 2002, 8). She attended the School of Visual Arts in New York

City from where she graduated in 1982 with a B.F.A degree, focusing on documentary photography.

Simpson's work caught critical flavor almost immediately after she graduated from UCSD in 1985. That year, she received the National Endowment for the Arts, and held her first major solo exhibition, "Gestures/Reenactments" in San Diego. Her photographs during this time made use of strategies that Wright (1992, 18) has described as "formulaic," suggesting that the female body "is self-consciously posed in the manner of conventional studio photography. Body parts may also be photographed in life-size scale to stand metonymically for the whole body, or to direct the viewer's reading of image and text to a specific site of disclosure." Falling within this group are *Water Bearer* (1986); *You're Fine* (1988); *Dividing Lines* (1989); *Proof Reading* (1989); and *Guarded Conditions* (1989). Simpson's photographs during the second half of the 1980s were concerned mainly with the exploration of issues pertaining to gender and culture, and the construction and interpretation of identity. She would expand her creative platform in the mid-1990s by working on large multiple felt panels on which her photographs, including accompanying text, were printed using serigraphy. Her 1995 *The Park* is a 67" × 67½" panoramic view of a city park that captures an aerial juxtaposition of two jungles: one, man-made and concrete; the other, which foregrounds the skyscrapers, an umbrella of forest foliage. In many of the pieces that Simpson worked on during this period—including *The Rock* (1995); *The Clock Tower* (1995); and *The Staircase* (1998)—the presence of human beings is suggested poignantly by their absence, and by the various edifices that they leave behind. A third phase of Simpson's career is marked by her film and video installations, which are remarkably different from the two previous phases. In that time, the fourth dimension, is accounted for; while the effacement of human agency, which made her earlier work quite enigmatic and enchanting, is discarded. In her first film project, *Interior/Exterior* (1997), the same ambiguity and suggestiveness that permeated her photographs remain discernible traits. The narratives are brief and morph in and out of sequences, emphasizing the fugitive nature of the medium.

The decision to explore new approaches and media was prompted by a one-decade survey of her work, which was exhibited at the Museum of Contemporary Art in Chicago. In an interview with Thelma Golden, Simpson further provides a pungent self-critique on why she stopped using the body in her work: "There was a feeling of discomfort that the audience immediately recognizes the way that the work operates and has a particular expectation of what they're going to see. The whole premise of the work was to engage with the audience in a way they wouldn't be used to—put them off balance" (Jones 2002, 16–17). The realization that her work was becoming so predictable to her audience was one of the reasons why she changed her method. The death of her mother and the loss of many of her friends to AIDS were also contributory to the need to move away from using the human body in her work.

Since the mid-1980s, when she made her mark as a professional artist, Simpson has taken part in numerous group and solo exhibitions at important sites nationally and internationally. Simpson had the distinction of being the first

African American female artist to have a solo show at the Museum of Modern Art in New York. She has had innumerable group exhibitions, and an impressive list of solo shows at major exhibition spaces nationally and internationally. These include the Jamaica Arts Center (New York); Wadsworth Athenaeum (Hartford, Connecticut); The Contemporary Arts Center (Cincinnati, Ohio); Galleria Javier Lopez (Madrid, Spain); Whitney Museum of American Art (New York); the Studio Museum in Harlem (New York); Wexner Center for the Arts (Columbus, Ohio); and the Walker Art Center (Minneapolis, Minnesota). In 1993, she represented the United States at the Venice Biennale, and has had repeat participations at the Whitney Biennale and the Documenta at Kassel in Germany. Her honors include nomination for the Hugo Boss Prize by the Solomon R. Guggenheim Foundation, and the Whitney Museum American Art Award in 2001.

Places to See Simpson's Work

Addison Gallery of American Art, Andover, MA
Albright-Knox Art Gallery, Buffalo, NY
Center for Contemporary Art, Kitakyushu, Japan
Columbia Museum of Art, Columbia, SC
Corcoran Gallery of Art, Washington, DC
Harvard University Art Museums, Cambridge, MA
Hirshhorn Museum and Sculpture Garden, Washington, DC
Indianapolis Museum of Art, Indianapolis, IN
Jersey City Museum, Jersey City, NJ
Museum of Contemporary Art, Chicago, IL
Museum of Contemporary Photography at Columbia College, Chicago, IL
Museum of Fine Arts, Boston, MA
Museum of Fine Arts, Houston, TX
San Francisco Museum of Modern Art, San Francisco, CA
Walker Art Center, Minneapolis, MN

Bibliography

Cotton, Angela L. *Unmaking Race, Remaking Soul: Transformative Aesthetics and the Practice of Freedom.* Albany: State University of New York Press, 2007.

Foster, Hal, Rosalind Krauss, Silvia Kolbowski, Miwon Kwon, and Benjamin Buehlow. "The Politics of Signifier: A Conversation on the Whitney Biennial." *October* 66 (Autumn 1993): 3–27.

Fusco, Coco. *English Is Broken Here: Notes on Cultural Fusion in the Americas.* New York: New Press, 1995.

Golden, Thelma. "Thelma Golden in Conversation with Lorna Simpson." In *Lorna Simpson,* edited by Kellie Jones, Thelma Golden, and Chrissie Iles, 8–25. New York: Phaidon, 2002.

Jones, Kellie. *Lorna Simpson.* New York: Phaidon Press, 2002.

Marcoci, Roxana, Diana Murphy, and Eve Sinaiko, eds. *New Art.* New York: Harry N. Abrams, 1997.

Oberlin College. *Contemporary Afro-American Photography.* Exhibition catalog. Oberlin, OH: Oberlin College, 1983.

Posner, Helaine. *Lorna Simpson.* New York: Harry N. Abrams in association with the American Federation of Arts, 2006.

Pressplay: Contemporary Artists in Conversation. New York: Phaidon Press, 2005.

Rogers, Sarah. *Lorna Simpson: Interior/Exterior, Full/Empty.* Columbus, OH: Wexner Center for the Arts/Ohio State University, 1997.

Smith, Cherise. "Fragmented Documents: Works by Lorna Simpson, Carrie Mae Weems, and Willie Robert Middlebrook at the Art Institute of Chicago." *Art Institute of Chicago Museum Studies* 24, no. 2 (1999): 244–59.

Willis, Deborah. *Lorna Simpson.* San Francisco: Friends of Photography, 1992.

Wolf, Sylvia. *Focus: Five Women Photographers: Julia Margaret Cameron, Margaret Bourke-White, Flor Garduño, Sandy Skoglund, Lorna Simpson.* Morton Grove, IL: Whitman, 1994.

Wright, Beryl J. *Lorna Simpson: For the Sake of the Viewer.* New York: Universe Publications; Chicago: Museum of Contemporary Art, 1992.

Renee Stout (b. 1958), Installation Artist, Painter.

Renee Stout's work traverses boundaries ranging from traditional two-dimensional media in which painting, drawing, printmaking, or photography is undertaken within a safe confine that explores standard routines and safe subjects, to explorations in three-dimensions where medium and mediumship, narratives, text, and subplots become intertwined, and the idea of art is expanded to include the excavation of ancestral legacies and cultural retention and regeneration. Prior to her foray into installations in which the fourth dimension of space and the sanctuaries of thought and spirituality are invoked, implicated, or suggested, Stout was content to work as a painter— and a versatile one, at that—whose figure paintings were done in the realist tradition of Edward Hopper. Her 1983 *Hanging Out* (MacGaffey and Harris 1994, 115), which comprises four African American men, three of whom cast a direct gaze at the viewer, exemplifies this style. It is a competent piece that displays all the basic elements of a good painting: contrast, balance, composition, and draftsmanship. But in an age when ideas are privileged over masterful execution and art assumes an unfettered potency where it seeks to disrupt conventional practices and initiate a new mode of presentation, Stout's paintings would probably not have had the irresistibility that her installation pieces do.

Although she was born in Junction City, Kansas, she grew up in the East Liberty section of Pittsburgh, Pennsylvania, to which the family returned when Stout was one year old. As a young girl, she was enrolled in Saturday morning classes at the Carnegie Museum of Art. This was where, for the first time, she encountered an *nkisi nkondi*, a nail-studded and amulet-laden power figure from the Democratic Republic of Congo, which enchanted the 10-year-old Stout; this enchantment would grow with time and constitute the basis for a

new creative, career-changing thrust. In an interview with Philip Ravenhill and Bryna Freyer (Harris 1993, 111), Stout recalls the import of the Carnegie Museum encounter with an *nkisi nkondi:* "I saw a piece there that had all these nails in it . . . And I think once I got exposed to more African art in my travels as I got older, I found that I started going back to the pieces like that." In 1980, she graduated from the Carnegie-Mellon University with a degree in Fine Arts.

Late in 1984, Stout left for Northeastern University in Boston for a six-month residency in the Afro-American Master Artist-in-Residence Program. The change in Stout's work—the break from the con-

Renee Stout. Courtesy of Renee Stout.

fines of mimetic or realist genres—was triggered by a sequence of events, which began soon after she left Pittsburgh in 1984. The environment in which she lived in Boston that year—away from the familiar Pittsburgh surroundings and working in a studio without windows—catalyzed an introspective pensiveness that resulted in her "fetish" series; finally, the *nkisi nkondi* that she saw as a youngster has undergone a mature creative processing that opened new vistas for reconfiguring things. The process in turn gave fillip, over time, to new explorations of the human condition and led to the creation of contexts that often include imaginary characters who inhabit a fictive world and play roles created by the artist. In 1985, she relocated to Washington, DC, where she continued full exploration of her family heritage. It soon became apparent that the connection that Stout has in the *nkisi nkondi* was not an isolated development. The penchant to collect all manner of objects, to preserve, recycle, and reconfigure them, runs in the family. Harris cites several examples that attest to this remarkable family trait. Stout's mother, who lost a brother long before the artist was born, filled a jar with an assortment of objects and used it as a grave marker for her beloved brother. The artist's father, a mechanic, has a garage full of objects that he has collected and preserved, including portions of a human skeleton that he had retrieved from a hospital that disposed of them. Stout's maternal grandfather was a musician whose music brought people together for merriment. Jesse Owens, the brother of the artist's mother, was a painter whose work Stout has incorporated into her own installation (Harris 1993, 111–21).

In 1993, the National Museum of African Art at the Smithsonian Institution in Washington, DC, had a major exhibition, "Astonishment and Power: Kongo Minkisi and the Art of Renee Stout" that revealed her compulsive acquisitiveness, and channeled her energy into creating multimedia pieces that worked best with her talents at the same time that they created new avenues for processing the multiplicity of texts and enactments that work best in installations. Stout acknowledges in her artist's statement (http://www.reneestout.com) that this process has been invigorating:

> The process of working out the many questions I have about the human condition directly through my work has been both cathartic and empowering. The alter ego Fatima Mayfield, a fictitious herbalist/fortuneteller, is the vehicle that allows me to role play in order to confront the issues, whether it's romantic relationships, social ills, or financial woes, in a way that's open, creative and humorous.

Another character that fascinated Stout is Madam Ching, a mysterious "old black woman" who lived in Pittsburgh and had a smorgasbord of weird and "strange things" in jars and bags all over her house. These, then, were some of the ideas that fascinated Stout as she made her transition from a safe painter to a daring multimedia artist. She drew eclectically from a variety of sources, including family, neighborhood, and personal experience. The series of three-dimensional objects that she created for her Smithsonian exhibition included the fetish series, which were three-dimensional objects with an accretion of dolls, beads, charms, sacks, amulets, cowrie shells, buttons, coins, and feathers, among other knickknacks, to simulate a personal power object. The most compelling of the fetish series is *Fetish No. 2,* a life-size nude female figure bedecked with all the simulated charms and amulets of a contemporary nkisi, all of which invoke the same fearsomeness of a power figure. *Fetish No. 2* is Stout's own body, which was cast in plaster and then painted and adorned with all the elements that conjure magic and occultism. This figure has two cowrie shells for eyes and wears braided extensions under a wig that is made of monkey hair. The picture of a black girl is tucked away in the sealed abdominal cavity, the spot that, in the Kongo *nkisi nkondi,* typically contains the *bilongo,* or medicine, which the *nganga* (the medicine man) implants in the *nkisi* for the purpose of activating its performance efficacy.

Stout's installations, which contain elements of conjuration, rootwork, and spirituality, evoke affinities with her African ancestry. As Merla Berns has observed, Stout's work is enriched by the multiplicity of spiritual systems from which she continually draws. These include African deities, Haitian Voudou gods and goddesses, and "the constructed devices and written formulas used in black folk conjuring, which are still available in spiritual supply stores in New Orleans and other urban areas" (Berns 1996). In drawing on the richness of ancestral spirituality, Stout joins a list of distinguished African American artists whose works have benefited from familiarity with the affective powers of African culture. This list includes **Loïs Mailou Jones**, Herman "Kofi" Bailey, **Jacob Lawrence**, **Aaron Douglas**, **Hale Woodruff**, and **Melvin Eugene Edwards Jr.**. In the 1920s during the Harlem Renaissance, Alain Locke

championed the notion of personhood for African Americans whom he enjoined to tap into their African heritage for empowerment and cultural identity.

Since the mid-eighties, Stout has participated in innumerable group and solo exhibitions at universities, galleries, and museums locally and nationally.

Places to See Stout's Work

Ackland Art Museum, University of North Carolina, Chapel Hill, NC
Art Museum at University of California, Santa Barbara, CA
Cooper Union School of Art, New York, NY
Dallas Museum of Art, Dallas, TX
Detroit Institute of Art, Detroit, MI
Hirshhorn Museum and Sculpture Garden, Washington, DC
National Gallery of Art, Washington, DC
National Museum of American Art, Washington, DC
Pennsylvania State University, University Park, PA
Renee Stout at the Smithsonian American Art Museum, Washington, DC
Rhode Island School of Design, Providence, RI
San Francisco Museum of Art, San Francisco, CA
St. Louis Museum of Art, St. Louis, MO

Bibliography

Berns, Marla. *Dear Robert, I'll See You at the Crossroads: A Project by Renee Stout.* Santa Barbara: University of California, Santa Barbara, 1996.

Hall, Robert L. *Gathered Visions: Selected Works by African American Women Artists.* Washington, DC: Anacostia Museum, Smithsonian Institution, 1992.

Harris, Michael D. "Resonance, Transformation and Rhyme: The Art of Renee Stout." In Wyatt MacGaffey and Michael D. Harris, *Astonishment and Power.* Washington, DC: National Museum of African Art, the Smithsonian Institution, 1993.

Hartigan, Lynda Roscoe. "Renee Stout." In *American Kaleidoscope: Themes and Perspectives in Recent Art,* edited by Jacquelyn Days Serwer. Washington, DC: National Museum of American Art, Smithsonian Institution, 1996.

Marcoci, Roxana, Diana Murphy, and Eve Sinaico, eds. *New Art.* New York: Harry N. Abrams, 1997.

Owen-Workman, Michelle A., Renee Stout, and Stephen Bennett Phillips. *Readers, Advisors, and Storefront Churches: Renee Stout, a Mid-Career Retrospective.* Kansas City, MO: Belger Art Center for Creative Studies, 2003.

Plagens, Peter. "Africa Meets the West." *Newsweek,* February 19, 1990, 68.

Stout, Renee. "Artist's Statement." http://reneestout.com/Statement.htm (accessed July 26, 2008).

Thompson, Robert Farris. "Illuminating Spirits 'Astonishment and Power' at the National Museum of African Art." *African Arts* 26 (1993): 61–69.

T

Henry Ossawa Tanner (1859–1937), Painter.

Generations of African and African American artists hold Henry Ossawa Tanner as an icon of inestimable value. He stood apart in a different category physically—on account of the fact that he was based in Paris—and professionally because of his pioneering status as a black man who went to France and, through commitment, sacrifice, and hard work, attained his dream of becoming a world-class artist and blazed a trail in the process. An astute painter with a delicate and sensitive palette, Tanner captured the imagination of Americans with his 1894 paintings *The Thankful Poor* and *The Banjo Lesson,* both of which depict a socialization process in a black homestead. In *The Thankful Poor,* which is Tanner's first attempt at painting a religious topic, a father and his son are caught in their sparse dining space praying prior to having a meal. In *The Banjo Lesson,* a dutiful father prepares to teach his son some a rudimentary but important skill on a banjo. Both paintings reveal an essential process of strengthening family cohesion: transmittal of healthy behavioral habits. From these two paintings, we learn something about the typical black family in nineteenth-century America. The environment speaks to viewers about the prevalent economic condition of these families as much as it does about strength of character, moral dignity, personhood, and pride.

The paintings were done when Tanner returned to Philadelphia from his base in Paris to recover from a typhoid fever attack (Mosby 1991, 116). Besides demonstrating Tanner's rejection of the prevalent racial stereotype and social incendiary that posited that blacks were incapable of producing any enduring art, these paintings represent Tanner's desire to use his art to project a positive aspect of the black person, that contrary to the widespread perception popularized by the dominant culture, the black person is not a buffoon fit only to be exploited, abused, and discarded. Tanner felt eminently qualified not only to paint blacks positively into history, but also to write about them in ways that debunk endemic pejorative beliefs. In a statement attributed to him in 1894, Tanner indicated that the desire to present blacks with empathy and seriousness was a driving factor in the paintings that he produced. Writing in third person, he proclaimed: "To his mind, many of the artists who have represented Negro life have only seen the comic, the ludicrous side of it, and have lacked sympathy with and appreciation for the warm big heart that dwells within such a rough exterior" (Mosby, 116).

In 1894, Tanner sold *The Banjo Lesson* and *The Thankful Poor* and others—*The Bagpipe Lesson* and *The Young Sabotmaker*—to fund his return to Paris. *The Banjo Lesson* was purchased by Tanner's patron, Robert C. Ogden, who then donated it to the Hampton Institute. *The Thankful Poor,* which John T. Morris purchased and loaned to the Philadelphia School of the Deaf, was acquired in 1981 at an auction by William H. and Camille O. Cosby for $250,000, at that time the highest prized ever commanded by an African American artist.

Tanner's love of art started early, at age 13, when he chanced upon a landscape painter while walking in Fairmont Park in Philadelphia with his father. The young Tanner, who was frail of build and delicate of health, was not enamored of the hint, often dropped by his father, that he should seriously consider the option of becoming a minister. The chance encounter with a painter in the park gave Tanner so much excitement that his mother had to hastily put together a makeshift artist's painting kit that night. Gushing with enthusiasm, Tanner returned to the same location at the park where he had seen the artist the previous day and made his first tentative attempt at painting. From that day on, becoming an artist would be a goal to which Tanner devoted his whole energy with passion and indescribable zeal.

Henry Ossawa Tanner was born on June 21, 1859 in Pittsburgh Northside a year after his parents, Benjamin Tucker Tanner, a minister in the African Methodist Episcopal Church, took Sara Elizabeth Miller as his wife. Tanner's father was a self-assured man who was conversant with key political and social issues of his time, especially as they affected the black population. He was industrious and well read. At some point, he combined his barbing profession with his studies at Avery College, at the end of which he proceeded to Western Theological Seminary in Pittsburgh, from where he graduated as minister.

In 1869, young Tanner was enrolled at Robert Vaux Consolidated School for Colored Students, graduating in 1877 as the valedictorian of his class. It was an uphill task for Tanner to find a steady and dependable source that would teach him the basic rudiments of painting. Very few artists were willing to take him on account of his race. The odds of becoming an artist were against him. Aside from his father's interest in having him pursue a vocation in the ministry, there were not too many black artists, Edward Mitchell Bannister (1828–1901) being an exception, to whom Tanner could look up as role models. Added to this was the social perception that saw the artist as a public liability. Determined to follow his dream, Tanner would follow any trail that promised to give him the much-desired training. He befriended J. N. Hess, an animal painter who convinced him that opting for animal painting instead of becoming a marine painter had greater prospects, since there were fewer painters dealing with that genre. Tanner focused his attention in that direction and purchased two animals—a goose and a sheep—that he used as subject for his painting studies (Bearden and Henderson 1993, 81). The site of a young black man determined to do nothing in life other than paint geese and sheep only exacerbated Tanner's dilemma; members of his family were amused and confounded at what appeared to be the indiscretion of an overly enthusiastic boy. His father secured employment for him in a flour mill. Soon, Tanner's health deteriorated, and he had to endure a long period of recuperation. This was enough

to change the elder Tanner's mind; he became determined to honor his son's wish and do all that was necessary to help him achieve his dream of becoming an artist.

In December 1879, Tanner became a student at the Pennsylvania Academy of Fine Arts and began studying with Thomas Eakins, who taught him essential skills and processes pertaining to form and color. Tanner studied at the Academy for the next two years, although he would continue his studies with Eakins well beyond 1881. Tanner endured racially motivated assaults, which inflicted on him deep pain and anguish that was mitigated only through the understanding and counseling that Christopher Shearer, a Philadelphia artist, showed. Shearer, who had encouraged Tanner to apply to the Pennsylvania Academy of Fine Arts, continued to provide him the necessary moral support, which Tanner deeply appreciated. In one traumatic episode during his years at the Pennsylvania Academy of Fine Arts, Tanner was bundled out one night, tied firmly to his easel, and left at the mercy of the elements. It was a sadistic gesture that was meant to drive home to poor Tanner the impudence of daring to dream: of having the temerity to excel in a field that was supposed to be exclusive to whites. In one note to Shearer, Tanner wrote, "I was extremely timid, and to be made to feel that I was not wanted, although in a place where I had every right to be, even months afterward caused me sometimes weeks of pain" (Bearden and Henderson 1993, 83).

In the 1880s, Tanner attempted to live on his art, but had little success. Occasionally, he would sell a painting or receive favorable press for a painting. But it was never enough to provide much-needed financial independence. In 1889, he went to Atlanta and ventured into photography. His commercial photographic studio did not fare well. An encounter with Bishop and Mrs. Joseph C. Hartzell changed Tanner's life. Hartzell, bishop of the Methodist Episcopal Church in Cincinnati and trustee of Clark University in Atlanta, showed interest in Tanner's work and secured a job for him to teach art at Clark. This brought relief to Tanner, who shut down his photographic studio and traveled to North Carolina and parts of Georgia taking photographs. The Hartzells also facilitated Tanner's first solo exhibition in Cincinnati. When no single sale was made, they purchased the entire collection for a total of $375. With that amount, Tanner realized his dream of going to study in Europe. On January 4, 1891, he sailed to Europe, intent on studying in Rome, but settled in Paris and enrolled at the Acedemie Julien, which was so welcoming and supportive that he felt liberated and empowered.

Places to See Tanner's Work

Art Institute of Chicago, Chicago, IL
Bowdoin College Museum of Art, Brunswick, ME
Carnegie Museum of Art, Pittsburgh, PA
Dallas Museum of Art, Dallas, TX
Detroit Institute of Arts, Detroit, MI
High Museum of Art, Atlanta, GA
Howard University Art Collection, Washington, DC

Metropolitan Museum of Art, New York, NY
Morris Museum of Art, Augusta, GA
Museum of Fine Arts, Boston, MA
Museum of Fine Arts, Houston, TX
Museum of the Rhode Island School of Design, Providence, RI
Muskegon Museum of Art, Muskegon, MI
National Academy of Design, New York, NY
National Gallery of Art, Washington, DC
Pennsylvania Academy of the Fine Arts, Philadelphia, PA
Philadelphia Museum of Art, Philadelphia, PA
Saint Louis Art Museum, St. Louis, MO
Sheldon Art Gallery, Lincoln, NE
Smithsonian American Art Museum, Washington, DC
Springfield Museum of Art, Springfield, OH
Terra Foundation for American Art, Chicago, IL
Weatherspoon Art Museum at The University of North Carolina, Greensboro, NC
Yale University Art Gallery, New Haven, CT

Bibliography

Adams, B. "Tanner's Odyssey." *Art in America* 79, no. 6 (June 1991): 108.

Bearden, Romare. *Six Black Masters of American Art.* New York: Zenith Books, 1972.

Bearden, Romare, and Harry Henderson. *A History of African American Artists from 1792 to the Present.* New York: Pantheon Books, 1993.

Boime, Albert. "Henry Ossawa Tanner's Subversion of Genre." *Art Bulletin* 75, no. 3 (September 1993): 415–41.

Burke, Daniel. "Henry Ossawa Tanner's 'La Sainte-Marie.'" *Smithsonian Studies in American Art* 2, no. 2 (Spring 1998): 65–73.

Grant, Susan. "Whistler's Mother Was Not Alone: French Government Acquisitions of American Paintings, 1871–1900." *Archives of American Art Journal* 32, no. 2 (1992): 2–15.

Harper, Jennifer J. "The Early Religious Paintings of Henry Ossawa Tanner: A Study of the Influences of Church, Family, and Era." *American Art* 6, no. 4 (Autumn 1992): 68–85.

Loughery, John. "Titian, Tanner, and the Remade SoHo." *The Hudson Review* 44, no. 2 (Summer 1991): 279–84.

Matthews, Marcia M. *Henry Ossawa Tanner, American Artist.* Chicago, IL: University of Chicago Press, 1969.

McCready, Eric S. "Tanner and Gilliam: Two American Black Painters." *Negro American Literature Forum* 8, no. 4 (Winter 1974): 279–81.

Morgan, Jo-Ann. *Uncle Tom's Cabin as Visual Culture.* Columbia: University of Missouri Press, 2007.

Mosby, Dewey F. *Henry Ossawa Tanner.* Philadelphia, PA: Philadelphia Museum of Art; New York: Rizzoli International Publications, 1991.

———. *Across Continents and Cultures: The Art and Life of Henry Ossawa Tanner.* Kansas City, MO: Nelson-Atkins Museum of Art, 1995.

Perry, Regenia. *Free Within Ourselves: African-American Artists in the Collection of the National Museum of American Art.* Washington, DC: National Museum of

American Art, Smithsonian Institution in association with Pomegranate Art-
books, San Francisco, 1992.

Pinder, Kymberly N. " 'Our Father, God; Our Brother, Christ; or Are We Bastard
Kin?': Images of Christ in African American Painting." *African American Review*
31, no. 2 (Summer 1997): 223–33.

Robertson, Bruce. "The Tipping Point: 'Museum Collecting and the Canon.' "
American Art 17, no. 3 (Autumn 2003): 2–11.

Skeel, Sharon Kay. "A Black American in the Paris Salon." *American Heritage* 42,
no. 1 (February–March 1991): 76.

Uzelac, C. P. "James Amos Porter Meets Henry Ossawa Tanner." *International
Review of African American Art* 20, no. 3 (2005): 3–11.

Fatimah Tuggar (b. 1967), Media and Installation Artist.

Fatimah Tuggar's video and digital work deals with ironies, probabilities, and
incongruities. Using digital technology, she constructs scenarios and cultural
landscapes that invite multiple readings and pose more questions than
answers. Her digital photo montages are constructed in modules that invite
the viewer to interact with them and, from a pool of available images, select,
replace, re-create, and individualize plots. Tuggar confirms the centrality of
technology and deliberate ambivalence in her work: "I use [technology] as a
metaphor for power dynamics to explore how media diversely impacts local
and global realities. Media is both a subject and the medium of the work. Bor-
rowing from the familiar language of advertisement and drawing from the
experiential, I investigate the cultural and social implications of technology"
(Civitella 2008).

Tuggar was born on August 15, 1967, in Kaduna, Nigeria. In high school, she
went beyond customary drawings and paintings and began to show an inter-
est in pieces that transcend standard boundaries and provoke the imagination.
She worked in collages and produced posters for imaginary horror movies in
which a serial killer subjected the lifeless bodies of his victims to some of the
most gruesome abuses. When she was not visualizing such horrifying posters,
she was busy designing "products" and constructing boom box or roller blade
of tissues, which would presumably attract the attention of teenage patrons
(Sullivan 2008). This interest in exercising the imagination and producing
works that transcend boundaries would become the hallmark of Tuggar's
work. She attended Blackheath School of Art in London between 1983 and
1985 for her foundation courses before moving to Kansas City Art Institute in
Missouri, where she studied from 1987 to 1992 for her B.F.A. degree. In the
summer of 1992, she attended the Skowhegan School of Painting and Sculpture
for a summer program before moving to Yale in the fall of the same year for her
M.F.A., which she obtained in 1995. Between 1995 and 1996, Tuggar partici-
pated in an Independent Study program at the Whitney Museum of American
Art in New York.

Graduating from Yale, Tuggar was in a quandary: in an art world that she perceived as lacking the focus and direction of the eighties, Tuggar did not have a mainstream currency to provide an initial creative fillip. She realized that she would have to address the situation directly:

> I'm leaving school, I'm no longer a student, and now more than ever . . . I decided that I needed to get even more serious about what I wanted to do. So, the idea—I'd been taking photographs of people for a while, but I hadn't used the photographs because I knew that, living in America, in this culture, I learned early on with other pieces, that using the images of black people from Africa was such a huge trigger, that everything I would do would be reduced to race. So I had been careful about using actual people and it was something I was always skirting around and never really quite did. So that was one reason to come to it, other than the fact that I was disillusioned. So, I just decided, I'm just going to do what I'm going to do, and some people are going to get it, and some people probably won't get it. Most people probably won't get it. So, that's sort of how it happened. It was more of a brave move from where I was sitting than I thought it was.
>
> (Sullivan 2008)

The resort to technology fired her imagination, as it gave her the opportunity to play with ideas that she had nurtured since her high school years. Employing technology would steer her away from the tendency by artists to become fixated on self at the same time that she would utilize the advantage of dealing with its effects on the two cultures—Western and African—with which she is familiar. One of the attractions of the medium is that it provides Tuggar the flexibility to confront orthodoxy and break the restrictive mold that she has always resisted since her days in boarding school. The ambiguity that Tuggar explores in her work is made more manifest in the relative lack of access to the medium in many of the African cultures that Tuggar juxtaposes with Western scenarios. In Africa, for example, available data suggest that less than 5 percent have access to the Internet, as opposed to 50 percent in Western countries. In her interview with Gary Sullivan, Tuggar reveals that a member of the audience at the screening of her video, *Fusion Cuisine*, expressed concern at the thought that technology might soon penetrate the continent and contaminate its pristine cultural climate. Tuggar's work ruptures such protectionist idealism, the type that sees Africa as an oasis of cultural Puritanism.

The adaptability of the medium enables Tuggar to create interactive environments—imaginary digital plays—that make it possible for all manner of implausible environments to be constructed, manipulated, and animated using appropriate computer applications. Tuggar supplements her archive of personal photographs of Nigerian scenes with additional images that she extrapolates from diverse sources, including the Internet, magazines, films, and video clips. In her 2000 *Shopping at the Meat Market*, for example, top fashion models in high fashion gear are placed in a meat market in what appears to be a developing country. It is a panoramic construct that features an open stall where slaughtered and skinned meat are hung in an open environment. The

incongruity created is apparent: the models are clearly disengaged from the environment and look out of sync in a market that is usually filled with an assortment of flies that are attracted by exposed meat. In *Labor for Flowers,* three women who could be Hausa from the northern part of Nigeria are engaged in a quotidian chore: pounding grains in a wooden mortar. The irony here is the environment, which is a flower garden with an array of colorful flowers that critiques the activity in which the women are engaged. It calls to question the aesthetic judgment of the women, since their act poses clear degradation and injury to the environment in which they are placed. In creating these series of amalgams, Tuggar aims at drawing attention to the ubiquitousness of technology in the life of people, and examines the extent to which seemingly disjunctive environments allow us to become aware of cultural correspondences.

Tuggar, who lives and works in New York City, has participated in several group exhibitions in Europe, the United States, and Africa. She has also had many solo shows at major centers across the United States, and at such places as Bamako, Mali; Cadiz, Spain; Geneva, Switzerland; and Lisbon, Portugal. She has received many grants and awards, including the Special Award in Recognition of Outstanding Contribution in Bamako, Mali; a Special Commission, Tempo Exhibition at the Museum of Modern Art, New York; Wheeler Foundation Grant, New York; and the Fund for U.S. Artists at International Festivals and Exhibitions.

Places to See Tuggar's Work

Private collections
The West Collection, Oaks, PA

Bibliography

Civitella Ranieri. "Fatimah Tuggar." http://www.civitella.org/fellows_personal .aspx?fellowid=174 (accessed July 26, 2008).
Fleetwood, Nicole R. "Visible Seams: Gender, Race, Technology, and the Media Art of Fatimah Tuggar." *Signs: Journal of Women in Culture and Society* 30, no. 1 (Autumn 2004).
Fortin, Sylvie. "Digital Trafficking: Fatimah Tuggar's Imag(in)ing of Contemporary Africa." *Art Papers,* March–April 2004, 24–29.
Janus, Elizabeth. "Fatimah Tuggar—Brief Article." *Artforum,* January 2001. *FindArticles.com,* December 22, 2007. http://findarticles.com/p/articles/ mi_m0268/is_5_39/ai_75577272.
———. "Geneva, Fatimah Tuggar, Art & Public." *Artforum,* January 2001, 147.
Kino, Carol. "Fatimah Tuggar at Greene Naftali." *Art in America,* September 2001, 155–56.
Njami, Simon. *Africa Remix.* Düsseldorf, Germany: Museum Kunst Palast, 2004.
Sullivan, Gary. "Fatimah Tuggar: Interview." http://home.jps.net/~nada/ tuggar.htm (accessed July 26, 2008).
Vine, Richard. "The Luminous Continent." *Art in America,* October 2004, 69–73.

U

Obiora Udechukwu (b. 1946), Painter, Poet.

In 1997, Obiora Udechukwu accepted a teaching position at St. Lawrence University in Canton, New York, and relocated from Nigeria where, since the early seventies, he had taught at the University of Nigeria Nsukka (UNN) as professor of painting. He was born on June 4, 1946, in the city of Onitsha, a thriving commercial center located east of the Niger River, with a population of over six million people. Although Udechukwu grew up in a large cosmopolitan city, his parents made sure that he maintained connection with Agulu, his ancestral village. There, he became accustomed to the rich tradition of indigenous architecture, with its carved posts and wall murals that were the specialty of the women. He grew to appreciate an assortment of masks and the colorful masquerades that appeared at local festivals and on special occasions. His early art education came in colonial Nigeria, with its emphasis on mimesis and realistic rendering of objects.

In 1965, Udechukwu entered the Ahmadu Bello University, Zaria, in the northern part of Nigeria, to study art. In January 1966, a military coup d'etat terminated the fledgling civilian government that came after Nigeria attained independence from Great Britain in 1960. In 1966, there was hostility against all Igbo people—Udechukwu's kinsmen—who were based in the northern part of Nigeria. Many of them were slaughtered, while several more were maimed. As a consequence of this pogrom, all Igbo were evacuated from northern Nigeria, and Udechukwu was forced to transfer to the UNN, where he completed his art education in 1972. In July 1967, the Nigerian civil war, which was generally referred to as the Biafran war, broke out as the eastern region of the country announced its readiness to secede from Nigeria. Udechukwu's art program at the University of Nigeria was once again interrupted as he joined efforts with other artists to produce materials for the Biafran government's Directorate of Propaganda. Out of college during the war and in his village at Agulu, Udechukwu had more time to study the nuances of the local culture. Artists became involved in using the arts to raise funds to prosecute the war and boost the morale of the troops. Udechukwu broadened his creative outlook to include poetry, theater, and play writing. As the bombs rained down from Nigerian warplanes on Biafran targets, and as federal troops took one town after another, Udechukwu and his tribe of artists were forced to move from village to village. A great deal of

the paintings and drawings that he did during the war years was lost, while the ravages of the war continued to surface in his work long after the Biafran war ended in January 1970.

In 1972, Udechukwu obtained his B.A. degree in painting, followed by the M.F.A. in 1977, from the UNN. Twenty years later, at St. Lawrence University in New York, Udechukwu's work has become much more mature, and although his efforts at fusing the cultural influences of his Nigerian ancestry with the sociopolitical experiences in the United States are subtle, they enrich his modernist flair. Udechukwu believes that as an artist who is resident in a different climate, it is in his interest to keep an open mind and be receptive to new ideas: "We have a saying that a traveler to distant places does not have enemies. . . . We also have a saying that if things are good for the river, things will be good for the fish" (Udechukwu 2006). This notion of accommodation, inclusiveness, and responsible citizenship undergirds Udechukwu's creative philosophy.

His primary mediums are painting, drawing, and printmaking, although he has also done installation. In 1995, as one of two artists from Africa who were invited to participate in an exhibition in Erfurt, Germany, Udechukwu employed the concept of the public and private domains in traditional Igbo architecture to design a structure with walls constructed of clay and a cover comprised of painted canvas using the four traditional Igbo colors of black, yellow, white, and red. The public domain of his structure represented exteriority, while the private domain stood for inner sanctum and individuality. Incorporated into the inner chamber of Udechukwu's installation were written proverbs that were visible only to those privileged with an access, and who are literate in Igbo, the language in which the proverbs were written. This interface between exteriority and interiority is a major stylistic apparatus that Udechukwu constantly employs to resolve design and content problems.

In recent years, especially since his relocation to Canton, New York, he has intensified the incorporation of written text into his work. The tendency for calligraphic aesthetics goes back to the artist's undergraduate years at Nsukka, when he undertook the study of *uli* wall designs of the Igbo. *Uli* is the generic name given to abstract, poetic designs that Igbo women once painted on female bodies for adornment and beautification. These same designs were also applied to the exterior walls of private houses, shrines, and compounds, using the four traditional colors that Udechukwu employed in his Erfurt installation. Since the pigments are made from natural vegetable dyes, *uli* designs are easily washable. Those applied to buildings usually last a lot longer, but are generally repainted by women. As a result of his study of *uli* designs, Udechukwu embraced it as an aesthetic and pliable platform because it gave him creative credibility and offered a unique opportunity for synthesizing traditional elements with formalist idioms. The infusion of handwritten text into Udechukwu's work alludes to the external-internal duality that he has been exploring. He attributes this development to his interest in literature, particularly poetry. Written text provides additional textural nuance to an artwork at the same time that it expands the potentials for interpretation. It is based on the notion that texts—regardless of what language they are written in—are mark-making acts

that are translated as design elements by those who are unable to decipher them but enhance the depth of meaning for those who are literate in the language.

While his work has benefited from contact with other cultures, the aesthetic framework that sustains the content has remained largely Igbo-centric. For the casual viewer, Udechukwu's work, which in recent years has incorporated large color fields that are broken, intercepted, or complemented by subtle *uli* symbols, espouses a modernist flair that does not overwhelm the popular argument concerning the locale or status of work produced by contemporary African artists living in Western cities. In 1993, Udechukwu went to Germany on a three-month fellowship, during which he produced large, 6.5′ × 5.2′ pieces in acrylic and ink on canvas. These pieces are rich in colors and iconography.

In his 2006 solo exhibition at the Skoto Gallery in New York, Udechukwu pushed the interface between the internal and the external further. Some of his elaborate drawings are covered with sparsely bark cloth into which some holes were pierced, forcing the viewer to peer behind the front cover to see the work. This gesture alludes to the centrality of the mask in African cultures, and recalls the multiple personalities that individuals assume in Western cultures, based on roles and contexts. Udechukwu's latest work stems from the concept that, in theater, the mask represents an actor enacting a role; but in traditional African context, it is the personification of an ancestor who has the authority to affect the worldly affairs of their descendants. Above all, Udechukwu's work underlines the subtlety of his art and the duality of his status: you may enjoy his work purely on the basis of its aesthetic appeal, but you would appreciate it more when you are able to decipher the embedded meanings that draw upon the artist's experiences and creative language.

Places to See Udechukwu's Work

Continental Merchant Bank, Kano, Nigeria
Iwalewa-Haus, Bayreuth, Germany
National Council for Arts and Culture, Abuja, Nigeria
National Gallery of Modern Art, Abuja, Nigeria

Bibliography

David-West, Haig. "Uli Art: Master Works, Recent Works." *African Arts* 29, no. 1 (Winter 1996): 71–74.

Hassan, Salah M., and Olu Oguibe. " 'Authentic/Ex-Centric" at the Venice Biennale: African Conceptualism in Global Contexts." *African Arts* 34, no. 4 (Winter 2001): 64–96.

jegede, dele. Review of "New Traditions from Nigeria: Seven Artists of the Nsukka Group." *American Anthropologist*, n.s., 102, no. 2 (June 2000): 400–402.

Lawal, Babatunde. "Africa: The Search for Identity in Contemporary Nigerian Art." *Studio* 193 (March 1977): 145–50.

Oguibe, Olu. "Lessons from the Killing Fields." *Transition*, no. 77 (1998): 86–99.

———. "Finding a Place: Nigerian Artists in the Contemporary Art World." *Art Journal* 58, no. 2 (Summer 1999): 30–41.

Ohaeto, Ezenwa. "Orality and Craft of Modern Nigerian Poetry: Osundares's *Waiting Laughters* and Udechukwu's *What the Madman Said*." *African Languages and Literatures* 7, no. 2 (1994): 101–19.

Ottenberg, Simon. "Psychological Aspects of Igbo Art." *African Arts* 21, no. 2 (February 1998): 72–94.

———. "Sources and Themes in the Art of Obiora Udechukwu." *African Arts* 35, no. 2 (Summer 2002): 30–43, 91–92.

Udechukwu, Obiora. "Functionality, Symbolism and Decoration: Some Aspects of Traditional Igbo Art." *Conch* (New York) 3, no. 2 (September 1971): 89–96.

———. "Concept into Form: Religion and Aesthetics in African Art." In *Readings in African Humanities: Africa's Cultural Development*, edited by Ogbu U. Kalu. Enugu: Fourth Dimension Publishers, 1978.

———. "Uli and Li: Aspects of Igbo and Chinese Drawing and Painting." *Nigeria Magazine* (Lagos), nos. 134–35 (1981): 40–50.

———. Interview by author, Oxford, OH, June 2006.

Willis, Liz. " 'Ulli' Painting and the Igbo World View." *African Arts* 23, no. 1 (November 1989): 62–104.

V

James Van Der Zee (1886–1983), Photographer.

James Augustus Joseph Van Der Zee captured, through the lens of his camera, the ebullience and fantasy of African American culture, especially in the first half of the twentieth century. He lived and worked through two World Wars and the Great Depression, witnessed and documented aspects of the Harlem Renaissance until his career went into oblivion, only to be resuscitated with the 1969 exhibition "Harlem on My Mind" at the Metropolitan Museum of Art. From his studios in New York City, Van Der Zee became the chronicler of passages, events, and personalities in African American communities. Through his brilliantly composed studio portraits or spectacular shots of street scenes in New York City, his photographs are eloquent visual essays and historical records of the spirit of the times.

Born on June 29, 1886, in Lenox, Massachusetts to John and Susan Van Der Zee, butler and maid, respectively, to Ulysses S. Grant when the former president lived in New York, Van Der Zee's goal was to become an accomplished musician. By the time he left Lenox for Harlem, he had acquired skills as a pianist and violinist. His first exposure to photography occurred in 1914, when a magazine promotion fetched him his first toy camera. With his curiosity in the contraption picked, Van Der Zee's interest in the medium grew. As a teenager, he embraced this new hobby, took pictures of all manner of subjects and converted his closet into a darkroom in order to develop his film (Otfinoski 2003, 207). He relocated from Massachusetts to New York around 1905 and took on various jobs: waiter, office worker, elevator operator, part-time musician playing in Fletcher Henderson's band and also in the John Wanamaker Orchestra. With his background in photography, he worked in a Newark, New Jersey, department store as a dark room technician and, based on customers' appreciation of his work whenever he substituted as a photographer, he mustered the courage to establish his own studio on 135th Street in Harlem in 1916. His first marriage to Kate Brown, which took place in 1907, ended in divorce in 1915. His love for his second wife, Gaynella, was reflected in the name of his new studio: "James's and Gaynella's Guarantee Photo Studio."

In his capacity as the official photographer for the Universal Negro Improvement Association (UNIA), the sociopolitical force that was founded by Marcus Garvey in 1914 for the empowerment of blacks in the Diaspora, Van Der Zee's

photographs of activities of the UNIA, especially those of its African Legion, are as eloquent as they are truthful. Van Der Zee's ability to capture the aura of his subjects or the empathy and affinity that he felt for the throngs of African Americans that he portrayed are some of the distinctive features of his work. Equally important is his penchant for detail, or his embellishment and enhancement of his photographs through color touch-ups or by double-printing his images. For him, the photograph of his sitters represented a socio-historical record, one that he treated with utmost attention. In addition to thousands of ordinary African Americans whose portraits he took, he also has to his credit a wide array of celebrity portraits, which include those of Langston Hughes, Countee Cullen, Marcus Garvey, and Duke Ellington.

In an era when the media was redolent with images of blacks as bumbling buffoons and all means at the disposal of the dominant white culture were used to perpetuate the racial inferiority myth, Van Der Zee's photographs became a potent counter-hegemony instrument, even if in a subtle and unverbalized manner. The way that he posed his subjects, showing them in classy wear and at times with expensive automobiles, was an indirect aim at debunking the romanticization of Aunt Jemima. His portraits in particular became avenues through which the notion of an emergent black class was canvassed. Van Der Zee painstakingly removed all scratches or particles on his films and routinely touched up images of his sitters with an air brush. He stocked his studio with an assortment of props and costumes of which sitters availed themselves. In addition to portraits of African Americans of sundry callings, Van Der Zee also recorded unadulterated scenes involving weddings, funerals, and similar social events.

With the 1969 "Harlem on My Mind" exhibition at the Metropolitan Museum, Van Der Zee went back into photography and remained professionally active until his death in 1983. Van Der Zee's work was acquired by the Metropolitan Museum while the Photographers Forum conferred on him the Award of Merit. With his rediscovery in 1969 came the establishment of the James Van Der Zee Institute on West 125th Street in New York. In 1993, the National Portrait Gallery in Washington, DC, held a retrospective of his work. In 2002, the U.S. Postal Service issued commemorative stamps in honor of Van Der Zee and 14 other photographers. Van Der Zee died on May 15, 1983, in Washington.

Places to See Van Der Zee's Work

Cleveland Museum of Art, Cleveland, OH
Corcoran Gallery of Art, Washington, DC
Los Angeles County Museum of Art, Los Angeles, CA
Metropolitan Museum of Art, New York, NY
Minneapolis Institute of Arts, Minneapolis, MN
Museum of Fine Arts, Houston, TX
San Francisco Museum of Modern Art, San Francisco, CA

Bibliography

Behrend, Heike. " 'Feeling Global': The Likoni Ferry Photographers of Mombasa, Kenya." *African Arts* 33, no. 3 (Autumn 2000): 70–96.

Britton, Crystal A. *African American Art: The Long Struggle.* New York: New Line Books, 2006.

English, Daylanne K. "Selecting the Harlem Renaissance." *Critical Inquiry* 25, no. 4 (Summer 1999): 807–21.

Greenidge, Delano. *James Van Der Zee: Harlem Photographs 1928–1960.* New York: Delano Greenidge Editions, 2002.

Haskins, James. *James Van Der Zee, the Picture-Takin' Man.* New York: Dodd, Mead, 1979.

Moutoussamy-Ashe, Jeanne. *Viewfinders: Black Women Photographers.* New York: Dodd, Mead, 1986.

Otfinoski, Steven. *African Americans in the Visual Arts.* New York: Facts On File, 2003.

Van Der Zee, James, Owen Dodson, and Camille Billops. *Harlem Book of the Dead.* Dobbs Ferry, NY: Morgan & Morgan, 1978.

W

Kara Walker (b. 1969), Painter, Silhouettist, Printmaker, Installation Artist.

Since the mid-1990s, when she burst into the national and international art arena, Kara Walker has become perhaps the most celebrated African American artist in recent memory. Her works, which are often large-scale, cut-paper silhouettes that are installed against white or gray backgrounds, are at once simple and complex. They appear simple because the artist adroitly uses her skills to construct tableaux of imageries on a panoramic scale, the central thrust being the presentation stories, events, and situations that are shocking, titillating, repulsive, and visceral. This is what accounts for the complexity in Kara Walker's art. She has found a potent combination of medium and ideas, thesis and format, that effectively excavate a polarizing part of American history dealing with slavery, race, power, and sex in Antebellum South. Walker presents all of this as a reconstructed history in which facts are juiced up with fantasy and the theme of disempowerment and subjugation of blacks in eighteenth-century America is presented as visual vignettes that combine a disciplined ascetic with a textual narrative. Often, the result is provocative, with viewers falling into two camps: enraged or empathetic.

Kara Walker was born in Stockton, California, in 1969. She knew from an early age when she would watch her father—Larry Walker, then professor at the University of the Pacific—paint that she wanted to be an artist. In 1982, her father accepted appointment as chair at Georgia State University and relocated to Stone Mountain, a suburb of Atlanta. The relocation to Atlanta induced a culture shock of sorts for the artist, who began to critique her own selfhood and identity. Walker attended the Atlanta College of Art, from where she graduated with a B.F.A. in 1991, specializing in painting and printmaking. After her undergraduate studies, and while preparing for graduate work, Walker experienced some conflict in terms of the direction that she wanted her work to go; it was a conflict animated by a quest for identity: "There was so much identity-based art, and I had not really taken stock of where I was and who I am and who it is I'm looking to define me. It was always coming from outside sources" (Dixon 2002, 45).

The seeds of what would eventuate in her acerbic style were planted during the year that she took off to work in a bookstore in Atlanta before heading for graduate school. That was when she encountered the Harlequin romance novels and other literature on the status of black womanhood in the south.

Walker scoured historical sources, including cartoons, movies, and folklore, and visual imageries pertaining to cultural studies and black history, with particular emphasis on social conflicts and the institutionalization of racial stereotypes, especially of black women. This was the defining moment for her. The sources that she consulted and the novels she read sharpened her intellectual and creative curiosity: the core issues, she surmised, centered on power, submission, and glorified rape fantasies. Her challenge was to resolve all of this in a visual format that implicates the viewer in the scenarios, and constructs a link between the author and an imaginary heroine, whom Walker would eventually create in the way a novelist would create characters and develop plots (Sheets 2002).

That is precisely what Walker has been doing since 1994, when she received her M.F.A. from the Rhode Island School of Design, with a concentration in painting. While in graduate school, Walker perfected the cut-paper silhouette method and developed a number of stereotypical characters who populate a world in which libidinal favors are generously and publicly granted and mischief, bodily fluids, and depraved behavior are shamelessly advertised. Among the many characters developed by Walker are the master, the mistress/missus, the Negress/slave mistress, and the pikaninny "nigger wench" who exemplifies the sexual abuse that black women experienced at the hands of their white masters.

Through an introspective contemplation of black historical narratives, Walker developed a style that focuses on a genre, rendered in a cycloramic format that was popular in the late nineteenth century, that featured extremely large panoramic paintings based on specific themes. The intent was to involve viewers, to immerse them in the scenic view or epic narrative that they were viewing. Walker's installations, some of which are as high as 14 feet with width that could span 90 feet depending on the installation, are meant to invoke interactivity or, better still, provoke some reaction—which may range from incredulity to revulsion—in the onlooker. The combination of contextual poignancy and massive size of scenes in which people are constantly engaged in provocative acts that include sexual orgies, mutilation, and sheer bestiality, is a deliberate ploy by the artist to resuscitate the discourse on issues of sexism and racial stereotypes that black women have had to endure.

The artist's work is derived from her own personal experience and also from the realization that in art, blacks are presented from a substantially Eurocentric perspective. In one of the interviews that she granted in conjunction with her 2007 exhibition at the Walker Art Center in Minneapolis, Walker was unapologetic about the element of revulsion that seems to pervade her work: "I've seen people glaze over when they are confronted with racism. . . . I have no interest in making work that doesn't elicit a feeling, not just a mood. I mean, visceral, like 'Oh! You mean me?'" (Combs 2007).

Walker's success has been phenomenal. In 1997, she received the prestigious John D. and Catherine T. MacArthur Foundation "genius" Achievement Award, and had the honor of representing the United States at the 2002 Sao Paulo Bienal in Brazil. She has had solo and group exhibitions in major museums and key galleries nationally and internationally, including the Museum of

Modern Art; the Solomon R. Guggenheim Museum; the Whitney Museum of American Art; the San Francisco Museum of Modern Art; Musee d'Art Moderne de la Ville de Paris; Deste Foundation, Athens; Hayward Gallery for the Arts Council of England, London; the University of Michigan Museum of Art; the Walker Art Center, Minnesota; the Centre d'Art Contemporain, Geneva, Switzerland; Historic Museum of Frankfurt, Germany; and the Art Gallery of New South Wales, Sydney, Australia.

With success came controversy. Walker's odyssey on the status of the black female is deemed to be more pernicious than helpful by some notable African American artists and scholars, who are convinced that her themes turn history on its head and trivialize the unspeakable trauma that slavery entailed. Angela Davis, **Betye Irene Saar**, Howardena Pindell, and Gwendolyn Dubois Shaw are among those who expressed critical disapproval of Walker's handling of her subject matter. In the words of Shaw, "Kara Walker's representation in her work of these stereotypical signs of corrupt blackness couples with images of perverted whiteness challenges the limits of what is tolerable to a community striving to overcome the impact of two centuries negative imagery" (Dubois Shaw 2006). But there are those who believe that to take Walker's work literally, or to read her work as a historical fact, is to miss the liberty that the artist has taken in resuscitating an issue that America would like to see buried. In 1998, Henry Louis Gates organized a symposium at Harvard, at which Walker's work, "Presenting Negro Scenes Drawn Upon My Passage Through the South and Reconfigured for the Benefit of Enlightened Audiences Wherever Such May Be Found, By Myself, Missus K.E.B. Walker, Colored," was on show.

Apart from having the knack to pick the right combination that has become a lightning rod for controversy, Walker brings superb creative skills—draftsmanship, connoisseurship, and an uncanny ability to dominate the cut-paper silhouette, a medium that relies exclusively on the adroit manipulation of shapes, which become the principal mode of depicting mood and movement in the absence of color and texture. She works by drawing on the reverse side of cut paper with white chalk, which she then cuts out with an exacto knife and places on the wall with adhesive. With extraordinary dexterity, Walker is able to create characters, often in profile, which viewers can "read," based on their costumes, physiognomy, and placement within the panoramic field. After Walker has "assembled" these characters—and she does this in ways that sometimes hints at the context of action—the horrifying or titillating scenes that emerge approximate chapters from a novel or clips from a silent movie. The artist also employs lighting and color as a device to connect viewers and incriminate them in the scenes. Using an overhead projector, Walker projects images and colors onto the huge gallery walls in gradated hues that compliment the cut-paper silhouettes that are already placed on the walls. In recent times, the artist has broadened the scope of her experimentation to include projection and shadow, puppet performance, animation and film. Her titles are as scintillating as they are humorous and often read like excerpts from some of the novels that may have inspired the artist. The 16-mm film premier that accompanied her exhibition, "Kara E. Walker's Song of the South" has

the title, "8 Possible Beginnings: or the Creation of African-America. A Moving Picture by the young, self-taught, Genius of the South K. E. Walker."

Kara Walker teaches at Columbia University, where she is professor of art.

Places to See Walker's Work

Addison Gallery of American Art, Andover, MA
Art Institute of Chicago, Chicago, IL
Baltimore Museum of Art, Baltimore, MD
Broad Art Foundation, Santa Monica, CA
Colby College Museum of Art, Waterville, ME
Contemporary Museum, Honolulu , HI
Deutsche Bank, Frankfurt, Germany
Guggenheim Museum, New York, NY
Harvard University Art Museums, Cambridge, MA
Indianapolis Museum of Art, Indianapolis, IN
Milwaukee Art Museum, Milwaukee, WI
Museo di Arte Moderna e Contemporanea, Trento, Italy
Museum of Contemporary Art, Chicago, IL
Museum of Fine Arts, Houston, TX
Museum of Modern Art, New York, NY
Solomon R. Guggenheim Museum, New York, NY
Studio Museum in Harlem, New York, NY
Tate Gallery, London, UK
Walker Art Center, Minneapolis, MN
Whitney Museum of American Art, New York, NY

Bibliography

Berry, Ian. *Kara Walker: Narratives of a Negress.* Saratoga Springs, NY: Frances Young Tang Teaching Museum and Art Gallery at Skidmore College, Williams College Museum of Art; Cambridge, MA: MIT Press, 2003.

Combs, Marianne. "Artist Forces Racism Out of the Shadows." National Public Radio podcast, April 4, 2007. http://www.npr.org/templates/story/story.php?storyid=7898752 (accessed December 11, 2008).

Dixon, Annette. *Kara Walker: Pictures from Another Time.* Ann Arbor: University of Michigan Museum of Art, 2002.

Dubois Shaw, Gwendolyn. *Seeing the Unspeakable: The Art of Kara Walker.* Durham, NC: Duke University Press 2004.

Public Broadcasting Service. "Art in the Twenty-First Century. Kara Walker." http://www.pbs.org/art21/artists/walker/clip2.html# (accessed July 26, 2008).

Scholder, Amy. *Dr. Rice in the House.* New York: Seven Stories Press, 2007.

Searles, Erikka J. "Hype and Hypersexuality: Kara Walker, Her Work and Controversy." M.A. thesis, Georgia State University, 2006.

Sheets, Hilarie M. "Cut It Out!" *ARTnews,* April 2002.http://artnews.com/issues/article.asp?art_id=1097.

Sollins, Susan. *Art: 21: Art in the Twenty-First Century.* New York: Harry N. Abrams, 2003.

Walker Art Center. "The Art of Kara Walker." Minneapolis, MN: Walker Art
 Center. http://learn.walkerart.org/karawalker/Main/ExhibitionHistory
 (accessed July 26, 2008).
Walker, Kara. "Kara Walker's Response." *International Review of African American
 Art* 15, no. 2 (1998): 48–49.
———. *After the Deluge.* New York: Rizzoli, 2007.
———. *Kara Walker: My Complement, My Enemy, My Oppressor, My Love.* Minneapo-
 lis, MN: Walker Art Center, 2007.
Wallis, Simon. "Recent American Painting. London." *Burlington Magazine* 140,
 no. 1144 (July 1998): 494–96.

Ouattara Watts (b. 1957), Painter.

The work and success of Ouattara Watts exemplify the postmodernist concern
for de-centering and inclusiveness. The artist's ability to traverse disparate
worlds and function with relative ease mirrors an inevitable dualism that is
inherent in the works of many contemporary African artists who practice their
craft in western metropolises. The dualism manifests itself at a variety of lev-
els: creative, philosophical, linguistic, and spiritual. As one who grew up in
Cote d'Ivoire and studied in France before moving to New York, Watts has
developed a capacity to function at multifarious levels, with the added advan-
tage of tapping into those forces that enhance the uniqueness of his creative
output at the same time that they envelop his work with an enigmatic air.

Roberta Smith, who once noted that Watts's work has an "international-style
elegance," has also drawn comparison between Watts's work and that of Julian
Schnabel, perhaps because of the raw, emotional energy that seems to charac-
terize the work of both artists (Smith 2002). Working usually on large canvases,
Watts draws copiously on his understanding of the esoteric world of his Ivor-
ien ancestry, encoding his works in garbs and formats that recommend them
to the Western world even as the artist's new audience grapples with
embedded symbolisms and individuated imageries. Cotter (2001) alludes to
the vibrancy of Watts's work, which are "as hip to Paul Klee, 1980's graffiti
and world religion as they are to African art." In an interview that he had with
McEvilley (1993), Watts affirms that he shares a kindred alignment with a
number of Western literary and visual artists, including Franz Kafka, Henri
Michaux, Marcel Duchamp, Henri Matisse, Pablo Picasso, Joan Miro, Joseph
Beuys, and **Jean-Michel Basquiat**. This kindred alignment is based as
much on a spiritual force and a potent energy—what the Mande peoples of
Mali call *nyama*—as on Watts's notion of art that is in accord with cosmic
notions of creativity: "My vision is not based only on a country or a continent,
it's beyond geography or what you see on a map, it's much more than that. I
hope people will understand that it's more than geography. Even though I
localize it to make it understood better, it's wider than that. It refers to the cos-
mos" (McEvilley 1993, 81).

Ouattara Watts was born in Abidjan, Cote d'Ivoire, in 1957 to a large family that has its ancestral roots among the Senufo, who are in the northwestern part of the country. As a result of Western imperialism, the Senufo peoples were summarily partitioned and are now found among today's modern states of Mali, Burkina Faso, and Cote d'Ivoire. This is similar to what happened among other African groups—the Yoruba in Nigeria and the Republic of Benin, and the Kota in Cameroon and Gabon—who suffered the same fate. Watts grew up within a family that was protective of its religious practices and social ethos, even as it accommodated divergent views. His father, a surgeon, was also a shaman who was versed in traditional medicine. Although Watts received the standard French education at the primary and secondary (*lycee*) levels, the spiritual education imparted by the Senufo primed him for life and instilled in him the strong spiritual and creative values that are reflected in his art. Like most children his age, his introduction to traditional African education preceded his elementary education. Before age seven, he, like other children his age, went through the initiation ceremony, which was a part of the rites of passage, an entrenched, time-tested education that socializes children into a world with a healthy orientation in spirituality. Watts describes the centrality of spirituality to the initiation of Senufo children: "The spiritual school permits you to understand the world. You are allowed a vision that is cosmic rather than a nationalistic or a village-oriented one. therefore you are the sun, the rain, the Mexican, the American, the Japanese, etc. It is the cosmic view of the world" (McEvilley 1993, 72).

Growing up in Abidjan, Watts's early art education was influenced not, as with most children his age, by comic books or made-for-television cartoons, but by his immersion in the spiritual realm. His precociousness was recognized at the initiation ceremonies on the basis of his art-making output. Thereafter, Watts would do his drawings at home using water-based medium on paper. With the recognition by the initiatory powers of his ability to manage the creative surge, Watts had little need to impress anyone at school; he focused more on working on his art at his own pace, and at home (McEvilley 1993, 74). The spiritual connectedness that Watts imbibed during his initiation and rites of passage in Cote d'Ivoire has stood him in good stead, and remains central to the manner in which he continues to work in New York, where he is now based.

Watts dropped out of the lycee at the age of 16, thus putting an end to his father's hope that Watts would grow up just like him: become a medical doctor who also understands the traditional healing practice. In 1977, Watts left for Paris, drawn to it perhaps inevitably because France, the former colonial ruler that implanted its culture, education, and language on the peoples of Burkina Faso, continues to exert a dominant impact on young minds from its erstwhile colonies. For Watts, Paris also represented the ultimate destination for an aspiring artist. Although he abstained from attending art exhibitions while he was in Abidjan because they catered to a populist clientele with their popular art genre, Watts had nonetheless made the spiritual connection with a number of artists about whom he had read and whose work he had seen in books that he accessed in the libraries of foreign embassies—the French Cultural Center,

the Goethe Institute, and the British Council—in Abidjan. For nearly a decade, Watts lived a harsh and difficult life: "I lived as if in a barracoon, where they kept slaves. . . . I didn't want to show my work at this time. I had never showed my work in Abidjan and for nine years in Paris I didn't want to show it, because I needed to make a synthesis of everything I had learned in Africa and everything that I was learning in the West; I had to assimilate it all" McEvilley 1993, 77).

Watts's break came in 1986, when a Jewish art critic showed interest in his work and introduced him to the French culture establishment. His first exhibition in Paris received good media coverage; every piece of artwork in the show was sold. The attendant success enabled him to look beyond the Parisian environment. He linked up with a German dealer and was in the process of preparing for an exhibition in Germany when, early in 1988, he met Jean-Michel Basquiat, who purchased his paintings and introduced him to the New York art world. Watts's doctrinal position underlines the cyclicality of art and the recurrence of ideas. His deep spiritual background serves as a catalyst and becomes an instrument for an understanding of the world in which the notational is favored over the representational. His use of ideograms and other accruals recall the cycle of libations and the resultant encrustations, which in Western cycles have become the imprimatur of authenticity in African art. For Watts, art is a continuum connecting the past with the present. It represents a recurrent cycle in which claims to authenticity or originality are validated only when minimal attention is paid to precedents: "Artists in general speak of progress, but in creation there is no progress. it's a circle, you always come back to the same thing. You think there is a break but there isn't. You always do the same research, just four or five subjects, god, love, life, etc." (McEvilley 1993, 74).

It is within the African Diaspora that Watts's work becomes fully understood. The emphasis on his traditional roots and on his ability to embrace rather than disavow his knowledge of the esoteric and the spiritual are essential to an understanding of his work. In a way, the referents that energize Watts's work attract attention precisely because they exude an enigmatic, even if little-understood and ungraspable, force. Not unlike the way that traditional African art was perceived and received at the beginning of the twentieth century, with an embracement of the form but little understanding of the substance, Watts's work has become assimilated into the Western canon of contemporary art, but on purely aesthetic terms. The inability of most critics to grasp the polyvalent nature of Watts appears to explain the tendency to compare his work not with those of African American or African artists, but with the work of Western artists with whom they are most comfortable.

Watts has had numerous solo exhibitions and participated in several group shows across the continents. Among the numerous venues where his work has been exhibited are the 2002 Whitney Biennale; "The Short Century: Independence and Liberation Movements in Africa, 1945–1994, at P.S. 1, Long Island, New York; Documenta 11; the Hood Museum of Art, New Hampshire; Gagosian Gallery, New York; the New Museum of Contemporary Art, New

York; the 1993 Venice Biennale, Italy, and Fukui Fine Arts Museum, Fukui, Japan.

Places to See Watts's Work

Mike Weiss Gallery, New York, NY
National Museum of African Art, Smithsonian Institution, Washington, DC
Private collections

Bibliography

Carboni, Massimo. "Ouattara Watts." *Artforum* 42, pt. 9 (May 2004): 220.
Carrier, David. "Whitney Biennial, New York." *Burlington Magazine* 144, no. 1191 (June 2002): 382–83.
Cotter, Holland. "Art in Review; Claudia and Julia Mueller, Olu Oguibe, Senam Okudzeto, Ouattara Watts." *New York Times,* July 27, 2001. http://query .nytimes.com/gst/fullpage.html?res=9D01E4DA153DF934A15754C0A9679 C8B63 (accessed December 6, 2007).
Grabski, Joanna. "Dakar's Urban Landscapes: Locating Modern Art and Artists in the City." *African Arts* 36, pt. 4 (Winter 2003): 28–39, 93.
Lynn, Victoria. "Documenta 11: Border Crossings between Art and Politics." *Art and Australia* 40, pt. 3 (2003): 388–90.
McEvilley, Thomas. *Fusion: West African Artists at the Venice Biennale.* New York: Museum for African Art; Munich: Prestel, , 1993.
Okeke, Chika. "Black President: The Art and Legacy of Fela Anikulapo-Kuti." *NKA: Journal of Contemporary African Art,* no. 19 (Summer 2004): 90.
Smith, Roberta. "Art Review; a Profusion of Painting, Very Much Alive." *New York Times,* May 10, 2002. http://query.nytimes.com/gst/fullpage.html? res=9F05E5D81030F933A25756C0A9649C8B63&sec=&spon=&pagewanted=2 (accessed December 6, 2007).
Thompson, Barbara. *Crossing Currents: The Synergy of Jean-Michel Basquiat and Ouattara Watts.* Hanover, NH: Hood Museum of Art, 2004.

Carrie Mae Weems (b. 1953), Photographer.

Carrie Mae Weems utilizes her training in folklore and the experience that she acquired in political activism to construct visual narratives that seek to sensitize viewers to universal issues. In "Ritual and Revolution," one of her installations, Weems employs a smorgasbord of images—idyllic landscapes and morbid environments, riotous scenes, and the Holocaust—to jolt the conscience of the world to key political, historical, and environmental issues. Using the medium of photography, text, banners, and sound, Weems's installations comment on the human condition, with particular emphasis on the indignities and overt degradation that the African American character has been forced to endure in art, literature, and history. Weems is concerned with the way in which the art establishment has tended to lend weight to the perception

that the black persona matters but little. She is determined to use the agency of art to examine issues of race, class, and gender, focus attention on the marginalization of the black woman by artists and scholars, and examine the ways in which white women have been objectified with relatively little attention paid to her black counterpart.

Her creative projects—"Sea Island Series" (1991–92), "Africa Series" (1993), "From Here I Saw What Happened and I Cried" (1995–96), "The Hampton Project" (2000–2002); and "Louisiana Project" (2003), among others—are dedicated to the pursuit of conscientizing her audience to neglected or underappreciated heritages. Like a playwright, she writes the scenes and roles that are then "acted" by black characters, who often include herself. Within this context, she plays multiple roles: as a writer of scripts that are designed to advance a specific social, cultural, or political perspective; as an actor who enacts assigned roles; and as a director who coordinates the whole setup. The passion and determinism that Weems brings to bear on her work are reflective of her experiential attributes. In seeking to address the largely pejorative and stereotypical perceptions about the black persona, Weems has acquired the sociocultural temperament, the political astuteness, and the professional qualifications that are important credentials for success. As Piché (1998, 9) has noted, Weems is familiar with the work of an array of intellectuals, radical and revolutionary authors, and creative and literary artists including Karl Marx, Bessie Smith, Vladimir Tatlin, Zora Neale Hurston, and Roy DeCavara. Her affinity with

Installation view of the exhibition "The Path of Resistance," part of the exhibition cycle "Open Ends," The Museum of Modern Art, New York, 2000–2001. © The Museum of Modern Art/ Licensed by SCALA/Art Resource, NY.

Hurston stems from the latter's phenomenal impact on American culture as a folklorist, ethnologist, writer, and activist: traits that are obvious in Weems's social, professional and creative profile. Hurston's work, which celebrates her African American roots, remains a source of inspiration to many others. Weems shares the passion and sensitivity of DeCarava, the African American painter, graphic artist, and master photographer who has had a lifelong passion for elevating the status of black people whom he believes have not always been accorded the dignity that they deserve in art. Like DeCarava, Weems is committed to using her art to address the artifice and indignity that have characterized the portrayal of African Americans across ages.

Weems was born in 1953 to Mississippi sharecroppers who relocated to Portland, Oregon, in the 1950s. She moved to San Francisco after high school and studied modern dance. She supported herself by working in a clothing factory and was active in the labor movement, where she was a union organizer. While in San Francisco, in 1971, a friend gave her the first camera she ever owned as a birthday gift. She started by taking photographs of feminist marches and political protestations (Piché 1998, 10). Later, she became familiar with the work of documentary photographers and came across *Black Photography Annual,* a publication containing photographs by African American photographers. All of this provided the incentive for her to study photography. In 1981, she graduated from the California Institute of the Arts, Valencia, with a B.A. degree. She proceeded to earn her M.F.A. in 1984 at the University of California, San Diego. Between 1984 and 1987, she was in the graduate program in Folklore at the University of California, Berkeley.

Weems denies herself the luxury of producing noncommittal art and shuns the indulgence relished by many privileged artists that art should be cultivated and tempered to reveal itself, lead the artist on, and even take leave of the artist. Rather, she consciously constructs scenarios based on preconceived themes or theses and in which the status and experience of the African American are showcased. Weems's art is not meant to prettify or contribute to the romanticized notion of the black body as a tepid extension of the modernism: "I am not interested in romanticized reproductions of modernism but only through a black lens. I am only interested in figuring out the crafting in image—of recontextualizing the African body and family and socio-cultural position in order to think about the dynamics of who we are; to move us beyond this flat, one-dimensional stereotype" (Willis 2003).

The bodies of work that she has produced have either tackled one disputation after another or exploded spurious or unsupportable canons. Early in her career, she began with the familiar: her family. The series of pictures, "Family Pictures and Stories," which she did between 1978 and 1983, combined audiotaped interviews and text with visual images as she dug into her family roots and sought to understand the core cultural values that connect black families nationwide (Friis-Hansen n.d.). In "Kitchen Table Series," Weems appears in every one of the 20 images, which were accompanied by text panels, in a way that tends to insist that we deal with the reality of the African American presence; that we recognize the universality of our humanity. Focused as she has been on issues of race, she is aware of insipient resistance to the notion of

the black body as a prototypical representative of womanhood. In a 1989 interview, Weems demonstrates an awareness of the cultural barriers that society has installed, which constantly negate her attempts at contesting the notion that only white people could speak or represent universal concerns: "I wanted to use images of blacks . . . so that representations of blacks and materials associated with blacks could stand for more than themselves and for more than a problem, that they could speak about the human condition. But I've come to realize that the way blacks are represented in our culture makes it almost impossible to get that point across" (Piché 1998, 12). In yet another interview, this time in 2003, Weems's visual odyssey remained on course. In relation to "Ritual and Revolution," which was accompanied by an audiotape in which the artists recites a poem, Weems declares: "I'm using the 'I' voice, not in the guise of Weems, but as something deeper. I'm trying to understand something about the human spirit, how it operates, where it goes awry, how to address it, how to look at it, how to unravel it" (Carr 2003).

Weems has won laurels and accolades. She has a strong list of solo and group exhibitions at major museums and galleries nationally and internationally, and has had shows and installations on university campuses across the nation. She has received numerous commissions, awards and residencies, including the 2005 residency at Syracuse University. She was the recipient of the 2002 Pollack Krasner Foundation grant in Photography, the Alpert Award for Visual Arts, and the National Endowment for the Arts Visual Arts grant.

Places to See Weems's Work

Art Institute of Chicago, Chicago, IL
Cleveland Museum of Art, Cleveland, OH
Fotomuseum Winterthur, Switzerland
Hood Museum of Art, Hanover, NH
Maier Museum of Art at Randolph-Macon Woman's College, Lynchburg, VA
Miami Art Museum, Miami, FL
Modern Art Museum of Fort Worth, Fort Worth, TX
Museum of Contemporary Photography at Columbia College, Chicago, IL
Museum of Modern Art, New York, NY
Walker Art Center, Walker, MN

Bibliography

Acampora, Christa Davis, and Angela L. Cotten, eds. *Unmaking Race, Remaking Soul: Transformative Aesthetics and the Practice of Freedom.* Albany: State University of New York Press, 2007.

Carr, C. "More Than Meets the Eye: The Quiet Revolution of Carrie Mae Weems." http://www.villagevoice.com/art/0310,carr,42270,13.html.

Cottman, Michael H. *The Family of Black America.* New York: Crown Trade Paperbacks, 1996.

Farrington, Lisa. "Reinventing Herself: The Black Female Nude." *Woman's Art Journal* 24, no. 2 (Autumn 2003–Winter 2004): 15–23.

Friis-Hansen, Dana. "From Carrie's Kitchen Table and Beyond." N.d. http://www.nathanielturner.com/carriemaeweems.htm (accessed December 11, 2008).

Fusco, Coco. *English Is Broken Here: Notes on Cultural Fusion in the Americas.* New York: New Press, 1995.

Kirsh, Andrea. *Carrie Mae Weems.* Washington, DC: National Museum of Women in the Arts, 1994.

Piché, Thomas. *Carrie Mae Weems: Recent Work, 1992–1998.* New York: George Braziller in association with Everson Museum of Art, Syracuse, NY, 1998.

Smith, Cherise. "Fragmented Documents: Works by Lorna Simpson, Carrie Mae Weems, and Willie Robert Middlebrook at the Art Institute of Chicago." *Art Institute of Chicago Museum Studies* 24, no. 2 (1999): 244–59.

Turner, G. T. "Carrie Mae Weems at P.P.O.W." *Art in America* 84, no. 6 (1996): 103.

Willis, Deborah. "Visualizing Memory: Photographs and the Art of Biography." *American Art* 17, no. 1 (Spring 2003): 20–23.

Charles Wilbert White (1918–1979), Muralist, Painter, Printmaker.

The graphic work of Charles White commands attention in its massive proportions. His brand of realism is penetrating—even confrontational—in its inescapable presence. Charles White was born on April 2, 1918, in the south side of Chicago, Illinois. An only child, he grew up during the Great Depression, which compounded the crushing economic conditions that he had to endure. His parents did sundry jobs to eke out a living. At various times, his father, Charles White Sr., worked at the post office, the railroad, construction sites, and steel mills. His mother, Ethel Gary, started as a domestic worker at age eight and remained so for much of her life (Hoag 1965). It was difficult enough growing up as a lonely child in a very poor household with an alcoholic stepfather during the Great Depression. But White's situation was made much worse because of the difficulties that he encountered in a predominantly white school, where his interest in participating in acting and other school activities were rebuffed, a situation that turned him toward truancy.

White grew up reading voraciously. At about seven years of age, his mother would leave him in a public library whenever she went shopping. Since the library was close to the Art Institute of Chicago, White quickly developed a habit that would yield multiple dividends for him later in life: he learned to read in the library and also to spend inordinate hours at the gallery appreciating—indeed, studying—art on his own. Through elementary and high school, he participated in art activities under the aegis of the Art Institute and won honorable mentions and prizes. During his library visits, he read a variety of authors all on his own, and discovered Alain Locke's *The New Negro,* which had a major impact on his understanding of black culture and led him to discover other African American authors such as Countee Cullen and Paul Robeson. His discovery of the seminal role of African American personages, including Harriet Tubman, Sojourner Truth, and Booker T. Washington, would

stand him in good stead in later years as he embarked on creating some of his innovative murals. Truancy in high school earned him an additional year; he graduated at age 19, but was exceedingly thrilled to have won a full scholarship to study at the Art Institute of Chicago in 1937. Despite his scholarship, White was financially strapped as he had no money for supplies and personal upkeep. He combined school work with two jobs—as a valet and cook, and as art teacher in a high school. Yet, White successfully completed the two-year program at the Art Institute in just one year.

At age 20, he qualified for employment at the Works Progress Administration (WPA) as a muralist in the South Side Community Center, Chicago's version of the WPA, a nationwide initiative that was designed to give succor to artists during the Great Depression. The establishment of the WPA substantially ameliorated the gloomy economic condition of African Americans in the 1930s through provision of employment in projects that benefited communities. Among artists who were employed in the scheme were **Aaron Douglas**, Joseph Delaney, **Hale Woodruff**, Augusta Savage, and **Jacob Lawrence**. In Chicago, White was one of several African American artists whose expertise was called upon for the various projects that were undertaken. Although White developed his own particular creative style, he benefited from his association with other artists in Chicago during his time: Mitchell Siporin, Francis Chapin, and Aaron Bohrod, all of whom influenced his painting in one way or another. During his time at the WPA, he became acquainted with the murals of Mexican artists and embraced the concept of social realism.

In 1941, White secured employment at Dillard University in New Orleans, in the company of his new wife **Elizabeth Catlett**, whom he had met and married in Chicago. Shortly thereafter, he won a Julius Rosenwald Fellowship and returned to New York where, as part of his fellowship, he studied graphics for three months with Harry Sternberg at the Art Students League. This was when he became fascinated with the potency of the graphic medium and began to shun color for black-and-white renderings. In doing this, he was influenced by the graphic work of such artists as Kathe Kollwitz, Francisco Goya, and Honoré Daumier. For his second Julius Rosenwald Foundation fellowship, White chose to do a mural, *The Contribution of the Negro to American Democracy* at Hampton Institute in Hampton, Virginia. In 1943, he accepted a teaching position at Hampton, where he met Viktor Lowenfeld, the art educationist and psychologist who established the art department at Hampton, and who was a major influence on many students, including John Biggers.

The 1940s was a definitive period for White. He got married, received two Rosenwald Fellowships, secured employment, and made significant professional strides. It was a decade that White experienced some life-altering situations. In 1943, he was drafted into the army and, after basic training, was posted to Missouri, where he was diagnosed with tuberculosis, given a medical discharge, and spent two years in the hospital. Upon discharge, he resumed his professional life and, in 1947, had his first solo exhibition at the American Contemporary Artists Gallery in New York. At this time, White's reputation as a powerful artist with a monochromatic palette had earned him a comfortable financial life. He traveled to Mexico with his wife, where he studied at

Esmeralda National School of painting and sculpture and also at the Taller de Gráfica. He benefited professionally through his acquaintance with major Mexican muralists: José Clemente Orozco, Diego Rivera, and David Alvaro Siqueiros, in whose house he lived with his wife for about a year. The decade ended with his marriage to Catlett falling apart at the same time that he continued to be wracked by poor health. In 1950, he married Francess Barrett and relocated to Los Angeles in 1957. Before he was offered an appointment at Otis Institute of Art in Los Angeles in 1965, he had become active in the Civil Rights Movement and participated in several exhibitions on university campuses in California, Georgia, and Washington, DC, among several.

The philosophical tenet of White's work eschews hate or recrimination and espouses instead a transcendental dignity that radiates its own authority. White experienced extreme hardship as a young man and suffered social indignity as an adult. He was born into poverty on the south side of Chicago —to an alcoholic father who was an embarrassment to him. His mother started as a domestic worker at age eight and remained so for virtually all her life. He had his share of racial brutalization and bore the scars of social injustice. Over a period of time, two uncles and three cousins on his maternal side were lynched. He was beaten up in Virginia and also in New Orleans. Yet, White possessed the mental strength to produce works that rise above the specter of acrimony and malice; he subscribed to the doctrine that humanity is inherently good. His art sought to address or examine three key issues: truth, beauty, and human dignity. In his 1965 interview with Betty Hoag, White explains the premise of his work:

> I try to deal with truth as truth may be in my personal interpretation of truth and truth is a very spiritual sense—not "spiritual." . . . I try to deal with beauty, and beauty again as I see it in my personal interpretation of it, the beauty in man, the beauty in life, the beauty, the most precious possession that man has is life itself. And that essentially I feel that man is basically good. I have to start from this premise in all my work because I'm almost psychologically and emotionally incapable of doing any meaningful work which has to do with something I hate. . . . The other thing I try to deal with, the third point, is dignity. And I think that once man is robbed of his dignity he is nothing. . . . I deal with Negro people primarily in terms of image I try to give [it] the meaning of universality to it. I don't address myself primarily to the Negro people.

White's works—be they portraits of notable African American personages or poor peasants involved in quotidian chores—are infused with an unmistakable masterliness and self-assuredness that came from somebody who had extreme passion for the profession. He did not simply rely on his talents, superb as those were; he supplemented his professional education with a dedication that enabled him to develop an intellectual and philosophical base for his art. At a time when the art the development of new art movements cast doubts on the relevance of social realism and figuration, White remained an undaunted authority and forceful voice in the relevance of the underclass and the marginalized. According to Driskell, "White used his art as a tool

through which to inform his people of their sufferings, their culture, and their history" (Driskell 1976, 124).

By the 1970s, White's health deteriorated. He died on October 3, 1979, of respiratory illness.

Places to See White's Work

Atlanta University, Atlanta, GA
Allen Art Museum, Oberlin College, Oberlin, OH
Amon Carter Museum, Fort Worth, TX
Art Institute of Chicago Collection Database, Chicago, IL
Barnett Aden Gallery, Washington, DC
Deutsche Academie der Kunste, Berlin, Germany
Dresden Museum of Art, Germany
Gibbes Museum of Art, Charleston, SC
Howard University, Washington, DC
Library of Congress, Washington, DC
Los Angeles State University, Los Angeles, CA
Metropolitan Museum of Art, New York, NY
Montclair Art Museum, Montclair, NJ
National Academy of Design, New York, NY
National Gallery of Art, Washington, DC
Oakland Museum, Oakland, CA
Schomburg Center for Research in Black Culture, New York, NY
Syracuse University, New York, NY

Bibliography

Bearden, Romare. "The Negro Artist and Modern Art." *Opportunity*, December 1934, 371–72.

Bearden, Romare, and Harry Henderson. *Six Black Masters of American Art.* Garden City, NY: Zenith Books, Doubleday, 1972.

———. *A History of African-American Artists from 1792 to the Present.* New York: Pantheon Books, 1993.

Driskell, David. *Two Centuries of Black American Art.* Los Angeles: Los Angeles County Museum; New York: Knopf, 1976.

Fax, Elton. *Seventeen Black Artists.* New York: Dodd, Mead, 1971.

Fine, Elsa Honig. *The Afro-American Artist: Search for Identity.* New York: Holt, Rinehart and Winston, 1973.

Hoag, Bettie Lochrie. "Oral History Interview with Charles Wilbert White, 1965 Mar. 9." Smithsonian Archives of American Art. http://www.aaa.si.edu/collections/oralhistories/transcripts/white65.htm (accessed December 11, 2008).

Three Graphic Artists: Charles White, David Hammons, Timothy Washington. Catalog of an exhibition held at Los Angeles County Museum of Art, January 26–March 7, 1971.

White, Charles, and Benjamin Horowitz. *Images of Dignity: The Drawings of Charles White.* Los Angeles: Ward Ritchie Press, 1967.

William Thomas Williams (b. 1942), Painter, Designer.

On his official Web site, Williams sits pensively on a simple, unadorned chair with the right leg crossed over, gazing intently at a large abstract painting, his. Although it is doubtful that this was the intent, this picture captures the soul of Williams. Seated in profile to the left of his studio space, and framed by a rack of stacked paintings that convey the frugal but colorful abstraction of his work, Williams comes across as a restrained, unpretentious, but disciplined persona, one whose unwavering and contemplative gaze is fixated on the task of making art—with as much passion and intensity as he is endowed with. His suite of abstract paintings commands a dignified luminosity and sheen that speaks to Williams's rapport with colors. They reveal the artist's versatility at installing a wide range of tactile surfaces, actual and implied, which evoke the encrustations that are a standard feature of many an African object that has been employed within an expected cultural context. What springs to mind here are some Dogon sculptures that have been bathed over a long life cycle in millet beer, sorghum, or blood of sacrificial animals. Whether the paintings are, like his 1973 *NuNile*, a monochromatic field of engaging patterns; or, as in *I Am A Genius*, a playful twirl of looping shapes cursing over concentric circles that are held together by intersecting bands of geometric shapes, they constitute a call and response pattern that is a familiar technique employed by jazz. Like jazz music, too, Williams's work resonates with a distinct cadence and improvisational flavor.

In addition to their stratified abstraction, Williams's paintings recall his indebtedness to colleagues and pioneers in the color field movement—Frank Stella, Sam Gilliam, Kenneth Noland, and Morris Louis, among others—at the same time that they acknowledge his appreciation of the principles that sustain creative impulse in traditional Africa. For him, the epiphany came during his trip to Nigeria in 1977, the year that Africa's most populous nation celebrated the interrelationship of the arts with a major international festival, the Second World Black and African Festival of Arts and Culture (FESTAC). The trip instilled in Williams a new attitude and audaciousness concerning the process of making art. This journey allowed him to connect what he saw and what he had experienced during his childhood years in North Carolina. The abstract expressionist vein in which his paintings are rendered does not preclude their reliance on autobiographical referents. Abstraction, he would eventually discover, is one of the principal ploys adopted by African artists and designers who invest their handwoven textiles and basket works with an assortment of geometric shapes. Among the Kuba in the Federal Democratic Republic of Congo, for example, geometric designs are embedded within their fabrics either in embroidered or appliquéd fashion.

Williams is one of the select breed of artists who achieved unqualified success not by any appeal to race or gender, but by the sheer power of their work and their contributions to the evolution of a new aesthetic. Although Williams's introduction often includes the notation that he is the first black artist to be included in H. W. Janson's *History of Art* textbook, the artist's

oeuvre demonstrates that his inclusion had nothing to do with his race. In 1971, Williams achieved an unprecedented feat: he sold out his entire body of work at his first solo exhibition, which he held at the Reese Paley Gallery in New York. This sent a clear message to the culture establishment. Most reviews of Williams's work acknowledge his remarkable ability to create work that answered to his personal rhythm and sensibility, even when the prevailing trend suggested that such a move was doomed. Mercer (1991) quotes Judith Wilson in her 1970s review of Williams's work as stating that "William T. Williams' paintings don't apologize for their good looks, won't hide their ambition by playing dumb, and aren't ashamed to show some emotion. Their beauty is serious and hard won, yet essentially mysterious. As a group, they offer shrewd variations on a single theme, but each canvas leads a life of its own." In an article in the *Detroit Free Press,* Marsha Miro suggests that the attention that Williams received issued from his race but also because Williams was compellingly good: "Williams also got attention because he was African-American. The '70s were the days of clenched-fist confrontations between artists and museums that rarely admitted contemporary works by black artists into their hallowed precincts. Williams was acceptable because his art was good, undeniably good." Marsha goes further to adduce reasons for her position regarding the power of the art of Williams: "Williams is a superb colorist. He infuses his personal history, cultural heritage and feelings easily into his rhythmic, pulsing abstract color structures. His Matisse-like line drawings are unassuming odes. He should be celebrated for finding a way to add content and human relevance to esoteric, dry art styles of the '70s."

Often described as soft-spoken, Williams has proved himself to be one with ideas that have been tested both on the canvas, in community spaces, and in exhibition arenas. While he was a graduate student at Yale in the late sixties, Williams had the idea of involving his community—the population that had no incentive to go to art museums—in art-related events. With the funding that he secured, Williams brought together a team, called Smokehouse Painters, comprising **Melvin Eugene Edwards**; a sculptor, Guy Ciarcia, Williams's fellow student at Pratt and the only white artist in the group; and Billy Rose, then a student at Pratt. Smokehouse involved members of the community in executing its site-specific designs. Working anonymously, it consulted with neighbors and employed teenagers and the elderly in painting designs on chosen walls (Oren 1990). Although Williams had qualified success with the Smokehouse experiment—the group soon found out that sustainability was the sole problem—the second component of his Yale proposal resulted in the highly successful artist-in-residence program of the Studio Museum in Harlem. The streak of creative independence has been one of the strengths of the artist. It was his ability to step back from a situation and assess options that would optimize the emotional thrust of his paintings, imbuing them with an individuated capacity that stood in opposition to the clean, industrial finish of hard-edge abstractions of the sixties.

Williams was born in Cross Creek, North Carolina, on July 17, 1942, the second son of William Thomas Williams, a federal employee at Fort Bragg, and Hazel David Williams, a domestic worker who was also a telephone operator.

As a young boy, Williams grew up in a poor but supportive family, comprised mainly of members who grew tobacco and cotton (Oleck 2008). He was fascinated by the quilts made by his aunts and his grandmother in Cross Creek, and by a domestic self-sufficiency that came from family members who created most of the household items that they needed, ranging from furniture to household utensils. It was an experience that Williams internalized and would eventually distill and utilize in different forms. Regardless of the poor status of his family, Williams's upbringing was rich, thanks to his grandmother who inspired him to draw on the most assured of surfaces: the ground. From rural Cross Creek, the family moved to New York when Williams was four years old. In Queens, Williams's talents came to the attention of his teachers, who gave him encouragement and support. His love of colors dates back to his youth and can be ascribed to the opportunity that he had to play and experiment with materials, including discarded paper that came from a press in his neighborhood. Playing with the papers fired his imagination and allowed him to play with shapes and form (Oleck 2008).

Williams attended the High School of Industrial Arts in Manhattan, which is now the High School of Art and Design in New York, when he was 14. The school took advantage of its proximity to museums and held many of its classes at the Museum of Modern Art and the Metropolitan Museum of Art. Williams would later capitalize on this uniqueness: the exposure to art at a city level, which was complemented by his upbringing in rural North Carolina.

In 1962, he began his studies at Pratt Institute. During his junior year, he studied at the Skowhegan School of Painting and Sculpture on a summer scholarship and returned to Pratt, graduating with a B.F.A. degree in 1966. With encouragement from Alex Katz and Phillip Pearlstein, notable figurative painters at Pratt, Williams applied to Yale and began his graduate studies in 1966. He studied with Al Held, an abstract expressionist painter who is noted for his large-scale paintings of colorful geometric abstractions. Williams graduated with an M.F.A. degree in 1968. In 1971, he joined the faculty of Brooklyn College where he is currently professor of art. Since 1970 when he had his inaugural exhibition at the Studio Museum in Harlem, Williams has continued to exhibit at an unrelenting pace. He has exhibited in over one hundred museums, galleries, and art centers in North America, Latin America, Europe, Asia, and Africa. His work is in numerous collections, public and private, including the Museum of Modern Art, the Whitney Museum of American Art, and the Studio Museum in Harlem. Among the numerous awards that he has received are the North Carolina Award for Fine Arts, (2006); the James Van DerZee Award, (2005); the Joan Mitchell Foundation Grant Award (1996); the Mid-Atlantic/NEA Regional Fellowship (1994); the Studio Museum in Harlem Artist's Award (1992); the John Simon Guggenheim Fellowship (1987); and the National Endowment for the Arts, (1970).

Places to See Williams's Work

Chase Manhattan Bank Collection, New York, NY
Columbia Museum, Columbia, SC

Detroit Institute of Art, Detroit, MI
Fisk University Art Gallery, Nashville, TN
Governor Nelson A. Rockefeller/Empire State Plaza Art Collection, Albany, NY
Hampton University Museum, Hampton, VA
Johnson & Johnson Corporation, New Brunswick, NJ
Library of Congress, Washington, DC
Mount Holyoke College Art Museum, South Hadley, MA
Museum of Modern Art, New York, NY
New Orleans Museum of Art, New Orleans, LA
North Carolina State Museum, Raleigh, NC
Philadelphia Academy of the Fine Arts, Philadelphia, PA
Philip Morris Corporation, Charlotte, NC
Schomburg Center for Research in Black Culture, New York, NY
Studio Museum in Harlem, New York, NY
University of Maine, Orono, ME
Wadsworth Atheneum, Hartford, CT
Whitney Museum of American Art, New York, NY
Yale University Art Gallery, New Haven, CT

Bibliography

American Images: The SBC Collection of Twentieth-Century American Art. New York: Harry N. Abrams, 1996.

Ammirati, Domenick. "Energy/Experimentation: Black Artists and Abstraction, 1964–1980." *Artforum International* 44, no. 10 (Summer 2006): 354–55.

Cotter, Holland. "Energy and Abstraction at the Studio Museum in Harlem." *New York Times,* April 7, 2006.

Driskell, David. *Contemporary Visual Expressions.* Washington, DC: Smithsonian Institution, 1987.

———, ed. *African American Visual Aesthetics: A Post Modernist View.* Washington, DC: Smithsonian Institution Press, 1995.

Driskell, David. *The Other Side of Color: African American Art in the Collection of Camille O. and William H. Cosby Jr.* San Francisco, CA: Pomegranate, 2001.

Gips, Terry. *Narratives of African American Art and Identity: The David C. Driskell Collection.* San Francisco: Pomegranate Communications, 1998.

Janson, H. W. *The History of Art.* 3rd ed. New York: Harry N. Abrams, 1986.

Jones, Kellie, and Lowery Stokes Sims. *Energy/Experimentation: Black Artists and Abstraction 1964–1990.* New York: The Studio Museum in Harlem, 2006.

Langley, Jerry. "A Passion for Prints." *International Review of African American Art* 18, no. 3 (2002): 32–37.

Mercer, V. J. "Behind Closed Doors." *American Visions* 6, no. 2 (April 1991): 15.

Miro, Marsha. "Master Colorist." *Detroit Free Press,* July 3, 1994. http://williamtwilliams.com/archive/articles/MasterColorist/page1/.

Oleck, Joan. "Black Biography: William T. Williams." Answers.com, 2008.http://www.answers.com/topic/william-t-williams (accessed December 11, 2008).

Oren, Michael. "The Smokehouse Painters, 1968–1970." *Black American Literature Forum* 24, no. 3 (Fall 1990): 509.

Powell, Richard, and Jock Reynolds. *To Conserve a Legacy: American Art from Historically Black Colleges and Universities.* Andover, MA: Addison Gallery of American Art; New York: The Studio Museum in Harlem, 1999.

Sims, Lowery Stokes. "The Mirror the Other: The Politics of Esthetics." *Art Forum*, 28, no. 7 (March 1990).

Successions: Prints by African American Artists from the Jean and Robert Steele Collection. College Park, MD: The Art Gallery, University of Maryland, 2002.

25 Years of African-American Art: The Studio Museum in Harlem. New York: The Studio Museum in Harlem, 1994.

Works on Paper/William T. Williams. New York: The Studio Museum in Harlem, 1992.

Hale Woodruff (1900–1980), Painter.

Hale Woodruff remains one of the most conscientious synthesizers of creative ideas from across several cultures and periods. His work exemplifies the essence of multiculturalism, while his life is a sterling testimony to his commitment to educating diverse audiences about the interconnectedness of art and life. He worked with the conviction that art should be democratized: "Art has been for the few, but it should be for the many. Great periods of art have been those in which some great purpose motivated all the artists" (Stoelting 1978, 209). He was acutely aware of his place in the social history of American art, having been born into a segregated America, and having grown up during the depression and lived through the struggles of the Civil Rights Movement. His paintings show his quest for relevance as he wrestled with concepts that necessitated shifts in styles and subject matter.

The body of work that best defines Woodruff's universalist quest is the *Art of the Negro* murals that now adorn the rotunda of the Trevor Arnett Library at Clark Atlanta University in Georgia. Commissioned in 1950, the murals are comprised of six 11-square-foot paintings, each dealing with a separate topic, without any narrative or distinctive chronological sequence, but all drawing copiously from major world art and epochs. One thematic underpinning is the influence of African art on world culture. In the panel titled *Native Forms*, Woodruff presents an assemblage of some African icons and motifs and emphasizes their inseparability from life experiences. Hunters are presented in colorful costumes disguised as birds at the upper left side, while two sculptors are busy at work at the bottom right. At the center is the depiction of an assertive sculpture, which has iconological resemblance to Sango, god of thunder and lightning of the Yoruba of southwestern Nigeria. Elsewhere on this panel, there are warriors with masked shields. There is also a depiction of cave paintings.

In *Interchange*, another panel from the *Art of the Negro* murals, three streams of cultural influence—Greek, Roman, and African—are fused together. This panel is a symphony of cultures with each giving and receiving and

producing, in the process, a harmonious even if idealistic existence. *Parallels* re-echoes the theme adumbrated in *Interchange*: the interconnectedness of all art forms and cultures. A fourth panel, *Influences,* is concerned with the development of twentieth-century Western art, and the explication of its indebtedness to other cultures. While acknowledging the complementarity of cultures, *Influences* asserts the resilience of African art which, in spite of sustained efforts at discrediting it, emerged not only to assert its authority and innovativeness, but also to influence other art forms.

In *Dissipation,* the visual signification of the devastating effect of Eurocentrism is portrayed. Here, the destruction of Benin City, Nigeria, by the British is invoked to capture the persistent assault on African cultures by imperialist forces. This painting recalls a specific event in 1897 when British soldiers descended on the ancient kingdom of Benin and burned it down. Their excuse was that a Bini chief, Ologbosere, was bold enough to have prevented the British consul from visiting the Oba of Benin during the annual Ighue festival when, by tradition, the king could neither see nor be seen by any non-Bini. About a decade earlier, at the 1884 Berlin conference, the entire continent of Africa had been sliced up and shared amongst European powers. Nigeria, which had been occupied since 1860, was under British colonial rule. Thus, it was considered impudent that a Bini could insist on upholding the sanctity of the kingdoms tradition. Not only was the ancient city destroyed, the Oba was sent into exile and priceless artworks were plundered.

The last panel, *Muses,* is the curtain call, Woodruff's "Who's Who" of 17 black artists for whom he has respect and admiration. Among these are Joshua Johnston, portrait painter and the first black artist to gain public recognition in the United States. Of course, there is Woodruff's idol, **Henry Ossawa Tanner**, depicted standing second from left. Other artists whom Woodruff depicts in this panel include **Jacob Lawrence** (third from left) and Edward Bannister (fourth from left). Sitting in the foreground, left, and in yellow shirt is Charles Alston. Significant in this inclusion is the thirteenth-century Bini sculptor Igueghae. In the Trevor Arnett murals, Woodruff pays homage to African art and the African artist, who has been much maligned and in the West. In a 1968 interview that he granted All Murray, Woodruff avers that the *Art of the Negro* is an acknowledgment of his enduring interest in African art. "There are many artists, and other people, today, who believe that we have no part of Africa's history. I look at the African artist certainly as one of my ancestors regardless of how we feel about each other today. I've always had a high regard and respect for the African artist and his art" (Murray 1968). The location of the murals on the portals of the library was a strategic ploy by Woodruff, who wanted African American students and patrons of the library to gain an awareness of their ancestry.

Woodruff's interest in African art was sparked by a German gallery owner in Indianapolis, Herman Lieber, who gave Woodruff Carl Einstein's 1923 book on African sculpture, *Afrikanische Plastik,* insisting that Woodruff would benefit by it. This book set Woodruff on a path that significantly influenced not only his art but also his aesthetic preferences, as he collected a number of African

objects. Woodruff was fascinated by mural painting. In July 1936, he left for Mexico, where he apprenticed himself to Diego Rivera and studied the philosophy, techniques, and materials of Mexican murals. He became exposed to the works of Jose Clemente Orozco and learned about fresco painting in general.

The *Art of the Negro* murals were not Woodruff's first. In 1938, he was commissioned by the president of Talladega College in Alabama, Dr. Buell Gallagher, to paint two sets of murals for the Savery Library, which was then under construction. Talladega, a black southern college, was founded by the American Missionary Association in 1867. The first set of murals, which Woodruff completed in 1939, portrays the founding of the college, and depicts student activities during registration for classes, and the construction of the Savery Library. The second set of murals, *Mutiny Aboard the Amistad*, commemorates the centennial anniversary of the revolt of some 54 Africans who had been abducted from Sierra Leone and taken to Havana, Cuba, where they were sold as slaves. Woodruff conducted rigorous and detailed studies for the Amistad murals. He examined relevant documents in the collection of the New Haven Colony Historical Society and studied the more than 32 pencil drawings of the Africans at the Yale University Library, which had been done by a young American artist, William Townsend. Dedicated on April 16, 1939, the Talladega murals instantly became a celebrated achievement not only for Hale Woodruff or Talladega, but also for all blacks, for all Americans.

Hale Aspacio Woodruff was born in Cairo, Illinois, in 1900. At a very early age, his mother relocated to Nashville, Tennessee, where Woodruff, an only child, had his early education. In high school, he drew cartoons for the newspaper, the *Pearl High Voice.* After high school, he moved to Indianapolis and attended the John Herron Art Instute. In 1926, he won the Harmon Award, newly established by the Harmon Foundation. This event elicited substantial excitement in Indiana, where the governor personally handed Woodruff the award. The resultant publicity led to further support from a group in Franklin, Indiana, who raised $200 that paid Woodruff's trip to Paris in 1927. There, Woodruff studied at the Academie de la Grande Chaumiere, and finally had the opportunity of meeting Henry Ossawa Tanner, his idol. In Paris, he met with other African American artists and writers, including Claude McKay, Augusta Savage, and his close friend and cowinner of the Harmon Award, **Palmer C. Hayden.** In 1931, Woodruff returned to the United States with an offer of appointment to teach art at Atlanta University. Upon his return, Woodruff engaged in outdoor painting with his students, a movement that became known as the "Outhouse School" or the "Atlanta School."

In addition to teaching, Woodruff also organized art exhibitions, especially at the exhibition space of the Atlanta University Library. But the series of annual National Exhibitions that Woodruff initiated in 1942 formally established the ascendancy of Atlanta as a formidable art center in the South in the 1940s. He succeeded, as he had planned, in propagating an awareness of art among the people and in offering opportunity to artists to have national exposure through exhibitions. In 1943, he went to New York on a Rosenwald grant

to teach, and remained there until 1945 when he went back to Atlanta. In 1946, Woodruff finally accepted the offer to teach at New York University, where he embraced abstract expressionism. While paintings that he produced during this phase represented a significant stylistic change, the subject matter and theme that he explored did not abandon his interest in his African ancestry.

Places to See Woodruff's Work

Art Institute of Chicago, Chicago, IL
Brooklyn Museum of Art, Brooklyn, NY
Detroit Institute of Arts, Detroit, MI
Harvard University Art Museums, Cambridge, MA
High Museum of Art, Atlanta, GA
Howard University Art Collection, Washington, DC
Indianapolis Museum of Art, Indianapolis, IN
Montclair Art Museum, Montclair, NJ
Smithsonian American Art Museum, Washington, DC
Spellman College, Atlanta, GA

Bibliography

Amaki, Amalia K. *Hale Woodruff, Nancy Elizabeth Prophet, and the Academy.* Atlanta, GA: Spelman College Museum of Fine Art in association with Seattle: University of Washington Press, 2007.

Driskell, David. *Two Centuries of Black American Art.* Los Angeles: Los Angeles County Museum; New York: Knopf, 1976.

Fax, Elton. *Seventeen Black Artists.* New York: Dodd, Mead, 1971.

Fine, Elsa Honig. *The Afro-American Artist: Search for Identity.* New York: Holt, Rinehart and Winston, 1973.

Hewitt, John H. "Remembering Hale A. Woodruff." *International Review of African American Art* 14, no. 4 (1997):, 51–56.

Hills, Patricia. *Syncopated Rhythms: 20th-Century African American Art from the George and Joyce Wein Collection.* Boston, MA: Boston University Art Gallery; Seattle: Distributed by University of Washington Press, 2005.

Huggins, Nathan Irvin, ed. *Voices from the Harlem Renaissance.* New York: Oxford University Press, 1995.

Leinninger-Miller, Theresa. *New Negro Artists in Paris: African American Painters and Sculptors in the City of Light, 1922–1934.* Piscataway, NJ: Rutgers University Press, 2001.

Lewis, Samella. *African American Art and Artists.* Berkeley: University of California Press, 2003.

Murray, Al. "Oral History Interview with Hale Woodruff," November 18, 1968. Smithsonian Archives of American Art. http://www.aaa.si.edu/collections/oralhistories/transcripts/woodru68.htm (accessed July 26, 2008).

Perry, Regenia. *Free Within Ourselves: African-American Artists in the Collection of the National Museum of American Art.* Washington, DC: National Museum of American Art, Smithsonian Institution in association with San Francisco: Pomegranate Artbooks, 1992.

Stoelting, Winifred L. "Hale Woodruff, Artist and Teacher: Through the Atlanta Years." PhD diss., Emory University, 1978.

Studio Museum. *Hale Woodruff 50 Years of His Art.* New York: Studio Museum in Harlem, 1979.

Taylor, William E. *A Shared Heritage: Art by Four African Americans.* Indianapolis, IN: Indianapolis Museum of Art, with Indiana University Press, 1996.

Bibliography

Abiodun, Rowland, Henry John Drewal, John Pemberton, and Museum Rietberg, eds. *The Yoruba Artist: New Theoretical Perspectives on African Arts.* Washington, DC: Smithsonian Institution Press, 1994.

Adoff, Arnold, and Benny Andrews. *I Am the Darker Brother: An Anthology of Modern Poems by African Americans.* New York: Aladdin Paperbacks, 1997.

Altbach, Phillip G., and Salah M. Hassan, ed. *The Muse of Modernity: Essays on Culture as Development in Africa.* Trenton, NJ: Africa World Press, 1996.

Amaki, Amalia K. *Hale Woodruff, Nancy Elizabeth Prophet, and the Academy.* Atlanta, GA: Spelman College Museum of Fine Art, 2007.

Andrews, Benny, and ACA Galleries. *Benny Andrews: Paintings and Watercolors Including "Trash": April 25–May 13, 1972.* New York: ACA Galleries, 1972.

Andrews, Benny, and New Jersey State Museum. *Benny Andrews: The America Series.* Santa Clara, CA: Triton Museum of Art, 1992.

Andrews, Benny, and Studio Museum in Harlem. *The Collages of Benny Andrews: September 18, 1988–February 26, 1989, an Exhibition.* New York: Studio Museum in Harlem, 1988.

Andrews, Benny, Anne Timpano, Dorothy W. and C. Lawson Reed, Jr. Gallery, and DAAP Galleries. *Benny Andrews: A Different Drummer: The Music Series 1991–98.* Cincinnati, OH: DAAP Galleries, 1999.

Arnett, Paul, and William Arnett. *Souls Grown Deep: African American Vernacular Art of the South.* Atlanta, GA: Tinwood Books in association with the Schomburg Center for Research in Black Culture, the New York Public Library, 2000.

Art Papers. Special Issue on Contemporary Black Artists. Atlanta, GA: Atlanta Art Papers, 1988.

Ater, Renée, and Keith Morrison. *Keith Morrison.* The David C. Driskell Series of African American Art. Vol. 5. San Francisco: Pomegranate, 2005.

Barnwell, Andrea D., and Charles White. *Charles White.* San Francisco: Pomegranate, 2002.

Basquiat, Jean Michel, and Civico museo Revoltella. *Basquiat.* Milan: Charta, 1999.

Basquiat, Jean Michel, Glenn O'Brien, Diego Cortez, and Deitch Projects. *Jean-Michel Basquiat 1981: The Studio of the Street.* Milan: Charta, 2007.

Bearden, Romare, and Harry Henderson. *Six Black Masters of American Art.* New York: Zenith Books, 1972.

———. *A History of African-American Artists: From 1792 to the Present.* New York: Pantheon Books, 1993.

Beckman, Wendy H. *Artists and Writers of the Harlem Renaissance.* Berkeley Heights, NJ: Enslow Publishers, 2002.

Belton, Sandra, and Benny Andrews. *Pictures for Miss Josie*. New York: Greenwillow Books, 2003.

Benezra, Neal David. *Martin Puryear*. London: Thames and Hudson; Chicago: Art Institute, 1991.

Benjamin, Tritobia H. *The Life and Art of Lois Mailou Jones*. San Francisco: Pomegranate Artbooks, 1994.

Berger, Maurice, Brian Wallis, Simon Watson, and Carrie Mae Weems. *Constructing Masculinity*. New York: Routledge, 1995.

Bester, Rory, and Lauri Firstenberg. "African Experiences: Kay Hassan, Odili Donald Odita, Moshekwa Langa." *Flash Art (International)* 33, no. 210 (January–February 2000): 68–70.

Biggers, John T. *Ananse, the Web of Life in Africa*. Austin: University of Texas Press, 1979.

Bill Hodges Gallery. *African-American Artists*. New York: Bill Hodges Gallery, 2006.

Binstock, Jonathan P. *Sam Gilliam: A Retrospective*. Berkeley: University of California Press; Washington, DC: Corcoran Gallery of Art, 2005.

Bolden, Tonya. *Wake Up Our Souls: A Celebration of Black American Artists*. New York: Harry N. Abrams in association with the Smithsonian American Art Museum, 2004.

Bontemps, Alex. *Forever Free: Art by African-American Women, 1862–1980*. Alexandria, VA: Stephenson, 1980.

Bowie, David, Dennis Hopper, et al. *Basquiat*. Video recording. Burbank, CA: Miramax Home Entertainment, 2002.

Braddock, Alan C. "Eakins, Race, and Ethnographic Ambivalence." *Winterthur Portfolio* 33, no. 2–3 (Summer–Autumn 1998): 135–61.

Brielmaier, Isolde. "Re-Inventing the Spaces Within: The Images of Lalla Essaydi." *Aperture*, no. 178 (Spring 2005): 20–25.

Brown, Kay. "The Emergence of Black Women Artists: The 1970s, New York." *International Review of African American Art* 15, no. 1 (1998): 45–51, 54–57.

Brownlee, Andrea Barnwell. *Charles White*. San Francisco: Pomegranate, 2002.

Bush, Martin H. *The Photographs of Gordon Parks*. Wichita, KS: Edwin A. Ulrich Museum of Art, Wichita State University, 1983.

Calo, Mary Ann. *Distinction and Denial: Race, Nation, and the Critical Construction of the African American Artist, 1920–40*. Ann Arbor: University of Michigan Press, 2007.

Campbell, Bolaji. *Painting for the Gods: Art and Aesthetics of Yoruba Religious Murals*. Trenton, NJ: Africa World Press, 2008.

Campos-Pons, Maria Magdalena. *Maria Magdalena Campos-Pons: Everything Is Separated by Water*. Indianapolis, IN: Indianapolis Museum of Art in association with Yale University Press, New Haven, 2007.

Carpenter, Jane H. *Betye Saar*. San Francisco: Pomegranate, 2003.

Catlett, Elizabeth. *Elizabeth Catlett Sculpture: A Fifty-Year Retrospective*. Purchase: Neuberger Museum of Art, Purchase College, State University of New York, 1998.

Childs, Adrienne L. *Evolution: Five Decades of Printmaking by David C. Driskell*. San Francisco: Pomegranate, 2007.

Clement, Jennifer. *Widow Basquiat*. Edinburgh: Payback, 2000.

Coker, Gylbert, and Okwui Enwenzor. "Black Male: Representations of Masculinity in Contemporary American Art." *International Review of African American Art* 12, no. 2 (1995): 60–64.

Coleman, Floyd. "African American Art Then and Now: Some Personal Reflections." *American Art* 17, no. 1 (Spring 2003): 23–25.

Collins, Lisa Gail. *The Art of History: African American Women Artists Engage the Past.* New Brunswick, NJ: Rutgers University Press, 2002.

Collins, Lisa Gail, and Margo Natalie Crawford. *New Thoughts on the Black Arts Movement.* New Brunswick, NJ: Rutgers University Press, 2006.

Crown, Carol, and Charles Russell. *Sacred and Profane: Voice and Vision in Southern Self-Taught Art.* Jackson: University Press of Mississippi, 2007.

Crutchfield, Margo A. *Martin Puryear.* Richmond: Virginia Museum of Fine Arts, 2001.

Cullum, Jerry. "Starting Out from Atlanta: Three Artists Imagine History." *International Review of African American Art* 3 (2002): 43–48.

Daigle, Claire. "Personal Affects: Power and Poetics in Contemporary South African Art." Sculpture (Washington, DC) 24, no. 4 (May 2005): 78–79.

Dallas Museum of Art. *Black Art Ancestral Legacy: The African Impulse in African-American Art.* Dallas, TX: Dallas Museum of Art. Distributed by Harry N. Abrams, New York, 1989.

David C. Driskell Center. *David C. Driskell Center for the Study of the Visual Arts and Culture of African Americans and the African Diaspora.* College Park: University of Maryland, 2005.

Davis, Willis. *The Art of Willis Bing Davis: Ceremony and Ritual.* Dayton, OH: Dayton Visual Arts Center, 1997.

De Jager, E. J. *Contemporary African Art in South Africa.* Cape Town: C. Struik, 1973.

De Zegher, Catherine. *Julie Mehretu: Drawings.* New York: Rizzoli, 2007.

Dial, Thornton. *Thornton Dial: Image of the Tiger.* New York: Harry N. Abrams in association with the Museum of American Folk Art and the American Center, 1993.

―――. *Thornton Dial in the 21st Century.* Atlanta, GA: Tinwood Books in association with the Museum of Fine Arts, Houston, 2005.

Dimitriadis, Greg, and Cameron McCarthy. *Reading and Teaching the Postcolonial: From Baldwin to Basquiat and Beyond.* New York: Teachers College Press, 2001.

Dirlik, Arif. "The Postcolonial Aura: Third World Criticism in the Age of Global Capitalism." *Critical Inquiry* 20, no. 2 (1994): 328–56.

Earle, Susan, ed. *Aaron Douglas: African American Modernist.* New Haven, CT: Yale University Press in association with Spencer Museum of Art, University of Kansas, Lawrence, 2007.

Drewal, Henry John, and David C. Driskell. *Introspectives: Contemporary Art by Americans and Brazilians of African Descent.* Los Angeles: California Afro-American Museum, 1989.

Driskell, David C. *Amistad II, Afro-American Art.* Nashville, TN: Dept. of Art, Fisk University, 1975.

―――. *Two Centuries of Black American Art: [Exhibition].* New York: A. A. Knopf, 1976.

―――. *Hidden Heritage: Afro-American Art, 1800–1950.* San Francisco: Art Museum Association of America, 1985.

―――. "Skunder." *International Review of African American Art* (Los Angeles) 6, no. 3 (1985): 33–51.

―――. *Contemporary Visual Expressions: The Art of Sam Gilliam, Martha Jackson-Jarvis, Keith Morrison, William T. Williams.* Washington, DC: Smithsonian Institution Press, 1987.

―――. *Twentieth Century African American Art from the Collection of Mr. and Mrs. Darrell Walker.* Little Rock: University of Arkansas at Little Rock, 1996.

Driskell, David C., David L. Lewis, and Deborah Willis. *Harlem Renaissance: Art of Black America.* New York: Studio Museum in Harlem; New York: Abradale Press, 1994.

Duggleby, John, and Jacob Lawrence. *Story Painter: The Life of Jacob Lawrence.* San Francisco: Chronicle Books, 1998.

Edelstein, Debra, ed. *A Shared Heritage: Art by Four African Americans.* Indianapolis, IN: Indianapolis Museum of Art in cooperation with Indiana University Press, 1996.

Emmerling, Leonhard. *Jean-Michel Basquiat: 1960–1988.* London: Taschen, 2003.

Enwezor, Okwui, ed. *In/Sight: African Photographers 1940 to the Present.* New York: Guggenheim Museum, 1996.

―――. *The Short Century: Independence and Liberation Movements in Africa, 1945–1994.* New York: Prestel, 2001.

―――. *Democracy Unrealized: Documenta 11, Platform 1.* Ostfildern-Ruit: Hatje Cantz, 2002.

Enwezor, Okwui. *Personal Affects: Power and Poetics in Contemporary South African Art.* New York: Museum for African Art, New York and Spier, Cape Town, 2004.

―――. *Snap Judgments: New Positions in Contemporary African Photography.* Göttingen: Steidl, 2006.

Everett, Gwen. *African American Masters: Highlights from the Smithsonian American Art Museum.* New York: Harry N. Abrams; Washington, DC: Smithsonian American Art Museum, 2003.

"Extreme Times Call for Extreme Heroes." *International Review of African American Art,* no. 3 (1997): 2–15, 64.

Farber, Jane. "Change the Joke and Slip the Yoke: A Series of Conversations on the Use of Black Stereotypes in Contemporary Visual Practice." *New Art Examiner* (1985) 26, no. 2 (October 1998): 14–15.

Farr, Francine. "Art/Artifact: African Art in Anthropology Collections." *African Arts* 21, no. 4 (August 1988): 78–80.

Farrell, Laurie Ann, ed. *Looking Both Ways: Art of the Contemporary African Diaspora.* New York: Museum for African Art; Gent: Snoeck, 2003.

Farrington, Lisa E., and Faith Ringgold. *Faith Ringgold.* San Francisco: Pomegranate, 2004.

Fax, Elton C. *Seventeen Black Artists.* New York: Dodd, Mead, 1971.

Firstenberg, Lauri. "Representing the Body Archivally in South African Photography." *Art Journal* (New York, 1960) 61, no. 1 (Spring 2002): 58–67.

Fleming, Tuliza K. *Breaking Racial Barriers: African Americans in the Harmon Foundation Collection.* Washington, DC: National Portrait Gallery, Smithsonian Institution; San Francisco: Pomegranate, 1997.

Fonvielle-Bontemps, Jacqueline, David C. Driskell, and Alex Bontemps. *Forever Free: Art by African-American Women 1862–1980.* Alexandria, VA: Stephenson, 1980.

Francis, Jacqueline, Mary Ann Calo, and James Smalls. "Writing African American Art History." *American Art* 17, no. 1 (Spring 2003): 2–25.

Fraustino, Lisa Rowe, and Benny Andrews. *The Hickory Chair.* New York: Arthur Levine Books, 2000.

Frye, Daniel J. *African American Visual Artists: An Annotated Bibliography of Educational Resource Materials.* Lanham, MD: Scarecrow Press, 2001.

Gedeon, Lucinda H. *Melvin Edwards Sculpture: A Thirty-Year Retrospective, 1963–1993.* Purchase: Neuberger Museum of Art, State University of New York at Purchase, 1993.

Genshaft, Carole Miller, Kenneth W. Goings, et al. *Symphonic Poem: The Art of Aminah Brenda Lynn Robinson.* Columbus, OH: Columbus Museum of Art in association with Harry N. Abrams, New York, 2002.

Gilliam, Sam. *Red & Black to "D": Paintings by Sam Gilliam, November 16, 1982–February 27, 1983.* New York: Studio Museum in Harlem, 1982.

Golden, Thelma. *Black Male: Representations of Masculinity in Contemporary American Art.* New York: Whitney Museum of American Art, 1994.

Govenar, Alan. *Portraits of Community: African American Photography in Texas.* Austin: Texas State Historical Association, 1996.

Gruber, J. Richard, and Benny Andrews. *American Icons: From Madison to Manhattan, the Art of Benny Andrews, 1948–1997.* Augusta, GA: Morris Museum of Art, 1997.

Hardin, Kris L. "Inaugural Exhibitions: National Museum of African Art." *African Arts* 21, no. 3 (May 1988): 72–73.

Harris, Juliette. "Samella Lewis: An Art Institution in Her Own Right." *International Review of African American Art* 18, no. 1 (2001): 14–15.

Harris, L., ed. *The Critical Pragmatism of Alain Lock: A Reader on Value Theory, Aesthetics, Community, Culture, Race, and Education.* Lanham, MD: Rowman & Littlefield, 1999.

Harris, Michael D. *Astonishment and Power.* Washington, DC: Published for the National Museum of African Art by the Smithsonian Institution Press, 1993.

———. *Colored Pictures: Race and Visual Representation.* Chapel Hill: University of North Carolina Press, 2003.

Harris, Michael D., and Moyo Okediji. *Transatlantic Dialogue: Contemporary Art In and Out of Africa.* Chapel Hill: Ackland Art Museum, University of North Carolina at Chapel Hill, 1999.

Haskins, James. *James Van DerZee, the Picture-Takin' Man.* New York: Dodd, Mead, 1979.

Hassan, Salah M. *Art and Islamic Literacy among the Hausa of Northern Nigeria.* Lewiston, NY: E. Mellen Press, 1992.

———. *Gendered Visions: The Art of Contemporary African Women Artists.* Trenton, NJ: Africa World Press, 1997.

Heartney, Eleanor. "Recontextualizing African Altars." *Art in America* 82, no. 12 (December 1994): 58–65.

Henkes, Robert. *The Art of Black American Women: Works of Twenty-Four Artists of the Twentieth Century.* Jefferson, NC: McFarland, 1993.

Herzog, Melaine. *Elizabeth Catlett: An American Artist in Mexico*. Seattle: University of Washington Press, 2000.

————. *Elizabeth Catlett: In the Image of the People*. Chicago: Art Institute of Chicago ; Distributed by Yale University Press, New Haven, 2005.

Hewitt, M. J. "Vital Resources." *International Review of African American Art* 14, no. 2 (1997): 18–46.

Hills, Patricia. *Syncopated Rhythms: 20th-Century African American Art from the George and Joyce Wein Collection*. Boston, MA: Boston University Art Gallery; Distributed by University of Washington Press, Seattle, 2005.

hooks, bell. *Art on My Mind: Visual Politics*. New York: New Press, 1995.

Houze, Rebecca. "Lorna Simpson: For the Sake of the Viewer." *Chicago Art Journal* 4, no. 1 (Spring 1994): 65–68.

Huggins, Nathan Irvin, ed. *Voices from the Harlem Renaissance*. New York: Oxford University Press, 1995.

Hultgren, Mary Lou. "The African Art Collections: To Be a Great Soul's Inspiration." *International Review of African American Art* 20, no. 1 (2005): 33–43.

Hunussek, Christian, and Isabell Lorey. "How African Is It?" *Texte Zur Kunst* 11, no. 43 (September 2001): 190–98.

Hutchinson, G., ed. *The Cambridge Companion to the Harlem Renaissance*. New York: Cambridge University Press, 2007.

Jackson, Phyllis J. "(in)Forming the Visual: (Re)Presenting Women of African Descent." *International Review of African American Art* 14, no. 3 (1997): 30–37.

jegede, dele. *Contemporary African Art: Five Artists, Diverse Trends*. Indianapolis, IN: Indianapolis Museum of Art, 2000.

————. *Women to Women: Weaving Cultures, Shaping History*. Terre Haute: Indiana State University Art Gallery, 2000.

————. "This Is Lagos." In *Five Windows into Africa*, edited by Patrick McNaughton. Bloomington: Indiana University Press, 2000.

————. "Art in Contemporary Africa." In *Africa Vol. 5: Contemporary Africa*, edited by Toyin Falola, 705–34. Durham, NC: Carolina Academic Press, 2003.

Joselit, David. "Africa Rising." *Art in America* 78, no. 10 (October 1990): 160–61.

Kasfir, Sidney Littlefield. *Contemporary African Art*. New York: Thames and Hudson, 2000.

King-Hammond, Leslie. *Masters, Mentors and Makers*. Baltimore, MD: Artscape '92, Baltimore Festival of the Arts, 1992.

————. *Gumbo Ya Ya: Anthology of Contemporary African-American Women Artists*. New York: Midmarch Arts Press, 1995.

King-Hammond, Leslie, and Newcomb Art Gallery. *African-American Art: 20th Century Masterworks*. New York: Michael Rosenfeld Gallery, 1998.

Kirsh, Andrea. *Carrie Mae Weems*. Washington, DC: National Museum of Women in the Arts, 1994.

Kreamer, Christine Mullen. *Inscribing Meaning: Writing and Graphic Systems in African Art*. Washington, DC: Smithsonian National Museum of African Art, 2007.

LaDuke, Betty. *Africa Through the Eyes of Women Artists*. Trenton, NJ: Africa World Press, 1991.

————. *Women Artists: Multi-Cultural Visions*. Trenton, NJ: Red Sea Press, 1992.

Lampert, Catherine, and Clementine Deliss. *Seven Stories about Modern Art in Africa*. London: Whitechapel, 1995.

Lawrence, Jacob. "Over the Line: The Art and Life of Jacob Lawrence." *Museum News* 80, no. 3 (2001): 20.

Lawrence, Jacob, David C. Driskell, Fisk University, and University Galleries. *The Toussaint L'Ouverture Series*. Nashville, TN: Fisk University in association with the Art Gallery, 1968.

Leach, Deborah J., Suzanne Wright, and Phillips Collection. *I See You, I See Myself: The Young Life of Jacob Lawrence*. Washington, DC: Phillips Collection, 2001.

Ledes, Allison Eckardt. "Lawrence Retrospective." *The Magazine Antiques (1971)* 160, no. 1 (2001): 24–26.

Leininger-Miller, Theresa A. *New Negro Artists in Paris: African American Painters and Sculptors in the City of Light, 1922–1934*. New Brunswick, NJ: Rutgers University Press, 2001.

Lewis, David. *Thaddeus Mosley: African American Sculptor*. Pittsburgh, PA: Carnegie Museum of Art, 1997.

Lewis, Samella S., ed. *Black Artists on Art*. Los Angeles: Contemporary Crafts Publishers, 1969.

Lewis, Samella S. *African American Art and Artists*. 3rd ed. Berkeley: University of California Press, 2003.

Lewis, Samella S., Richard J. Powell, and Jeanne Zeidler. *Elizabeth Catlett: Works on Paper, 1944–1992*. Hampton, VA: Hampton University Museum, 1993.

Ligon, Glenn. *Glenn Ligon: Some Changes*. Toronto, ON: Power Plant, 2005.

Locke, Alain. *The Negro in Art: A Pictorial Record of the Negro Artist and of the Negro Theme in Art*. New York: Hacker Art Books, 1979.

———. *The New Negro: Voices of the Harlem Renaissance*. New York: Touchstone, 1997.

Logan, Fern. *The Artist Portrait Series: Images of Contemporary African American Artists*. Carbondale: Southern Illinois University Press, 2001.

Longhauser, Elsa Weiner, and Harald Szeemann. *Self-Taught Artists of the 20th Century: An American Anthology*. San Francisco: Chronicle Books, 1998.

Lord, Catherine. *The Theater of Refusal: Black Art and Mainstream Criticism*. Irvine: University of California Fine Arts Gallery, 1993.

Lucie-Smith, Edward. *Race, Sex, and Gender in Contemporary Art*. New York: Harry N. Abrams, 1994.

Macklin, A. D. *A Biographical History of African American Artists, A–Z*. Lewiston, NY: Edwin Mellen Press, 2001.

Magnin, Andre, and Museum of Fine Arts, Houston. *African Art Now: Masterpieces from the Jean Pigozzi Collection*. London: Merrell, 2005.

Mantegna, Gianfranco, and Ouattara. "Ouattara." *Journal of Contemporary Art* 3, no. 2 (Fall-Winter 1990): 26–33.

Mark, Peter. "Is There Such a Thing as African Art?" *Record of the Art Museum, Princeton University* 58, no. 1/2 (1999): 7–15.

Martin, Elizabeth. *Female Gazes: Seventy-Five Women Artists*. Toronto: Second Story Press, 1997.

Matthews, Marcia M. *Henry Ossawa Tanner, American Artist*. Chicago: University of Chicago Press, 1969.

May, Stephen. "Renaissance of a Modernist." *ARTnews* 107, no. 9 (October 2008): 146–49.

Mazloomi, Carolyn. *Spirits of the Cloth: Contemporary African-American Quilts.* New York: Clarkson Potter/Publishers, 1998.

McElroy, Guy C., Richard J. Powell et al. *African-American Artists, 1880–1987: Selections from the Evans-Tibbs Collection.* Washington, DC: Smithsonian Institution Traveling Exhibition Service in association with University of Washington Press, Seattle, 1989.

McEvilley, Thomas. "Report from Dakar: Toward a Creative Reversal." *Art in America* 89, no. 1 (January 2001): 41–45, 124.

McGee, Julie L. *David C. Driskell: Artist and Scholar.* San Francisco: Pomegranate, 2006.

Metcalf, Eugene W. "Black Art, Folk Art, and Social Control." *Winterthur Portfolio* 18, no. 4 (Winter 1983): 271–89.

Metropolitan Museum of Art. *African-American Artists, 1929–1945: Prints, Drawings, and Paintings in the Metropolitan Museum of Art.* New York: Metropolitan Museum of Art; New Haven, CT: Yale University Press, 2003.

Mirzoeff, Nicholas. *The Visual Culture Reader.* 2nd ed. London: Routledge, 2002.

Mitchell, Leatha Simmons. "Fresh Paint! National Scene." *International Review of African American Art* 14, no. 1 (1997): 14–28.

Mooney, Amy M., and Archibald John Motley. *Archibald J. Motley Jr.* San Francisco: Pomegranate, 2004.

Mosby, Dewey F. *Henry Ossawa Tanner.* Philadelphia, PA: Philadelphia Museum of Art; New York: Rizzoli, 1991.

Moss, Mark Richard. "Praised Hereafter: Three Contemporary Sculptors and Their Work." *International Review of African American Art* 15, no. 2 (1998): 18–23.

Museum of Contemporary Art of Georgia. *Transitions: Amalia Amaki, Benny Andrews, Linda Armstrong, Philip Carpenter, E.K. Huckaby, Jim Waters.* Atlanta: Museum of Contemporary Art of Georgia, 2002.

Nelson, Steven, Richard J. Powell, and Alan Reed. "What is Black Art?" *Art Journal* (New York, 1960) 57, no. 3 (Fall 1998): 91–94.

Nesbett, Peter T., Jacob Lawrence, and Michelle DuBois. *Jacob Lawrence: Paintings, Drawings, and Murals (1935–1999): A Catalogue Raisonne.* Seattle: University of Washington Press in association with Jacob Lawrence Catalogue Raisonne Project, 2000.

Newkirk, Pamela. "Shaping the Story of Black Art." *Art News* (New York) 99, no. 5 (May 2000): 198–201.

Nochlin, Linda. "Learning from 'Black Male'." *Art in America* 83, no. 3 (March 1995): 86–91.

Nzegwu, Nkiru. "Reality on the Wings of Abstraction." *International Review of African American Art* 13, no. 3 (1996): 3–12.

Oguibe, Olu, and Okwui Enwezor, ed. *Reading the Contemporary: African Art from Theory to the Marketplace.* London: Institute of International Visual Arts; Cambridge, MA: MIT Press, 1999.

———. *The Culture Game.* Minneapolis: University of Minnesota Press, 2004.

Okediji, Moyo. "Black Skin, White Kins: Metamodern Masks, Multiple Mimesis." In *Diaspora and Visual Culture: Representing Africans and Jews,* 143–62. New York: Routledge, 2000.

Otfinoski, Steven. *African Americans in the Visual Arts*. New York: Facts on File, 2003.

Owerka, Carolyn. "Contemporary African Art." *African Arts* 18, no. 2 (February 1985): 78.

Parker, Ian. "Golden Touch: In Harlem, Thelma Golden Has Big Plans for Contemporary Art." *New Yorker* 77, no. 43 (January 2002): 44–49.

Parks, Gordon. *Gordon Parks: Whispers of Intimate Things*. New York: Viking Press, 1971.

Patton, Sharon F. *African-American Art*. New York: Oxford University Press, 1998.

Pongracz, Patricia C., ed. *Threads of Faith: Recent Works from the Women of Color Quilters Network*. New York: Gallery of the American Bible Society, 2004.

Porter, James A. *Modern Negro Art*. Moorland-Spingarn Series. Washington, DC: Howard University Press, 1992.

Powell, Richard J. *Homecoming: The Art and Life of William H. Johnson*. New York: W.W. Norton, 1991.

———. " 'In My Family of Primitiveness and Tradition': William H. Johnson's Jesus and the Three Marys." *American Art* 5, no. 4 (Fall 1991): 20–33.

———. *Rhapsodies in Black: The Art of the Harlem Renaissance*. Berkeley: University of California, 1997.

———. *Beauford Delaney: The Color Yellow*. Atlanta, GA: High Museum of Art, 2002.

———. *Circle Dance: The Art of John T. Scott*. Jackson: University of Mississippi, 2005.

Powell, Richard J., and Norma Broude. *Jacob Lawrence*. New York: Rizzoli, 1992.

Puryear, Martin. *Martin Puryear*. New York: Museum of Modern Art, 2007.

Rampley, Matthew. *Exploring Visual Culture: Definitions, Concepts, Contexts*. Edinburgh: Edinburgh University Press, 2005.

Reed, Veronica. "Passing the Passion: African American Art Collectors in the NBA." *International Review of African American Art* 17, no. 3 (2000): 2–19.

Rickey, Carrie. "Art from Whole Cloth." *Art in America* 67, no. 7 (November 1979): 72–83.

Robertson, Eric. "African Art and African-American Identity." *African Arts* 27, no. 2 (April 1994): 1–10.

Rodman, Selden. *Horace Pippin, a Negro Painter in America*. New York: Quadrangle Press, 1947.

Rose, Barbara. "Sam Gilliam: Abstraction as Identity." *International Review of African American Art* 13, no. 3 (1996): 18–23.

Rubenfeld, Florence. "Sam Gilliam." *Arts Magazine* 63, no. 10 (Summer 1989): 79.

Shaw, Gwendolyn DuBois. *Seeing the Unspeakable: The Art of Kara Walker*. Durham, NC: Duke University Press, 2004.

Simpson, Lorna. *Lorna Simpson*. New York: Harry N. Abrams in association with the American Federation of Arts, 2006.

Sims, Lowery Stokes. "Leslie King-Hammond: Sister, Mentor, Prime Mover." *International Review of African American Art* 18, no. 1 (2001): 34–35.

Sims, Lowery S., and Philippe De Montebello. "Twentieth Century Art." *Notable Acquisitions (Metropolitan Museum of Art)*, no. 1980/1981 (1980): 61–71.

Smith, Jessie Carney. *Images of Blacks in American Culture: A Reference Guide to Information Sources*. New York: Greenwood Press, 1988.

Smith-Shank, Deborah Lee. *Semiotics and Visual Culture: Sights, Signs, and Significance*. Reston, VA: National Art Education, 2004.

Smyers, Robyn Minter. "Re-Making the Past: The Black Oral Tradition in Contemporary Art." *International Review of African American Art* 17, no. 1 (2000): 47–53.

Spaid, Sue. "Assembling Africa." *Art in America* (1939) 85, no. 5 (May 1997): 46–53.

Stein, Judith. *I Tell My Heart: The Art of Horace Pippin*. New York: Universe, 1993.

Stuckey, Sterling. *Going Through the Storm: Influence of African American Art in History*. New York: Oxford University Press, 1994.

Taha, Halima. *Collecting African American Art: Works on Paper and Canvas*. Rev. ed. Burlington, VT: Verve Editions, 2005.

Teal, Harvey S. *Partners with the Sun: South Carolina Photographers, 1840–1940*. Columbia: University of South Carolina Press, 2001.

Thompson, Robert Farris. "Afro-Modernism." *Artforum* 30, no. 1 (September 1991): 91–94.

Turner, Steve, and Victoria Dailey. *William H. Johnson: Truth Be Told*. Los Angeles: Seven Arts Publishing, 1988.

Van Hoesen, Brett M. "The Short Century: Constructing a Contemporary Critical Biography of Africa." *New Art Examiner* (1985) 29, no. 3 (January–February 2002): 36–41.

Veneciano, Jorge Daniel. "Invisible Men: Race, Representation and Exhibition (Ism)." *Afterimage* 23, no. 2 (September–October 1995): 12–15.

Wahlman, Maude. *Signs and Symbols: African Images in African American Quilts*. Atlanta, GA: Tinwood, 2001.

Walker, Kara Elizabeth. *After the Deluge*. New York: Rizzoli, 2007.

Walker, Kara Elizabeth, Ian Berry, and Frances Young Tang. *Kara Walker: Narratives of a Negress*. Saratoga Springs, NY: Frances Young Tang Teaching Museum and Art Gallery at Skidmore College, 2003.

Walker, Kara Elizabeth, Philippe Vergne, et al. *Kara Walker: My Complement, My Enemy, My Oppressor, My Love*. Minneapolis, MN: Walker Art Center, 2007.

Walker, Kara Elizabeth, Robert F. Reid-Pharr, Thelma Golden, and Annette Dixon. *Kara Walker: Pictures from Another Time*. Ann Arbor: University of Michigan Museum of Art, 2002.

Washington, Johnny. *A Journey into the Philosophy of Alain Locke*. Westport, CT: Greenwood Press, 1994.

Weathers, Diane. "Images of an Era, 1976–1996." *International Review of African American Art* 13, no. 2 (1996): 13–27.

Weems, Carrie Mae. *In These Islands: South Carolina, Georgia*. Tuscaloosa: University of Alabama, Sarah Moody Gallery of Art, 1995.

———. *Carrie Mae Weems: Recent Work, 1992–1998*. New York: George Braziller in association with Everson Museum of Art, Syracuse, 1998.

Weems, Carrie Mae, Thomas Piche, Jr., and Thelma Golden. *Carrie Mae Weems: Recent Work, 1992–1998*. New York: George Braziller in association with Everson Museum of Art, Syracuse, 1998.

Weinstein, Jeff. "Yinka Shonibare." *Artforum* 40, no. 9 (May 2002): 174–75.

Wheat, Ellen Harkins, Jacob Lawrence, Patricia Hills, and Seattle Art Museum. *Jacob Lawrence, American Painter*. Seattle: University of Washington Press in association with the Seattle Art Museum, 1986.

Willis, Deborah. *Reflections in Black: A History of Black Photographers, 1840 to the Present*. New York: W.W. Norton, 2000.

Willis, Deborah, and Carla Williams. "The Black Female Body in Photographs from World's Fairs and Expositions." *Exposure* (New York) 33, no. 1/2 (2000): 11–20.

Wilson, Jackie N. *Hidden Witness: African American Images from the Dawn of Photography to the Civil War*. New York: St. Martin's Press, 1999.

Woodlaw, Alvia. *The Art of John Biggers: View from the Upper Room*. Houston, TX: Museum of Fine Arts in association with Harry N. Abrams, 1995.

Zeidler, Jeanne. "John T. Biggers, 1924–2001." *International Review of African American Art* 17, no. 3 (2001): 64.

Zeidler, Jeanne, and Samella Lewis. "Reflections on 20 Years of IRAAA: A Conversation with Samella Lewis." *International Review of African American Art* 13, no. 2 (1996): 4–12.

Index

About the Author

dele jegede is the Chairperson for the Department of Art at Miami University, Oxford, Ohio. He holds a Ph.D. in Art History from Indiana University, has published numerous articles, and has participated in many group shows and exhibitions.